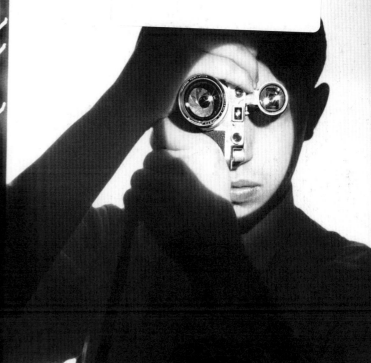
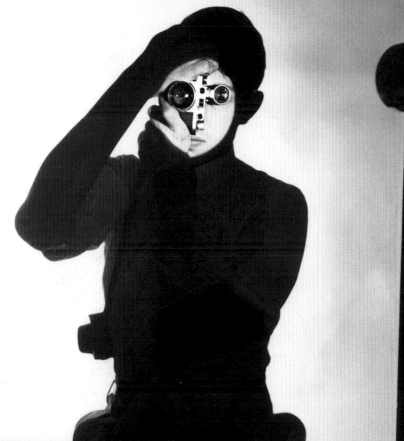
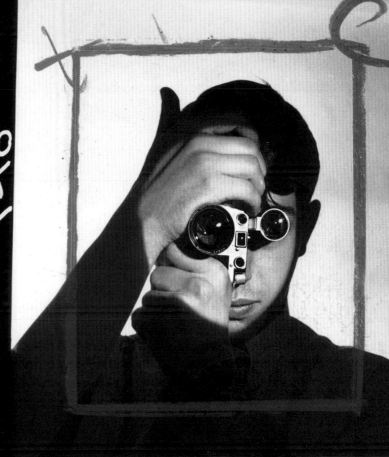

PHOTOGRAPHERS

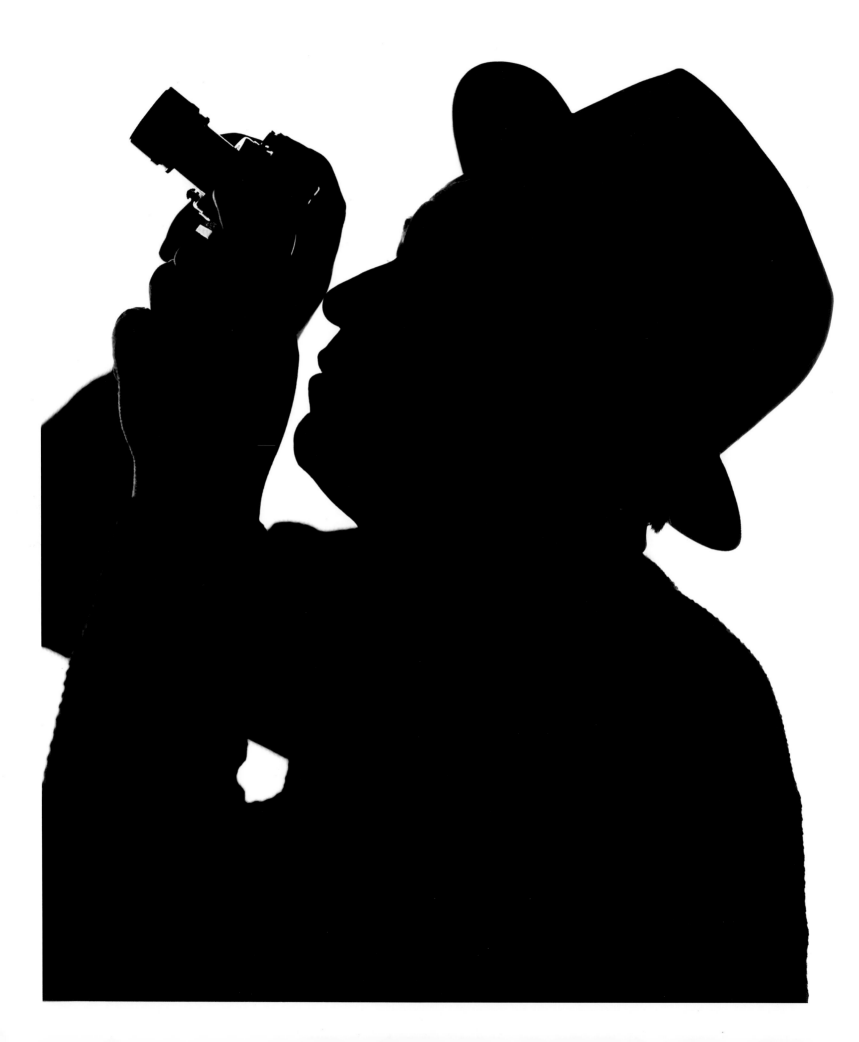

PHOTOGRAPHERS

MICHAEL PRITCHARD AND TONY NOURMAND

REEL ART PRESS

R|A|P
REEL ART PRESS

gettyimages®

For Alan and Lesley: words and pictures living together. Michael Pritchard

First published 2012 by Rare Art Press Ltd., London, UK.
www.reelartpress.com

ISBN: 978-0-9566487-7-8

Printed by Hampton Printing (Bristol), England.

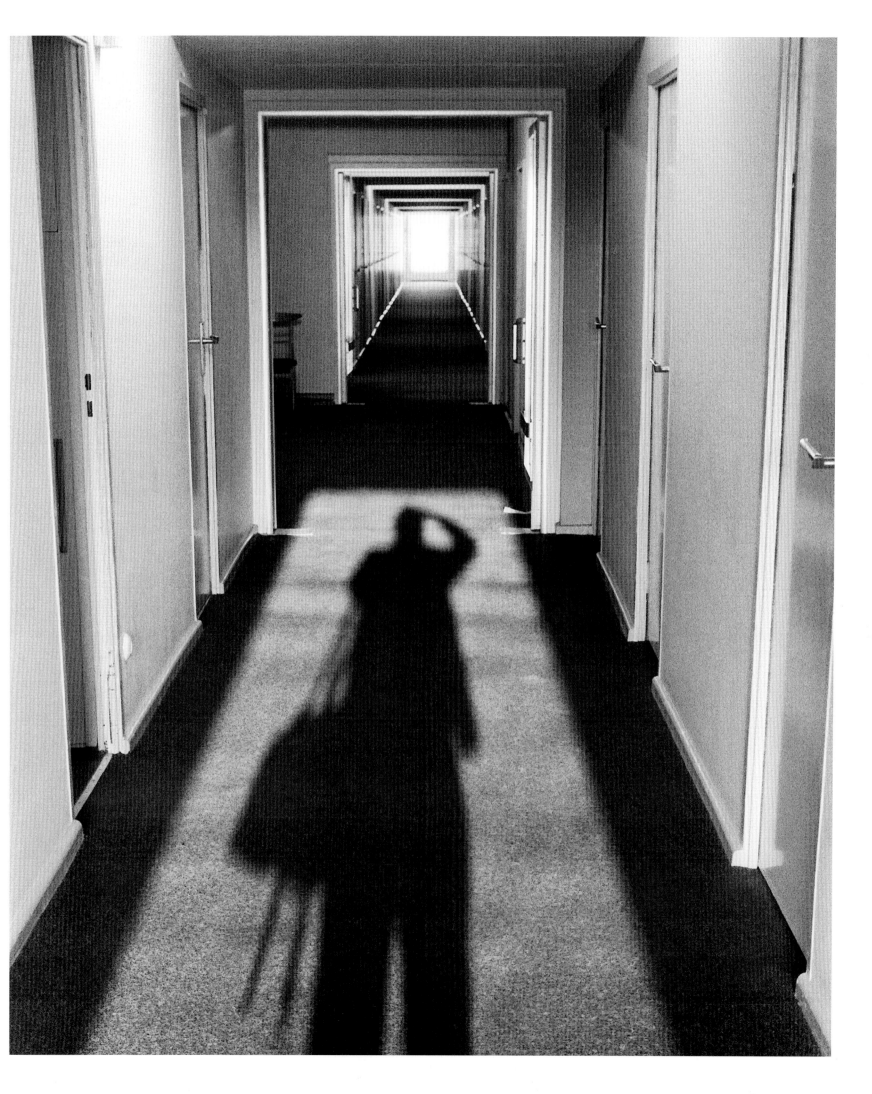

CONTENTS

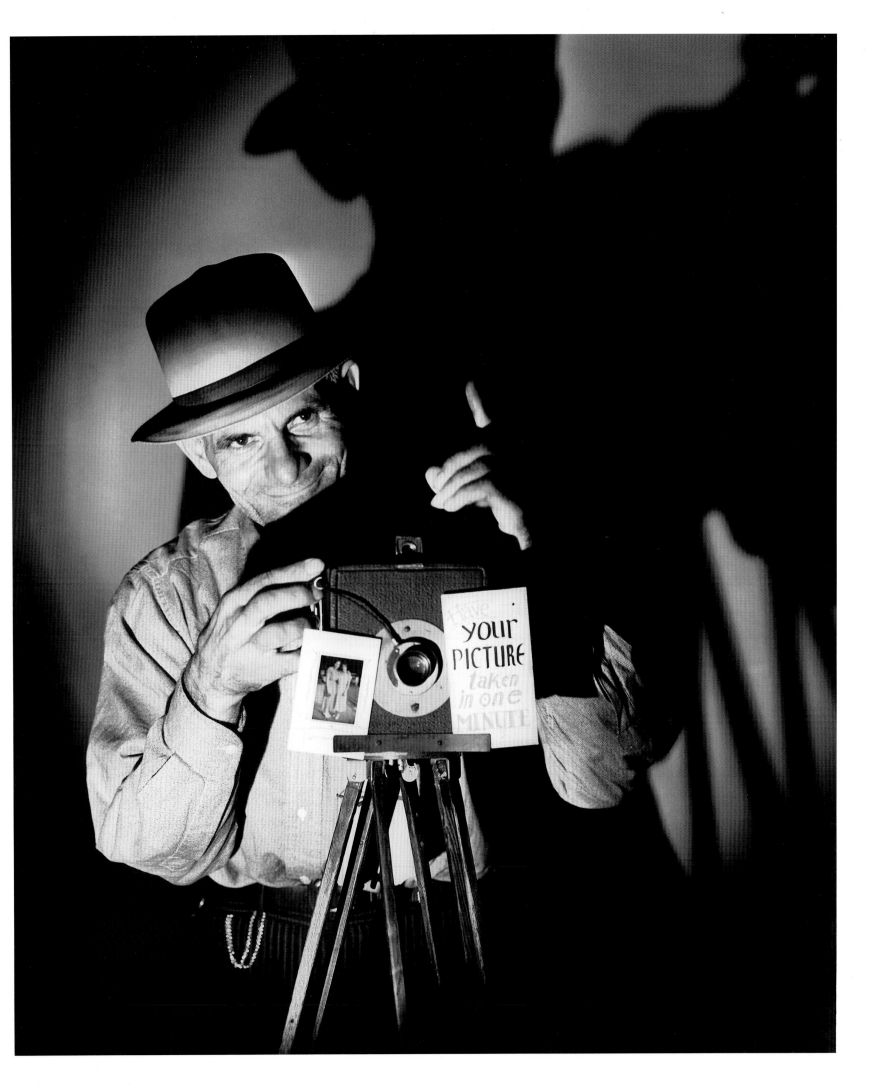

Edited by: **TONY NOURMAND**

Written by: **MICHAEL PRITCHARD**

Art direction and design by: **GRAHAM MARSH**

Text edited by: **ALISON ELANGASINGHE**

Layout by: **JOAKIM OLSSON**

p.2 **Clarence Sinclair Bull** (1896-1979). A silhouette portrait of American actor Stuart Erwin (1903-1967) holding a camera, 1935. *p.5* **Willy Ronis** (1910-2009). Self-portrait, East Berlin, Germany, 1967. *p.7* **Underwood & Underwood** (publishers). Street photographer, c.1930. *p.8* **Larry Schiller** (b.1936). Actress Ann Margret leans back to take a photograph on a Polaroid camera, c.1963. Margret (b.1941) is using a Polaroid Land 100-series camera which appeared in a number of models between 1963 and 1967 offering automatic exposure control. *Opposite:* A woman holding a Leica 35mm camera, c.1955. *p.22* **Weegee** [Arthur Fellig] (1899-1968). A group of photographers at an event in New York, c.1950.

Michael Pritchard is Director-General of The Royal Photographic Society in Bath, UK, where he is involved in running The Society, photographic education and acting as an advocate for photography and photographers. He was a director, photographic specialist and auctioneer at Christie's, London, for twenty years before leaving in 2007 to spend three years researching a PhD on the history of British photographic manufacturing and retailing.

He is a widely respected authority and commentator on the history of photography and the camera and has contributed to numerous books including *London Photographers 1841-1908* (1986, 1994), *Technology and Art* (1990), *Spy Camera* (1993), *The Oxford Companion to the Photograph* (2005), *Phaidon Design Classics* (2006), *Encyclopedia of Nineteenth-Century Photography* (2008), *Jubilee. 30 Years ESHPh* (2008) and *Photography, The Whole Story* (2012) and publications such as *The Ephemerist*, *The Guardian*, *History of Photography* and *Photographica World*. He continues to write, lecture and broadcast internationally on different aspects of photography and photographic history.

His website is at: www.mpritchard.com

Tony Nourmand is founder of Reel Art Press and editor of all R|A|P publications, including the critically acclaimed *The Rat Pack, Hollywood* and *The Ivy Look* and *The Kennedys: Photographs by Mark Shaw*.

Before launching Reel Art Press, Tony authored a further sixteen books on entertainment related imagery. They have sold over a million copies worldwide and are recognized as authoritative texts. Titles include *James Bond Movie Posters, Audrey Hepburn: The Paramount Years, The Godfather in Pictures* and *Stars and Cars*. He also co-authored *Hitchcock Poster Art* and co-edited a series of books with Graham Marsh on movie poster art by the decade and by genre.

Tony is also renowned as a world expert on original vintage film posters. He co-owned The Reel Poster Gallery in London for twenty years and was the Christie's, London, consultant for Vintage Film Posters.

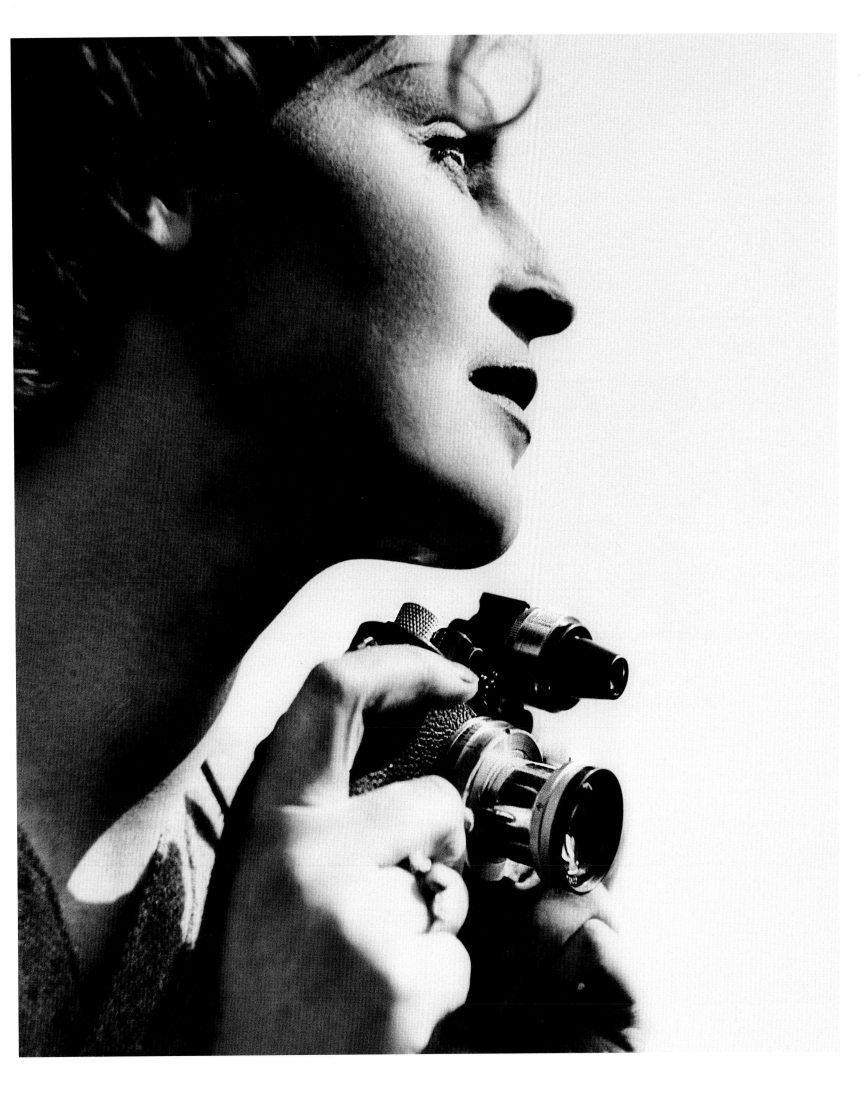

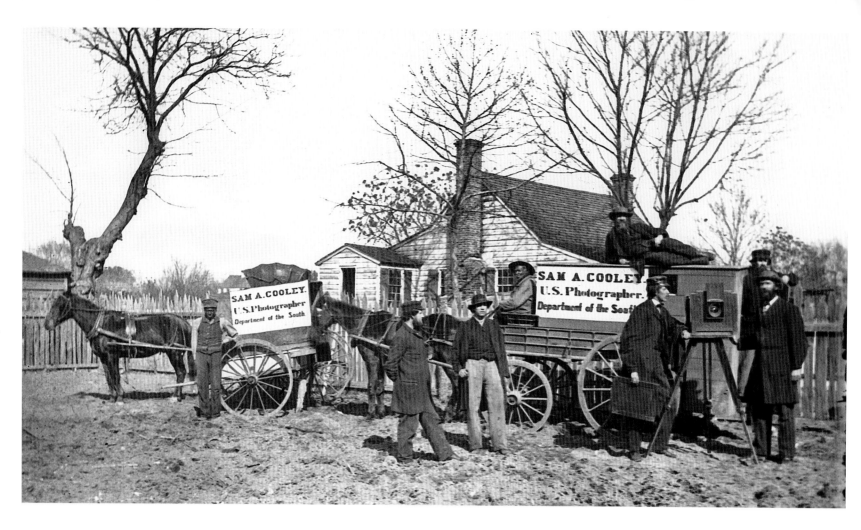

American photographer **Sam Cooley** with his camera on a tripod and assistants beside their photographic wagons used to transport their equipment and darkroom, c.1860.

INTRODUCTION

This book is about photographers. It takes a look at some of the men and women who took photographs for a living during the twentieth century: the anonymous and the well known; press, photojournalist and studio-based. It looks at some of the cameras that they used as well as the people they photographed.

We see amateur photographers all around us. Look around any city and tourists are taking pictures of themselves and sights on their cameras or camera-phones. Local residents are photographing each other in a bar or at a social occasion. These days, we barely give the photographer or his subject a second glance.

It is not just the snapshotter who is always present. In cities it does not take long before you find a huddle of paparazzi waiting for their next victim to emerge from a gallery opening, restaurant or party into a barrage of flash light from multiple cameras. At events, there will usually be an official photographer roaming around taking pictures of those attending. Elsewhere, press photographers corralled into groups can be waiting for a sportsman, politician or movie star to present themselves in a choreographed show of apparent spontaneity. Some will play up to the camera knowing that they and the photographer are part of an elaborate set piece, others do the minimum required and see it as a necessary evil. As the theorist Roland Barthes maintained, photography made the celebrity. And everyone, celebrity or not, seems to want Warhol's fifteen minutes of fame.

This is not a new phenomenon. In the mid-nineteenth century it was the photographer that was the centre of attention with his large and heavy cameras and processing equipment. A photographer on the street would be surrounded by adults and children looking at what he was doing and wanting to be part of the picture. Celebrities, which back then were writers, politicians, artists, church dignitaries, aristocracy or royalty, would present themselves at the photographer's studio by invitation and be photographed discretely away from the general public. Sometimes the photographer would pay for the right to photograph the subject – expecting that public sales of the photograph would bring in a profit. It was made available to the public through stationers, from the photographer's own studio, and by mail order. The *carte-de-visite* of the most famous sitters sold thousands.

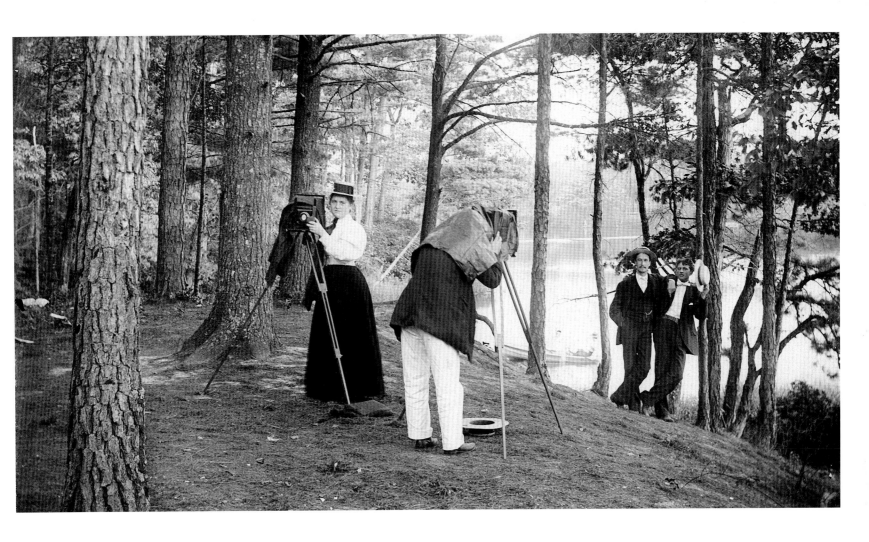

A changing relationship: So how and why did that relationship between the photographer and the subject change? By the 1880s, photographic technology enabled cameras to become smaller, lighter and more portable. They could be disguised and used more discretely. The impractical wet plate was superseded by dry plates and photographic emulsions became more sensitive. Photographs could be taken under conditions that had once been impossible. Most importantly, by the mid-1890s the camera was becoming an increasingly familiar sight. The local photographer was frequently present at special occasions and public events. Amateur and camera club photography boomed as the practice of photography became easier and more affordable and the burgeoning middle and lower classes looked for hobbies to fill newly available leisure time.

For the snapshotter – those people simply wanting to record family, friends and places they visited – the camera and film was not expensive or difficult. Taking a picture was, in the words of Kodak's advertising of the time, simply a case of, 'You press the button, we do the rest'. By 1905, some ten per cent of the United Kingdom's population, around four million people, took photographs. A camera in the hands of a press photographer might still attract attention but it was no longer the novelty that it had once been. Photography had become democratised.

New markets for photography: For the photographer, the market for photographs grew dramatically from the 1880s. The rise of illustrated magazines and increasingly newspapers looking to fill space created a demand for images of news events, celebrities and illustrations to accompany general features. Photographs had been the basis of printed illustrations since the early 1840s but the development of half-tone reproduction capable of being printed cheaply on high-speed presses transformed the demand for them. There was no longer a need to have photographs reinterpreted by an engraver for reproduction. Other methods of transferring photographs on to paper, such as the Woodburytype and later gravure printing, produced excellent results but were slow and expensive and consequently only had a limited application for high-quality publications such as fine-art reproductions.

In the United Kingdom, mass-circulation magazines such as *The Graphic*, *The Sphere* and *The Illustrated London News*, as well as weekly and daily newspapers, increasingly required

A woman amateur photographer adjusts her camera while her male accomplice photographs two men, c.1900.

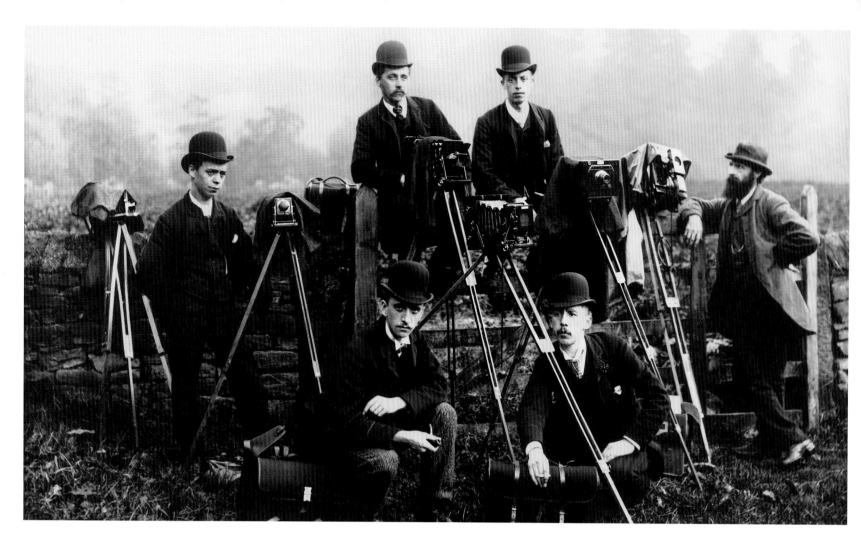

A group of British photographers in Cheshire, c.1910.

photographs to fill their pages. In the United States, *The Daily Graphic: An Illustrated Evening Newspaper*, which appeared in 1873, became the first newspaper with daily illustrations and the first to publish half-tone illustrations from 1880. *Collier's* magazine renamed itself in 1895 to *Collier's Weekly: An Illustrated Journal*, reflecting its use of half-tone illustrations. Other magazines, such as *The Saturday Evening Post* and *Harper's Weekly*, similarly made use of photographs although other forms of illustration continued to be used alongside them.

This rapid growth was repeated in the 1930s when a new range of weekly, illustrated magazines appeared to try and satisfy the public's demand for new photo-features and stories. In Britain, the greatest of these was *Picture Post*, which began publication in 1938 and continued until 1957. Its success was boosted by the Second World War, which lent itself to being reported by photography fuelled by the public's demand for information. In the United States, *Time* magazine commenced publication in 1923 and *The New Yorker* in 1925 but the greatest of them all, which made the best use of photography and picture stories, was *Life* magazine, commencing publication in 1936. *Picture Post* and *Life* – as well as similar publications in continental Europe and Asia – employed talented photographers and writers working together on stories.

Photographers and photography: A new type of specialised photographer appeared, the press photographer, and found a ready demand for his skills. He was able to work quickly away from a studio, often in demanding conditions, and had an ability to capture the shot. This style of photography was no longer simply an adjunct to a conventional studio photographer's work, although many studios undertook both. Companies were established – we would now call them press agencies – to syndicate and distribute newsworthy photographs and to meet the demand for pictures from the press. The ability to transmit half-tone photographs by telegraph or telephone had its origins in 1847 but it was not until 1908 that practicable systems became available. In 1921 Western Union, followed by others, demonstrated the first commercial system and ensured that newsworthy images could be sent around the world in a matter of minutes.

Developments in photographic technology supported this demand for photographs by further reducing previous technical constraints. New photographic emulsions improved sensitivity,

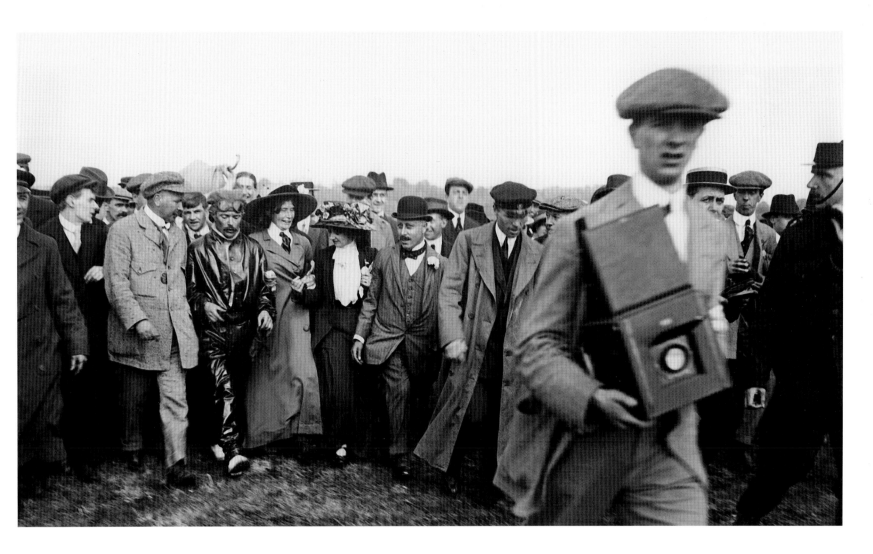

extending the hours in which photographers could secure an image. Cut film sheets and roll film, which had not previously been considered for serious commercial work, began to find favour as improvements in the stability of the film base and emulsion coating were made. Despite this, for many photographers the glass plate remained the medium of choice well in to the 1950s. These improvements were supported by the development of flash powder from the late 1880s and later, in the late 1920s, by the flash bulb powered by a battery, which gave photographers the ability to work indoors and at night. Electric light in photographic studios became increasingly widespread from the 1890s, negating the need to work only in daylight hours.

Cameras, too, changed. The introduction of the Leica camera in 1925, which used lengths of 35mm film to take forty or more exposures, supported the proto-photojournalist. It gave him the ability to capture new picture stories and make repeated exposures without the need to change his dark slide after two exposures. Improved photographic optics saw the introduction of larger aperture lenses allowing low-light photography.

Cinema and celebrity: The cult of celebrity has always been part of society. The growth of mass circulation publications in the nineteenth century had promoted and enhanced the public's awareness of individuals from the arts, politics and society. The theatre and music hall had provided celebrated actors, but it was the popularity of cinema that created a whole new group of people that the public, from all social classes, wanted to read about.

The first films from 1895 did not generally name the actors appearing in them but this changed as studios, producers and distributors realised that some actors were more popular than others and tried to capitalise on this. The first illustrated film magazines, such as *Motion Picture Story Magazine* and *Photoplay*, both launched in 1911, initially focused on the stories of the films they described. This shifted to the lives of the actors themselves, reflecting a desire from the public to know more about them. Photographs were essential to support this. News photographs from screenings and film premieres and portraits taken during interviews were published. The film companies saw the need to control their stars' image and had them photographed in studios or on set and controlled which to release.

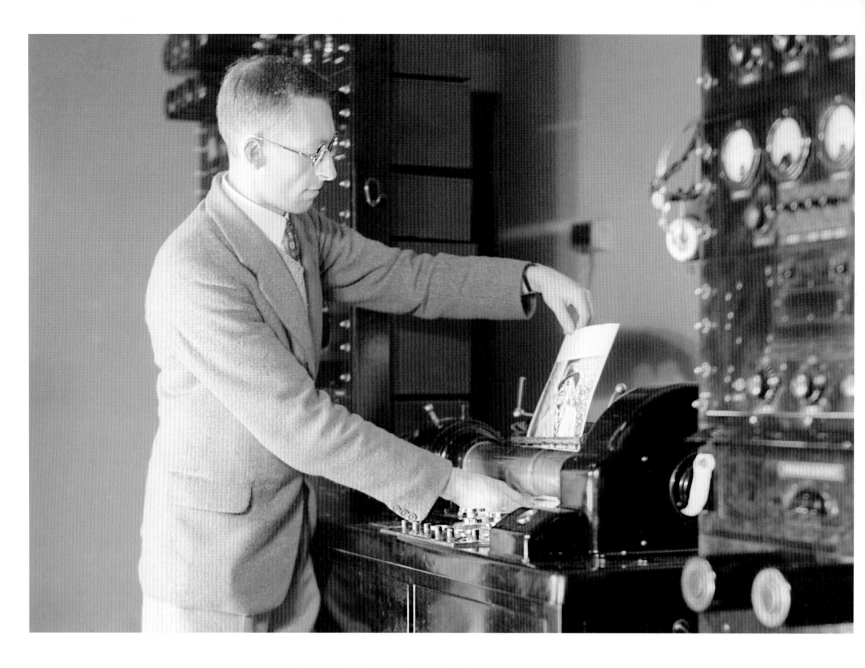

Chaloner Woods (dates unknown). A man sending a picture by wire machine, c.1938.

The rise of the Hollywood studio system in the 1920s through the so-called Golden Age of Hollywood between 1927-1949 reinforced the control the studios exerted over image and news. In Britain the Rank Organisation, formed in 1937, attempted to replicate this for its roster of stars, as did studios in France, Germany, Japan and Hong Kong. It was no coincidence that this period coincided with some of the best photography of film stars. Actors were the studios' greatest, and frequently most expensive, asset and their public image was an important investment to protect.

Public relations and news management: An appreciation of an individual's image was not confined to the film world. Public relations and image management was not new but it was not until 1897 that the term 'public relations' was first used in its modern sense. Effective news management came of age during the First World War and from the 1920s public relations firms grew – often employing individuals from the press who knew how to handle and manage their former employers. Companies and individuals made use of their services. Managing the press and controlling what, how and when it reported was aided by the introduction of the press release, widely believed to date from 1906. This could present a particular slant on a 'news' story. Words were just part of this. When they were supported by a carefully selected photograph, the chances of the text being used rose as journalists simply re-wrote the text and used the supplied image.

What this book is about: This book addresses the overall themes of this history. It looks at the photographer, his cameras and his celebrity subjects. Unsurprisingly, it concentrates on the movie world. It concentrates on the period from around 1910 to the 1960s, with a particular emphasis on the 1930s to 1960s which was, in many respects, the heyday of the press and celebrity photographer.

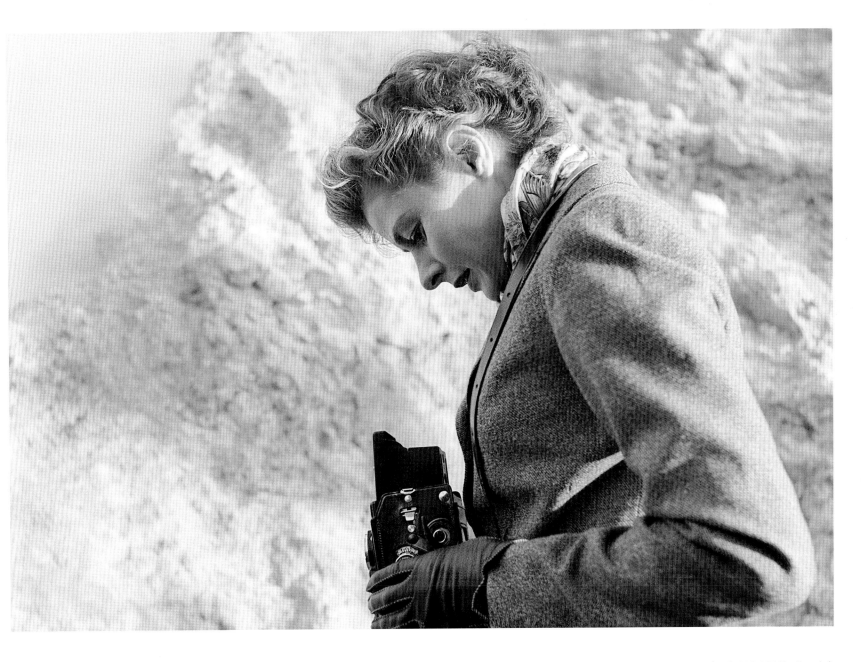

Bert Hardy (1913-1995). Swedish actress Ingrid Bergman takes a photograph during a break from filming *Journey to Italy* in Naples, 1953.

The photographer: The press photographer is captured as an individual and in groups preparing to shoot their subject or in the act of doing so. It shows many individual photographers from *Life* magazine and *Picture Post*. It includes the photojournalist, of which Robert Capa, Larry Burrows and Don McCullin are perhaps three of the best known, with their images of war becoming familiar to successive generations. Photographers from the Magnum Photos cooperative, probably the world's best-known grouping in the world, are led by Henri Cartier-Bresson and Philippe Halsmann amongst others. Other photographers, some of whom are rarely seen in front of the camera, include J. H. Lartigue, Tony Ray Jones, David Bailey, Arnold Newman and the ubiquitous Weegee amongst many. Most, though, are anonymous and are included because the photograph is distinctive or the subjects are representative of their contemporaries.

The cameras: The changes to the photographic camera were in part a response to the need for more photographs of people and events that the public wanted to read about. While the studio photographer's equipment did not change significantly other than in the materials it was made from, the cameras used by the photojournalist changed enormously. The Leica camera was part of this. The original model of 1925 quickly evolved in to one capable of taking different lenses and a whole range of accessories. The introduction of the Leica M3 in 1954 was the first substantive change to the original design and offered the photographer bayonet-mounting lenses and other modifications that were designed to improve and speed up the picture-taking process. The Leica was joined by competitors, of which Zeiss Ikon's Contax range, introduced in 1932, was the best known. Although the Zeiss lenses it used were amongst the best, the camera had a reputation for unreliability and was never popular with professional photographers.

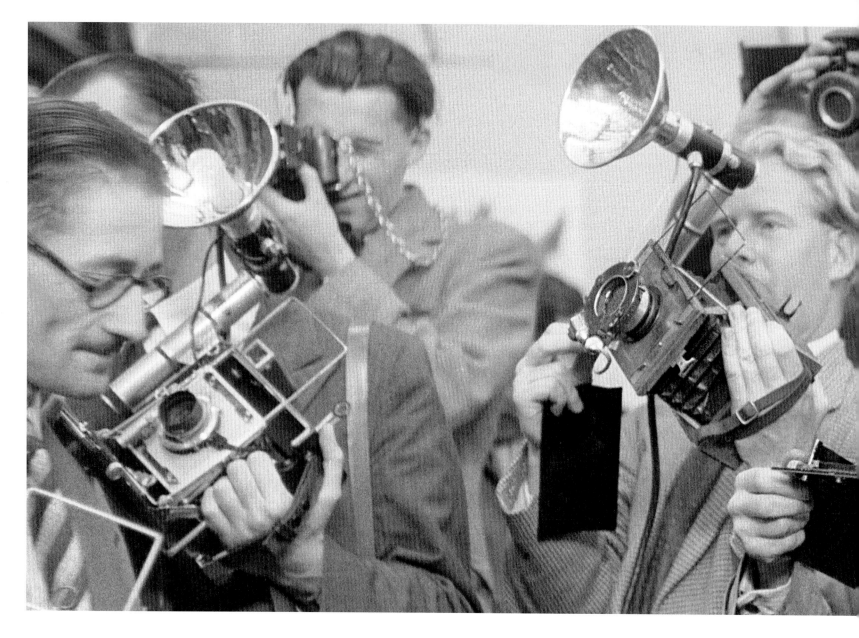

After the Second World War, the Japanese 35mm camera began to dominate and photojournalists began to adopt the Nikon rangefinder camera, which acquired a reputation for the quality of its lenses. Photographers working in Japan during the American occupation up to 1952, and in the Korean and Vietnam conflicts, quickly discovered the camera and returned home with it. The introduction of Nikon's single lens reflex camera – the Nikon F – in 1959, further transformed the tools of the trade and the 35mm SLR quickly supplanted the larger and less versatile Rolleiflex camera.

Press photographers in the early twentieth century made use of the cameras then available, notably large wooden field cameras. As the reliability and the practical advantages of the plate reflex camera became clear, it became popular. The flatbed Speed Graphic camera, familiar through its large side-mounted flashgun, was also widely used pre- and post-1939, along with its post-war British competitor, the MPP. More compact was the twin-lens Rolleiflex camera, which had been introduced in 1929 and offered a 6 x 6cm (2¼ inch square) negative which bettered the Leica's 24 x 36mm format. The Rolleiflex evolved and by the 1950s offered a built-in light meter and wide aperture lenses. It was always constrained by its lack of interchangeable lenses, although other manufacturers offered twin lens reflex cameras with this feature.

The Rolleiflex and Speed Graphic cameras were the mainstay of the press photographer's kit and the Leica and Nikon were those of choice for the photojournalist for all of this period. There were other cameras in use but they never quite matched the popularity of these marques. For the photographer working within a studio, where the size and weight of the camera was less of a problem, even these had often given way by the 1960s to medium-format and 35mm cameras for shooting people and fashion, as studio pictures left behind the formality of the

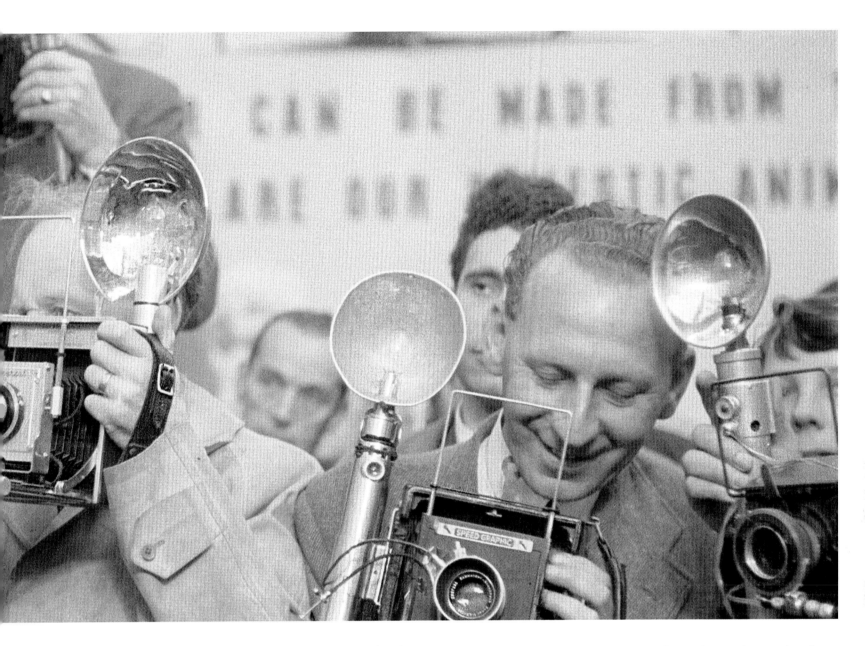

past and made way to an informality that has remained to this day.

The celebrities: The film world was so intrinsically bound up with celebrity, promotion and image management that it is inevitable that many of the images here show film stars on the set of a movie, at public events or in formal poses intended by the studio to show their star off in an appropriate way. The camera was frequently used as a prop to add interest to what might otherwise have been a very static shot. Less surprising is the fact that a number of stars were interested in photography and took their own photographs and home movies and had fun in photographing their contemporaries and other photographers. For sportsmen and politicians, the publicity photograph or set piece event was a necessary part of the job and the photographer important in recording the event.

What of the future? The following pages picture the heyday of the press photographer and the growth of celebrity. The wider interest of the public in famous people continues unabated and now seems an embedded part of modern society.

Except for a small number of celebrity photographers who have become known to a wider public, most photographers have become anonymous. The 'citizen journalist' shooting still and moving images on an iPhone is increasingly supplying images to websites and the press. Several picture agencies have deliberately courted the public and encouraged them to supply them with their celebrity images. The growth of magazines picturing and writing about celebrities – however loosely that term might be used – suggests that the public still want to see and read about famous people. The internet has made millions more of these images available and far more easily distributed than ever before. A trend that has been around for more than a century does not look like abating any time soon.

Michael Pritchard

Press photographers gather for a shot of the 'Queen of Leather' during the National Leather Week Exhibition at Earls Court, London, 10 October 1953.

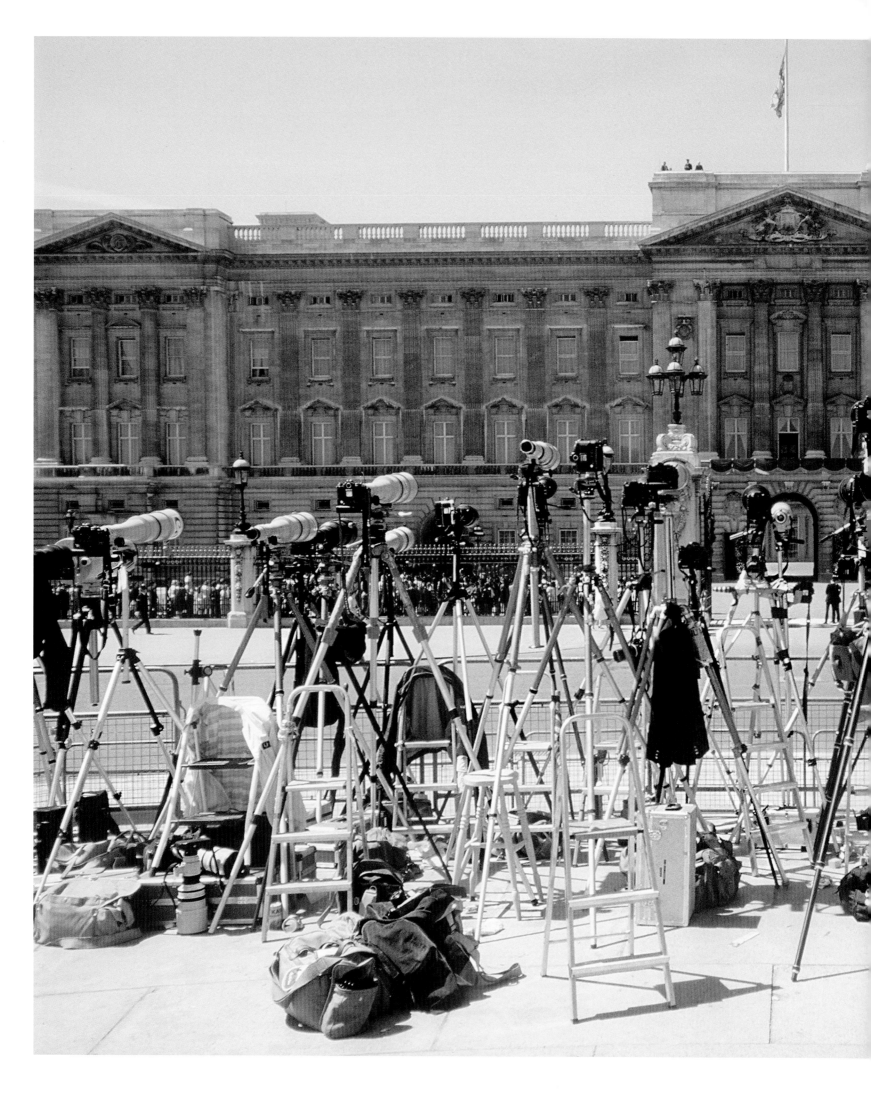

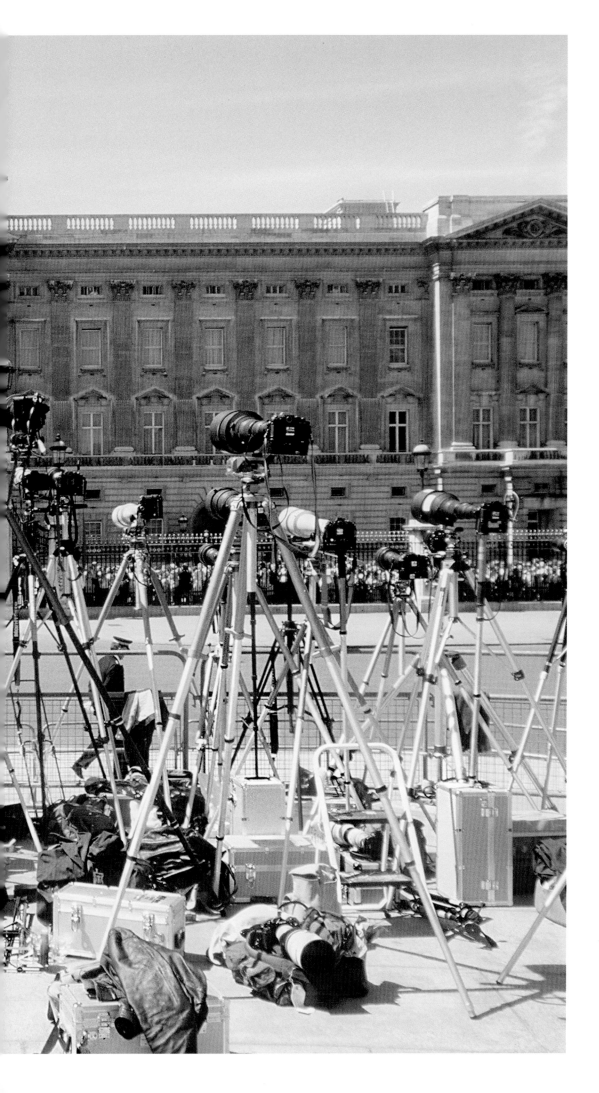

Tim Graham (b.1948). Photographic equipment left by members of the media outside Buckingham Palace, c.1990s.

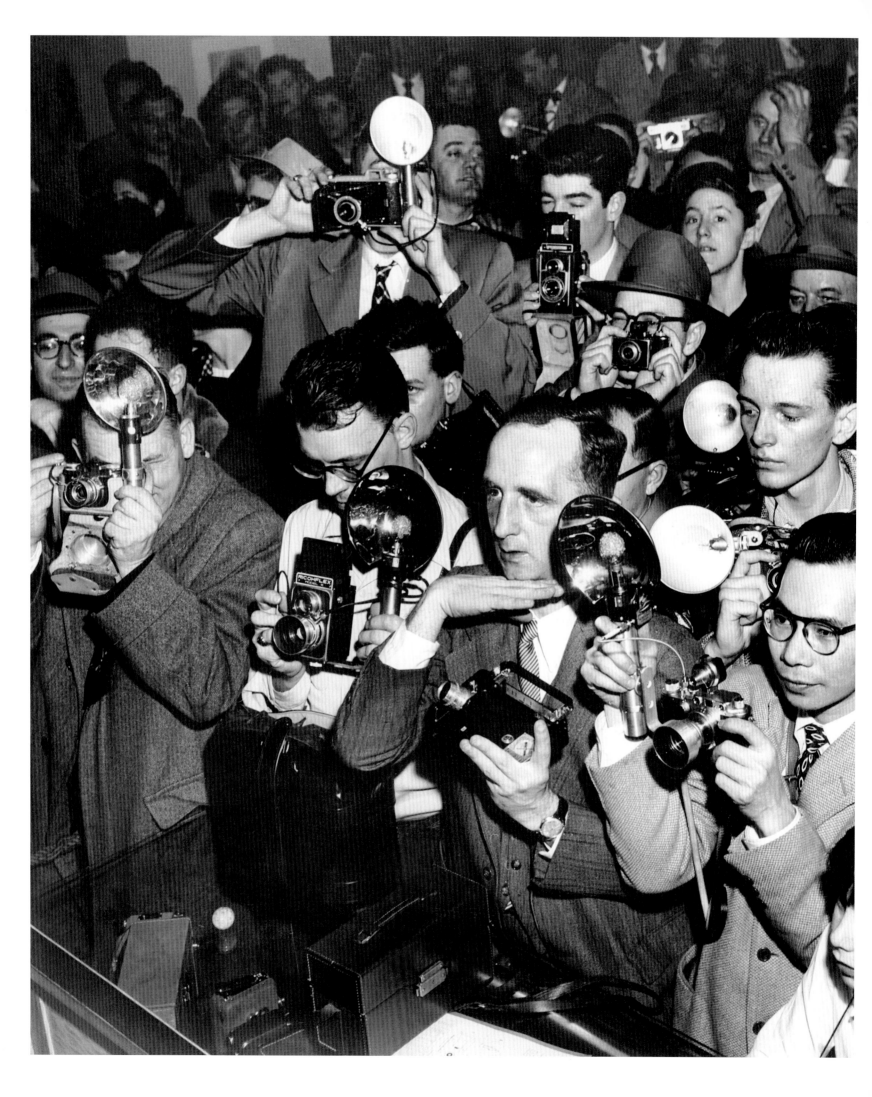

THE PHOTOGRAPHERS

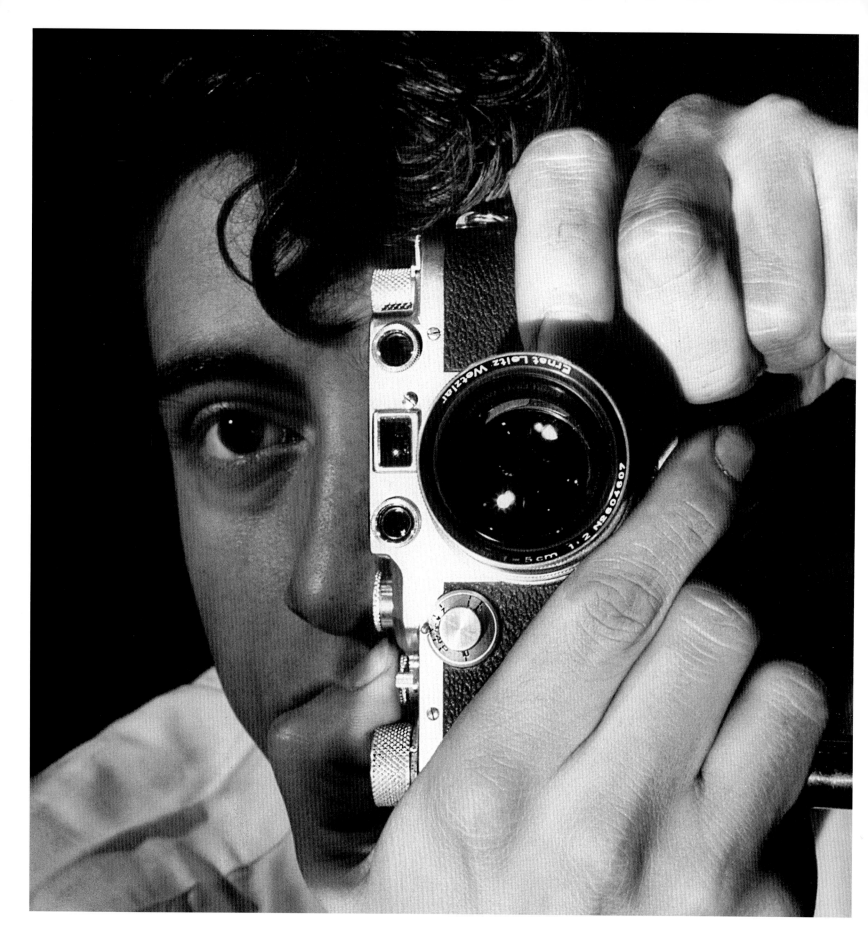

Andreas Feininger (1906-1999). Portrait of Dennis Stock, 1951. The American photojournalist and Magnum Photos member Dennis Stock (1928-2010) was photographed by Feininger for *Life* magazine in 1951 after Stock had won a competition for young photographers. Stock holds a Leica IIIc camera fitted with a Leitz Summitar 5cm f/2 lens dating from 1946. Stock became a full member of Magnum in 1954.

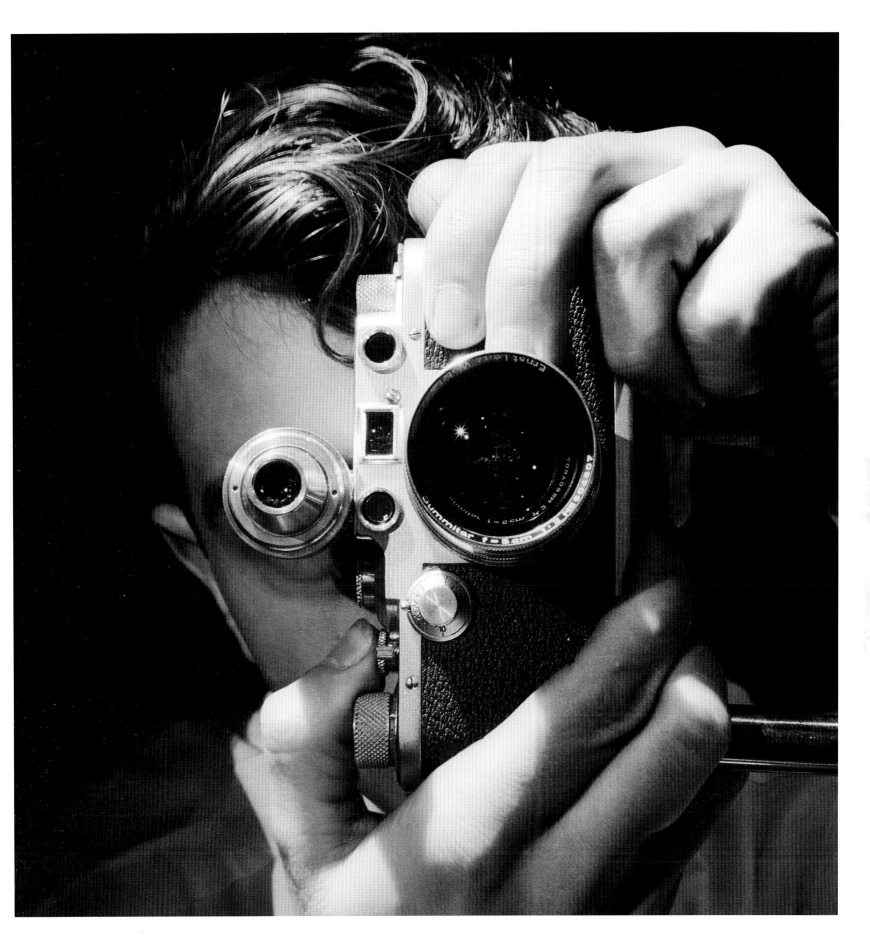

Andreas Feininger (1906-1999). Portrait of Dennis Stock, 1951. Feininger was born and educated in Germany, later moving to Sweden. Just before the outbreak of war in 1939, Feininger emigrated to the United States where he worked as a freelance photographer. He joined the staff of *Life* magazine in 1943, remaining with it until 1962. He wrote a number of respected photographic manuals and technical books.

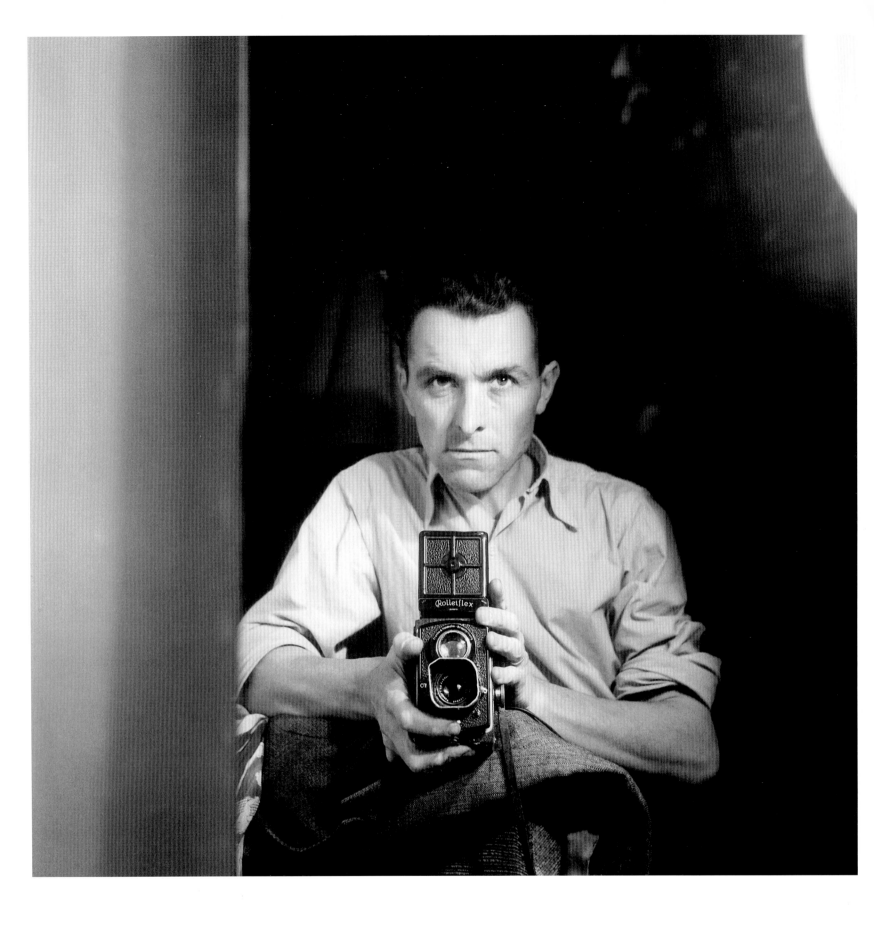

Robert Doisneau (1912-1994). Self-portrait, 1947. Doisneau sold his first photo story in 1932 to *Excelsior* magazine and joined Renault as an industrial advertising photographer in 1934. In 1939 he joined Charles Rado's photographic agency, Rapho, and began the street photography work for which he would became best known. Doisneau is shown with a Rolleiflex twin lens reflex camera rather than the Leica with which he is more usually associated.

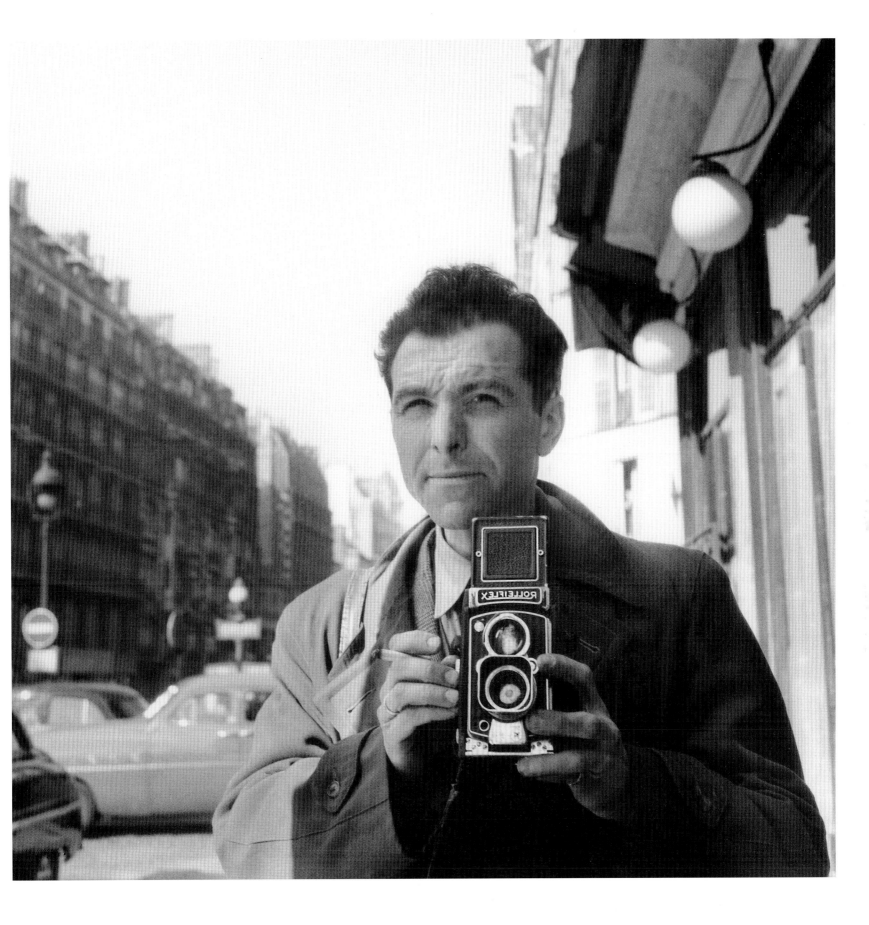

Robert Doisneau (1912-1994). Self-portrait, March 1953. After war service with the French resistance, Doisneau returned to freelance photography. He sold photographs to *Life* and other international magazines and rejoined the Rapho agency in 1946, remaining with it throughout his career despite receiving an invitation from Henri Cartier-Bresson to join Magnum Photos. Doisneau's best-known image, *Le baiser de l'hôtel de ville* (Kiss by the Hôtel de Ville), of 1950 was shot for *Life* magazine.

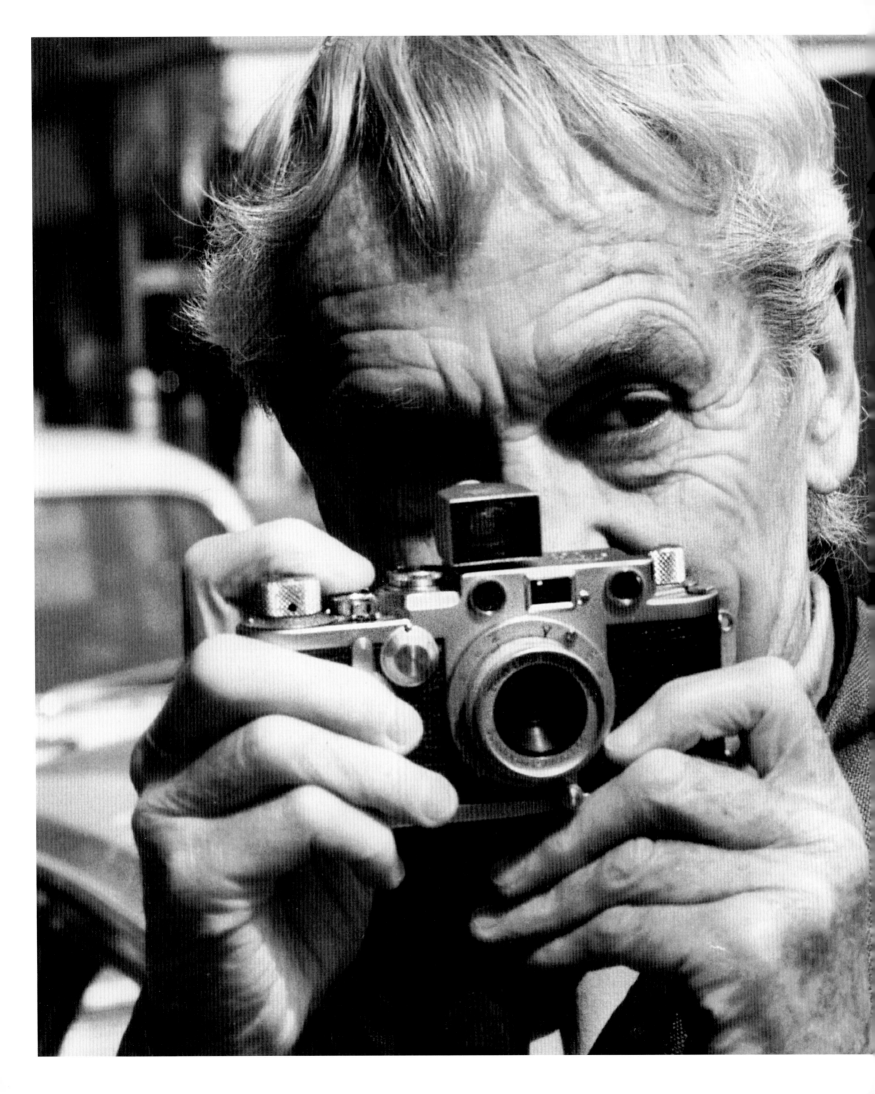

Victor Drees (c.1915-1985). Jacques-Henri Lartique, 18 June 1971. Lartigue (1894-1986) started taking photographs when he was 7 years old and is best known for his pictures of motorcars and fashionable women. His early work was rediscovered when he was 69 years old and his photographic career was resurrected. He is shown holding a Leica IIIf camera with a top-mounted 35mm optical viewfinder.

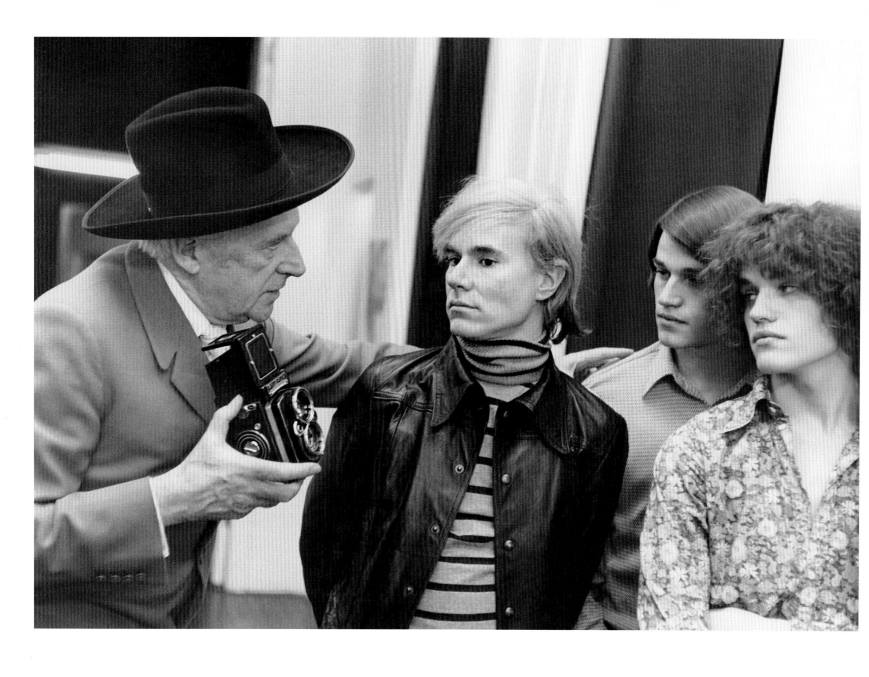

Above: **Fred W. McDarrah** (1926-2007). Photographer Cecil Beaton with Andy Warhol and Jed and Jay Johnson at The Factory, New York, 24 April 1969. McDarrah was the staff photographer for the New York *Village Voice,* recording the Beat generation and New York counter culture. *Opposite:* **Fred W. McDarrah** (1926-2007). Photographer Cecil Beaton takes photographs in Andy Warhol's studio The Factory, New York, 24 April 1969. Cecil Beaton (1904-1980) was a costume designer, interior designer and photographer. He started photographing as a schoolboy and became a photographer for *Vogue* magazine in 1927. He was a staff photographer for both *Vogue* and *Vanity Fair.* For many years, Beaton was the official photographer to the British Royal Family. In this photograph he is shown with his Rolleiflex camera on a tripod and is holding a Pentax 35mm single lens reflex camera.

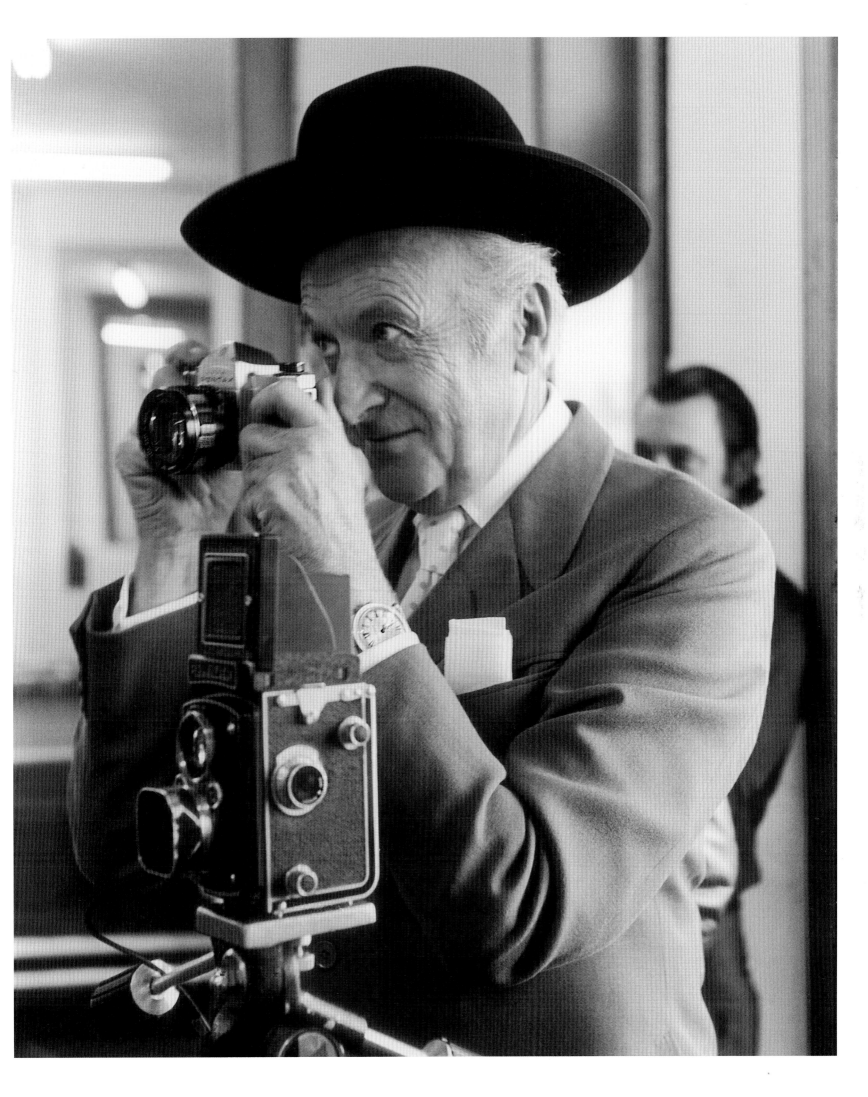

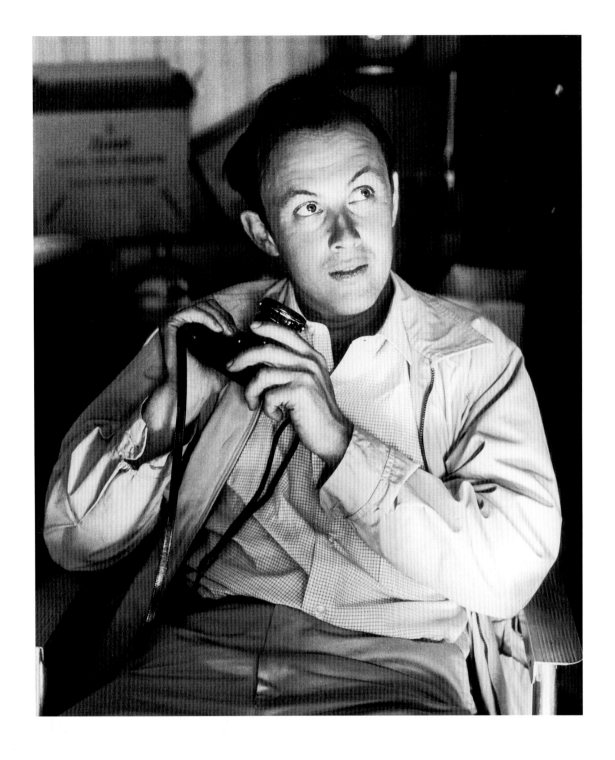

Above: **Ernst Haas** (1921-1986). Bruce Davidson, 1960. Davidson (b.1933) was assigned by Magnum Photos to document the making of *The Misfits*, which was being filmed in the Nevada desert near Reno in 1960. He holds his Nikon camera. The movie starred Clark Gable, Marilyn Monroe and Montgomery Clift and was directed by John Huston. Haas was a fellow member of Magnum Photos and was asked by Huston to direct the creation sequence for Huston's 1964 film, *The Bible. Opposite:* **Fred Stein** (1909-1967). Portrait of Robert Frank, 1954. Frank (b.1924) was born in Switzerland and moved to America in 1947. His 1958 book, *The Americans*, remains one of the most influential photo books documenting all strands of American society. He holds a pre-war Leica camera.

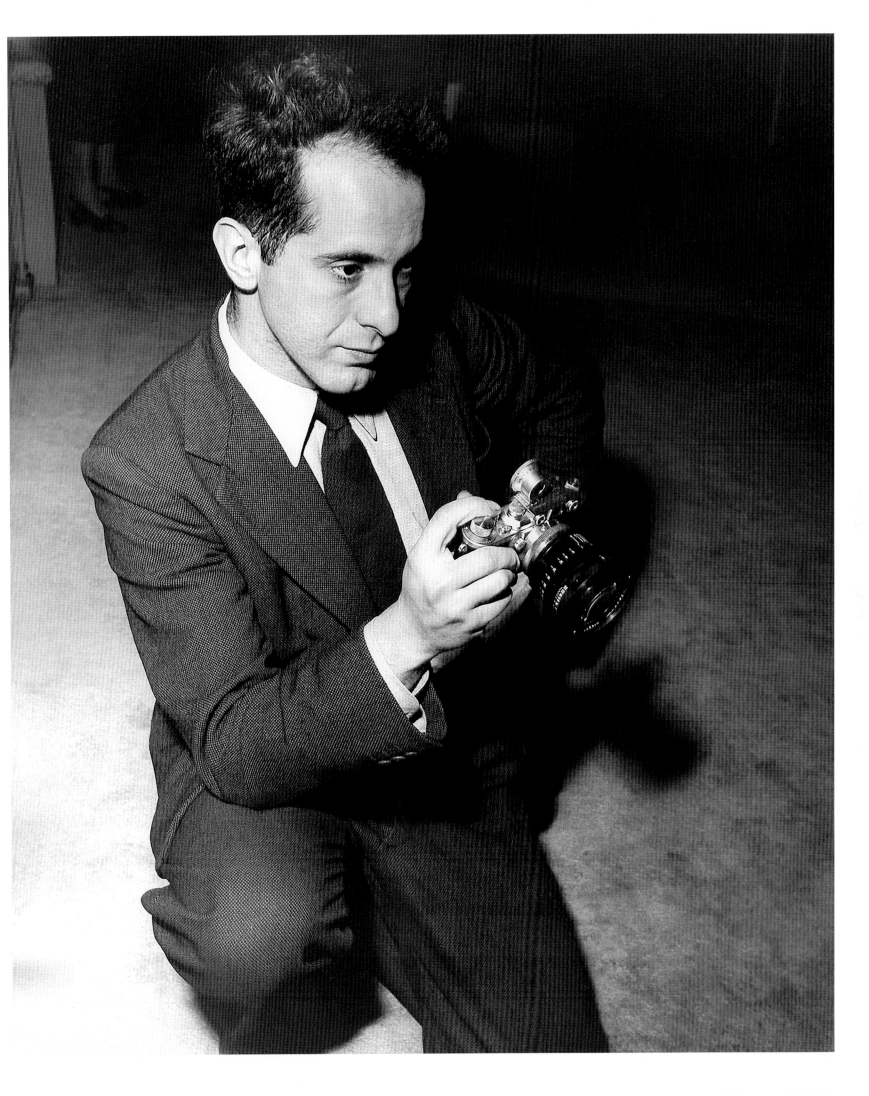

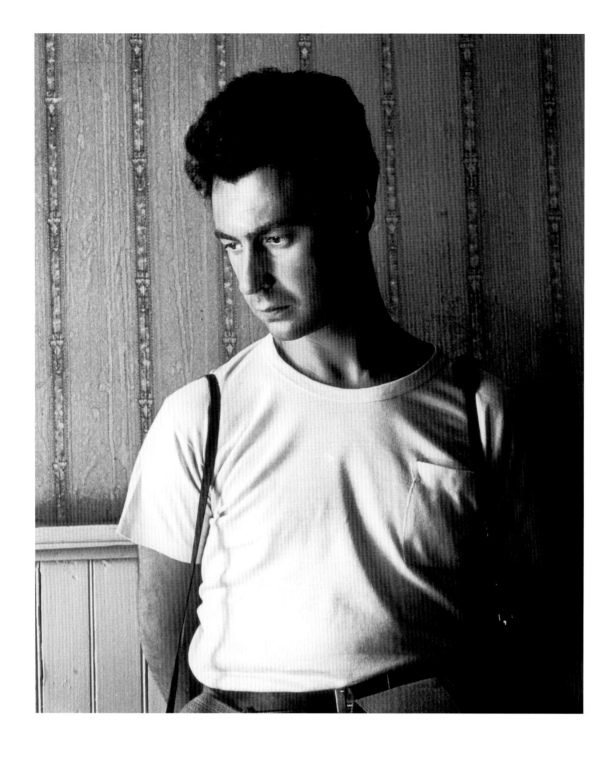

Above: **Ernst Haas** (1921-1986). Elliott Erwitt on the set of *The Misfits* in the Nevada desert, 1960. Erwitt's 35mm camera hangs off his shoulder. *Opposite:* **Ernst Haas** (1921-1986). Elliott Erwitt on the set of *The Misfits* in the Nevada desert, 1960. Erwitt (b.1928) joined Magnum Photos in 1953. He is shown here with a large format Graflex single lens reflex camera.

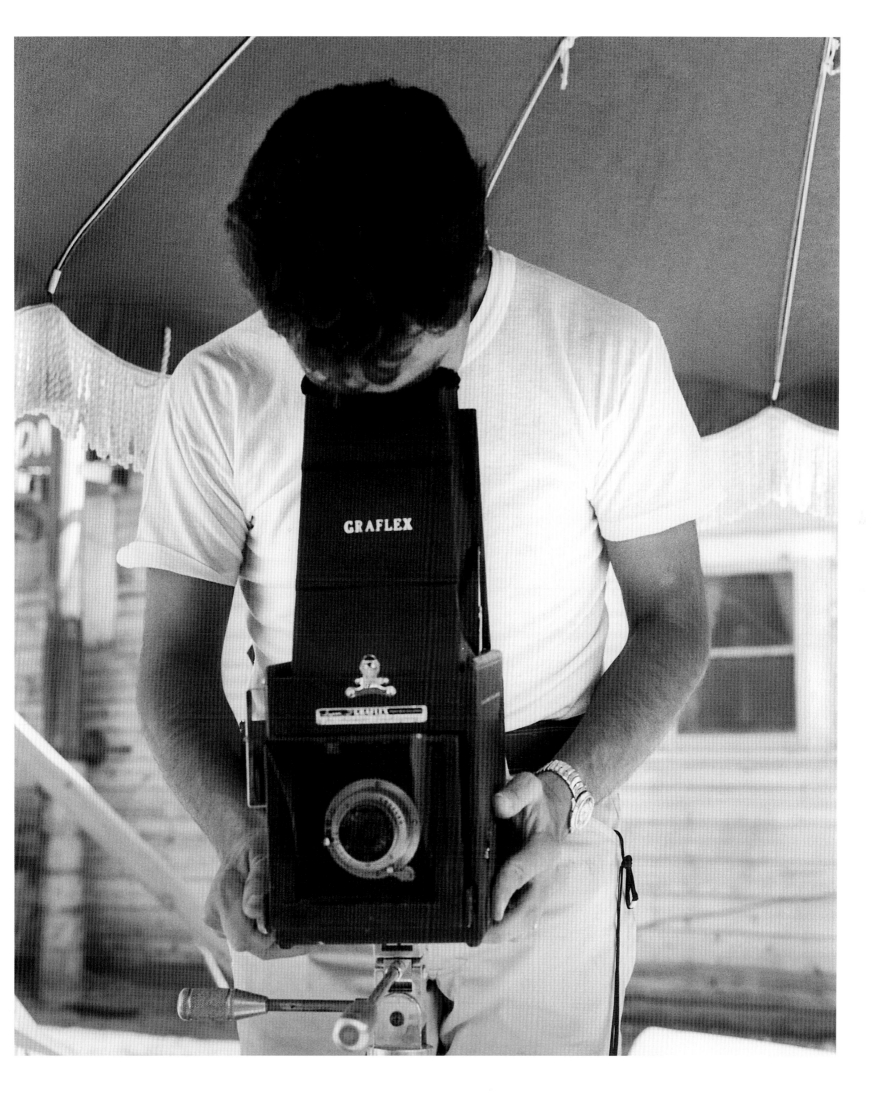

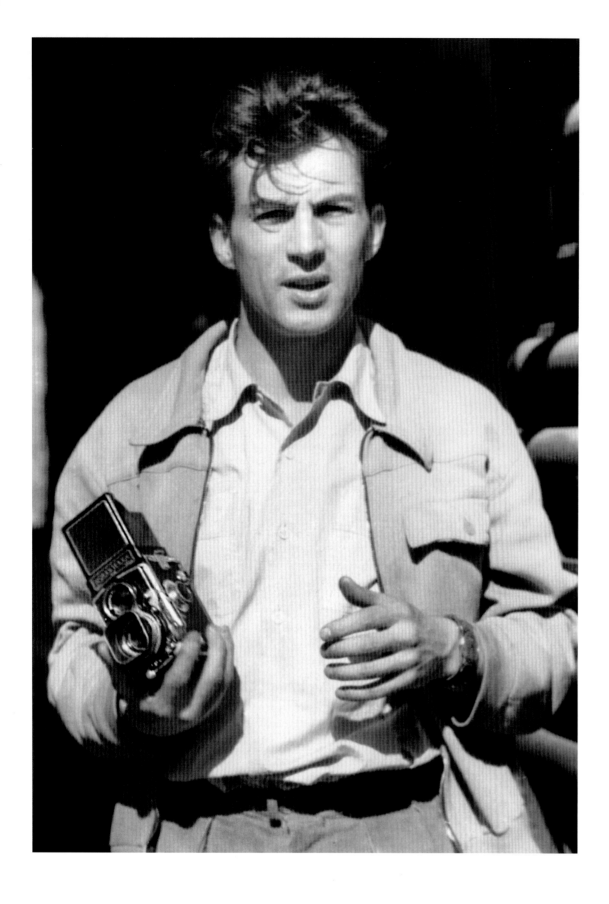

Above: **Ernst Haas** (1921-1986). Self-portrait with camera, Munich, 1948. Haas was a member of the Magnum Photos cooperative. He is holding a Rolleiflex camera. *Opposite:* **Ernst Haas** (1921-1986). A couple laugh at their distorted reflection in a Hall of Mirrors, 1952. Haas captures himself with his camera together with his subjects.

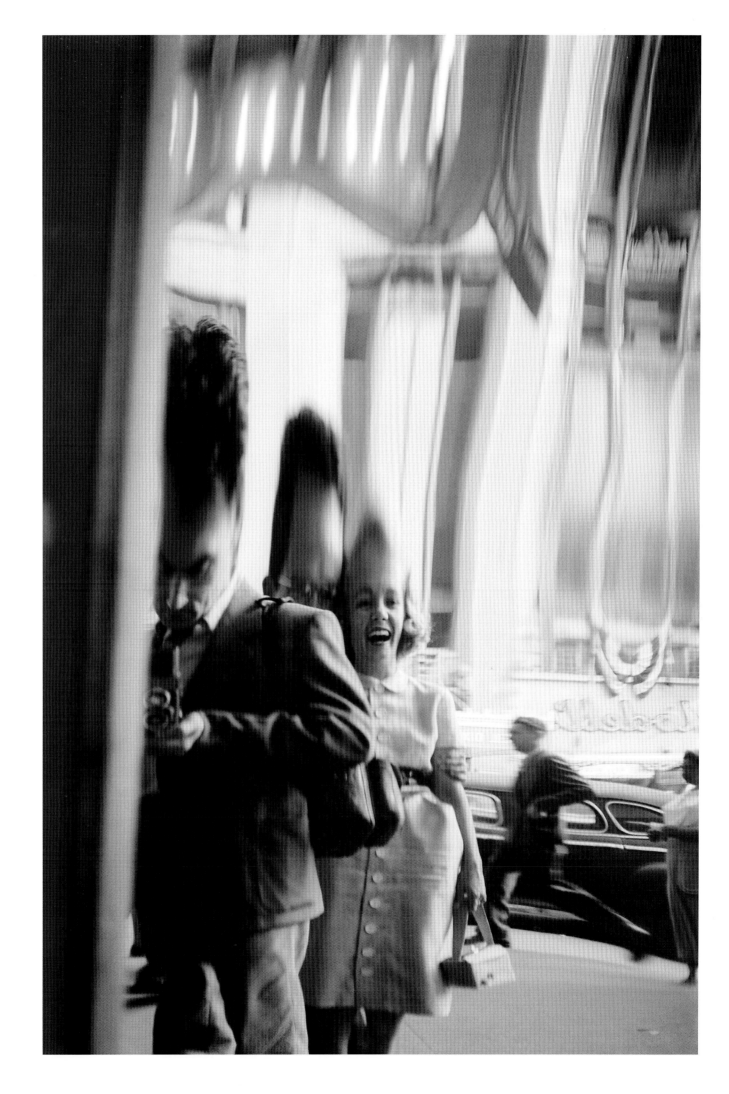

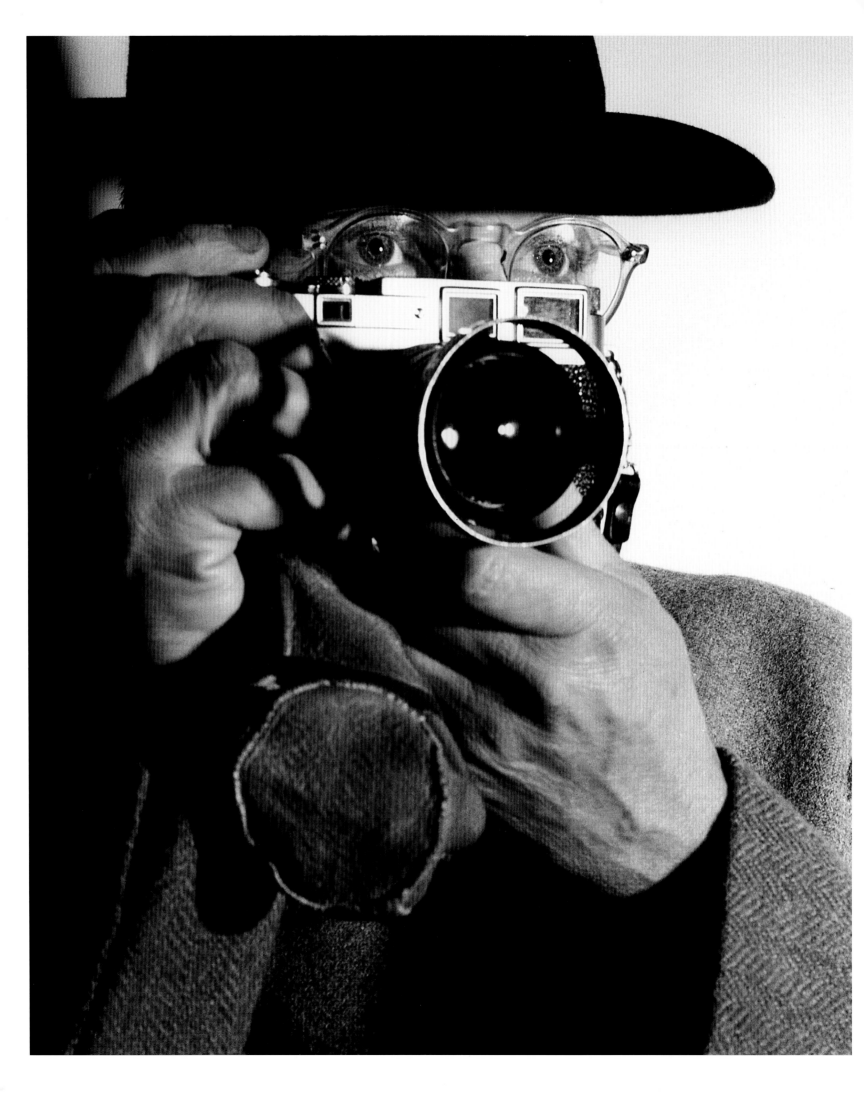

Opposite: **Dmitri Kessel** (1902-1995). Henri Cartier-Bresson, 1955. Kessel was a *Life* photographer who became a war correspondent in 1942. He was born in Russia, settling in New York in 1925. Kessel took a series of images of Cartier-Bresson with his Leica M3 camera that had been introduced the previous year. *Above:* **Arnold Newman** (1918-2006). Henri Cartier-Bresson in the doorway of a tenement building, New York, 7 January 1947. Cartier-Bresson (1908-2004) is considered the father of modern photojournalism and reportage photography. Newman developed a style of environmental portraiture capturing his subjects in their own surroundings and using it to show their personalities. He was one of only a few photographers that Cartier-Bresson – who had a reputation for being camera shy – allowed to photograph him. Newman took a series of portraits of him around New York. Cartier-Bresson has his cased Leica M3 over his shoulder.

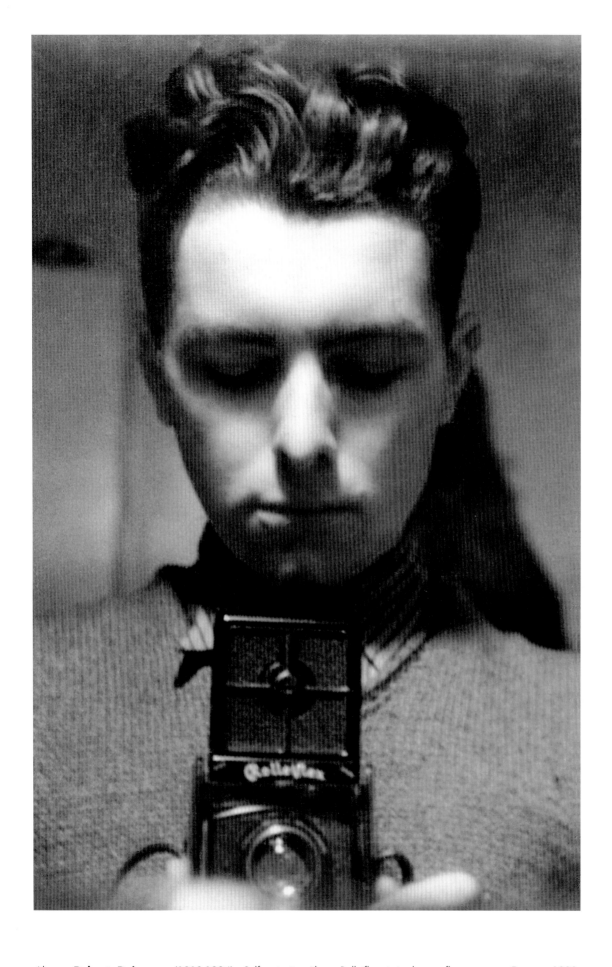

Above: **Robert Doisneau** (1912-1994). Self-portrait with a Rolleiflex twin lens reflex camera, France, 1932.
Opposite: **Pierre Jahan** (1909-2003). Self-portrait, c.1938. Jahan is using a German-made Bentzin 6 x 6cm Primarflex single lens reflex camera – a forerunner of the post-war Hasselblad camera.

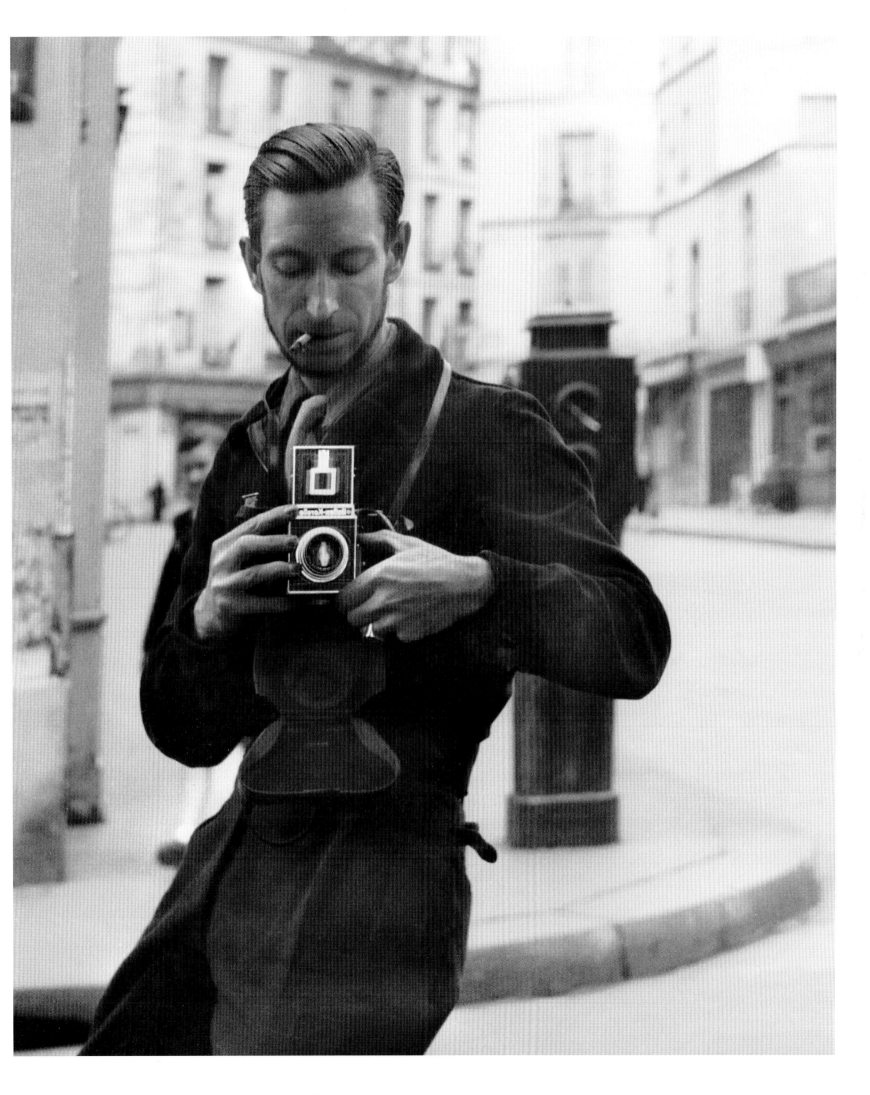

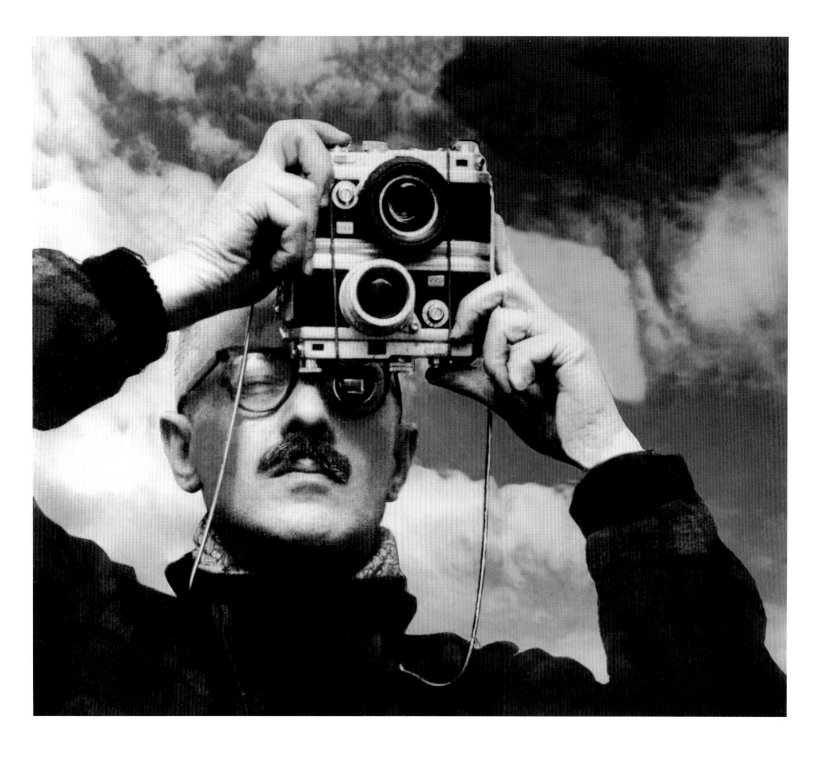

Above: **Willy Ronis** (1910-2009). Self-portrait, Mont-de-Marsan, France, c.1955. Ronis is shown holding two French-made Foca cameras mounted base to base. He was the first French photographer to work for *Life* magazine and his work was included in the ground-breaking *The Family of Man* exhibition in 1955. *Opposite:* **Willy Ronis** (1910-2009). Self-portrait, France, c.1951. Ronis has a twin lens reflex camera and is holding two lamps for illumination.

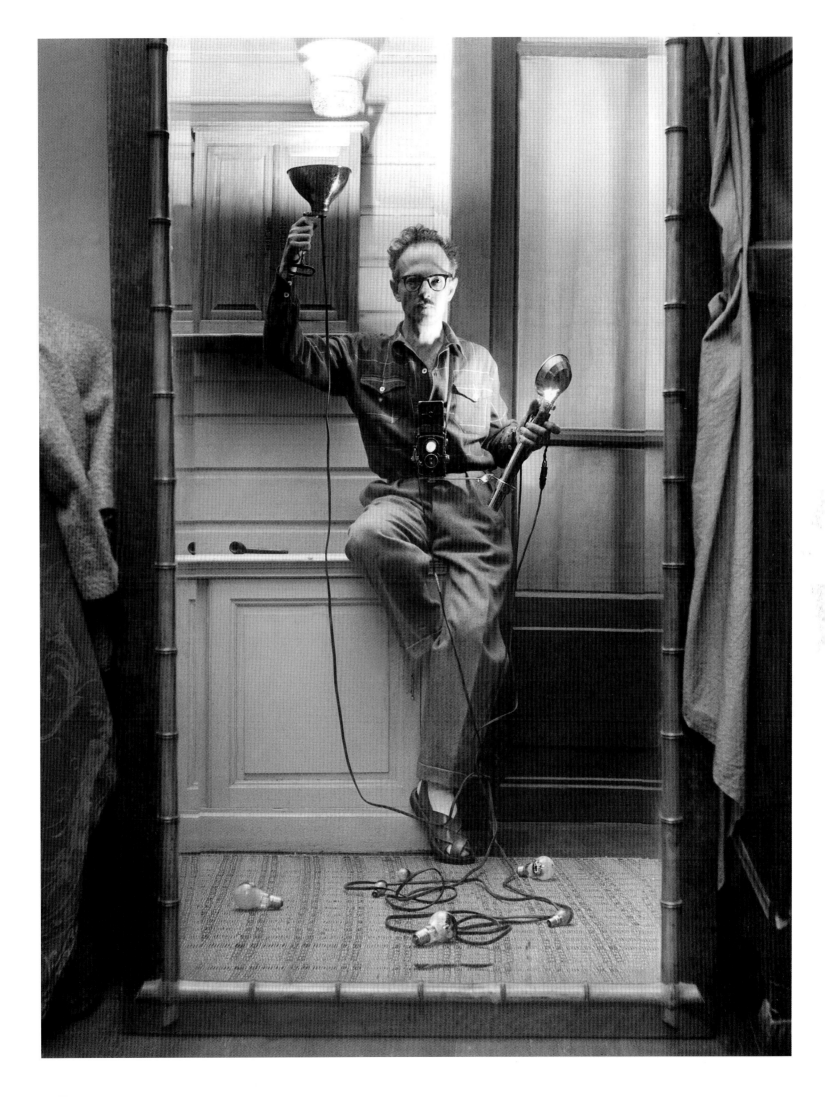

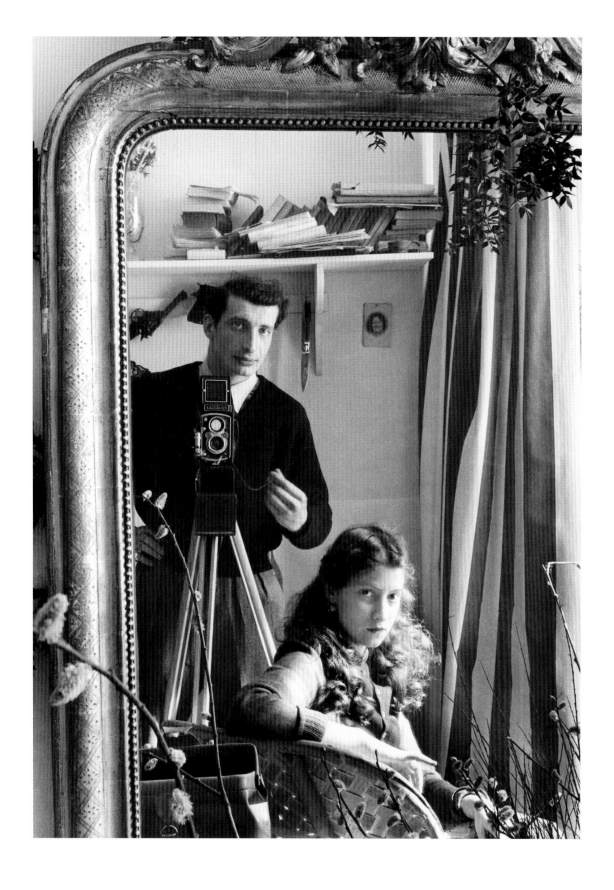

Above: **Édouard Boubat** (1923-1999). Self-portrait with Lella, Paris, 1952. Boubat took his first photograph in 1946 and was awarded the Kodak Prize the following year. He travelled the world for the magazine *Réalités* and he is shown with his Rolleiflex camera. *Opposite:* **Jean-Philippe Charbonnier** (1921-2004). Self-portrait with a film extra on the set of *Cyrano et d'Artagnan*, 1963. Charbonnier was a photographer and journalist.

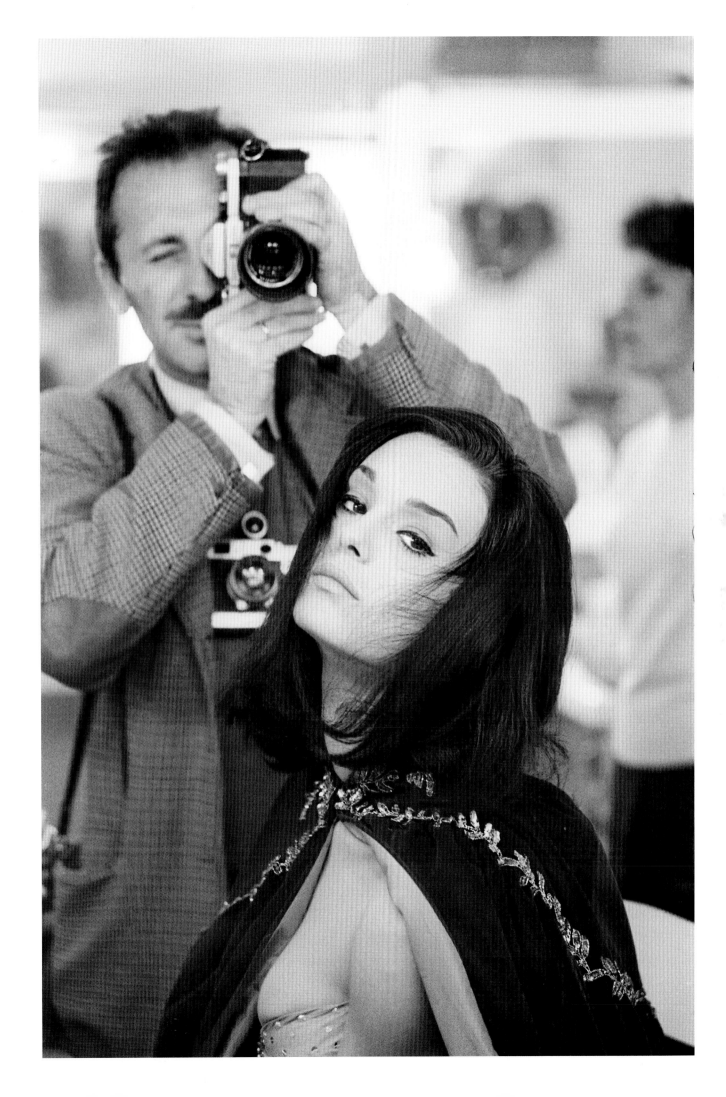

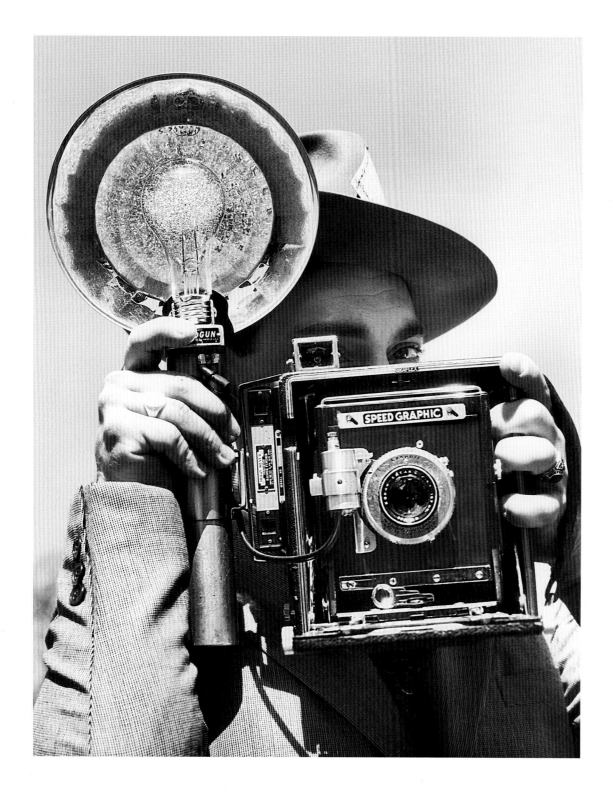

Above: **Harold M. Lambert** (1894-1963). Portrait of a photographer with his Speed Graphic camera and flash gun, 1955. *Opposite:* **Andreas Feininger** (1906-1999). Man with a Minox camera, c.1950. Feininger took a number of different views of his model with the Minox. The Minox was introduced in Riga, Latvia, in 1937. Production shifted to West Germany after the Second World War.

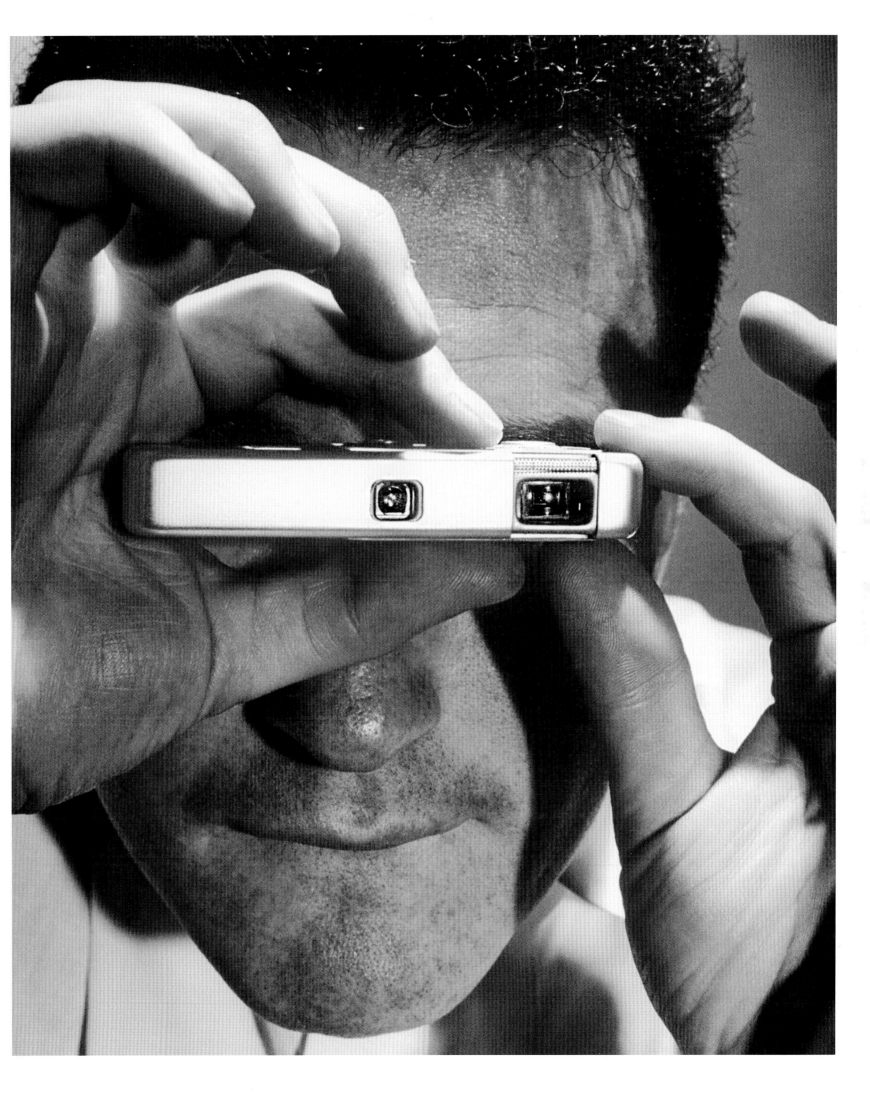

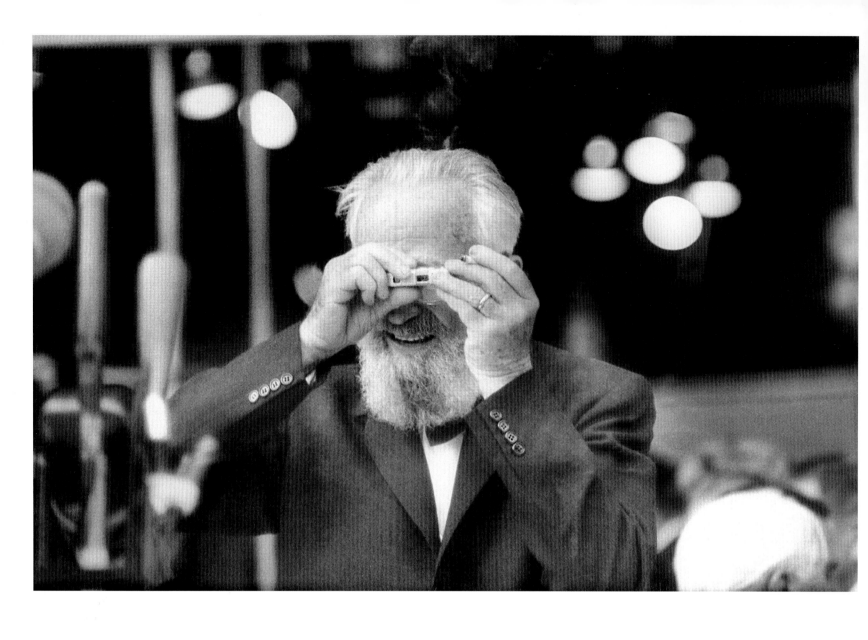

Above: **Howard Sochurek** (1924-1994). Portrait of Edward J. Steichen, 1959. Steichen (1879-1973) was an important art photographer in his own right during the early twentieth century. He became Director of the Department of Photography at New York's Museum of Modern Art in 1947, remaining until 1962. While at MoMa in 1955, he curated and assembled *The Family of Man* exhibition. He is shown holding a Minox 'spy' camera. *Opposite:* **Thiel** (dates unknown). A man with a subminiature camera, 11 February 1952. The sitter holds a Minox subminiature camera. Originally introduced in 1937, the Minox was re-introduced after the Second World War. It produced 8 x 11mm negatives or slides.

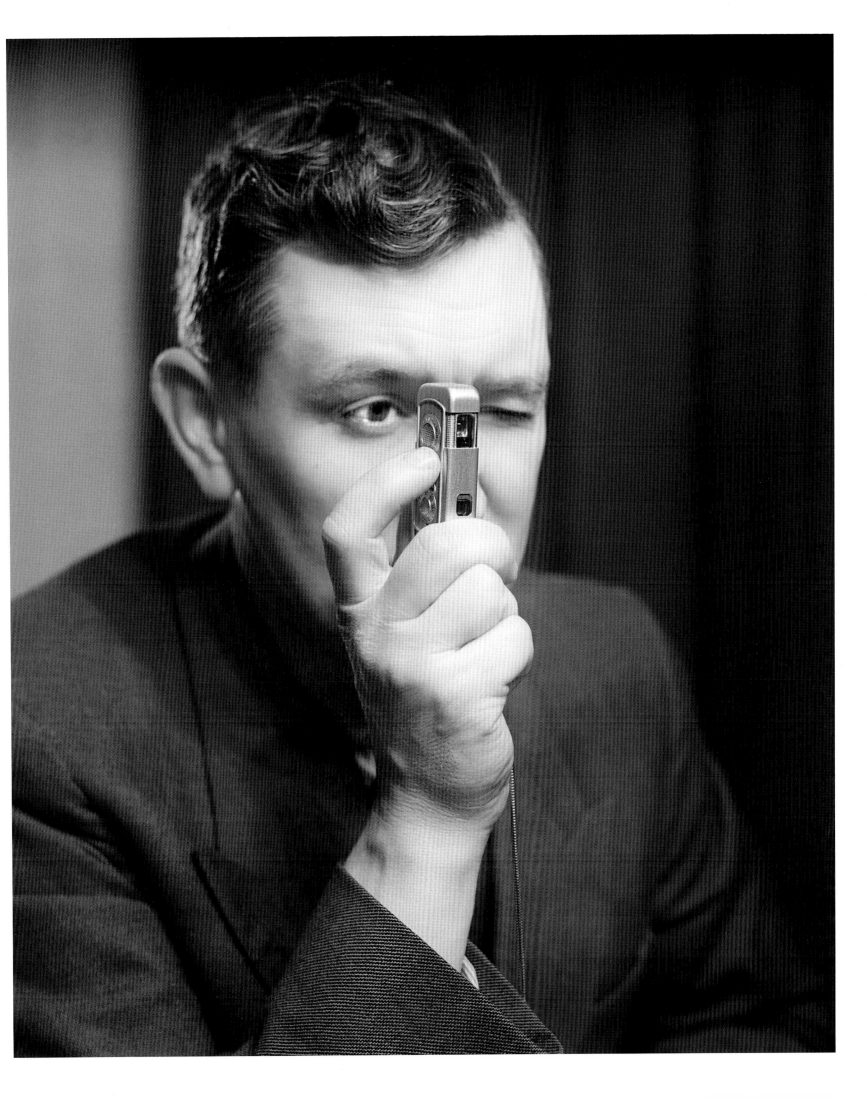

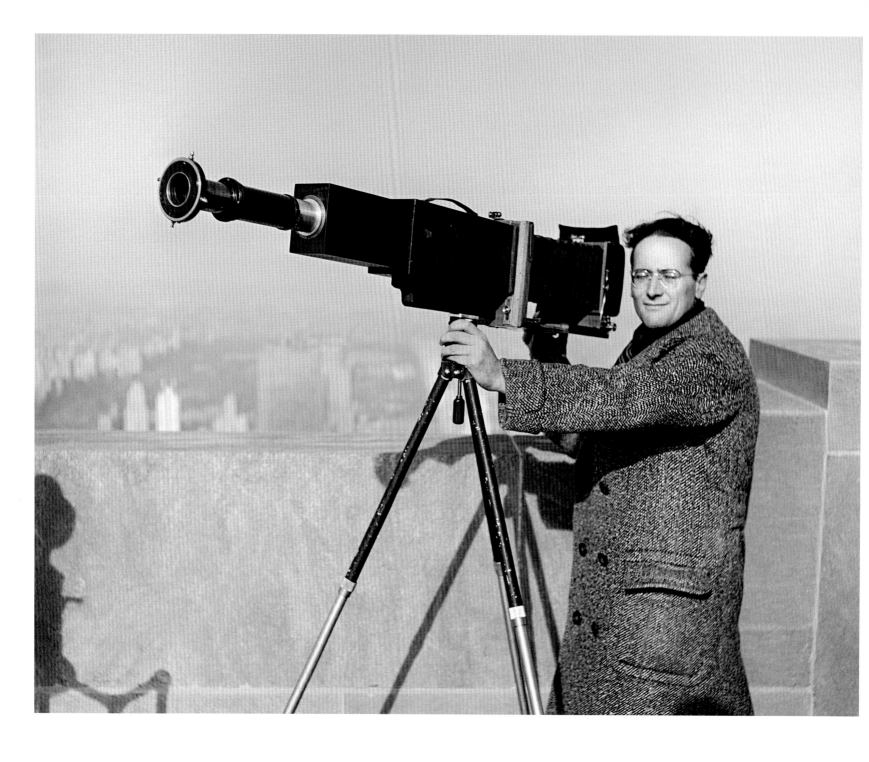

Above: **Ralph Morse** (b.1917). Andreas Feininger with his home-made camera, 1941. Feininger (1906-1999) designed the camera to accommodate a long focal length lens for capturing distant subjects. *Opposite:* Portrait of Andreas Feininger, 1941. Feininger (1906-1999) spent his formative years in Germany. He emigrated to the United States in 1939 and joined *Life* magazine in 1943, working for it until 1963. He became well known for his photographs of New York and for his pictures of science and nature subjects where he would often pick out distinctive shapes and patterns. He is shown in this picture – which may be a self-portrait – with his Contax II camera.

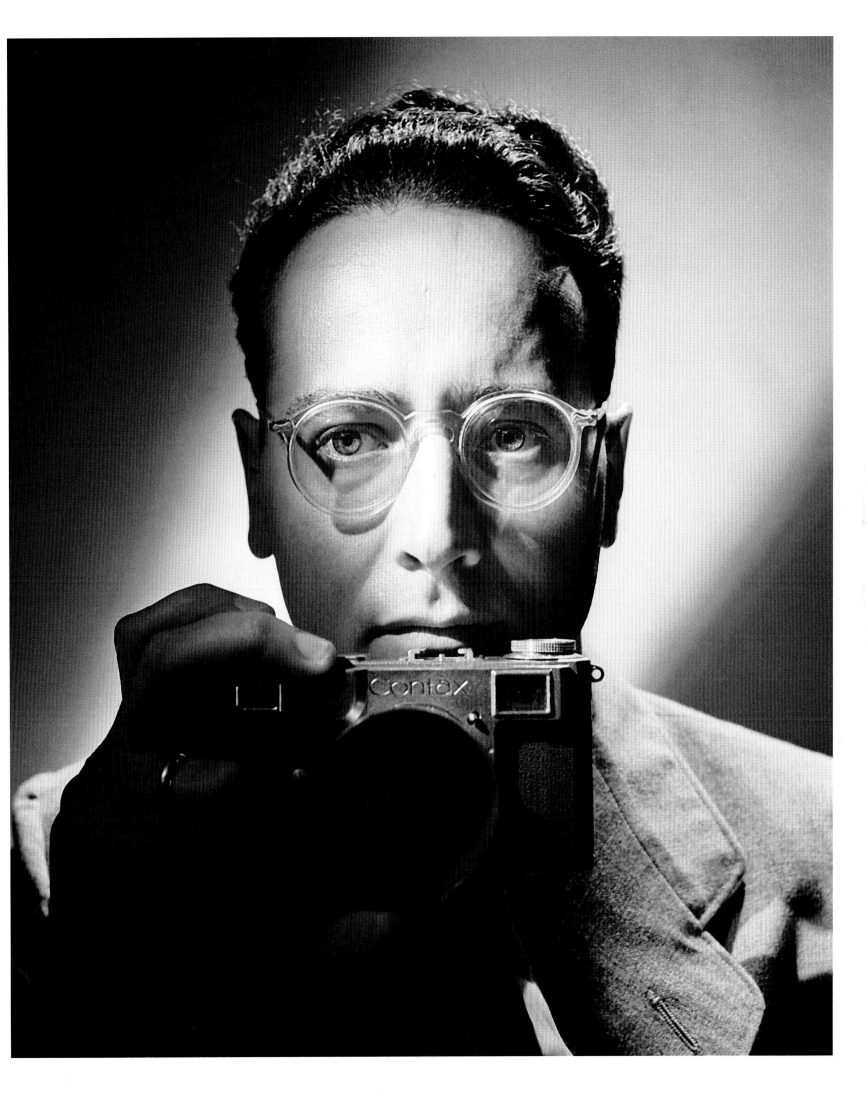

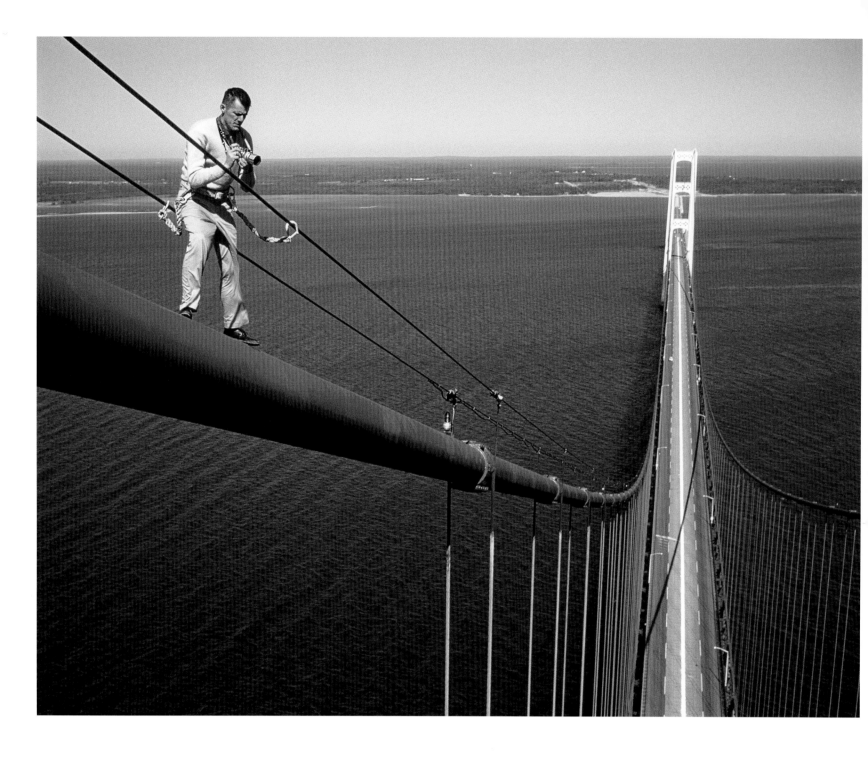

Above: **Willis D. Vaughn** (dates unknown). A photographer shoots from the top of a suspension bridge, Straits of Mackinac, Michigan, 4 April 1959. The bridge was opened in 1958. *Opposite:* Peter Stackpole [1913-1997] standing on the suspension cables during the construction of the Delaware Memorial Bridge, 1951.

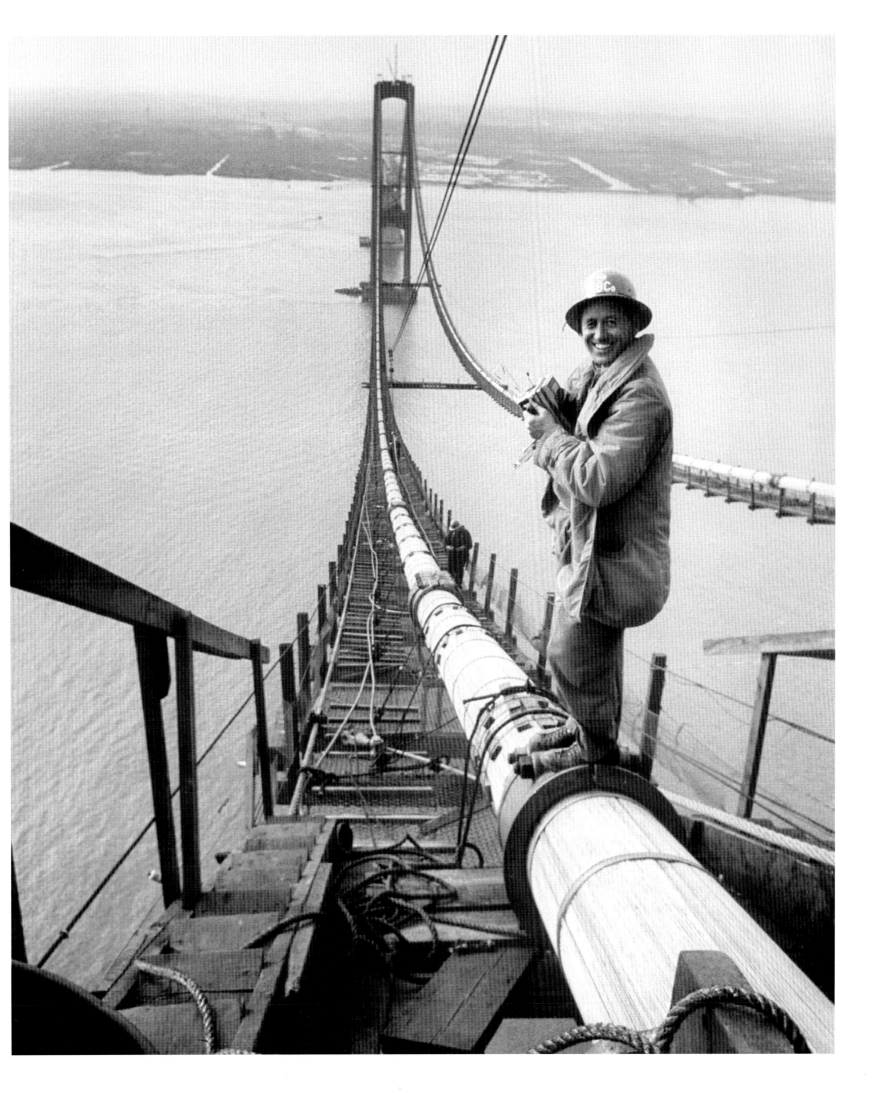

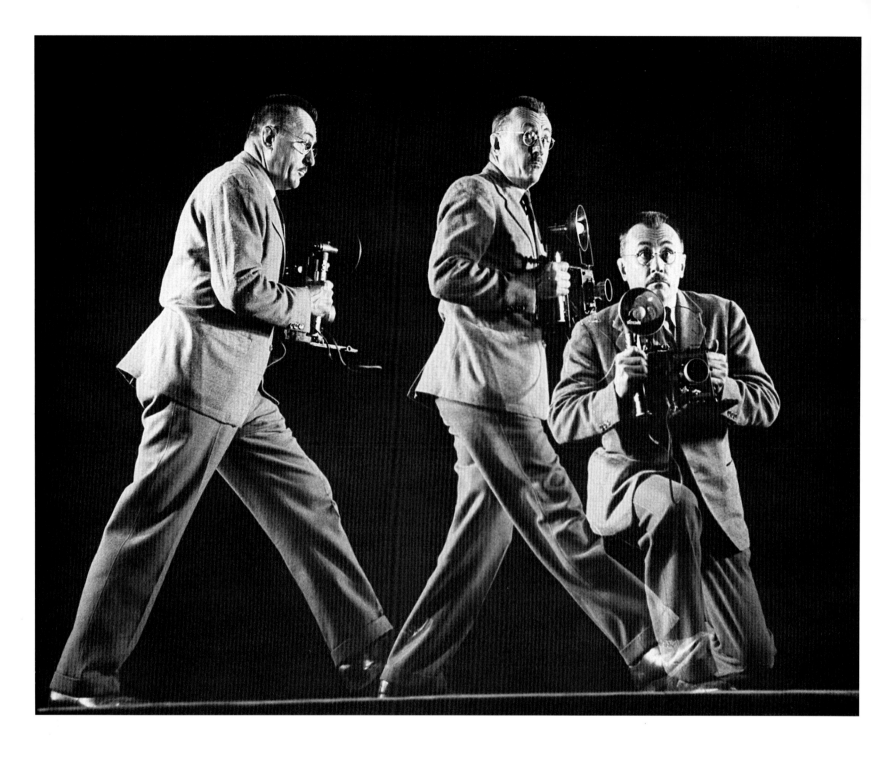

Above: **Gjon Mili** (1904-1984). Multi-exposure photograph of photographer Wallace Kirkland, 1942. Mili was a pioneer in the use of strobe light to capture a sequence of actions in one photograph. Kirkland (1890-1983) worked for *Life* magazine. *Opposite:* **Yale Joel** (1919-2006). Portrait of photographer Philippe Halsman at work, 1952. Halsman (1906-1979) is using a large format twin lens reflex camera of his own design mounted on a heavy studio tripod with geared adjustment. Halsman had the camera made for him by large format camera designer and photographer Peter Gowland.

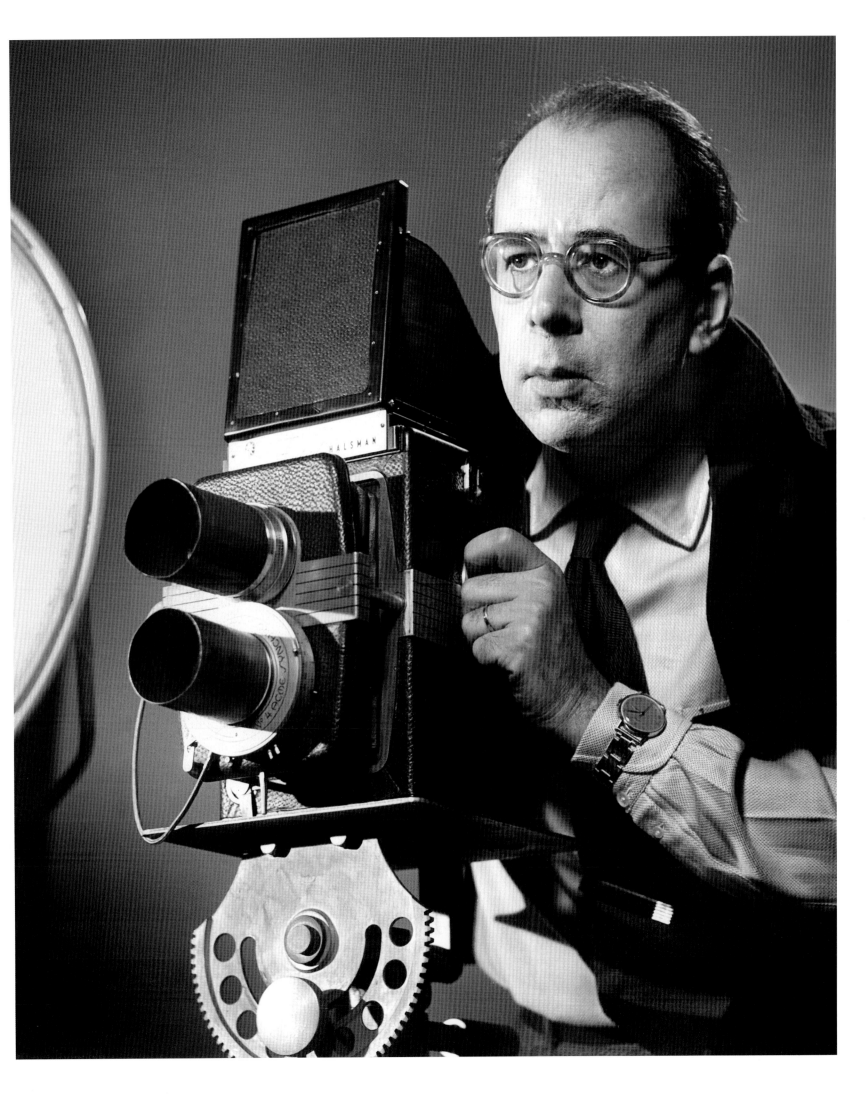

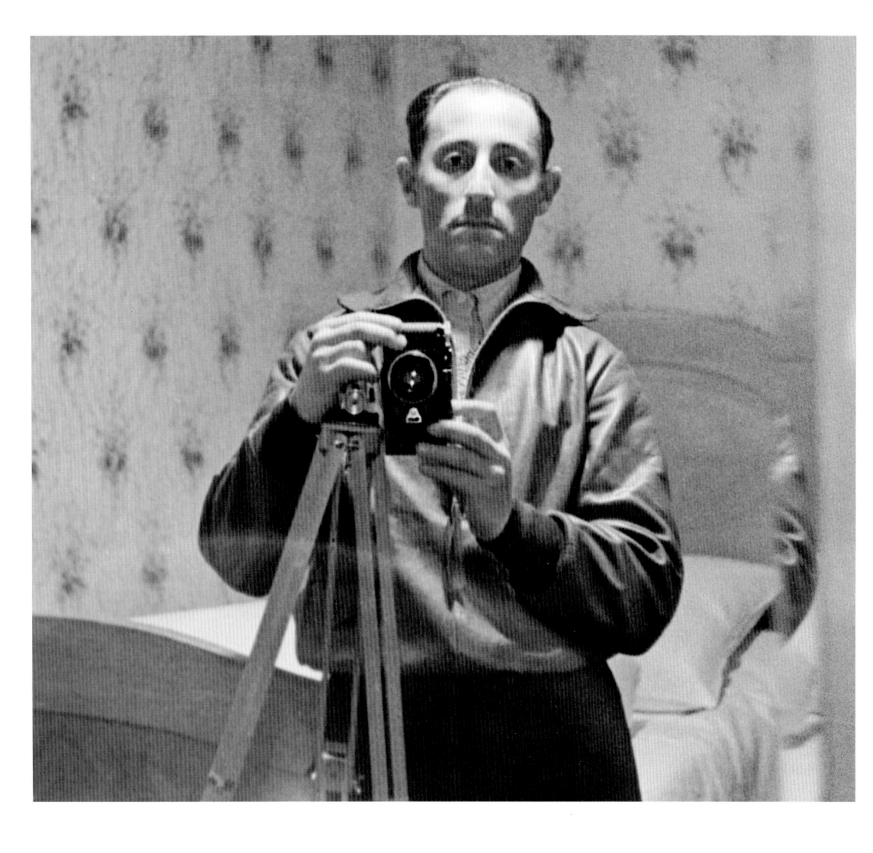

Above: **Alfred Eisenstaedt** (1898-1995). Self-portrait, c.1933. Eisenstaedt was born in Germany and fought in the First World War. He began taking photographs aged 14 and worked as a freelancer for various press agencies. He emigrated to the United States in 1935, joining *Life* magazine in 1936 where he stayed until 1972. Eisenstaedt had over nine hundred *Life* cover credits. *Opposite:* **Peter Stackpole** (1913-1997). Alfred Eisenstaedt [standing] shows actor Eli Wallach how to use the Leica camera, 1959. Wallach (b.1915) was playing the part of Eisenstaedt in NBC-TV's hour-long Sunday Showcase drama, *The Margaret Bourke-White Story*, which recounted Bourke-White's battle with Parkinson's disease. Bourke-White herself worked with actress Teresa Wright who was playing her.

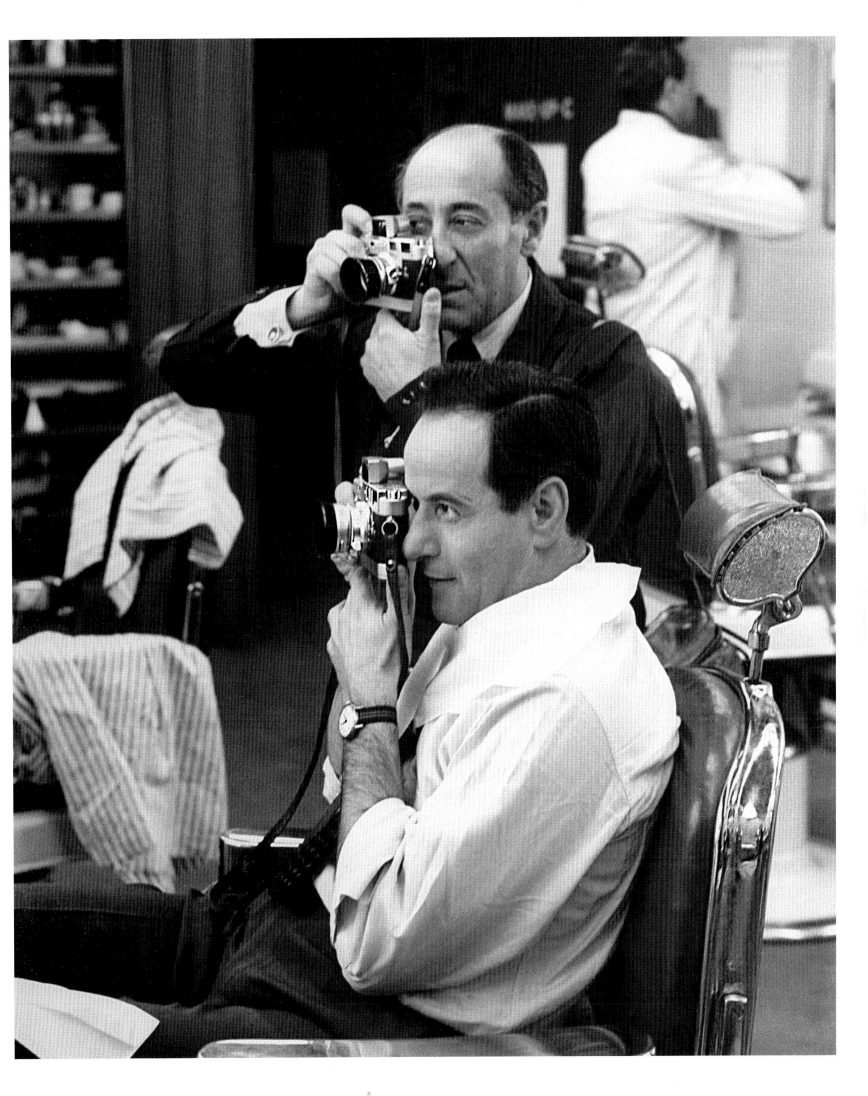

Above: **Alfred Eisenstaedt** (1898-1995). Self-portrait between two local men while on assignment in India, 1954. Eisenstaedt is carrying a 35mm single lens reflex with hand grip to support the telephoto lens. *Opposite:* Photographer Peter Schmid shooting below a sign banning photography during a visit to Bihal, India, 1950. Schmid uses a Swiss-made Alpa Reflex camera.

फोटो खींचना और क्यांमेरा
अन्दर लाना सकत मना है

PHOTOGRAPHY PROHIBITED

CAMERAS FORBIDDEN

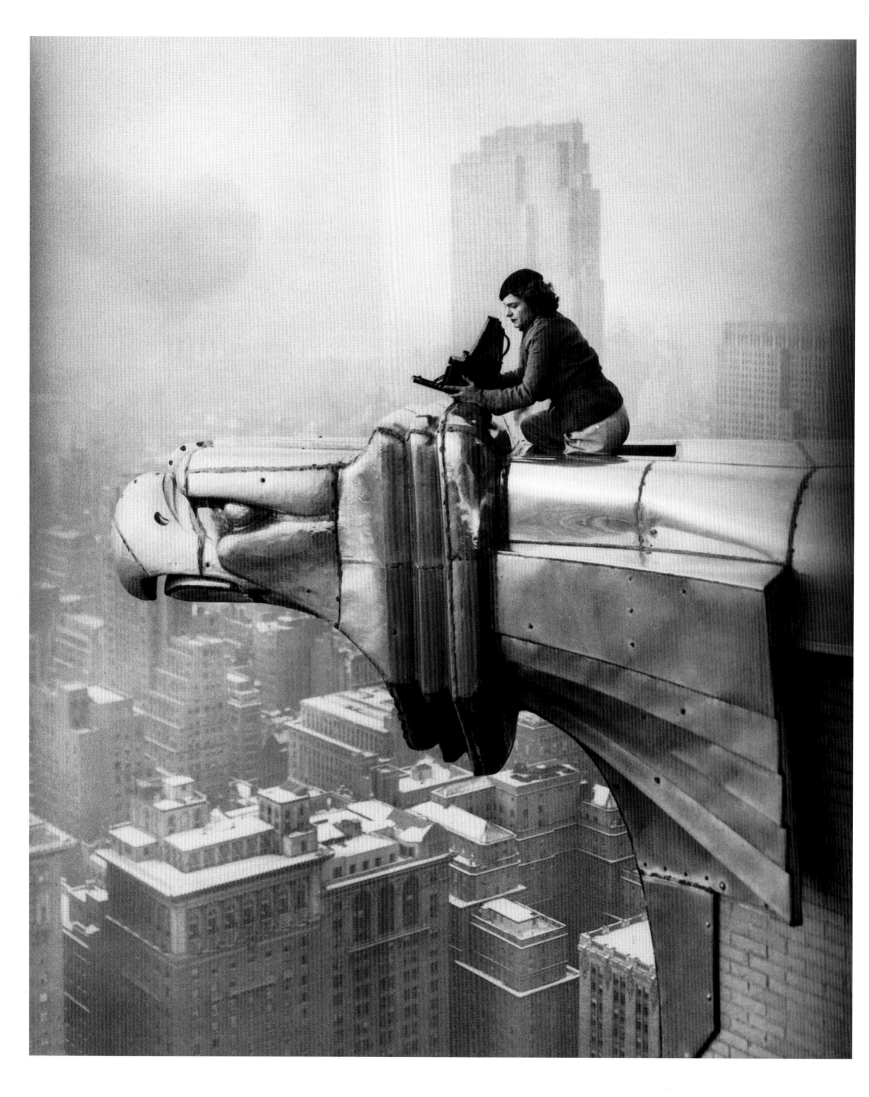

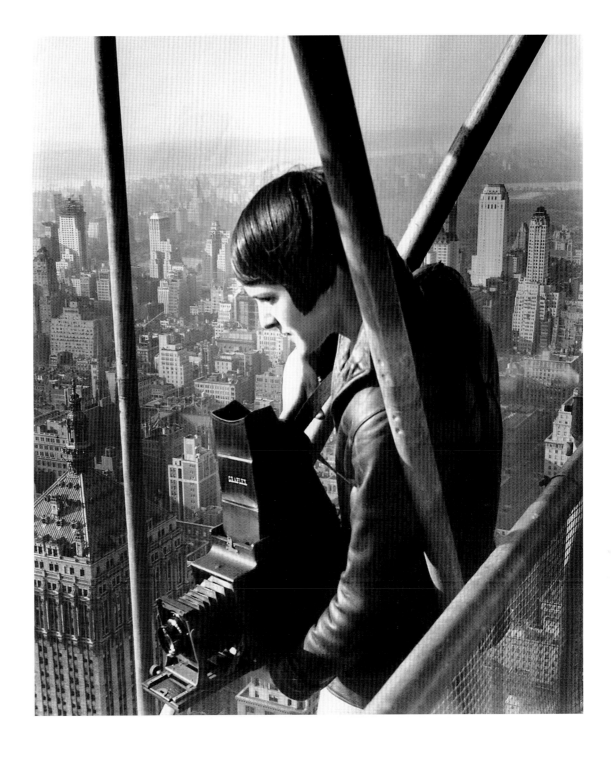

Opposite: **Oscar Graubner** (1897-1977). Margaret Bourke-White on the eagle head gargoyle at the top of the Chrysler Building, New York, 1935. Graubner was Bourke-White's long-time collaborator and moved with her to *Life* magazine. He became head of the *Life* darkrooms working with all the *Life* photographers. *Above:* **Oscar Graubner** (1897-1977). Margaret Bourke-White on a New York city building, 1931. Bourke-White (1904-1971) was the first female photographer for *Life* magazine and the first female war correspondent to work in combat zones. Bourke-White was the photographer of the first *Life* cover. She is shown here holding her Graflex single reflex camera.

Above: **Alfred Eisenstaedt** (1898-1995). Portrait of Margaret Bourke-White, 1959. Bourke-White suffered from Parkinson's disease and is shown in Eisenstaedt's photograph reloading her Rolleiflex twin lens reflex camera as rehabilitation after having brain surgery to relieve symptoms of the disease. *Opposite:* **Carl Mydans** (1907-2004). Portrait of Margaret Bourke-White, 1938. Mydans was one of the earliest *Life* photographers, joining in 1936 as a staff photographer alongside Bourke-White and Eisenstaedt amongst others. Bourke-White is shown with a Contax II camera that had been introduced in 1936. The camera is fitted with a supplementary rangefinder for close focusing and a pair of side-mounted flash guns.

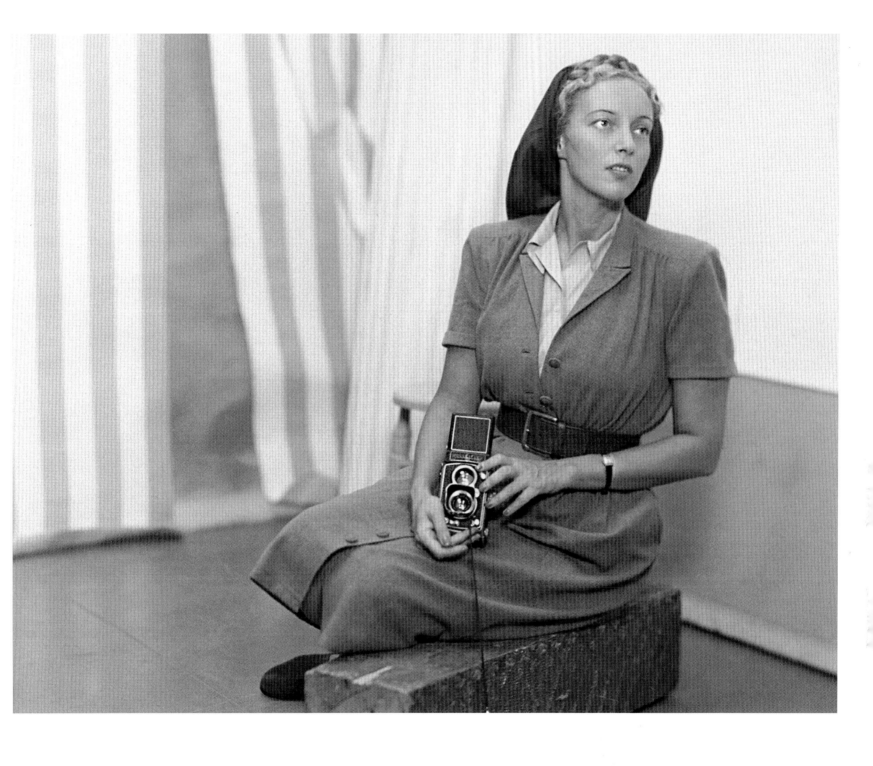

Opposite: **Larry Gordon** (dates unknown). Toni Frissell standing, 1944. Frissell (1907-1988) is shown holding her Rolleiflex twin lens reflex camera. She volunteered for war work in 1941, photographing the people she met during her work. After the war she specialised in fashion and portrait photography. *Above:* Nina Leen posing with Rolleiflex, 1949. Leen (1914-1995) joined *Life* magazine in 1945 and used a Rolleiflex for most of her career.

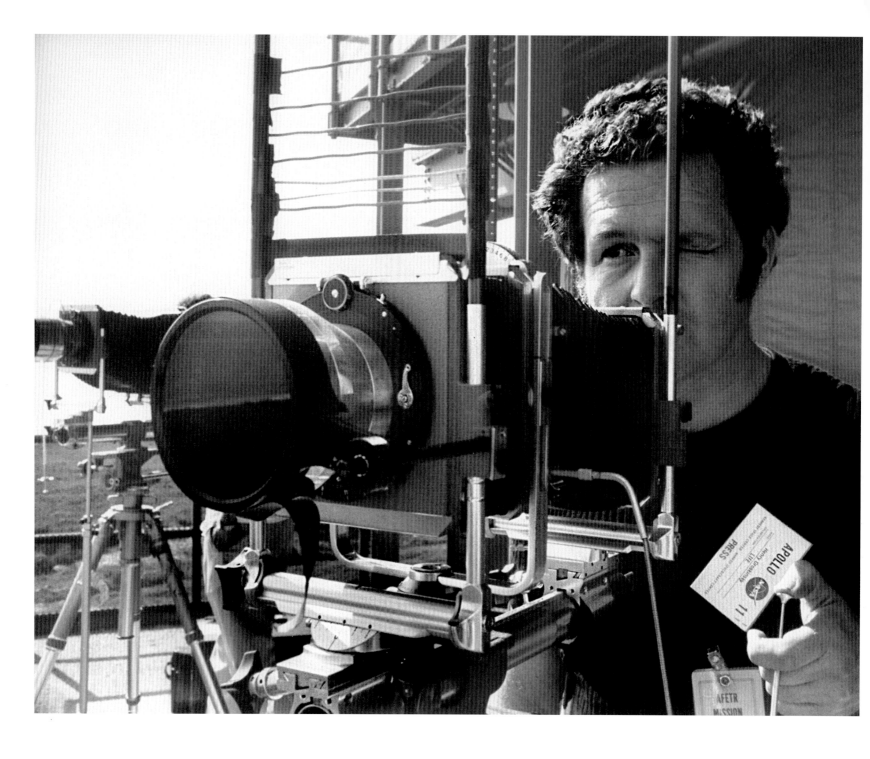

Above: **John Iacono** (b.1941). *Life* photographer Henry Groskinsky preparing to picture the Apollo 11 blast off, 1969. Groskinsky prepares his large format view camera. *Opposite:* **Morris Engel** (1918-2005). American photographer Paul Strand sets up his camera on a footpath, New Jersey, 1947. Strand (1890-1976) was one of the major figures in American photography. He is using a large view camera, possibly for 14 x 11 inch negatives, which would allow him to make contact prints while retaining the quality of the original negative.

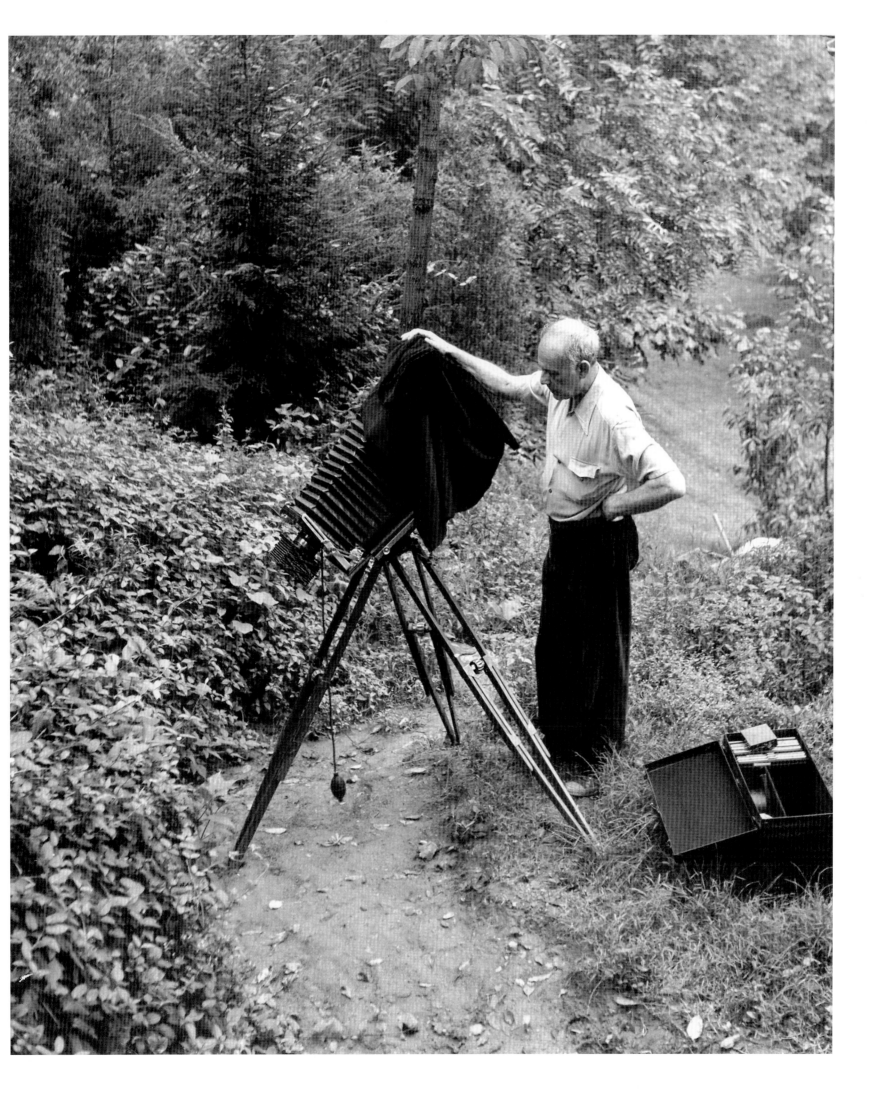

Willy Ronis (1910-2009). Martine Franck, c.1950. Franck (1938-2012) carries two Leica M3 cameras – one with a chrome body and one with a black-finished body. From 1963, she worked at Time-Life in Paris as an assistant to photographers Eliot Elisofon and Gjon Mili. She was a member of Magnum Photos and the second wife of photographer Henri Cartier-Bresson whom she married in 1970. She was President of the Henri Cartier-Bresson Foundation until her death.

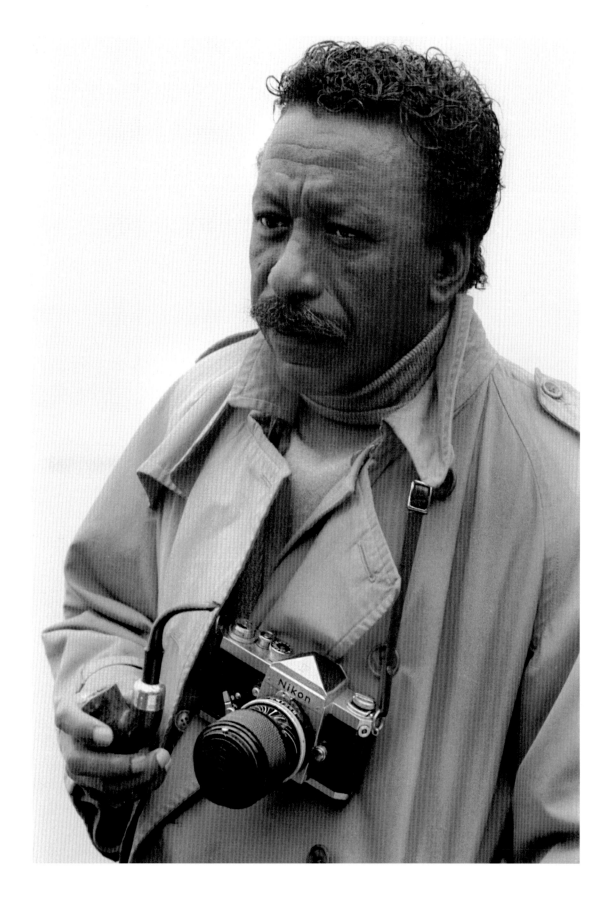

Above: Portrait of Gordon Parks during the filming of a CBS News Special, *The Weapons of Gordon Parks*, 6 February 1968. Parks (1912-2006) was an American photographer, musician, writer and film director. He is best remembered for his photographic essays for *Life* magazine and as the director of the 1971 film, *Shaft*. He holds a Nikon F camera. *Opposite:* **Gordon Parks** (1912-2006). Self-portrait, 1948. Parks started taking photographs aged 25 years with a Voigtländer Brillant camera he bought for $12.50 at a pawnshop. In 1941 he won a fellowship with the Farm Security Administration (FSA). He was the first African-American to work at *Life* magazine and the first to write, direct, and score a Hollywood film. Parks is shown holding a Rolleiflex twin lens reflex camera.

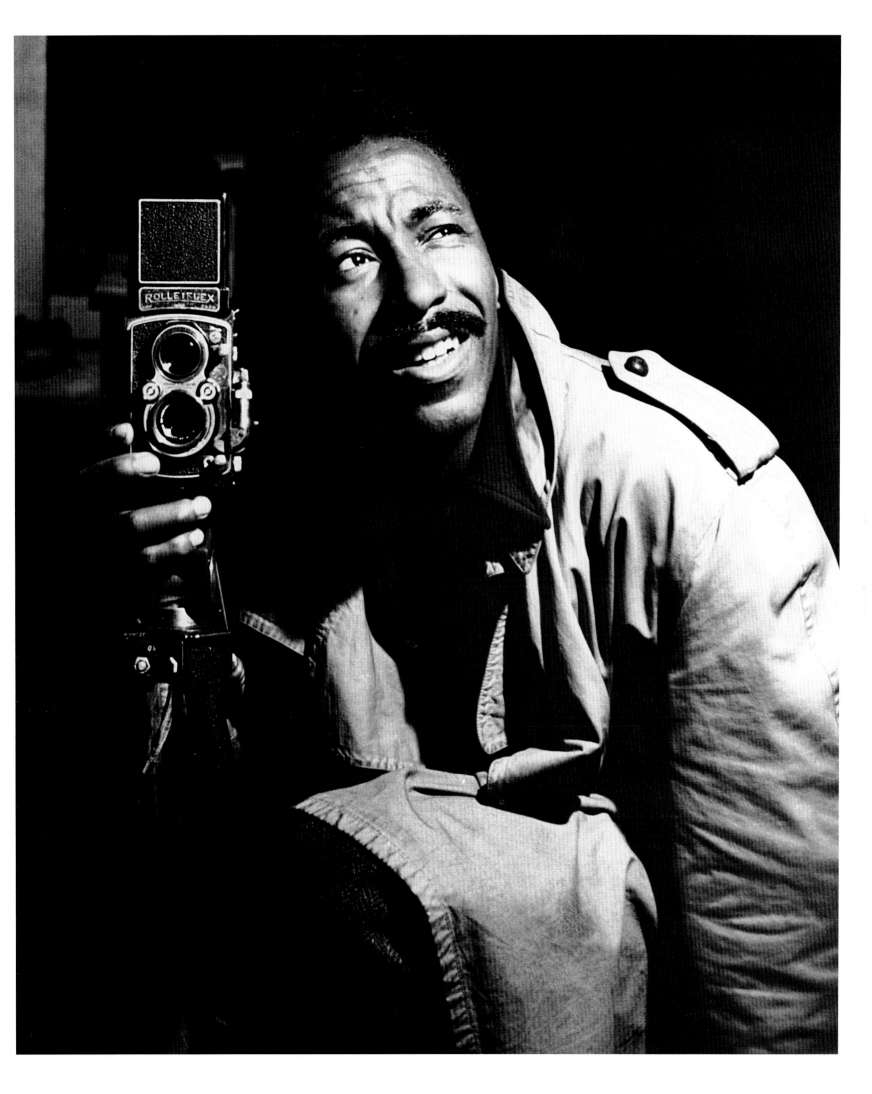

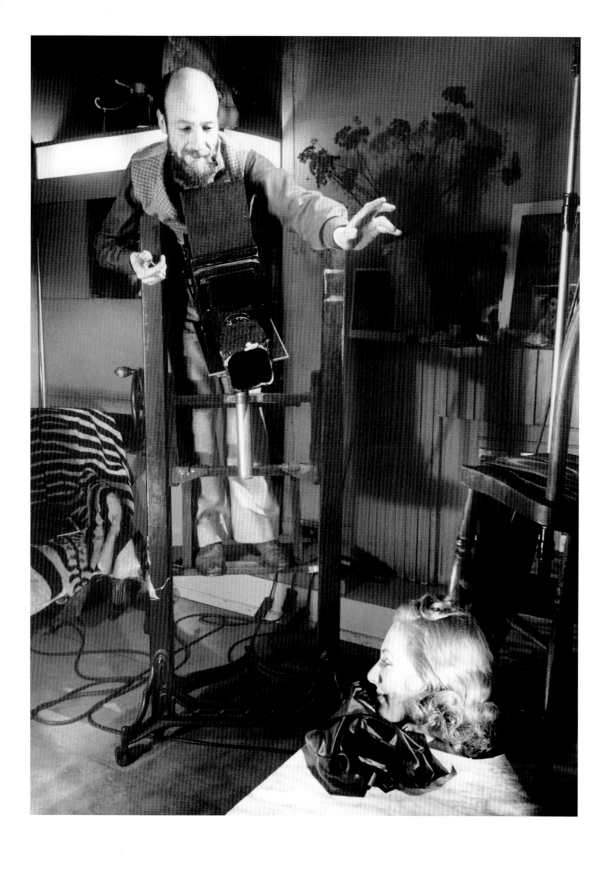

Above: **Kurt Hutton** (1893-1960). Photographer Angus McBean taking a trick photograph of Diana Churchill's head, 1940. McBean (1904-1990) established a reputation for surreal photographs, often making use of multiple exposures and montage techniques. Hutton was working for *Picture Post* and his photo story appeared as 'How to photograph a beauty' in February 1940. *Opposite:* **Michael Ward** (1929-2011). Self-portrait reflected in a silver tray, Portobello Road market, London, 1959. Ward was a news and portrait photographer and is shown here using a Leica M3 camera.

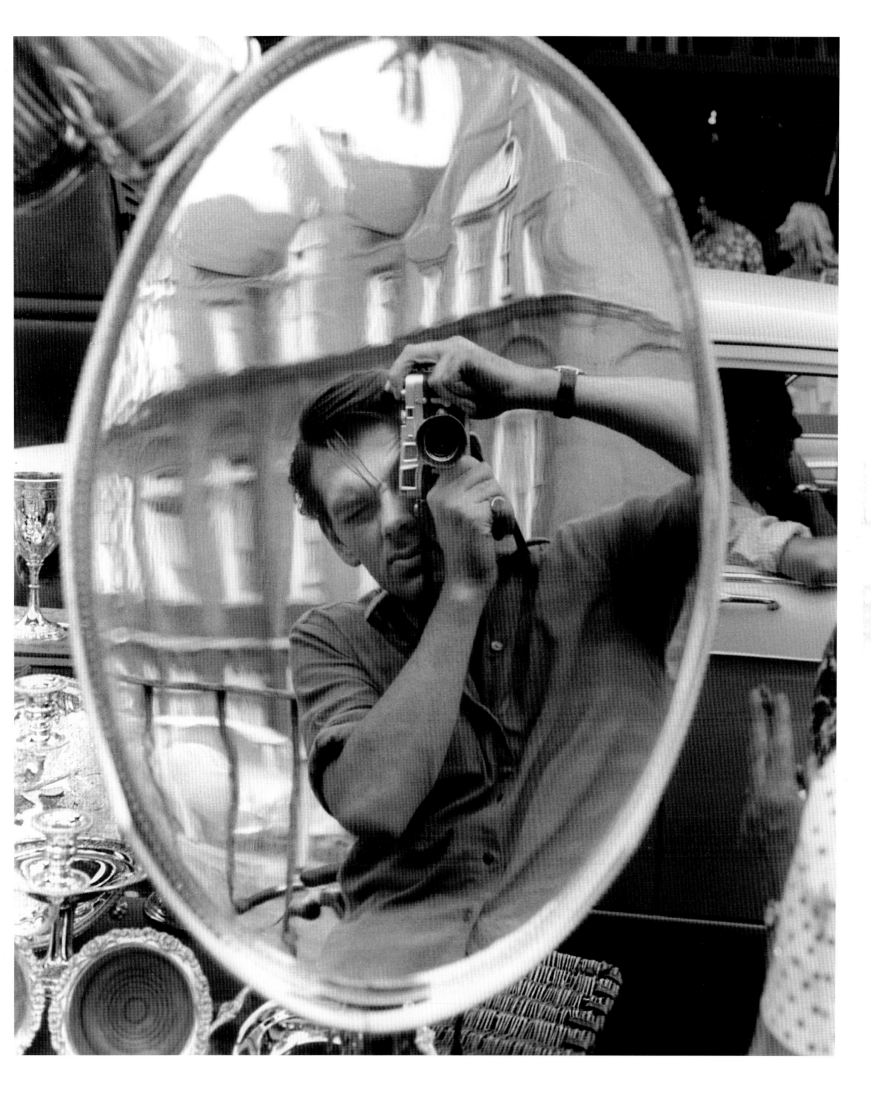

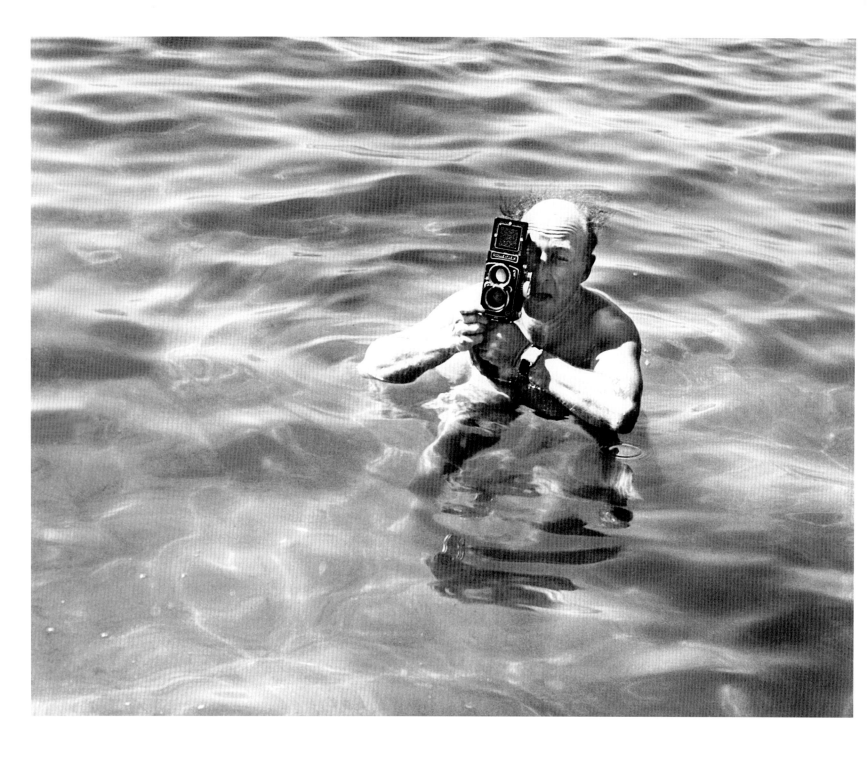

Above: Hungarian photographer Zoltán Glass taking a photograph from the sea, 1964. Glass (1903-1982) initially worked in Germany, particularly for Mercedes Benz, and photographed motor sports before moving to London in 1938. He pursued a second career as a fashion and glamour photographer. He is using a Rolleiflex twin lens reflex camera. *Opposite:* Zoltán Glass shooting a model, 29 June 1949. Glass is using his Rolleiflex twin lens camera in his studio.

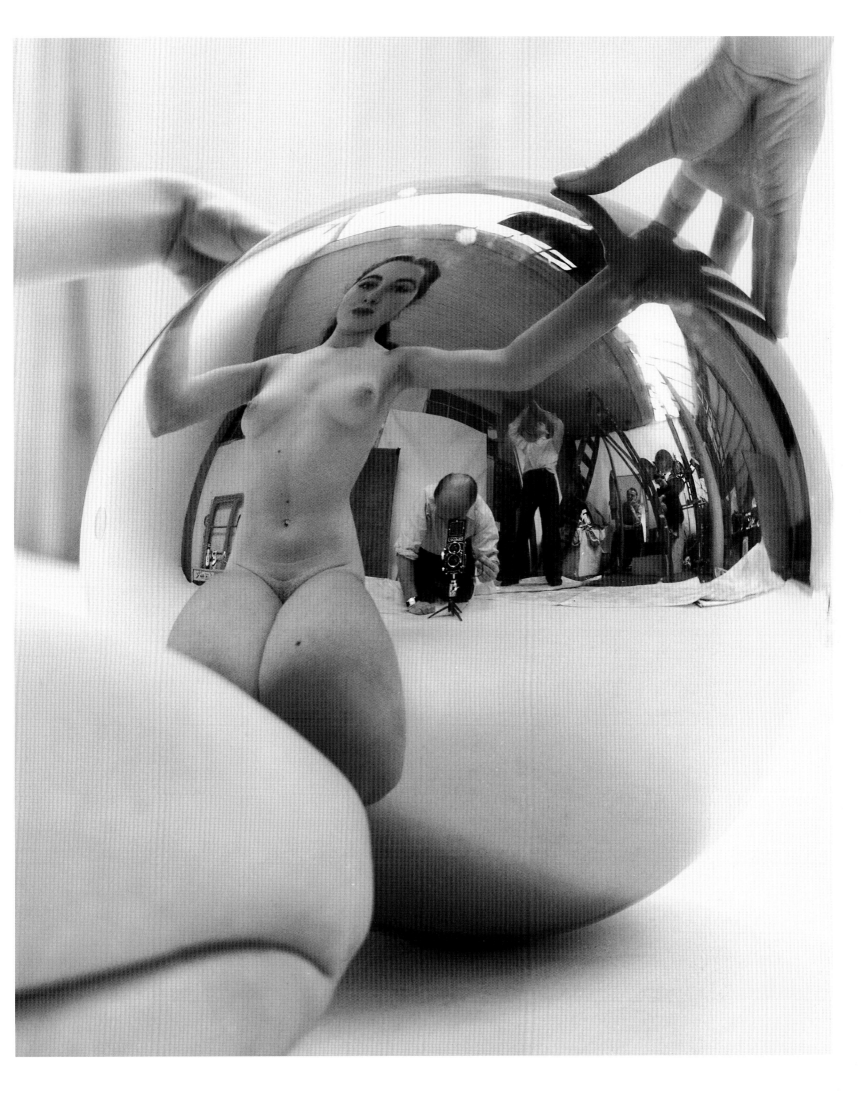

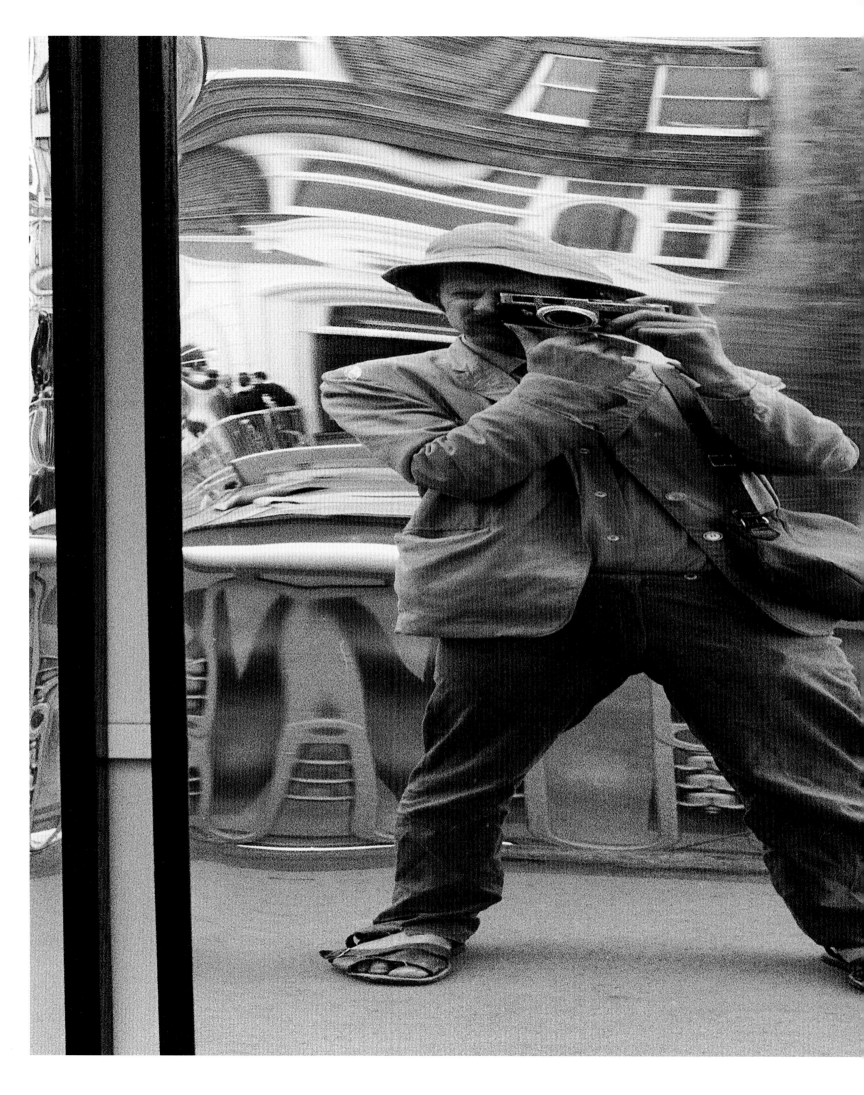

Tony Ray-Jones (1941-1972). Self-portrait, 1965. Ray-Jones created most of his work photographing the British at work and leisure between 1966 and 1969. It poked gentle fun at the British way of life and was a precursor to the later harder-edged work of Martin Parr and others. Some of Ray-Jones's work appeared posthumously in his book, *A Day Off* (1974). He is shown using a Leica M3 camera.

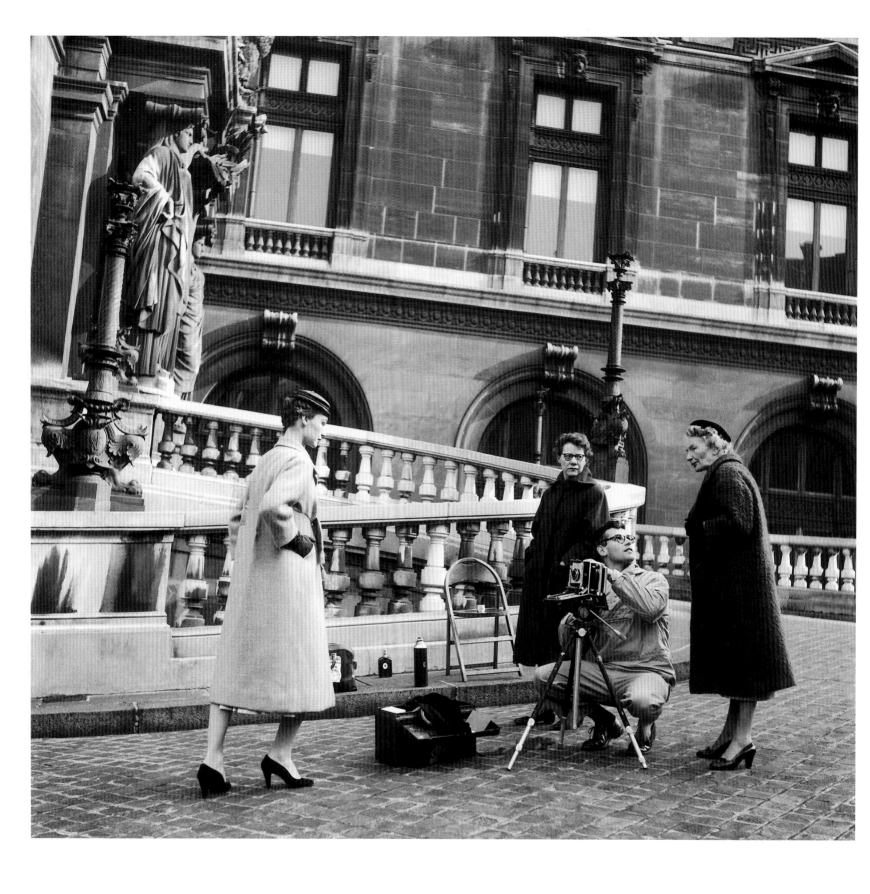

Above: **Robert Doisneau** (1912-1994). Photographer Richard Avedon with a Dior model in front of the Paris Opera, 1953. Avedon (1923-2004) is using a large format Technical camera for his shoot. Within a few years, smaller and lighter 35mm cameras would be preferred, heralding a new style of fashion photography. *Opposite:* **Arnold Newman** (1918-2006). Self-portrait, New York, 17 September 1964.

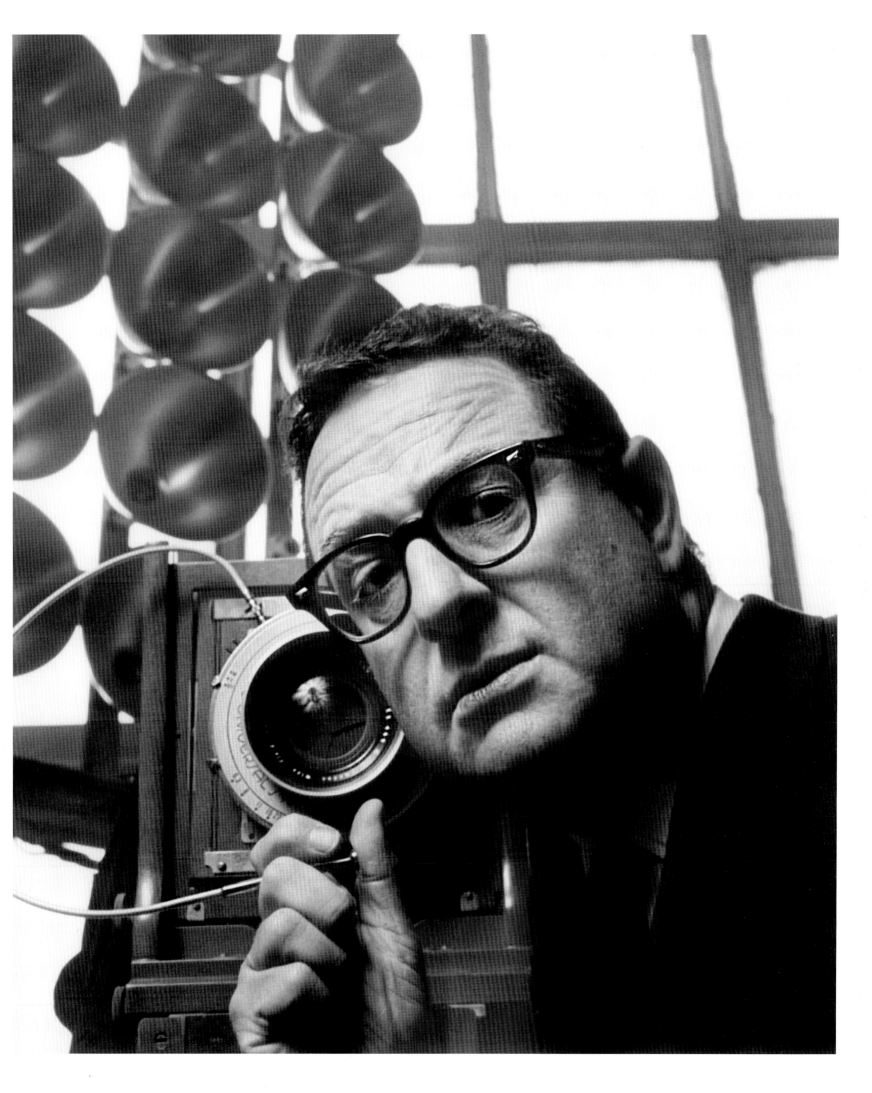

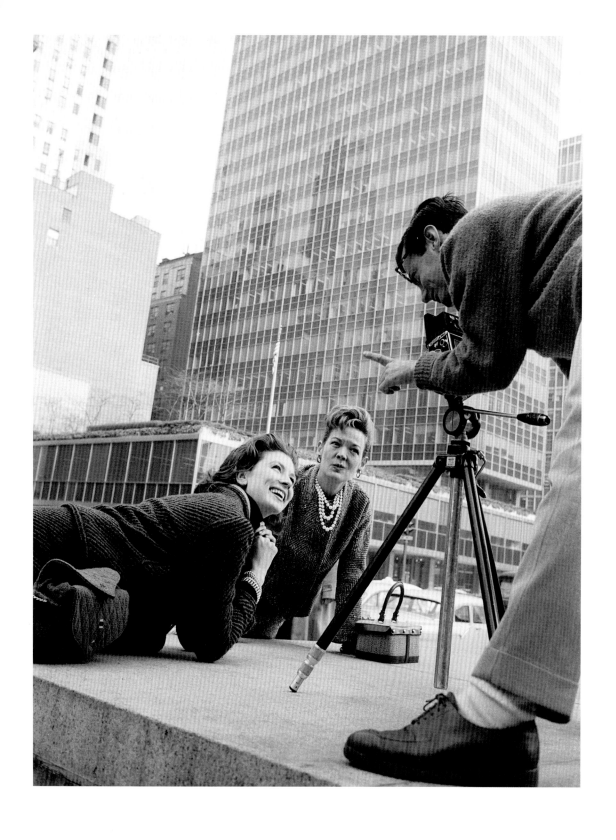

Above: **Martha Holmes** (1923-2006). Actress and photographer Suzy Parker and advertising executive Kathleen Daly look up at photographer Richard Avedon, New York, 1959. Avedon (1923-2004) was a fashion and portrait photographer and is seen here using a Rolleiflex twin lens reflex camera. Holmes was a *Life* photographer, joining the magazine in 1944.
Opposite: **Peter Stackpole** (1913-1997). Suzy Parker with camera, 1953. Parker (1932-2003) was an American model and actress and a photographer in her own right. She is seen here with a Leica IIIc camera.

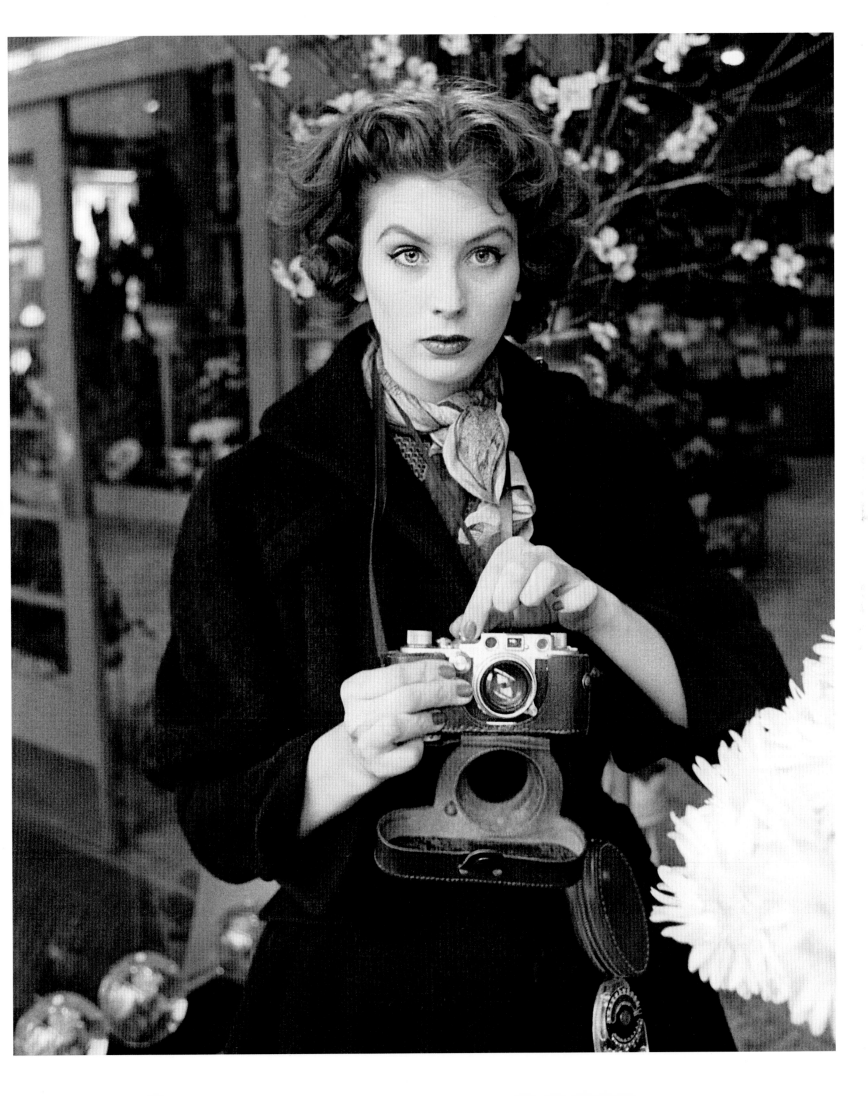

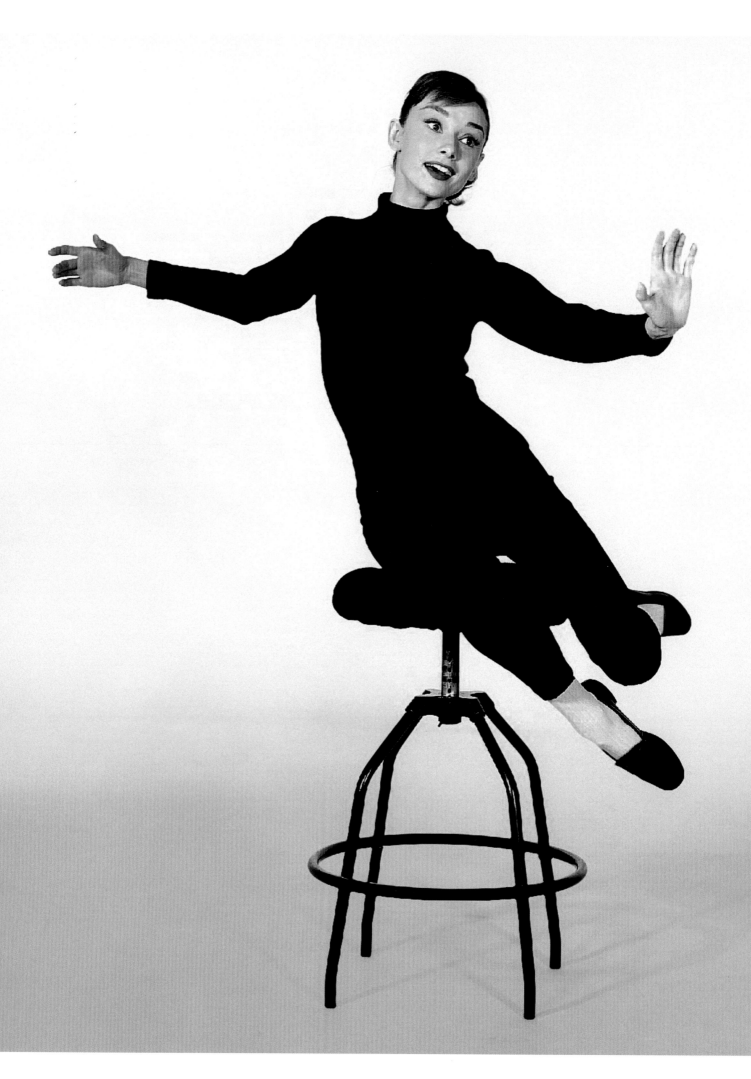

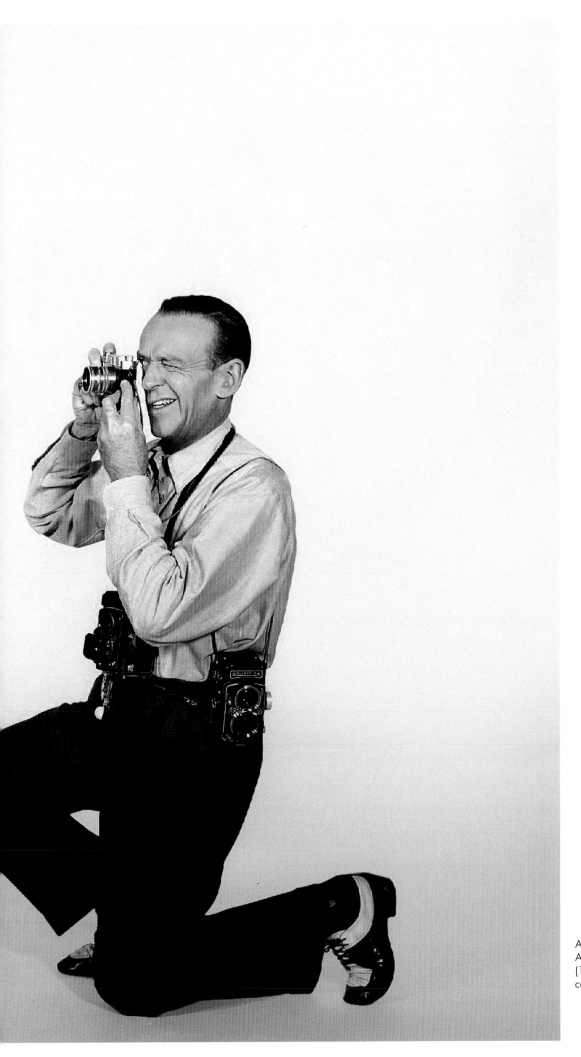

Audrey Hepburn models for fashion photographer Fred Astaire in Stanley Donen's film *Funny Face*, 1957. Astaire (1899-1987) holds a Leica camera and has two Rolleiflex cameras around his neck.

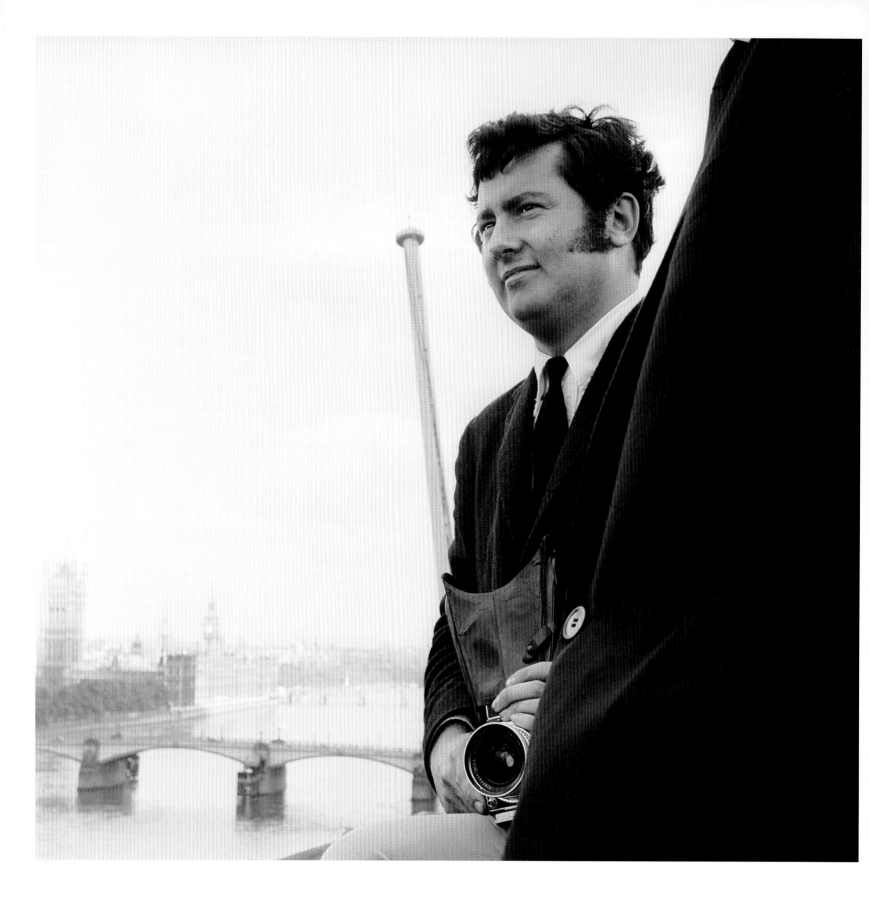

Above: British photographer Terence Donovan during a London photo shoot, July 1963. Donovan (1936-1996) holds a Hasselblad camera with binocular viewing hood. Donovan was best known for his fashion photography but he was also an accomplished film-maker and part of a wave of exciting new photographers emerging in the 1960s. *Opposite:* **Terence Donovan** (1936-1996). British fashion photographer John French, London, 13 April 1965. French (1907-1966) rests a Hasselblad camera on the top of a traditional studio stand.

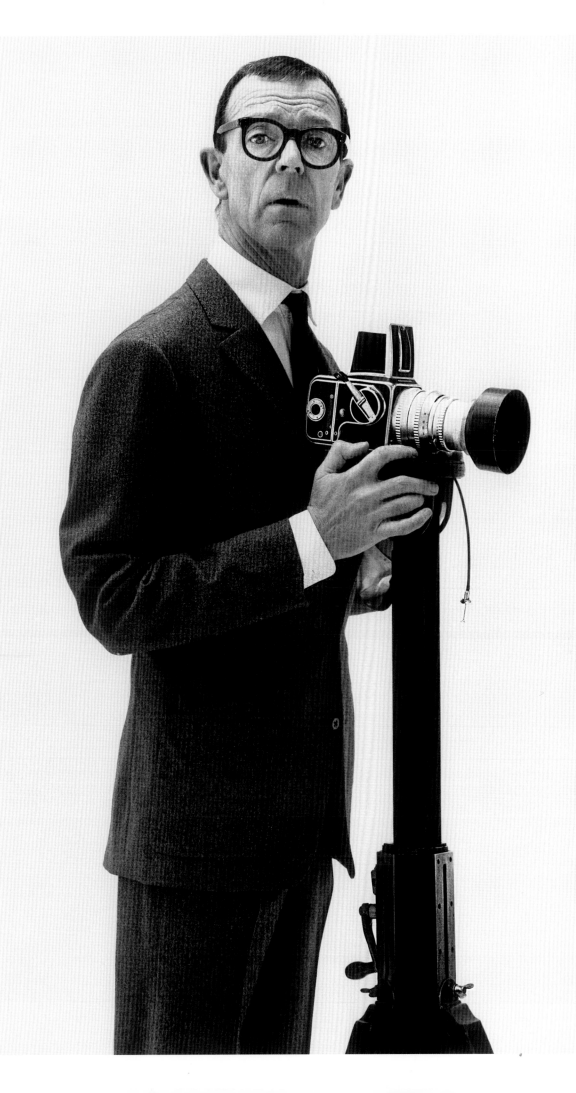

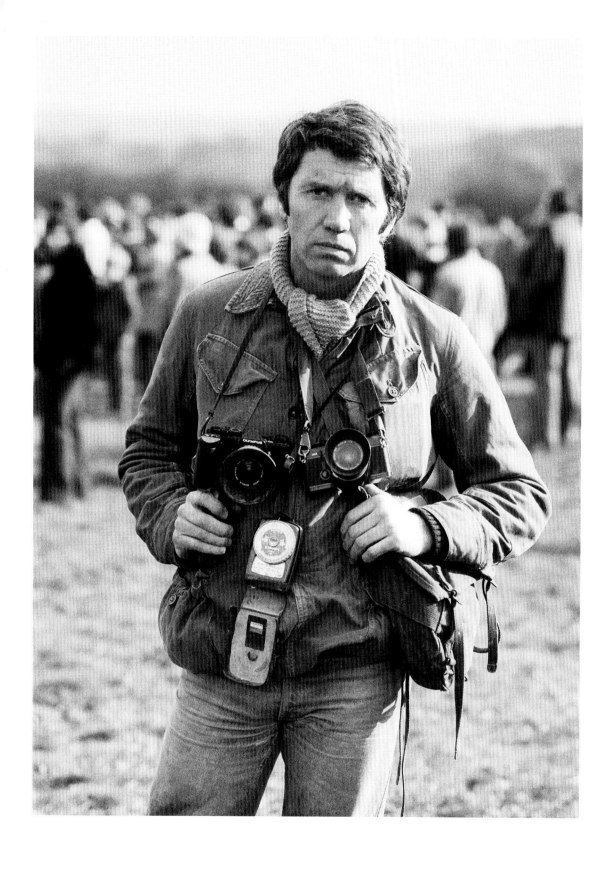

Above: **Brian Duffy** (1933-2010). Don McCullin, photojournalist, on a photo shoot for Olympus Cameras, c.1970. In the 1970s and 1980s, Olympus Cameras worked with a number of high profile photographers including McCullin (b.1935) to endorse and use their OM range of cameras and to promote their work through the Olympus Gallery in London. McCullin has two Olympus OM series cameras around his neck. *Opposite:* Portrait of Lord Snowdon at work, Venice, 14 October 1971. Antony Armstrong-Jones (b.1930) took up a career as a photographer and designer after leaving university. He became an advisor to *The Sunday Times* magazine, which also published his work, ranging from celebrity photographs to social documentary. He married Princess Margaret in 1960 and was elevated to Earl of Snowdon in 1961. He is shown using two Nikon F cameras.

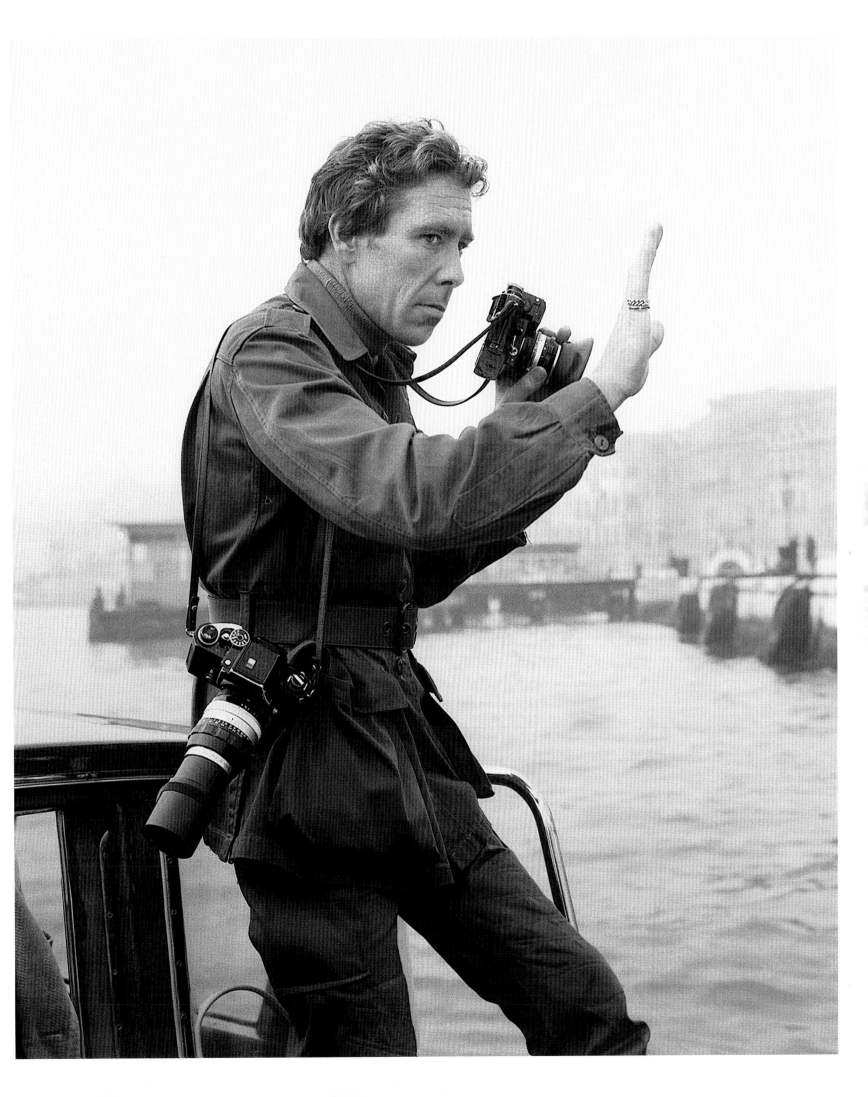

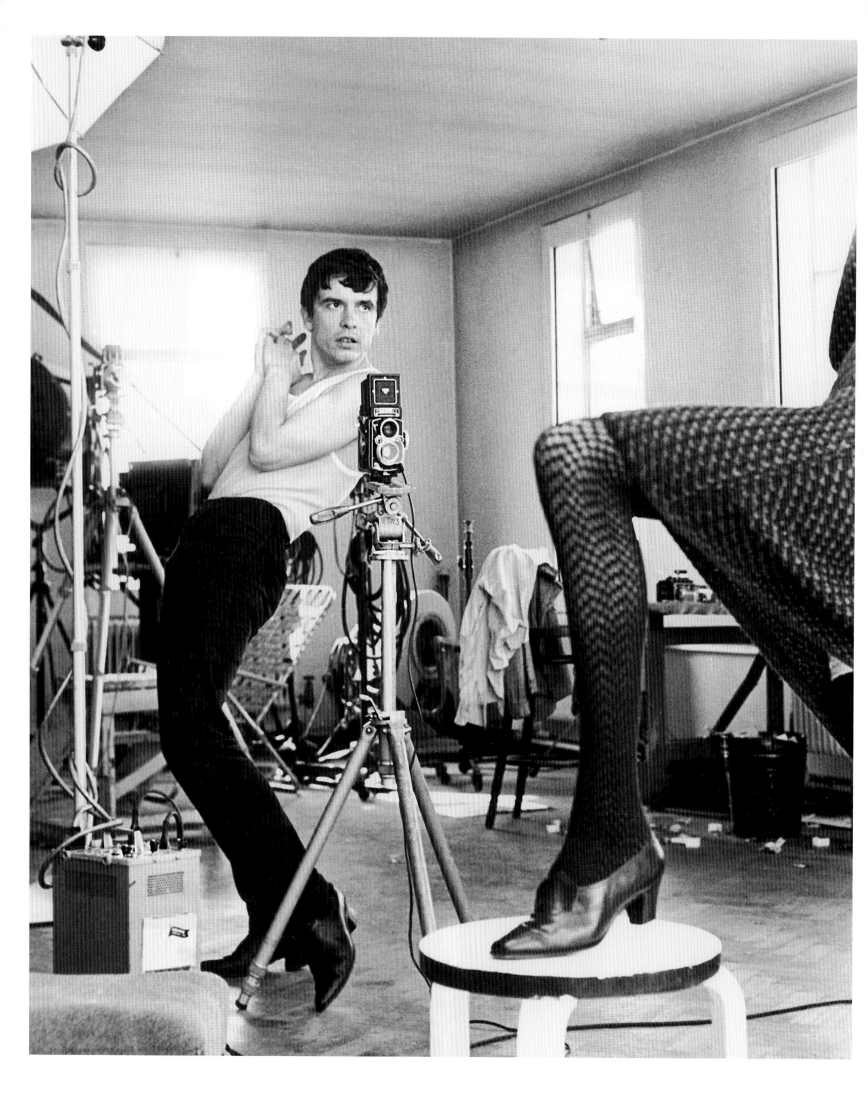

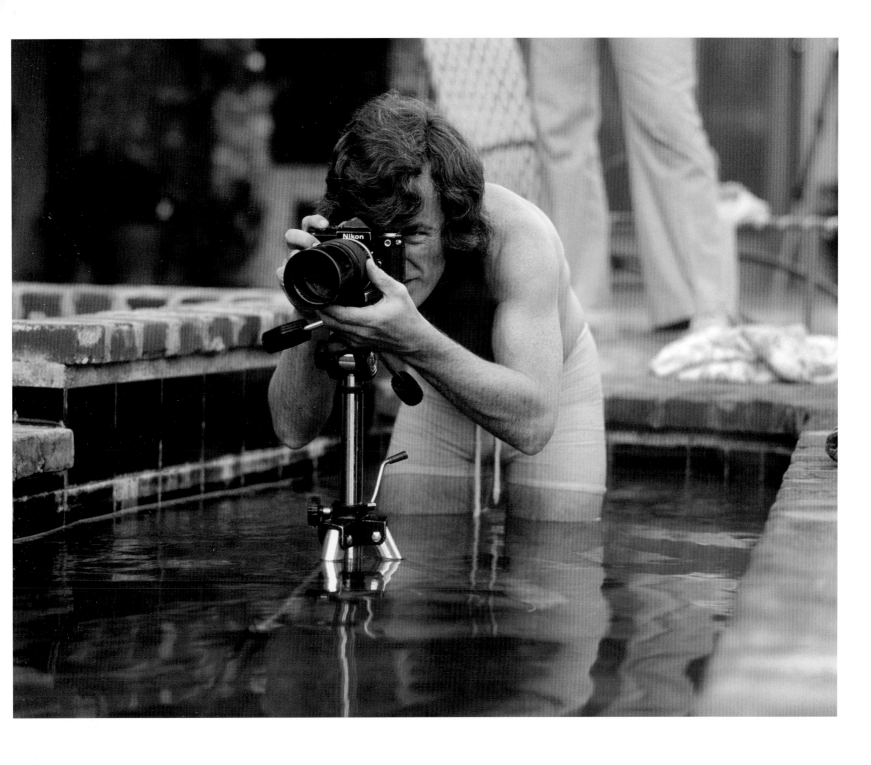

Opposite: **Terry O'Neill** (b.1938). David Bailey gives instructions to model Jean Shrimpton, 1964. O'Neill was a contemporary of Bailey (b.1938), with both becoming well known for photographing celebrities from the rock and film worlds and for their fashion work. Bailey described photographing Shrimpton: 'She was magic and the camera loved her too … she was just a natural' and he photographed her throughout the 1960s. *Above:* **Terry O'Neill** (b.1938). Self-portrait, photographing a model in a pool, c.1973. O'Neill started taking photographs for London's Heathrow Airport before gaining employment on *The Daily Sketch* in 1959. His career grew rapidly in the 1960s when he photographed show business celebrities alongside politicians and the Royal Family in his own distinctive style. He is shown here using a Nikon F camera.

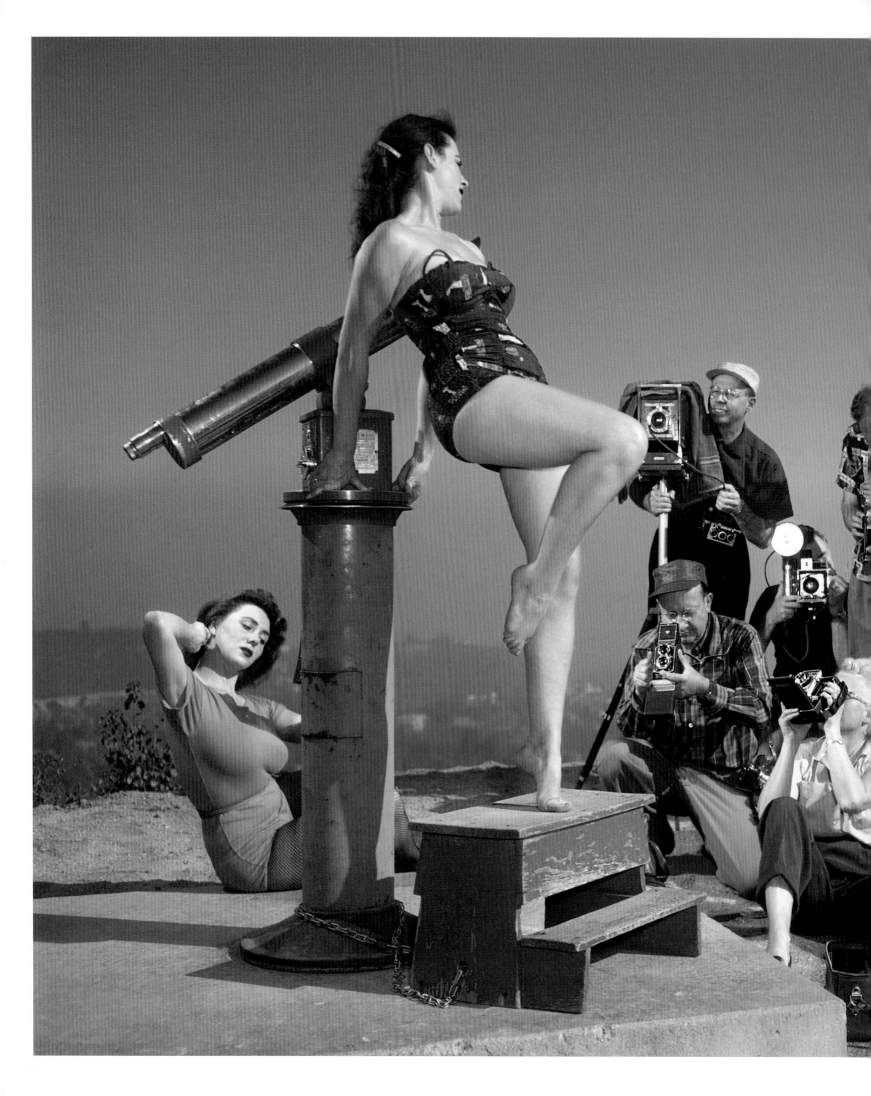

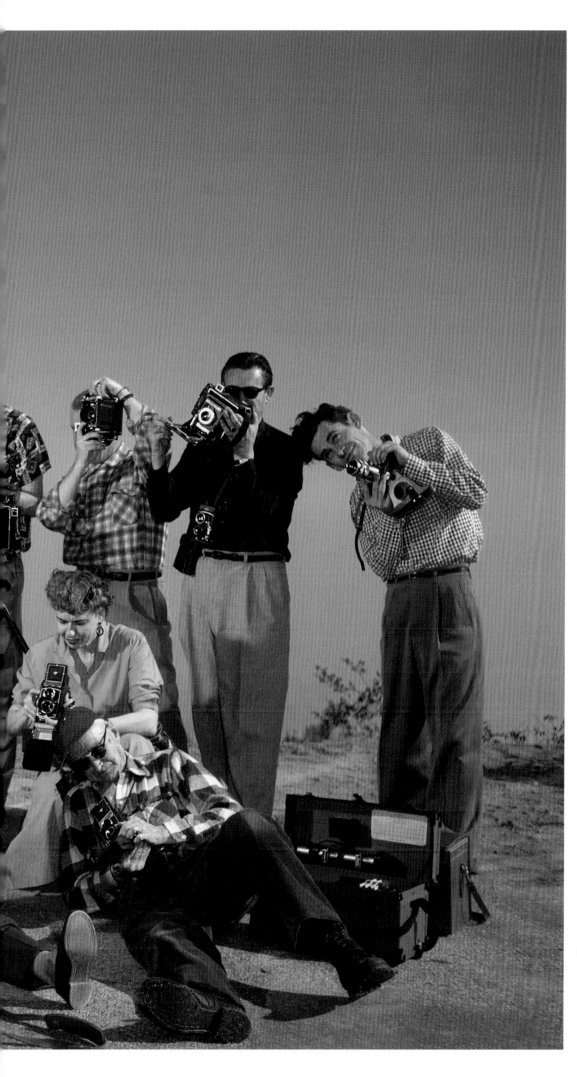

Gene Lester (c.1910-1994). A group of photographers shoot model Lonnie Carey in a one-piece swimsuit at the Griffith Observatory, Los Angeles, California, February 1954.

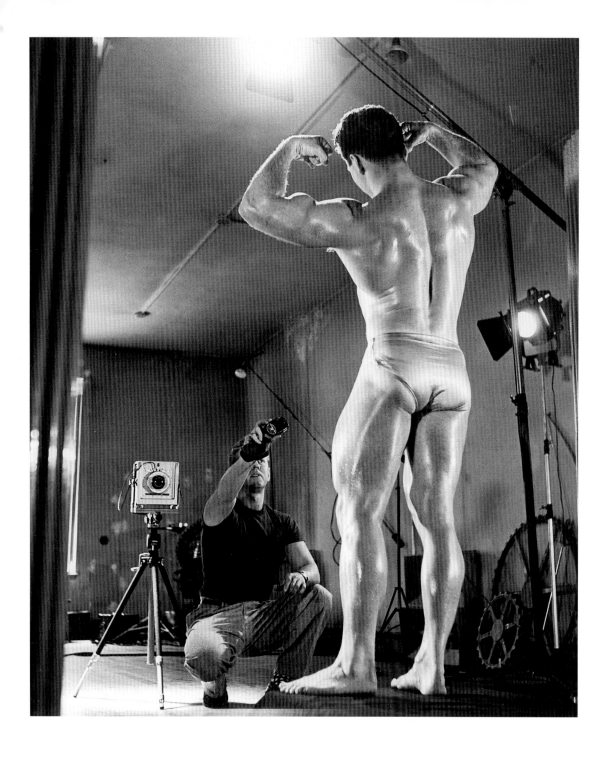

Above: American bodybuilder and fitness expert Jack LaLanne poses for photographer Russ Warner, 1953. Warner (1917-2004) established a reputation photographing West Coast physique celebrities during the 1950s beefcake era. He is using an American view camera and holding a light meter to gauge exposure [sic]. *Opposite:* **Weegee** [Arthur Fellig] (1899-1968). American pin-up Bettie Page, playmate of the month for January 1955, poses for photographers, 1955. Page (1923-2008) is posing for a camera club model session.

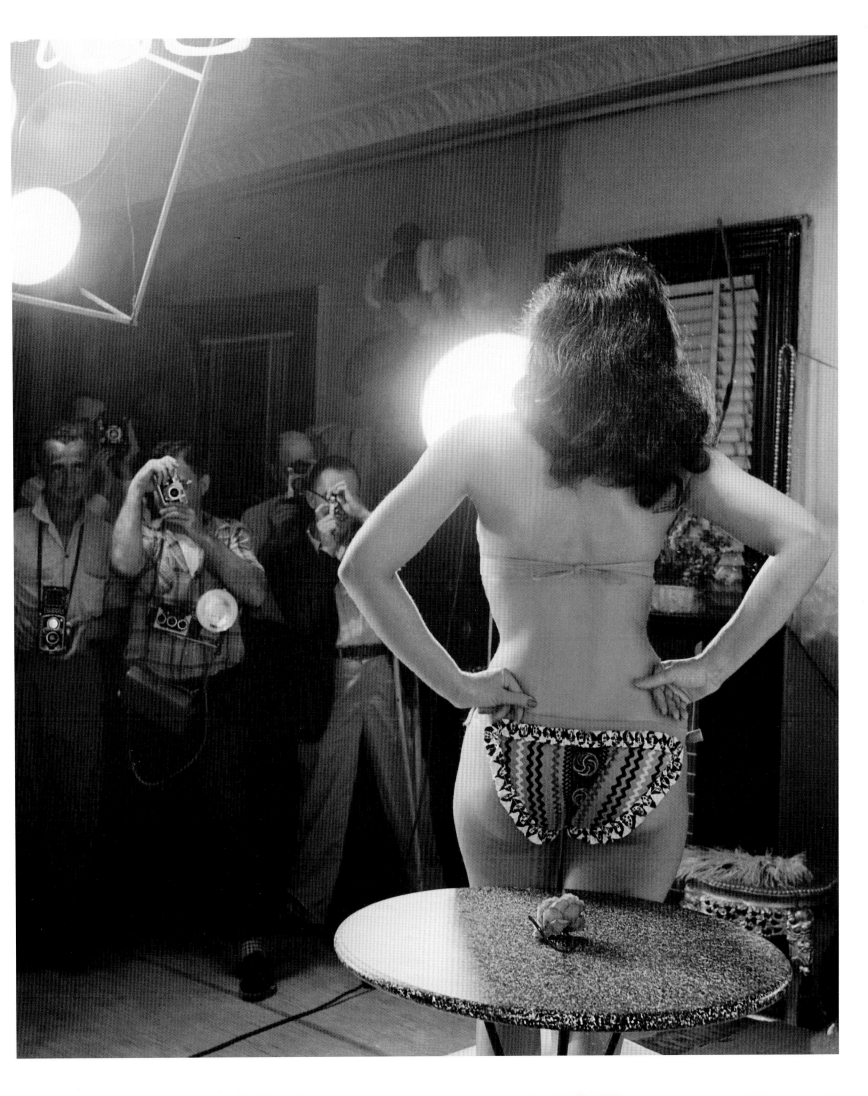

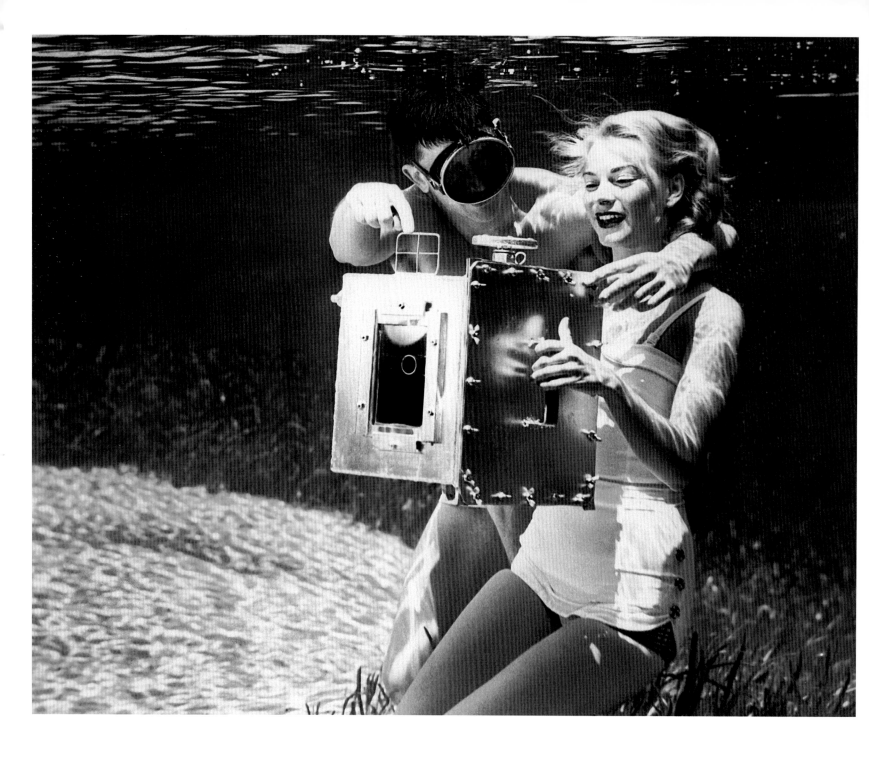

Above: **George Pickow** (1922-2010). Ginger Stanley is shown how an underwater camera works at Silver Springs, Florida, 1950. Stanley (b.1931) was variously a secretary, model and actress. She performed underwater stunts in B-movies including *Creature from the Black Lagoon* (1954). *Opposite:* Two women taking photographs underwater in a glass tank at the British Photo Fair, Olympia, London, 10 April 1957.

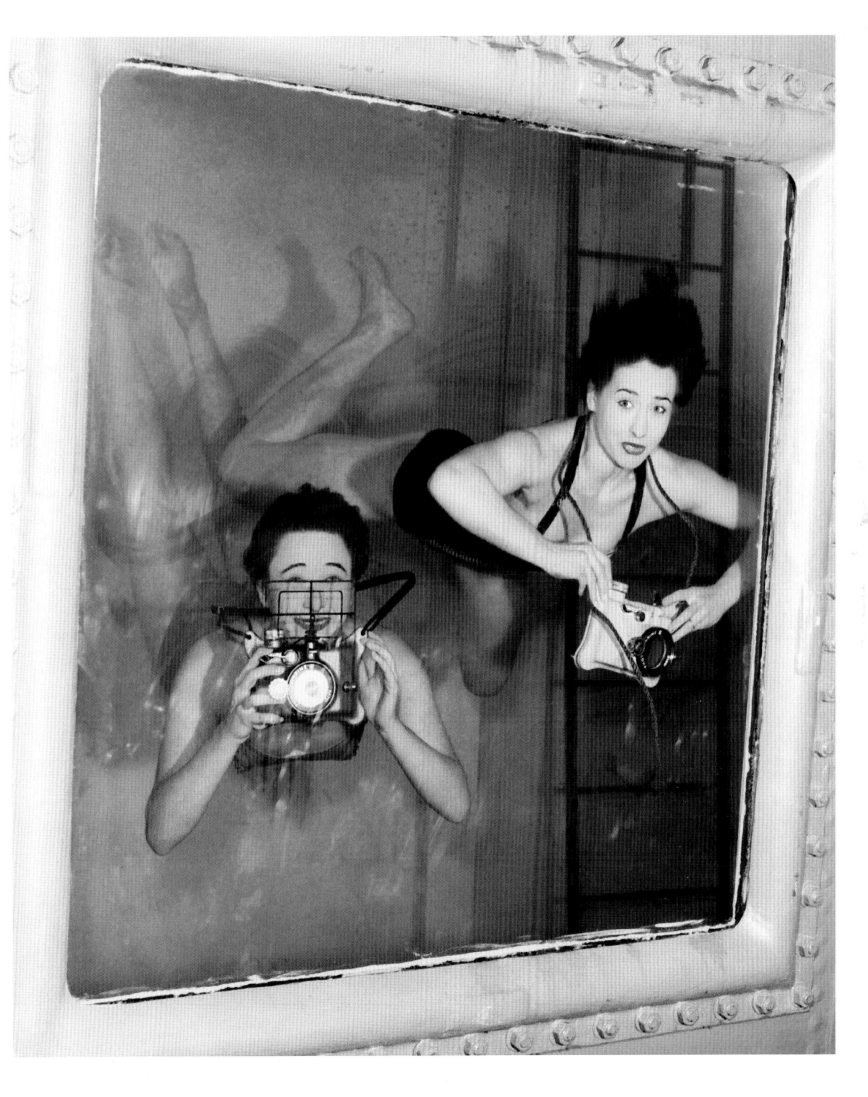

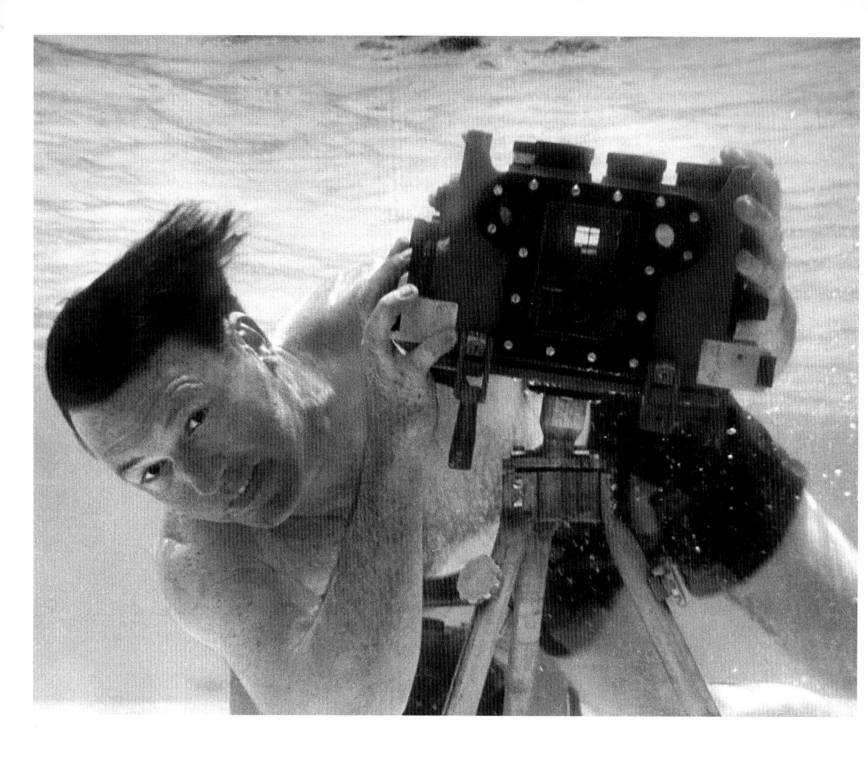

Above: **J. R. Eyerman** (1906-1985). Self-portrait while covering an essay on underwater warfare, 1951. Eyerman was on the staff of *Life* magazine from 1942 to 1961. His camera is contained within the special housing that he made for underwater photography with Otis Barton. The housing protected the camera from water and pressure at depth. *Opposite:* **J. R. Eyerman** (1906-1985). Self-portrait while on assignment photographing the aurora borealis, 1951. Eyerman made a special concave mirror for photographing the aurora borealis. He is using an American Meridian Instruments 5 x 4 inch view camera with a pre- or early-wartime Carl Zeiss Sonnar, lens number 2752358.

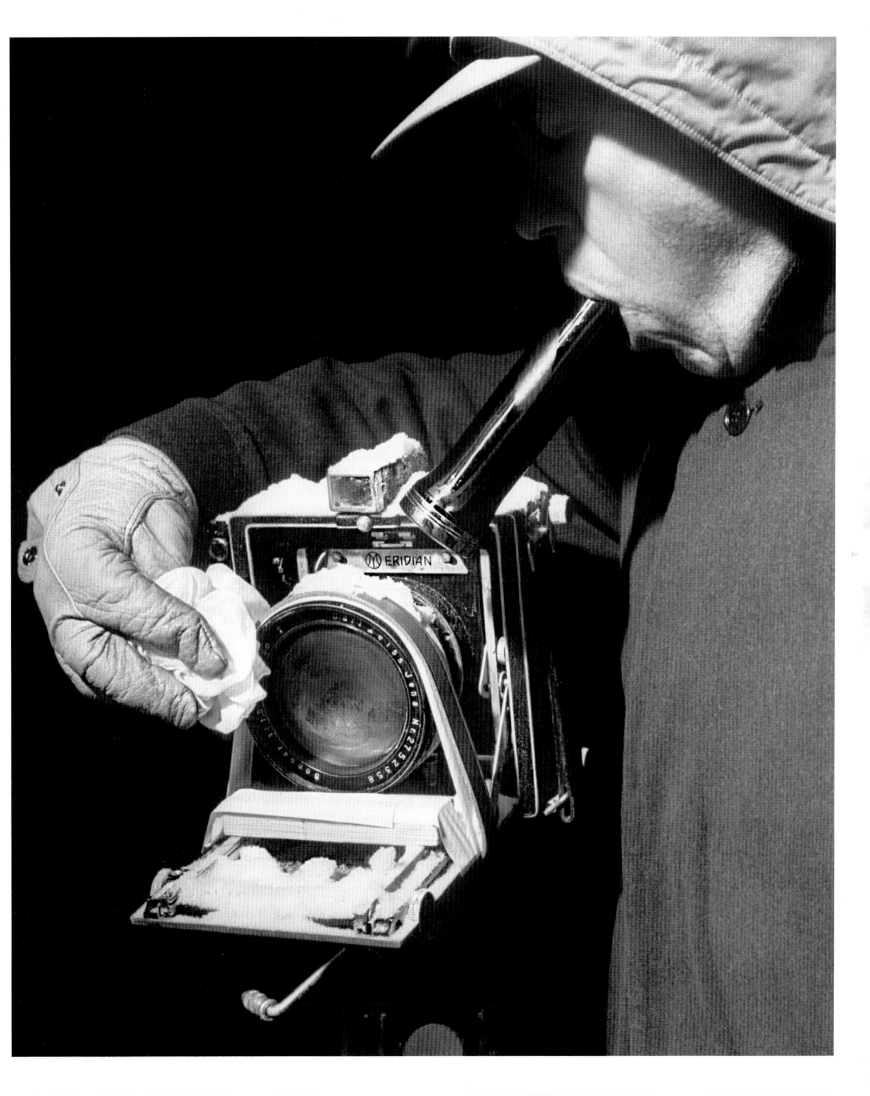

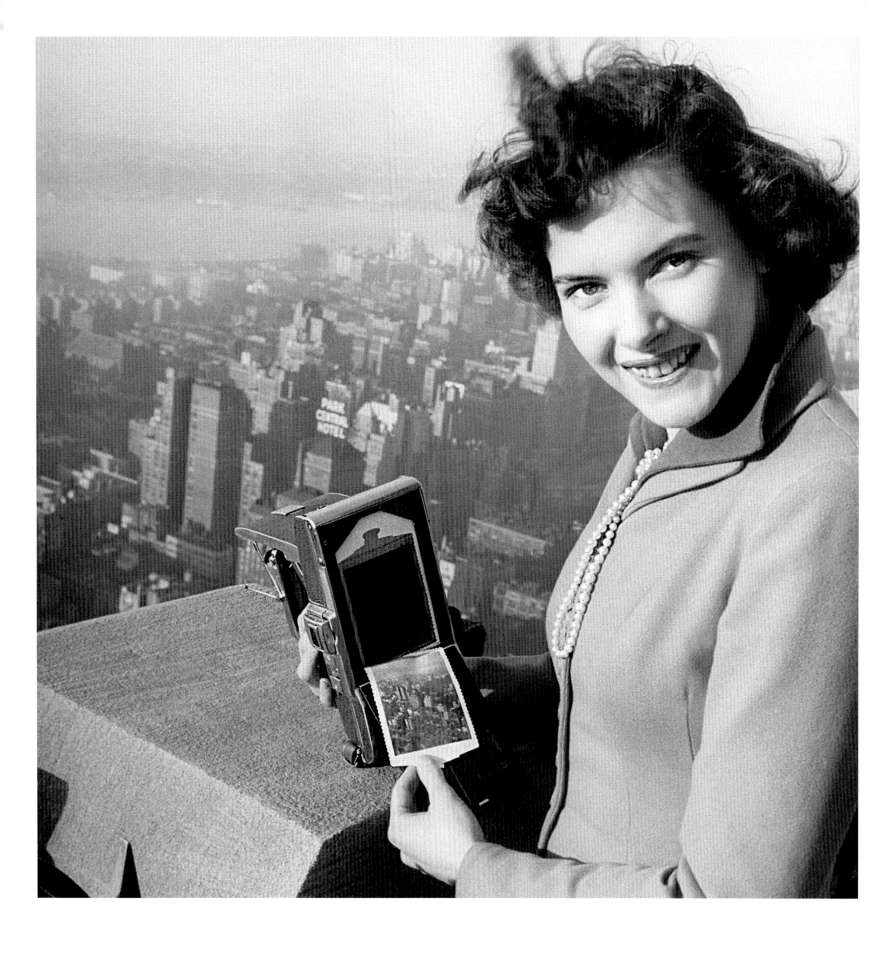

Tony Linck (1919-2004). A woman holding an instant photograph from her Polaroid camera, 31 October 1948. The woman holds a Polaroid Land camera Model 95 which was the first commercially available Polaroid instant camera introduced that year.

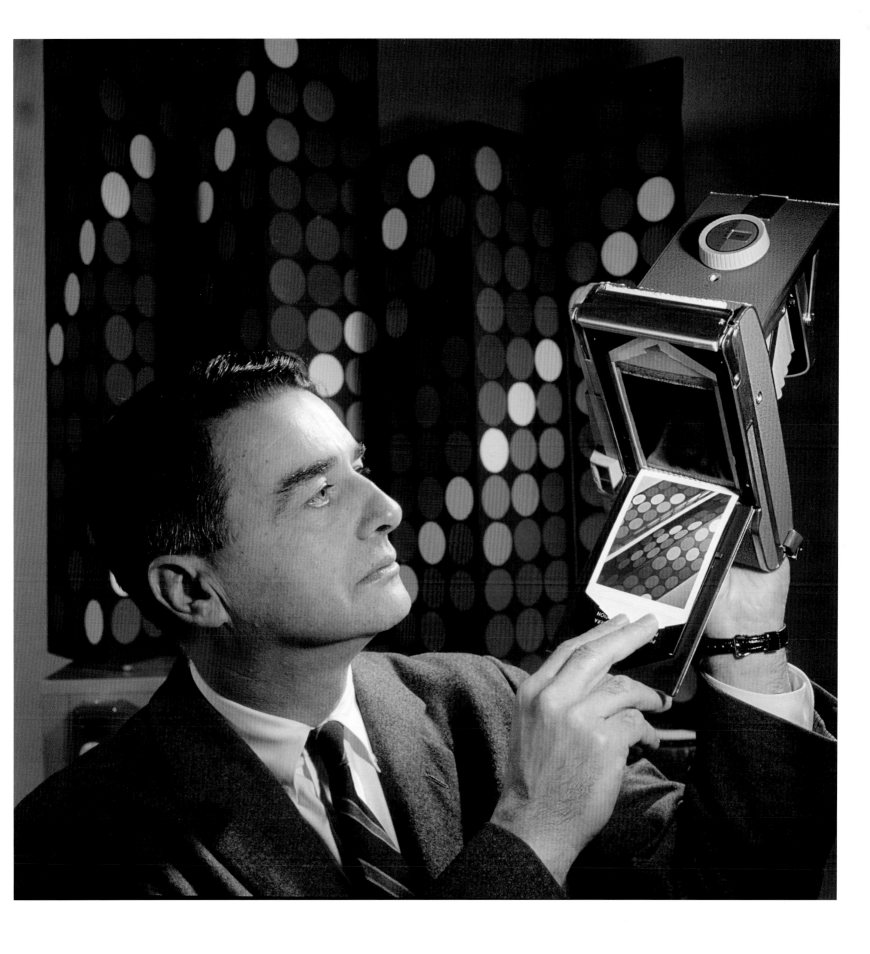

Fritz Goro (1901-1986). Edwin Land, president and co-founder of the Polaroid Corporation, 1963. Land (1909-1991) demonstrates his 60-second film.

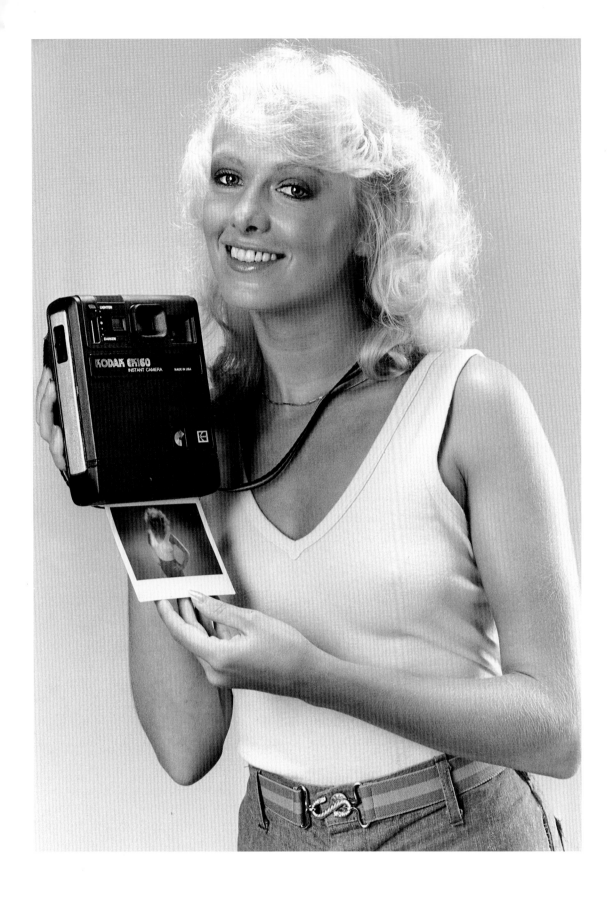

Above: Model with a Kodak EK160 instant camera, 1980. Eastman Kodak Company responded to Polaroid's dominance of the instant camera market with its own range of cameras, which was introduced in 1976. The EK160 was made between 1979 and 1982. Although Kodak claimed its instant film technology was significantly different from Polaroid's products, it lost an intellectual property law case brought by Polaroid and withdrew its instant camera range soon afterwards. *Opposite:* Edwin Land holding the new Polaroid SX-70 camera, 1 June 1972. The SX-70 camera was a design classic and the first significant change to the Polaroid camera range. The colour print was ejected by motor and developed before one's eyes. It did not need the peeling apart or any subsequent chemical coating to preserve it that earlier Polaroid prints had required.

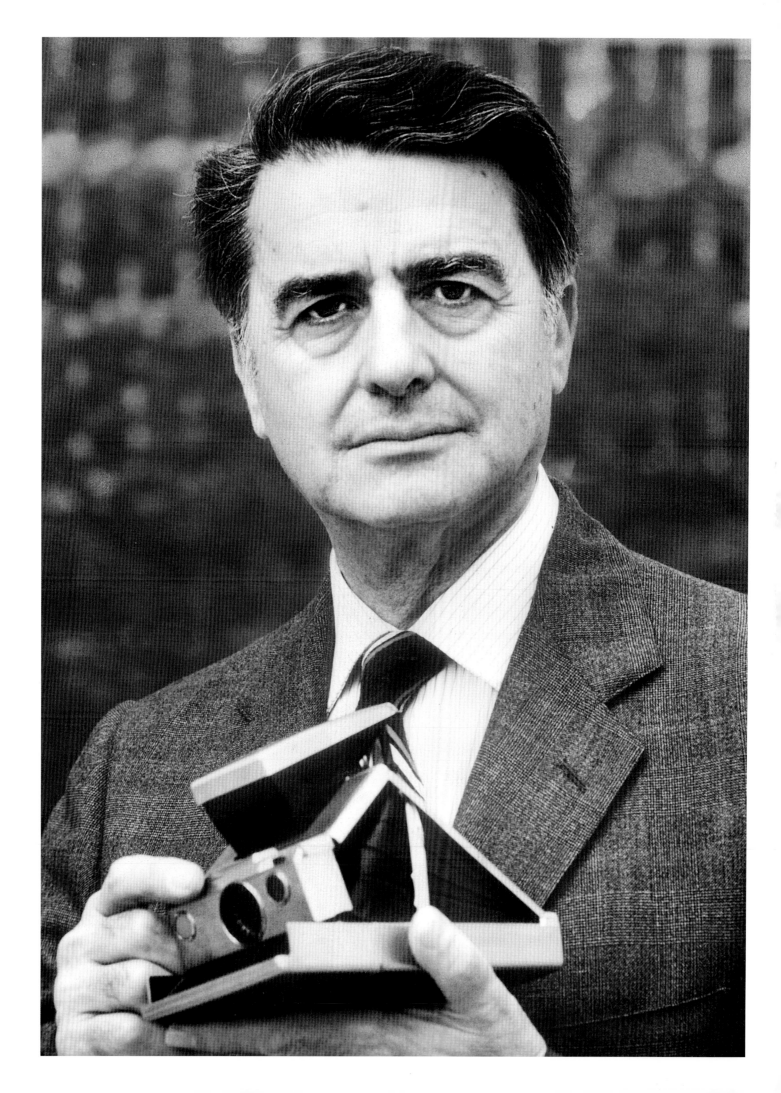

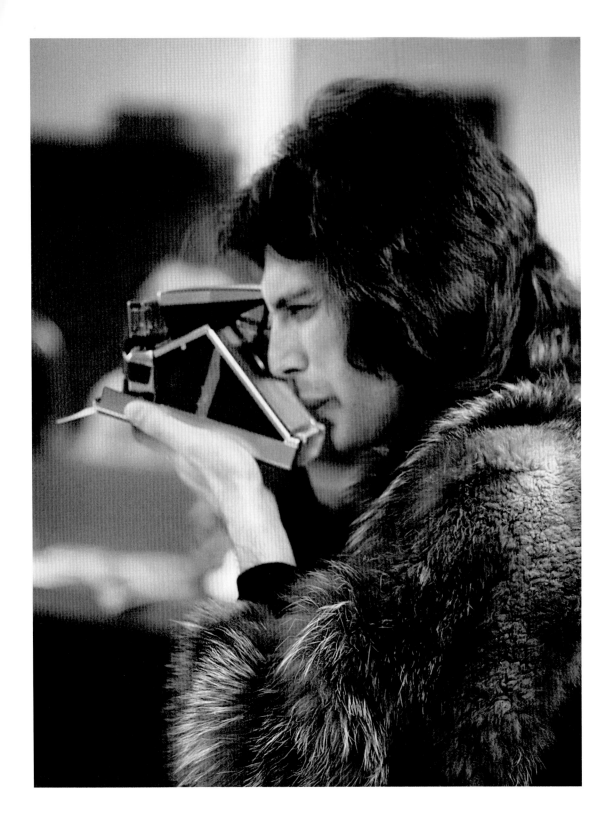

Above: Freddie Mercury of rock band Queen, c.1977. Mercury (1946-1991) uses a Polaroid SX-70 camera. The ejected photograph is just visible at the front of the camera. *Opposite:* American actress and model Christie Brinkley takes photographs while her boyfriend, the singer and songwriter Billy Joel, looks on, 4 May 1983. Brinkley (b.1954) uses a Polaroid camera and holds a series of Polaroid photographs in her left hand.

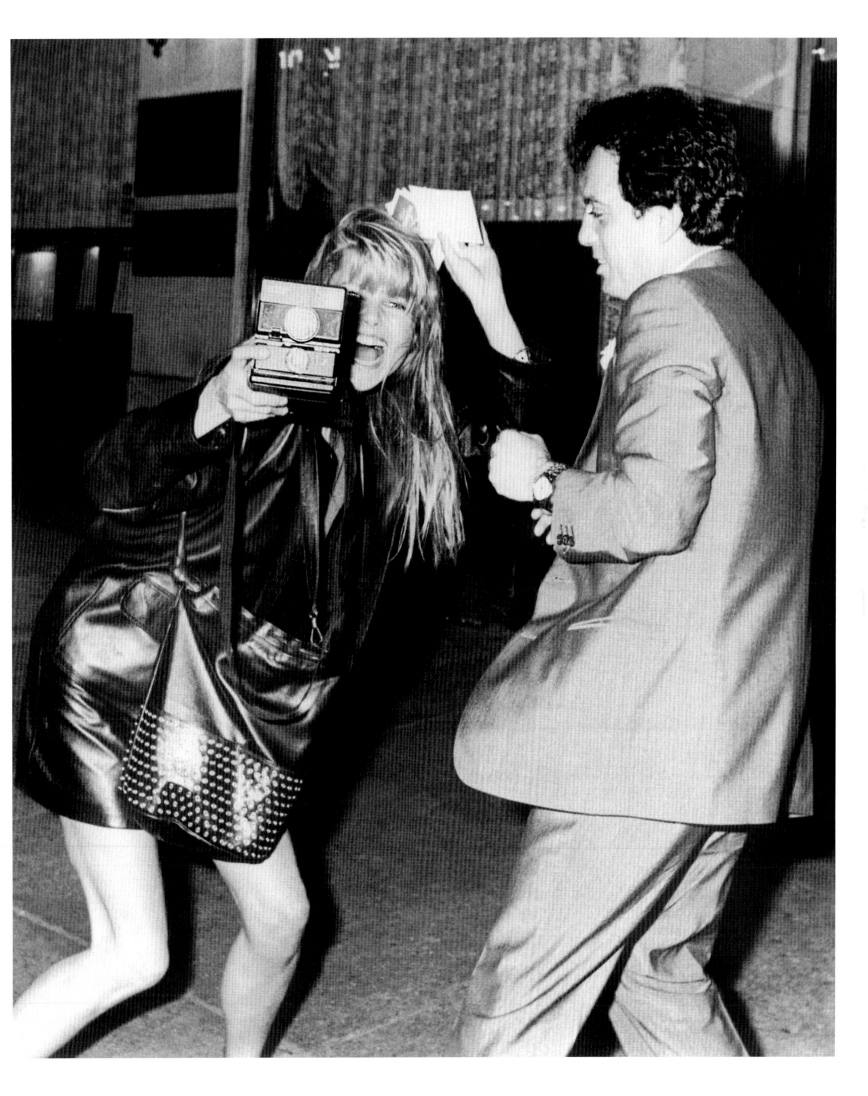

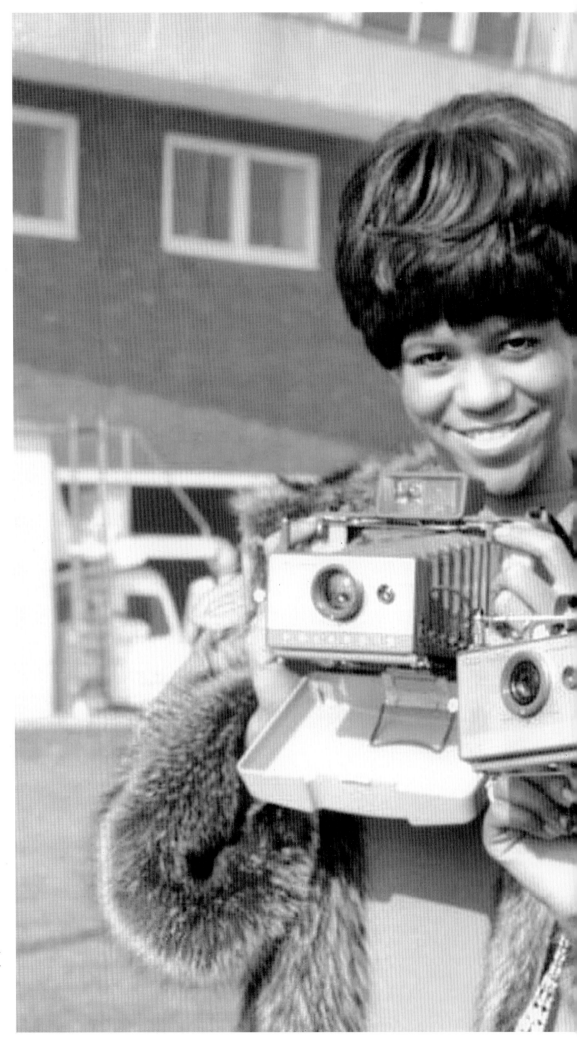

The Supremes with their Polaroid Land 100-series cameras. Diana Ross (b.1944) is on the right of the photograph, c.1964.

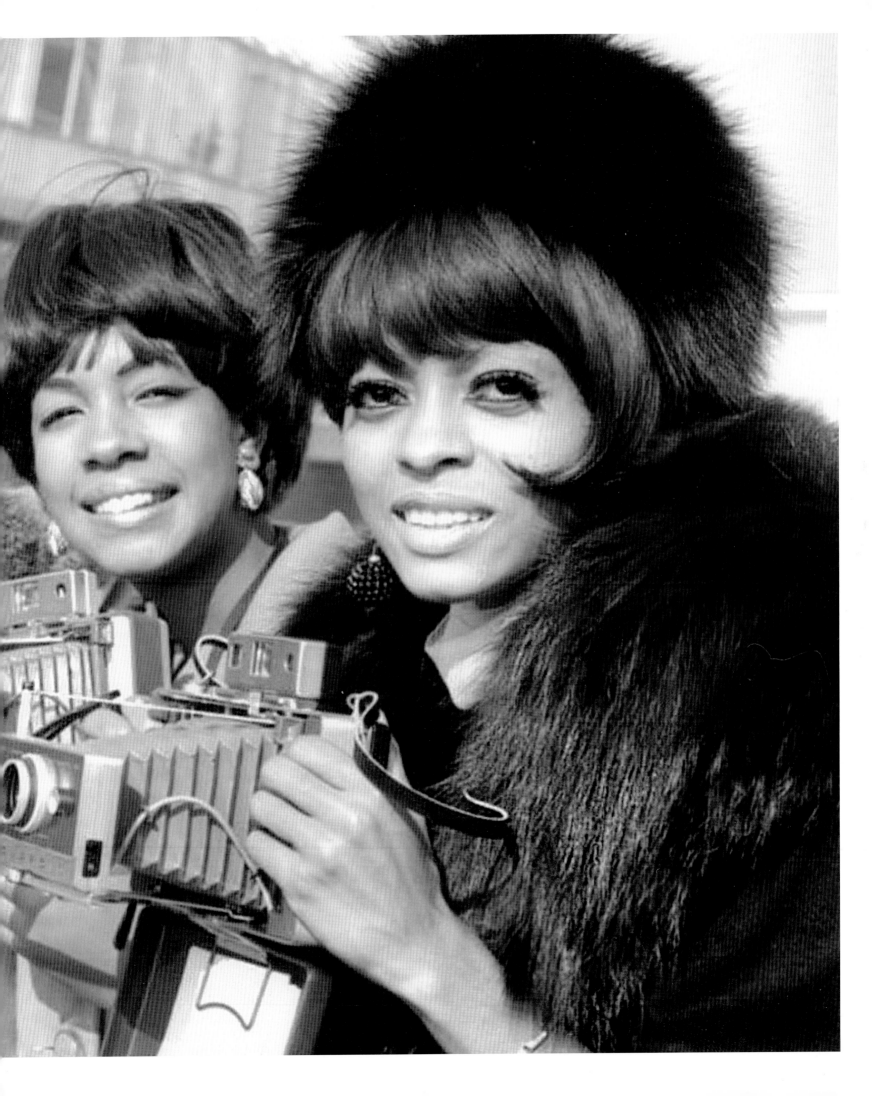

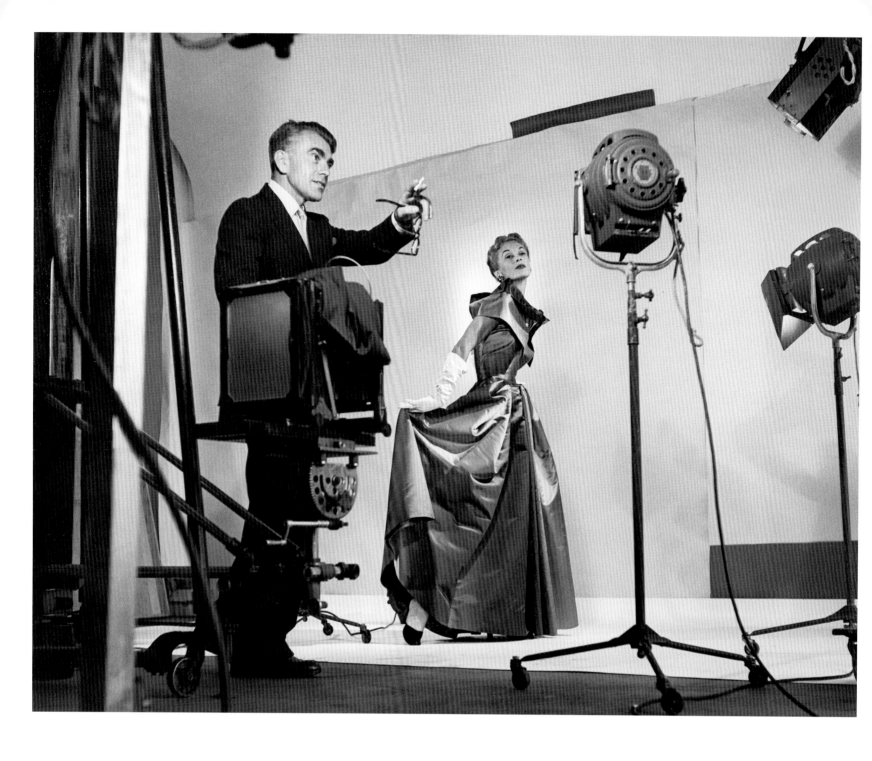

Above: **Roy Stevens** (1916-1988). Photographer Horst P. Horst directing lights and cameras before taking fashion pictures of Lisa Fonssagrives, 1 September 1949. Horst (1906-1999) started his career as an army photographer but spent most of it shooting fashion. In this photograph, he is shooting one of the first supermodels, Lisa Fonssagrives (1911-1992), and is standing in front of his large format studio camera mount on an adjustable stand. *Opposite:* **Weegee** [Arthur Fellig] (1899-1968). Celebrity portrait photographer Yousuf Karsh, 1944. Karsh (1908-2002) was of Turkish descent and spent most of his working life in Canada signing his work 'Karsh of Ottawa'. He is shown in front of his white painted studio camera.

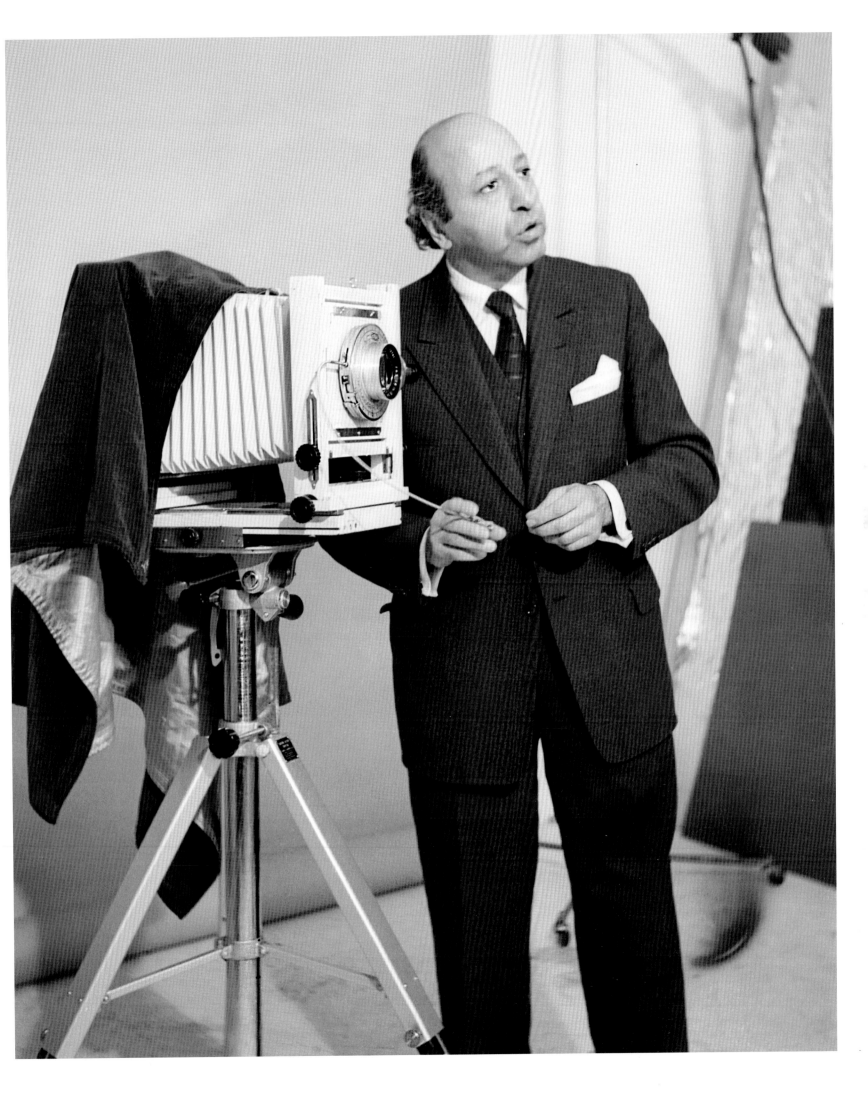

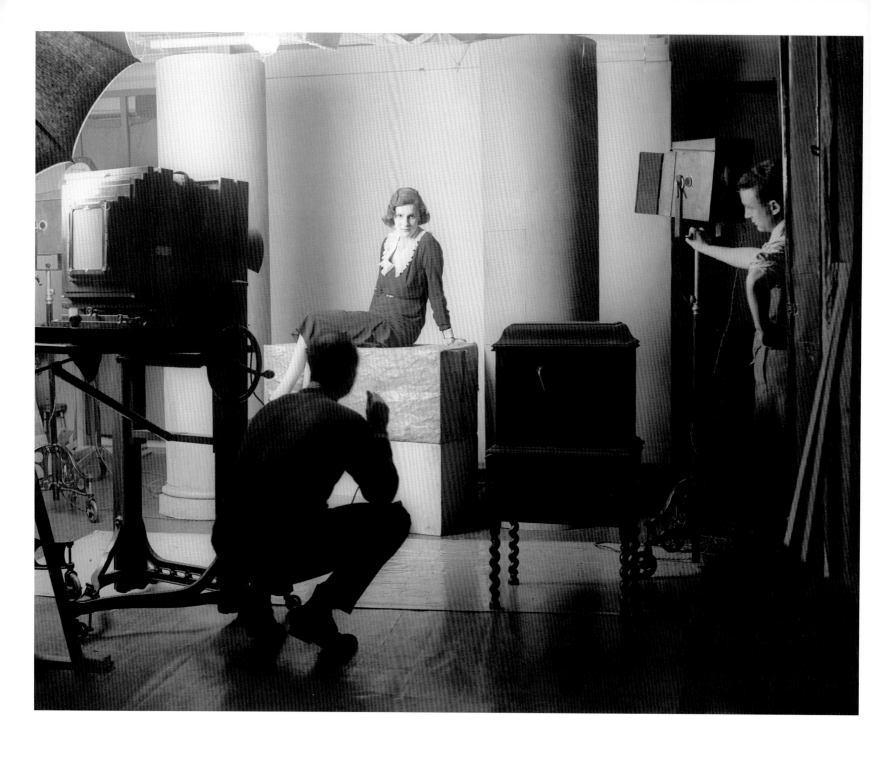

Above: **Peter North** (dates unknown). Lady Weymouth has her portrait taken in the studio of Captain Peter North, 24 October 1930. North was active between the 1930s and 1950s. His large Kodak Century studio camera mounted on a wheeled studio stand was typical of many portrait studios during this period. *Opposite:* **Don English** (1901-1964). Paramount studio photographer Don English photographs Marlene Dietrich during the filming of *Shanghai Express,* 1932. English uses a Kodak View camera mounted on a tripod to capture Dietrich (1901-1992) reflected in a mirror.

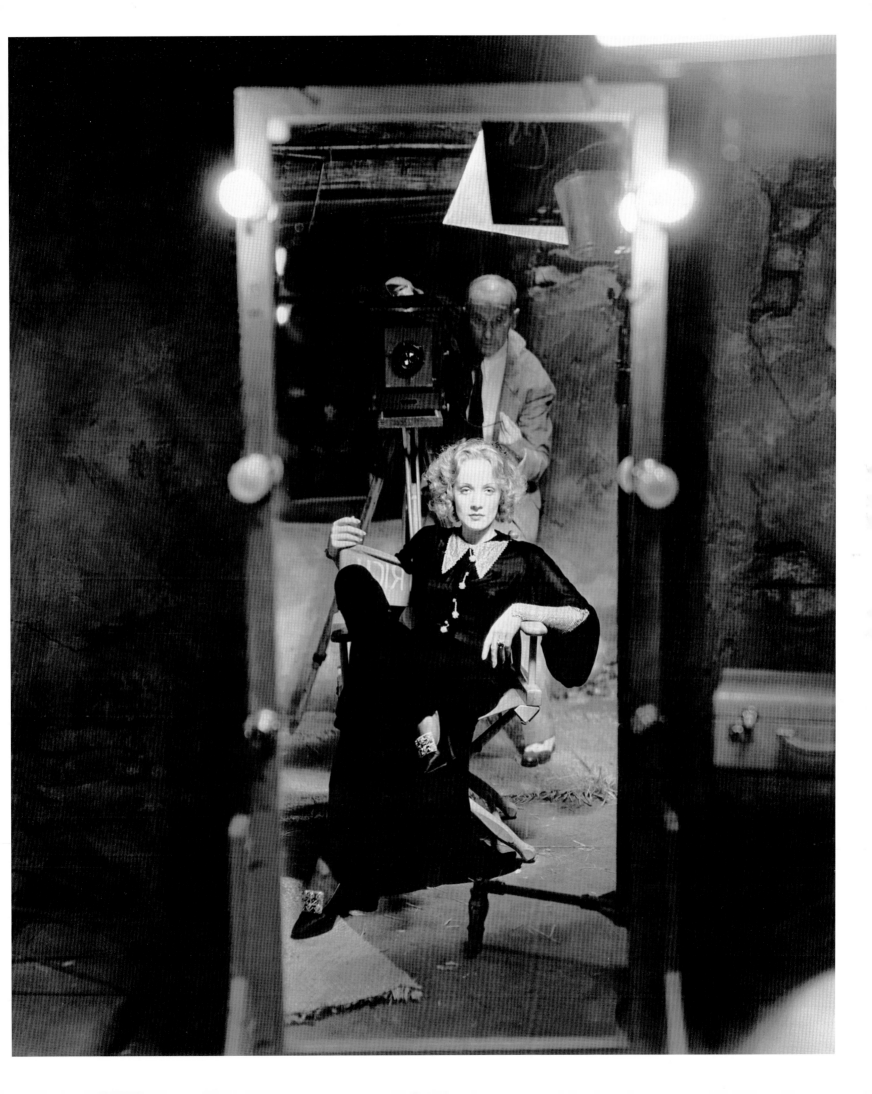

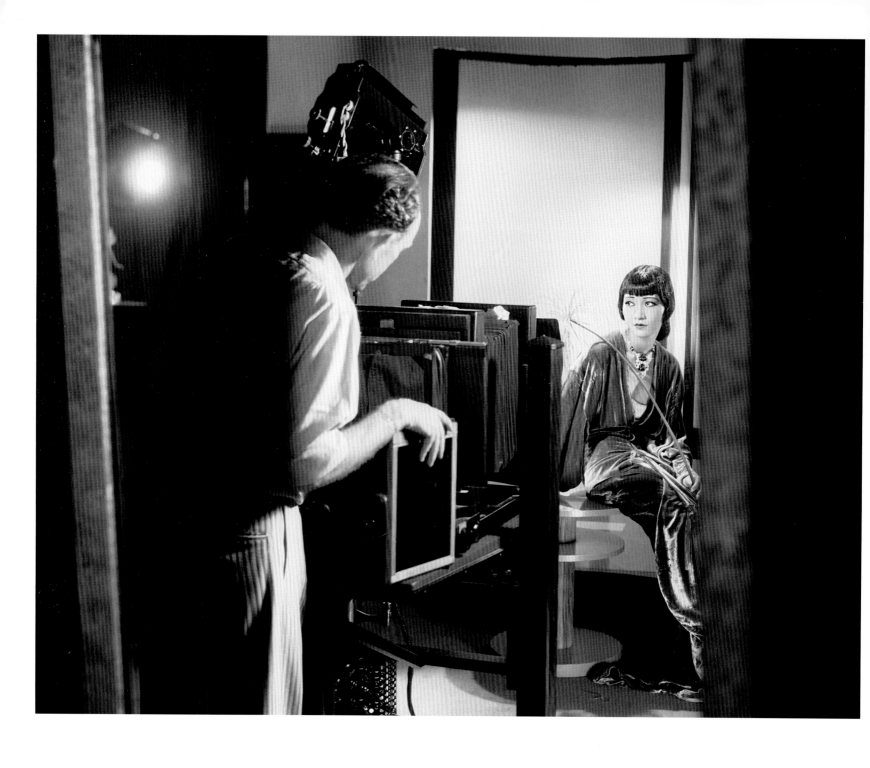

Above: **Otto Dyar** (1892-1988). Paramount studio photographer Otto Dyar takes a portrait of Anna May Wong (1905-1961), both reflected in a mirror, 1932. Dyar is using a large format studio camera, possibly a Kodak Century, mounted on an adjustable, wheeled, studio stand. *Opposite:* Paul Lukas and Madge Evans pose between takes of their film, *Age of Indiscretion*, 1935. Evans (1909-1981) holds an American Graflex reflex camera and Lukas (1891-1971) holds a large studio light to illuminate the scene.

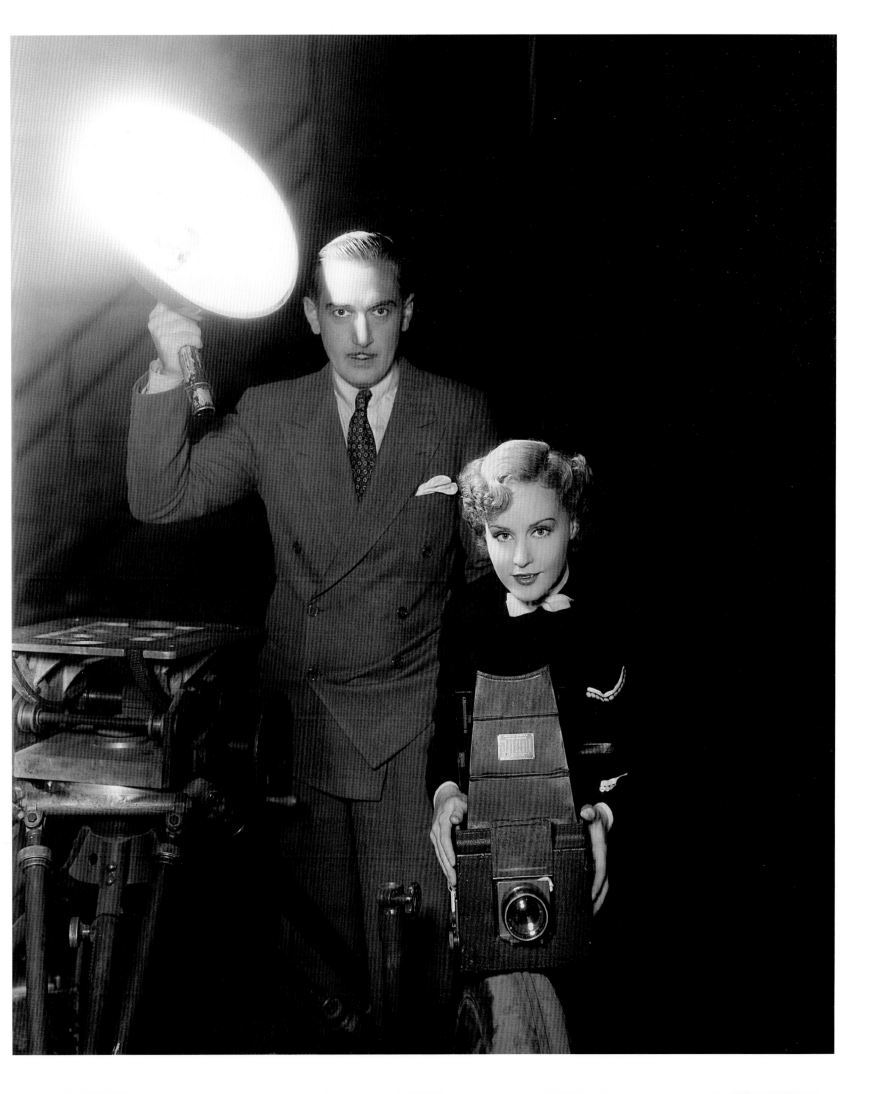

Naval photographer Austin Hansen, 1944. Hansen (1910-1996) carries a Speed Graphic camera with side-mounted flash gun. After his wartime work, he returned to Harlem where he photographed the city's people. His archive was donated to the Schomburg Center for Research in Black Culture in Harlem, New York City.

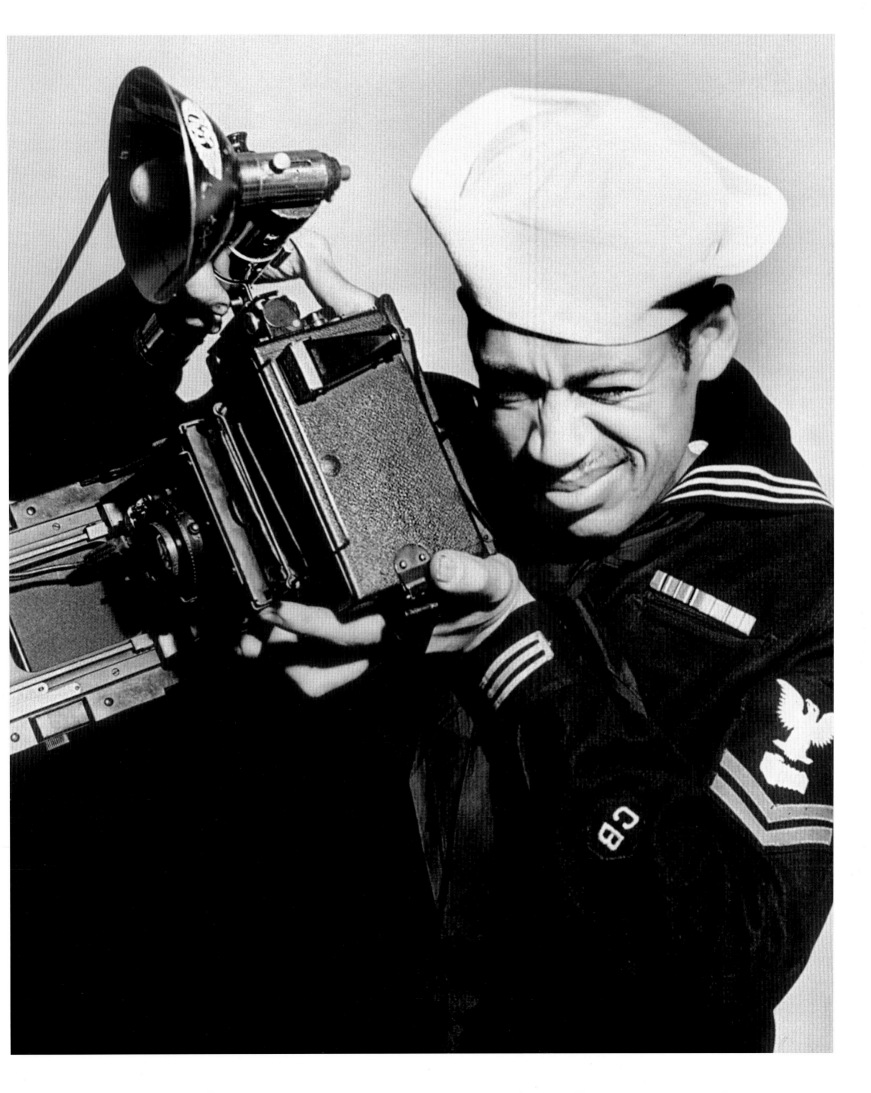

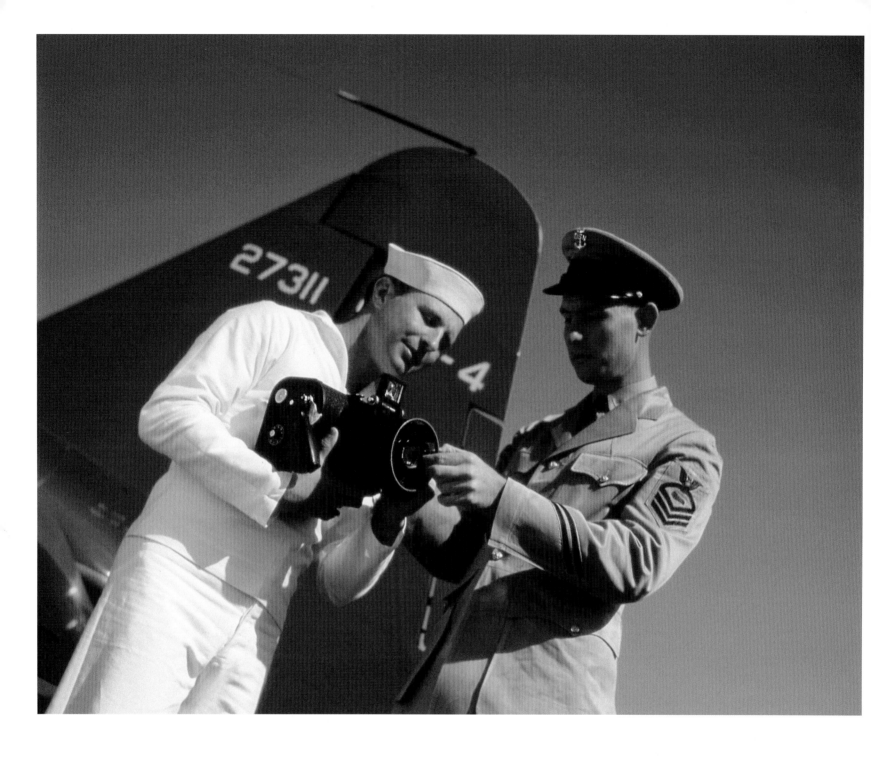

Above: A Chief Photographer instructs a student in the use of a hand-held aerial camera, Pensacola, Florida, February 1944. The two men stand in front of a North American Aviation SNJ-4 training plane. *Opposite:* Corporal Marshall Hull crouches on 16-inch shells at Viareggio, Italy, 1945. Hull was a photographer with the 196th Signal Photo Company and is shown with a Speed Graphic camera.

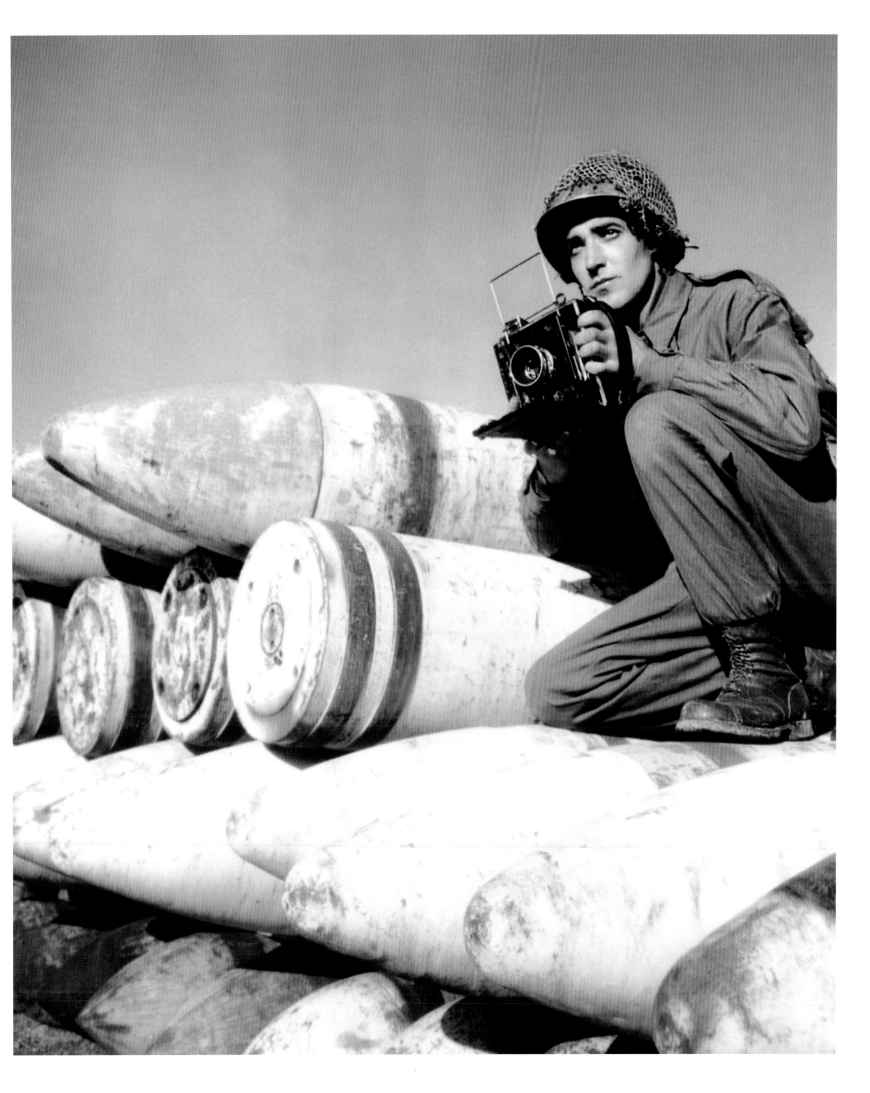

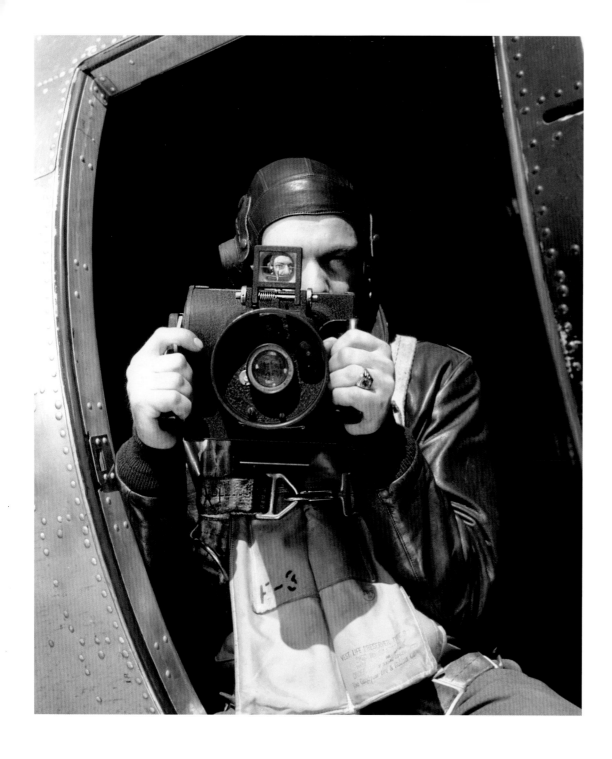

Above: Staff Sergeant Brush with his Fairchild F-20 aerial camera in the waist window on a B-17 Flying Fortress bomber, c.1944. The F-20 camera was a low altitude aerial camera designed for taking oblique photos. It was made by the Fairchild Aerial Camera Corporation under licence from the Graflex company. *Opposite:* Captain Dale E. Elkins, shown with his specially constructed camera, 6 June 1944. Elkins was reputedly the first person to obtain photographs of the Allies' Normandy invasion.

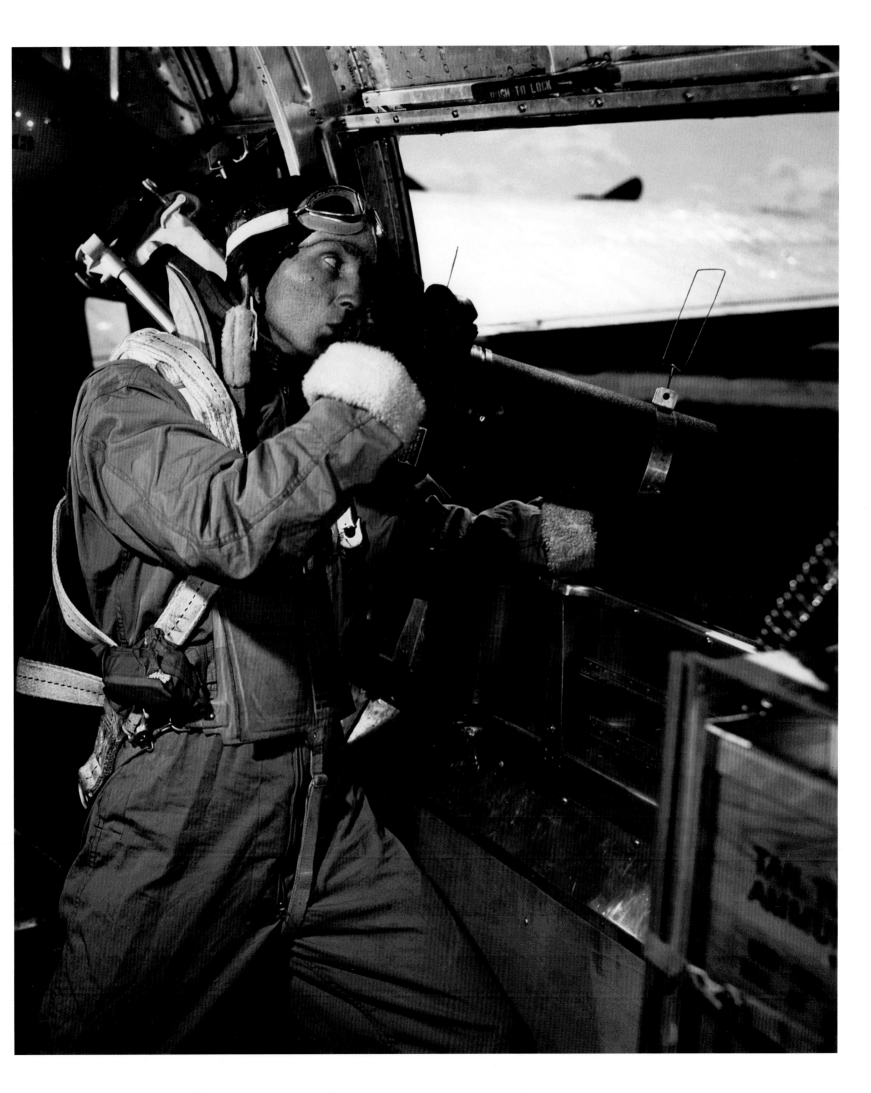

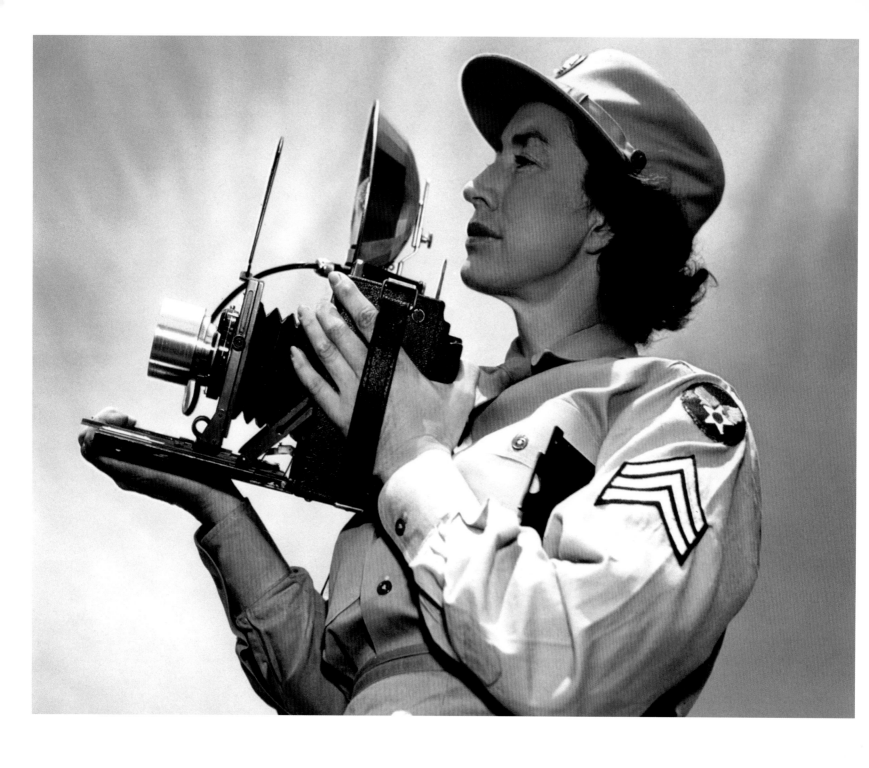

Above: A Women's Army Corps sergeant holds a Speed Graphic camera, 6 March 1946. The Speed Graphic camera was used extensively by American Second World War photographers and the manufacturer produced a special Combat Graphic model in drab olive green designed for war photographers. *Opposite:* American war correspondent and photographer Peggy Diggins using her Speed Graphic camera, September 1943. Diggins wears military uniform with 'War Correspondent' badge.

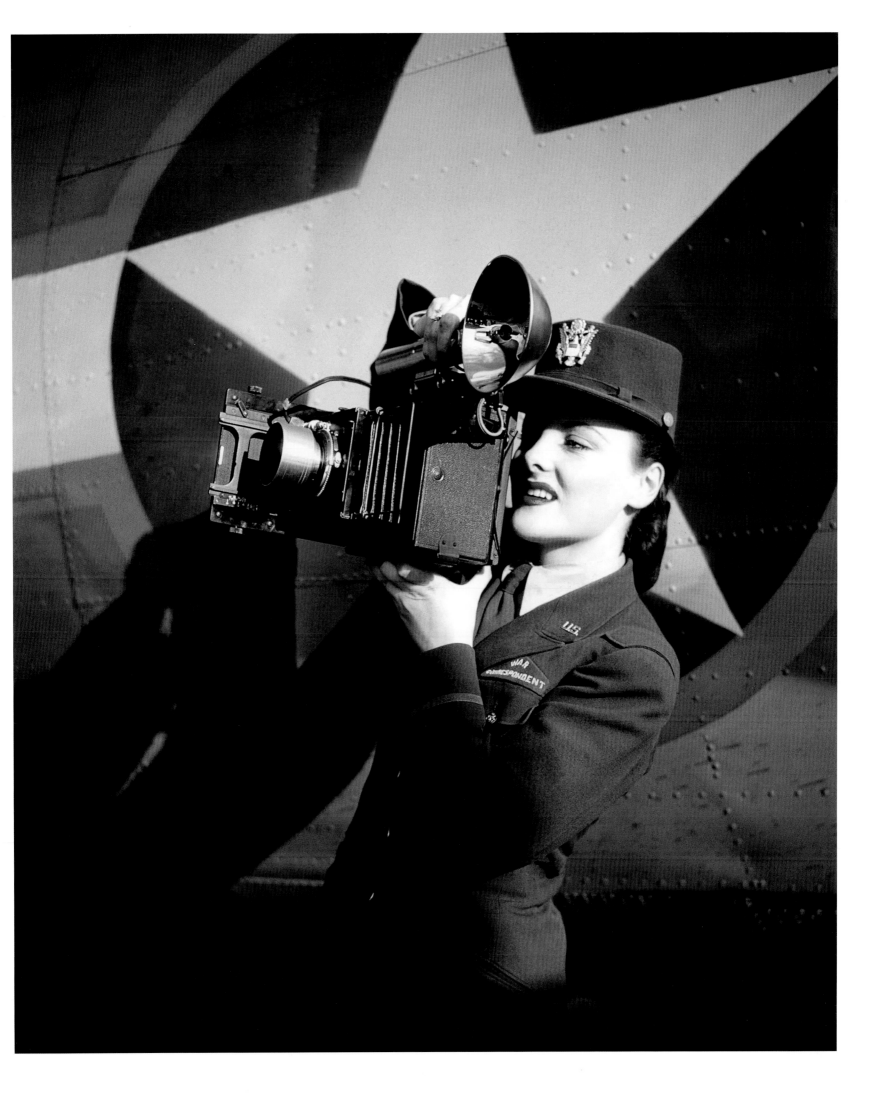

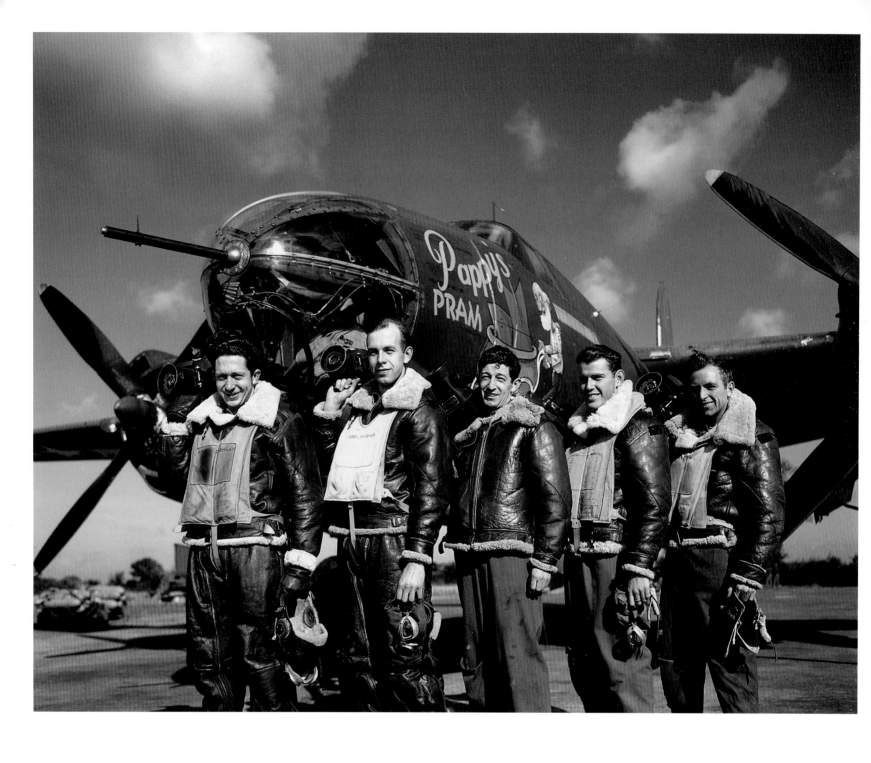

Above: **Frank Scherschel** (1907-1981). Photographers standing in front of 'Pappy's Pram', a B-26 bomber aircraft, 1942. Scherschel was a *Life* magazine photographer from 1942. The photographers each carry an aerial camera. *Opposite:* Photographer Margaret Bourke-White sits on top of a B-17 bomber, 1942. Bourke-White (1904-1971) carries her Rolleiflex twin lens reflex camera.

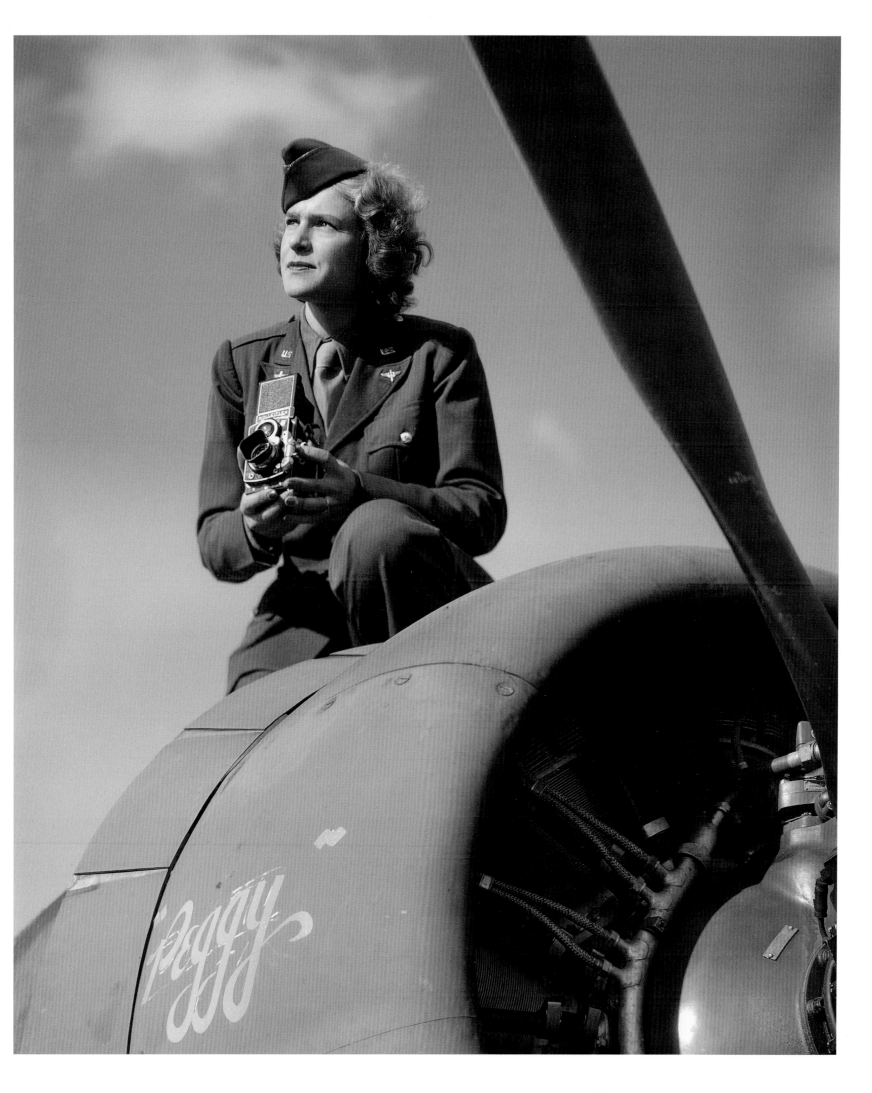

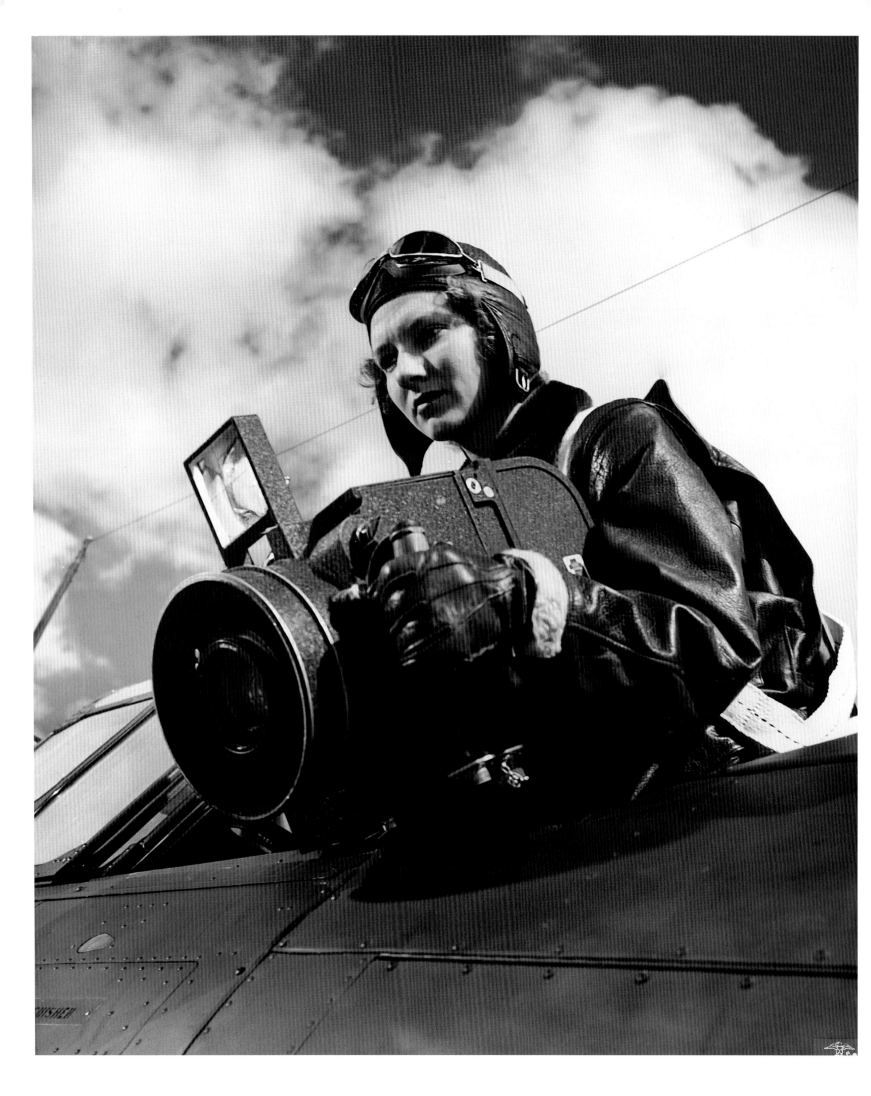

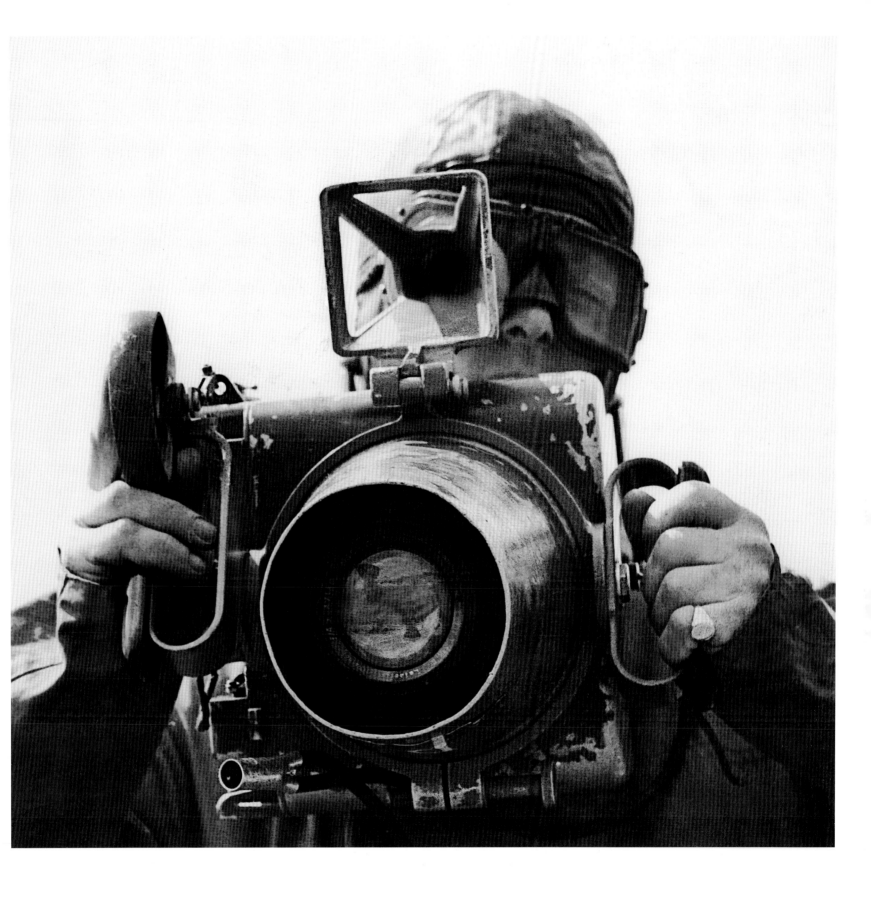

Opposite: Marine Sergeant Grace L. Wyman practices aerial photography at the United States Marine Corps Air Station at Cherry Point, North Carolina. During the Second World War, many women were trained in aerial photography to free up men for combat duties. *Above:* A British Royal Air Force photographer with a large aerial camera used for reconnaissance, 1939.

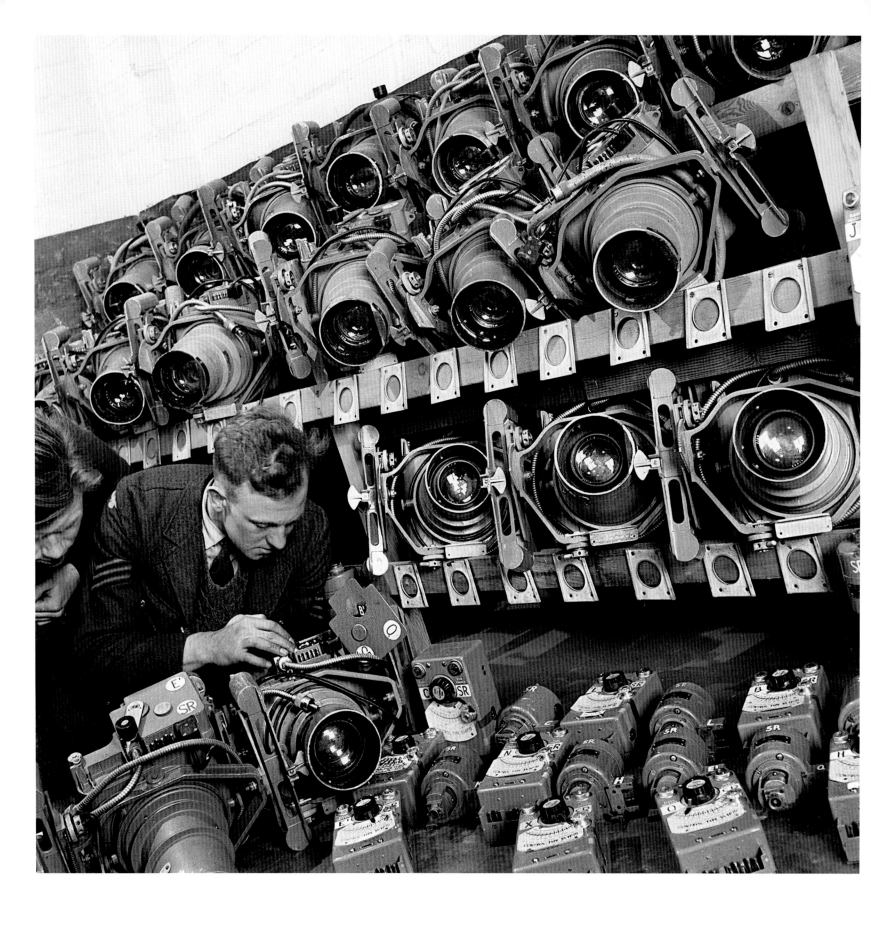

Photographers prepare aerial cameras for the Royal Air Force, 1943. The cameras were designed for mapping and reconnaissance purposes and to record the impact of British bombing. The cameras shown appear to be K-24 aerial cameras, which were made from 1925 to 1942. A version of the K-24 was also made by the Eastman Kodak Company for the American forces.

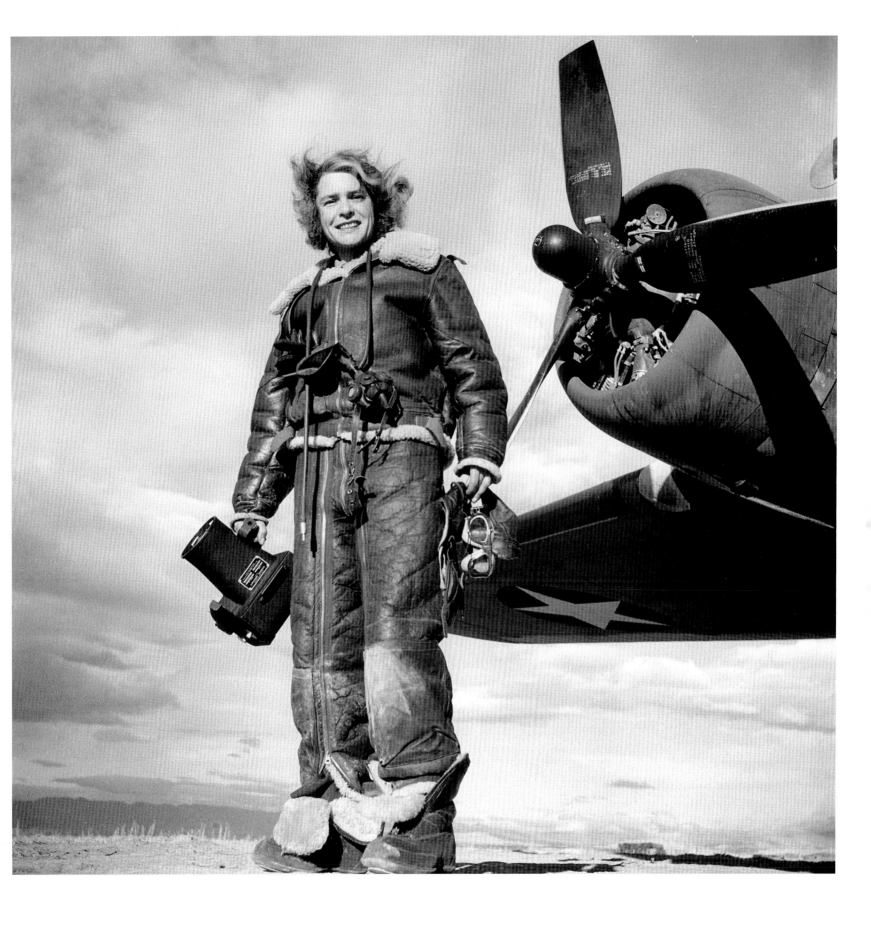

Margaret Bourke-White (1904-1971). Margaret Bourke-White holding an aerial camera in front of a Flying Fortress bomber in which she made combat photographs of the United States attack on Tunis, 1943. The Fairchild K-20 aerial camera was made by the Folmer-Graflex Corp and around 15,000 were made between 1941 and 1945. They made 5 x 4 inch negatives on long lengths of film.

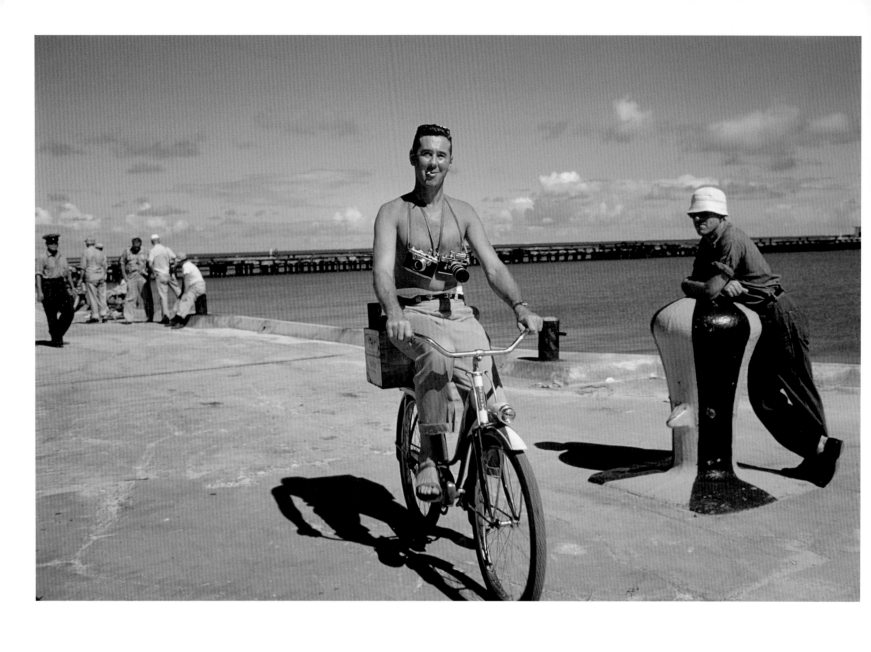

Slim Aarons (1916-2006). Photographer Slim Aarons riding a bicycle during the filming of *Mister Roberts* in Hawaii, 1955. The film starred Henry Fonda, James Cagney, William Powell and Jack Lemmon.

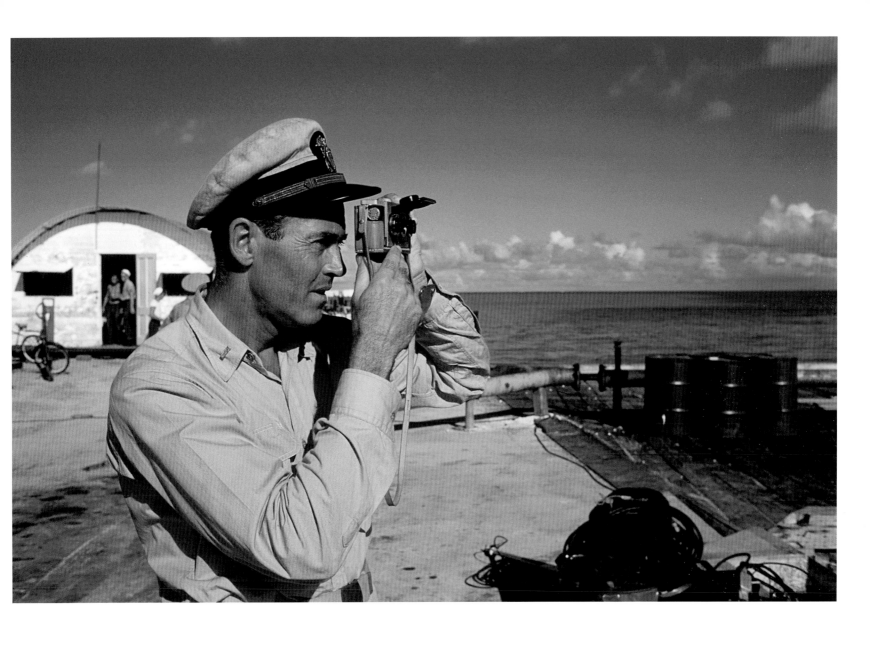

Slim Aarons (1916-2006). Actor Henry Fonda uses his camera while on the set of *Mister Roberts*, Hawaii, 1955. Fonda (1905-1982) is using a Stereo Realist camera which was designed to take a pair of photographs for use in a stereoscope or stereo projector.

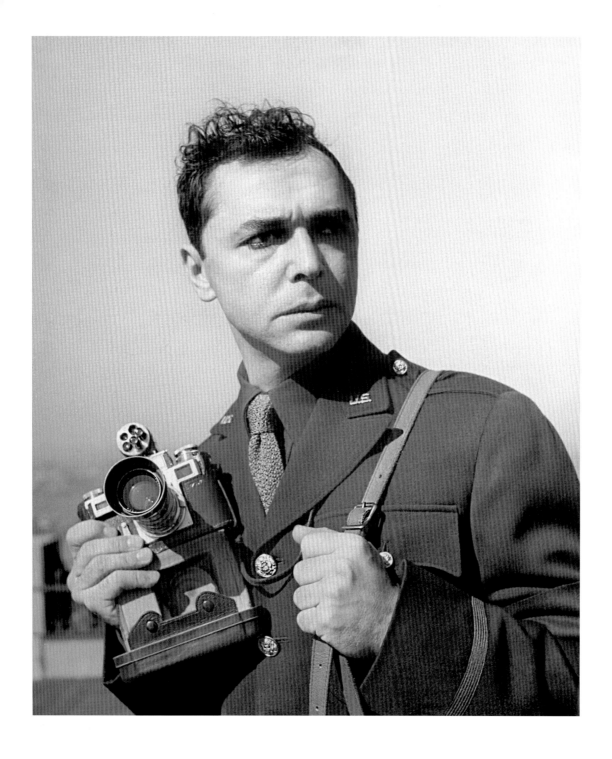

Above: **Alfred Eisenstaedt** (1898-1995). Eliot Elisofon on assignment during World War Two, 1942. Elisofon (1911-1973) was an American documentary photographer and photojournalist. He is carrying a Contax III camera, which was made between 1936 and 1942. The camera is fitted with a short telephoto lens and a turret viewfinder adjustable for five different focal length lenses. *Opposite:* **David E. Scherman** (1916-1997). Portrait of photojournalist Robert Capa, Portsmouth, United Kingdom, 6 June 1944. Capa (1913-1954) is one of the best-known war photographers and is shown preparing for the Allied invasion of Normandy where he made some of his most iconic photographs. His Rolleiflex camera is in its case hanging over his shoulder. Capa was killed after stepping on a landmine in Vietnam covering the First Indochina War.

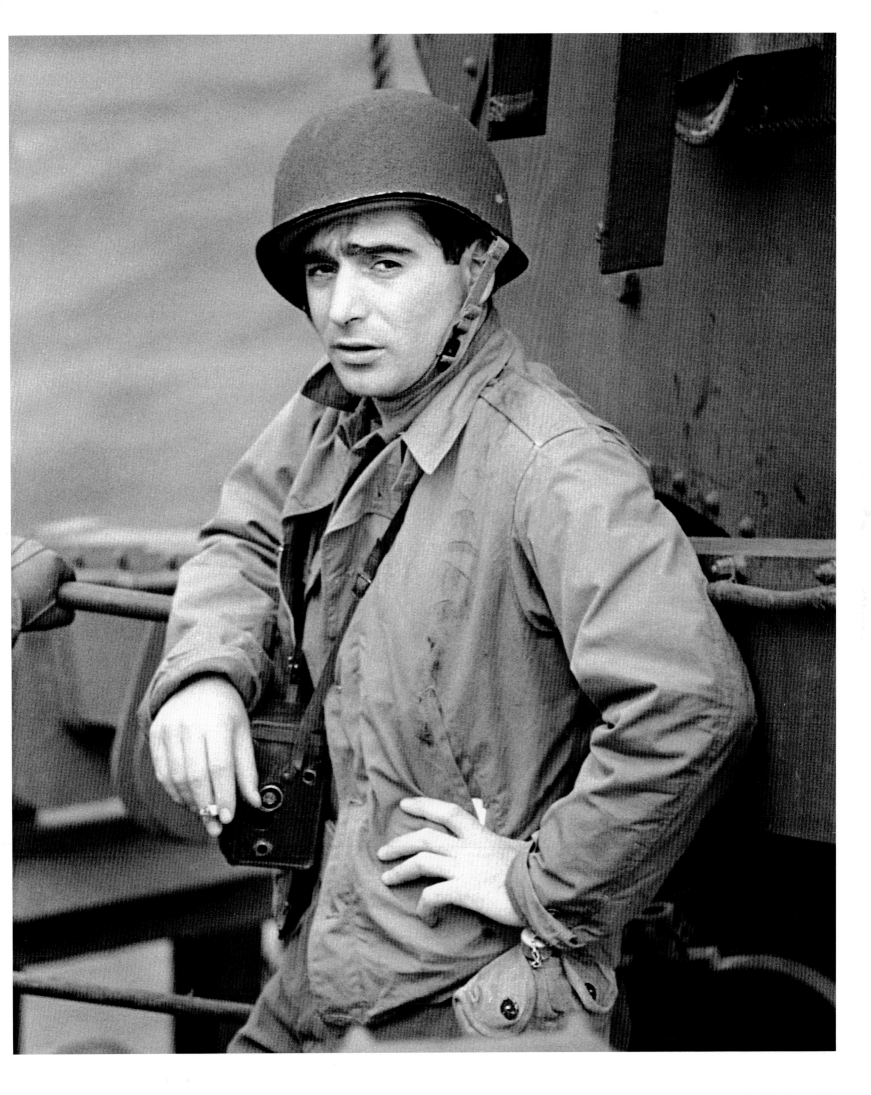

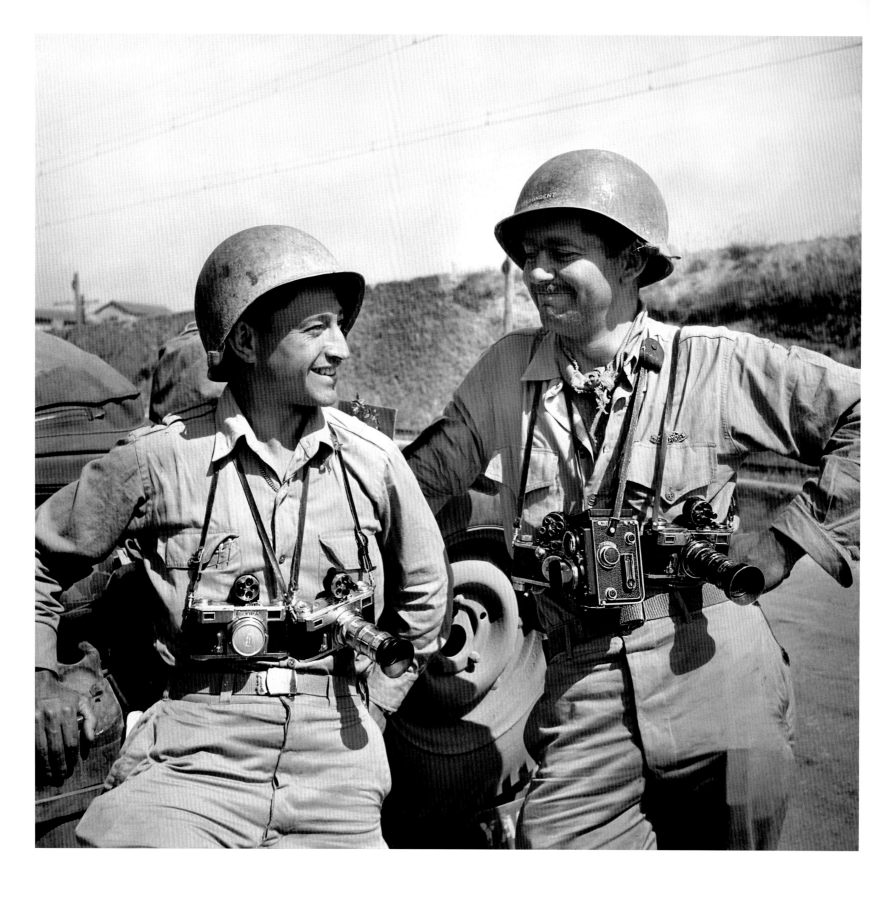

Life photographers George Silk and Carl Mydans on assignment in Italy, 1943. Mydans (1907-2004) carries two Contax II cameras made between 1936 and 1942 with different focal length lenses and turret viewfinders. Silk (1916-2004) carries a Contax II, a Leica fitted with a rapid winder and a Rolleiflex camera.

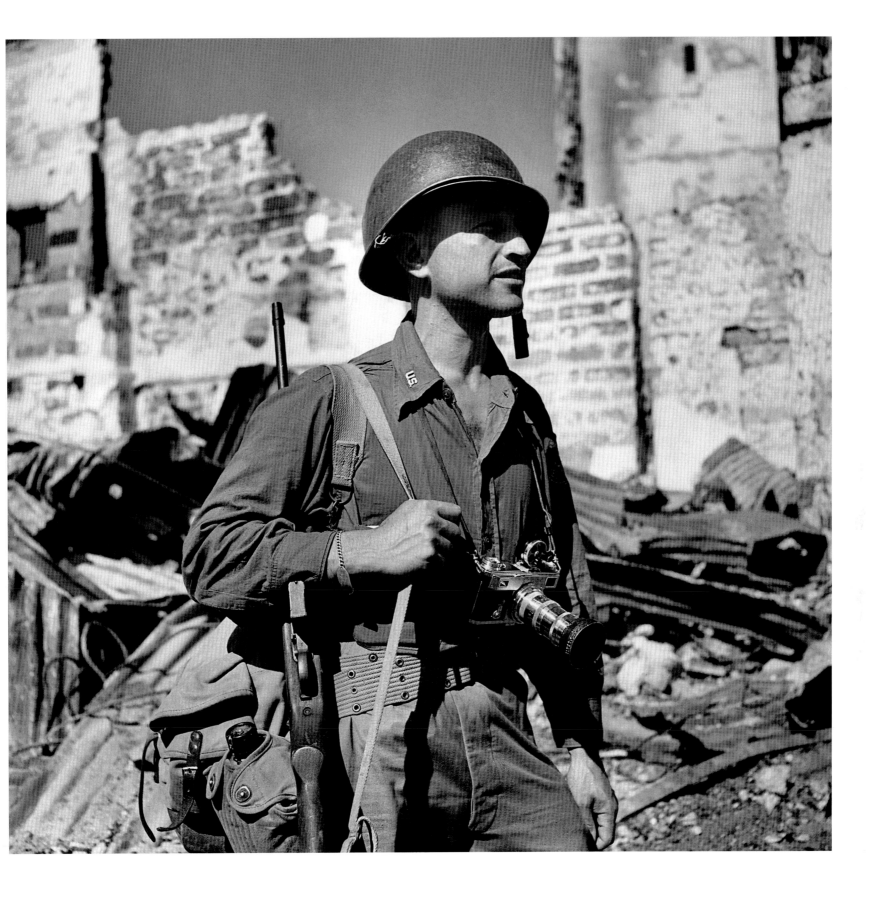

Life photographer Carl Mydans walks through Manila after its recapture by American forces, early 1945. Mydans (1907-2004) carries his Contax II camera with a telephoto lens mounted on it.

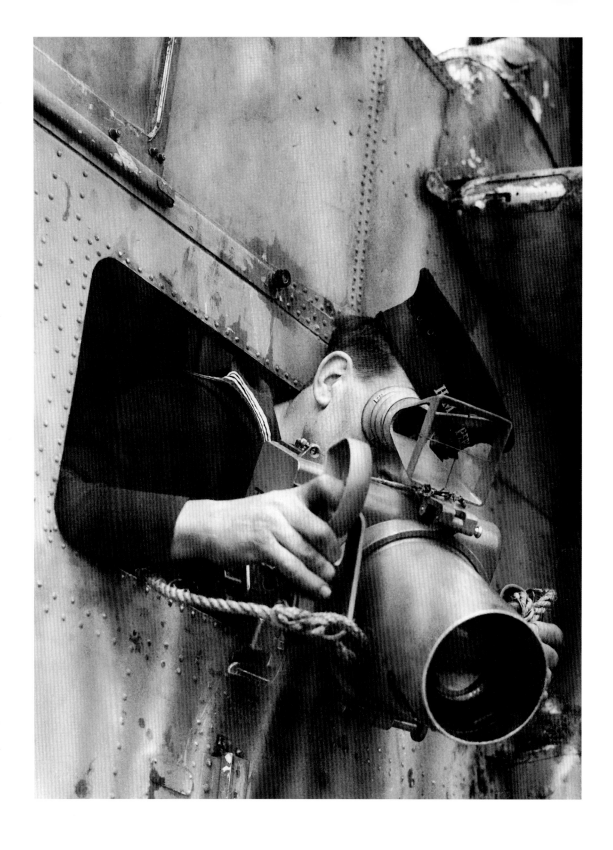

Above: A sailor trains to use a camera in order to enter the Royal Naval Air Station, 20 December 1939. *Opposite:* **Morris Engel** (1918-2005). Self-portrait of Morris Engel on board ship, c.1943. Engel holds a Speed Graphic camera with wide aperture lens suitable for low light photography. He was an influential photographer and, later, a film-maker.

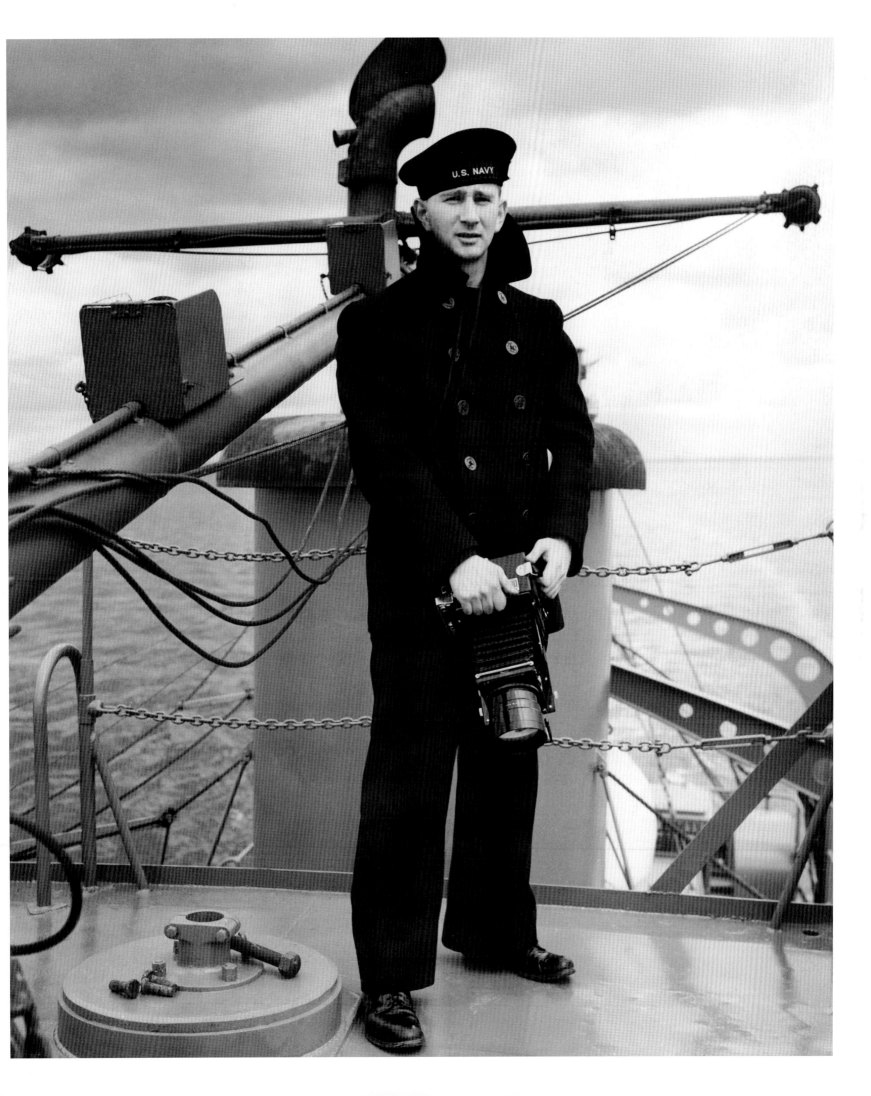

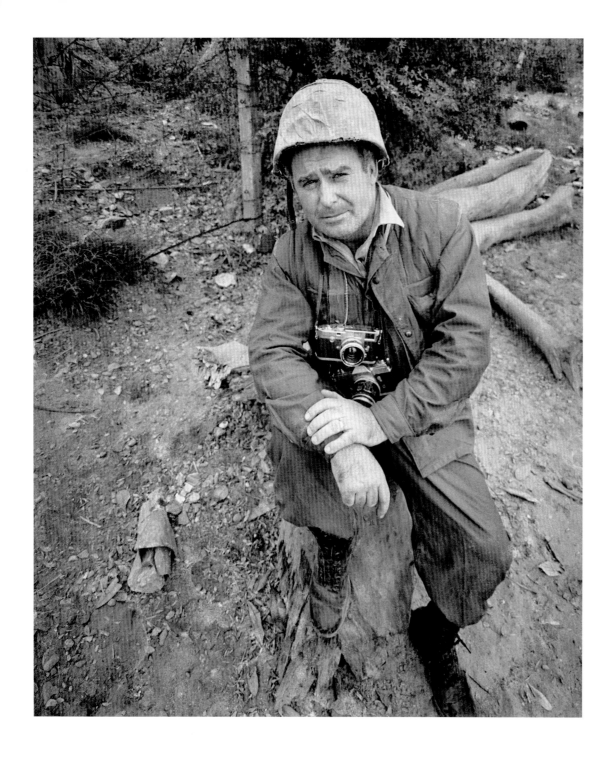

Above: Terry Fincher in Vietnam, 19 February 1968. Fincher (1931-2008) carries a Leica M3 and a Nikon F camera. He worked for the *Daily Express* newspaper and was British press photographer of the year in 1957, 1959, 1964 and 1967 and runner-up in 1968. *Opposite:* **John Olson** (b.1947). Self-portrait in battle fatigues, 1968. *Life* photographer Olson is holding a Nikon F camera in his left hand, two Nikkormat cameras and a Widelux panoramic camera are around his neck. Olson was assigned to *Stars and Stripes* newspaper in 1967 and less than a year later he had won the Robert Capa Gold Medal for his coverage of the Siege of Hue. He became *Life* magazine's youngest staff photographer.

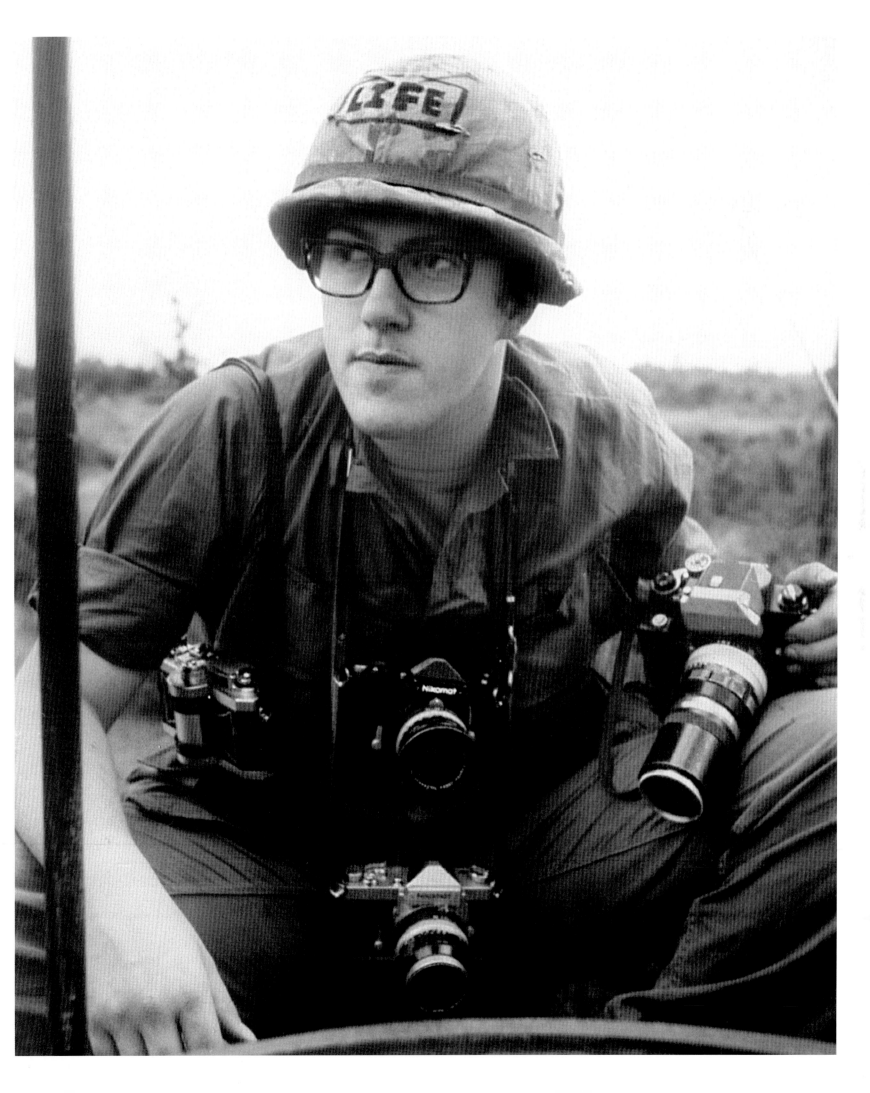

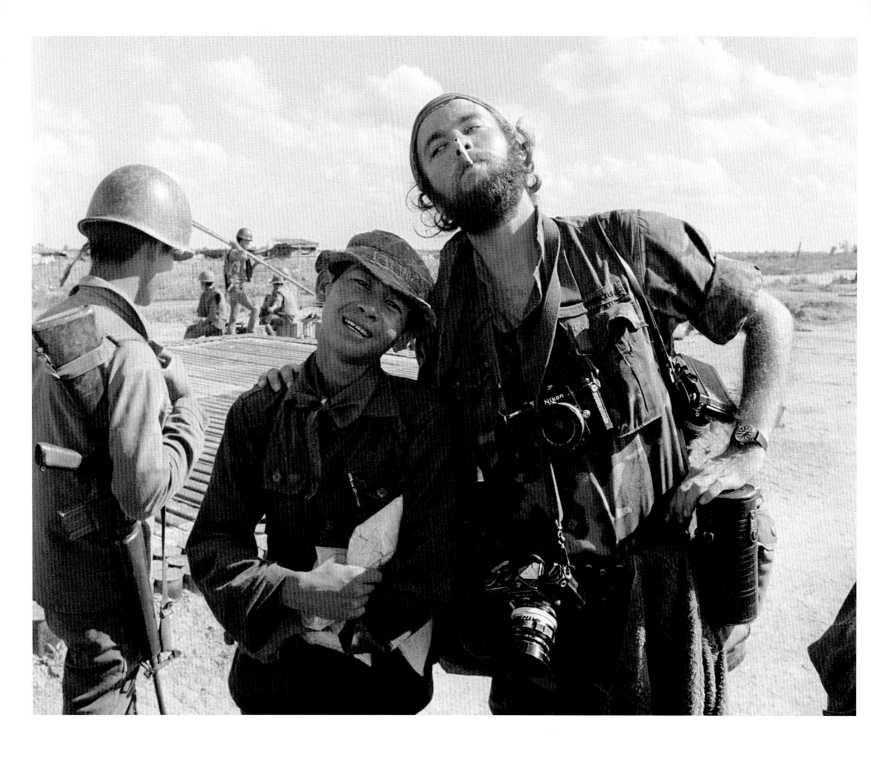

Above: **David Hume Kennerly** (b.1947). Self-portrait, smoking with a South Vietnamese soldier, My Tho, Vietnam, 1972. Kennerly is carrying a Nikon F camera. The photographs that he took in Vietnam won the Pulitzer Prize for Feature Photography in 1972. *Opposite:* Larry Burrows attaching cameras to helicopter Yankee Papa 13 prior to a mission during the Vietnam war, 1965. British-born Burrows (1926-1971) worked for *Life* magazine and covered the Vietnam War from 1962 until 1971. He was killed when a helicopter he was sharing with three other photojournalists was shot down. Burrows is shown with two Nikon F cameras and a Leica M3 camera around his neck and is attaching a Nikon F camera to a special mounting on the helicopter.

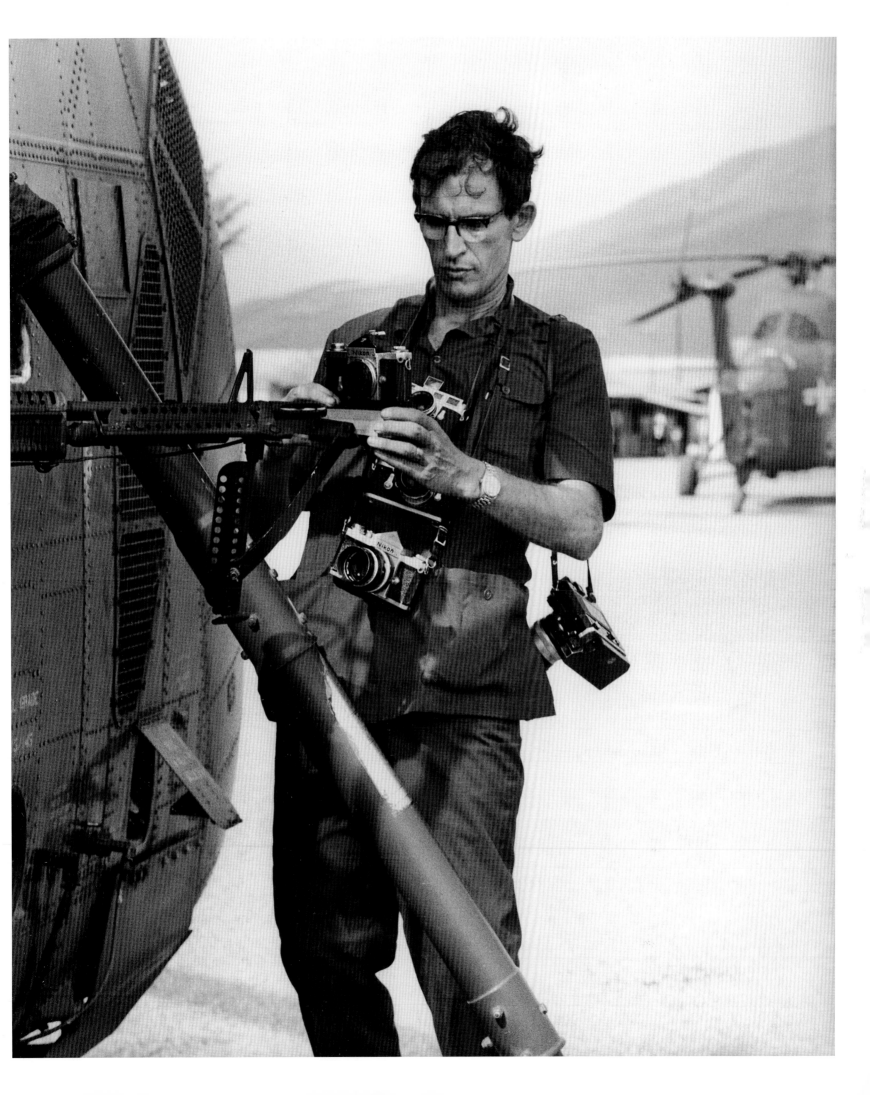

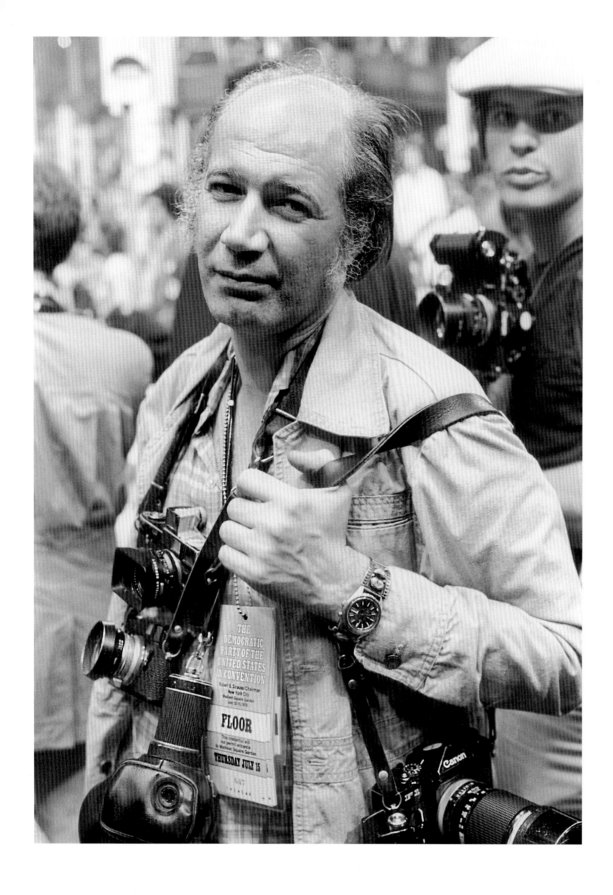

Above: **Fred W. McDarrah** (1926-2007). Pulitzer Prize-winning photographer Eddie Adams at the Democratic National Convention, Madison Square Garden, New York, 15 July 1976. Adams (1933-2004) carries a Canon F1 camera made between 1971 and 1976, two Leica M3 cameras and a light meter. *Opposite:* Photographer Dirck Halstead speaks to an extra on the set of Francis Ford Coppola's *Apocalypse Now*, Baler, Philippines, 28 April 1976. Halstead (b.1936) carries two Nikon cameras.

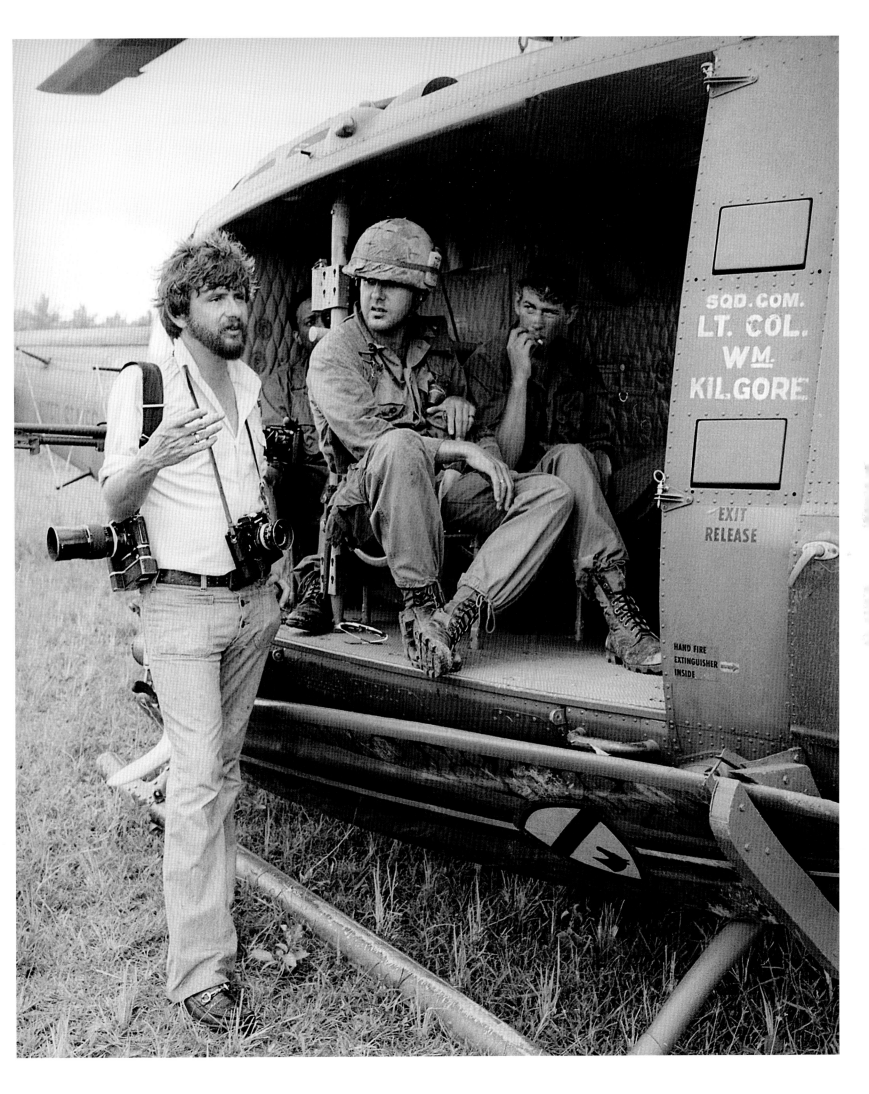

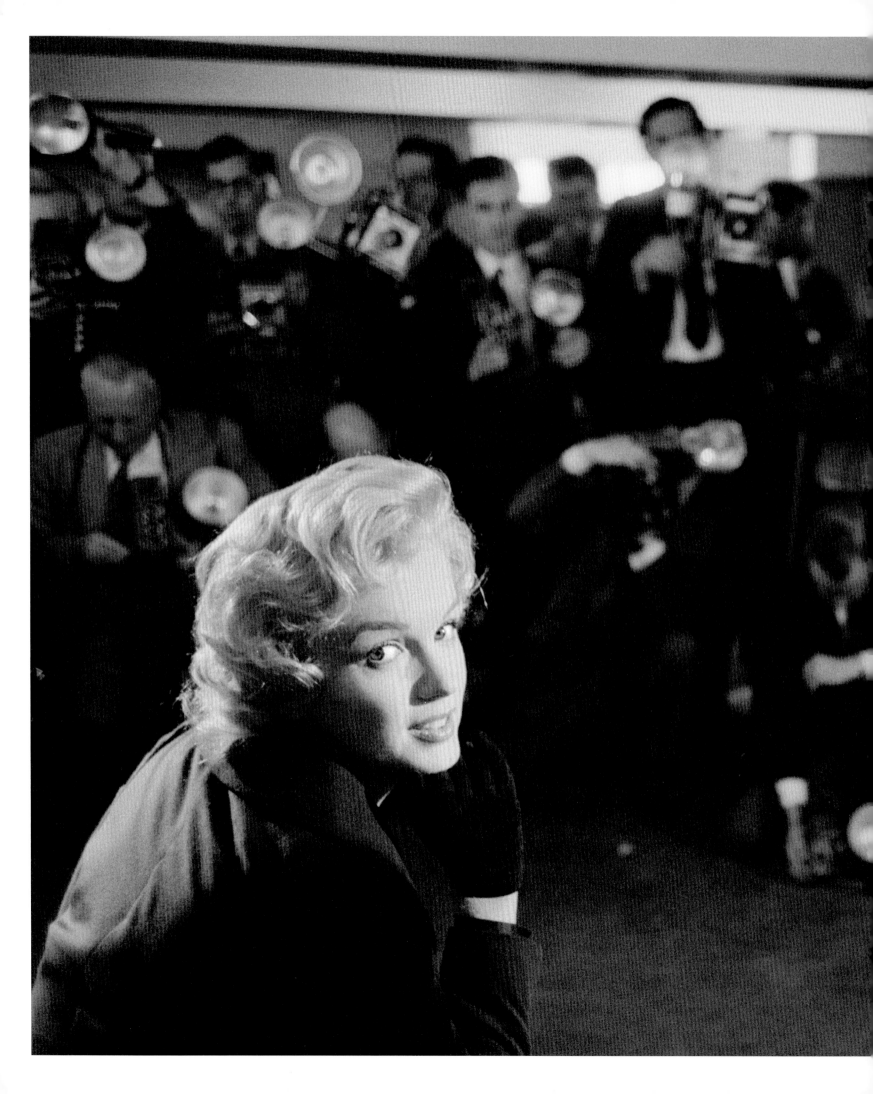

Marilyn Monroe at a press reception at London's Savoy Hotel, 1956. Photographers await their turn to get their shot. Monroe (1926-1962) understood exactly what the photographers wanted. She appreciated the power of the press and of her own image and used them both to further her career.

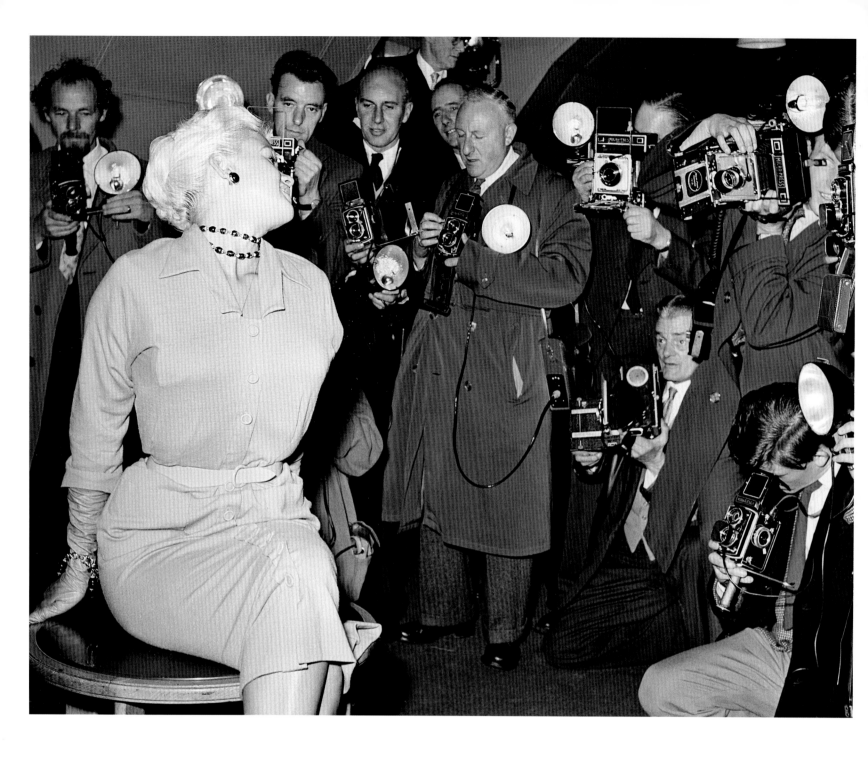

Above: American actress Jayne Mansfield surrounded by photographers and reporters while attending a press conference, London, 1957. Mansfield (1933-1967), the working man's Marilyn Monroe, sits on a table thrusting her breasts forward in characteristic pose giving the British photographers, using MPP and Rollei cameras, the shot their editors wanted. *Opposite:* Jayne Mansfield poses in a bathing suit with a camera and press hat, 1956. Mansfield (1933-1967) holds a Speed Graphic camera with flash gun.

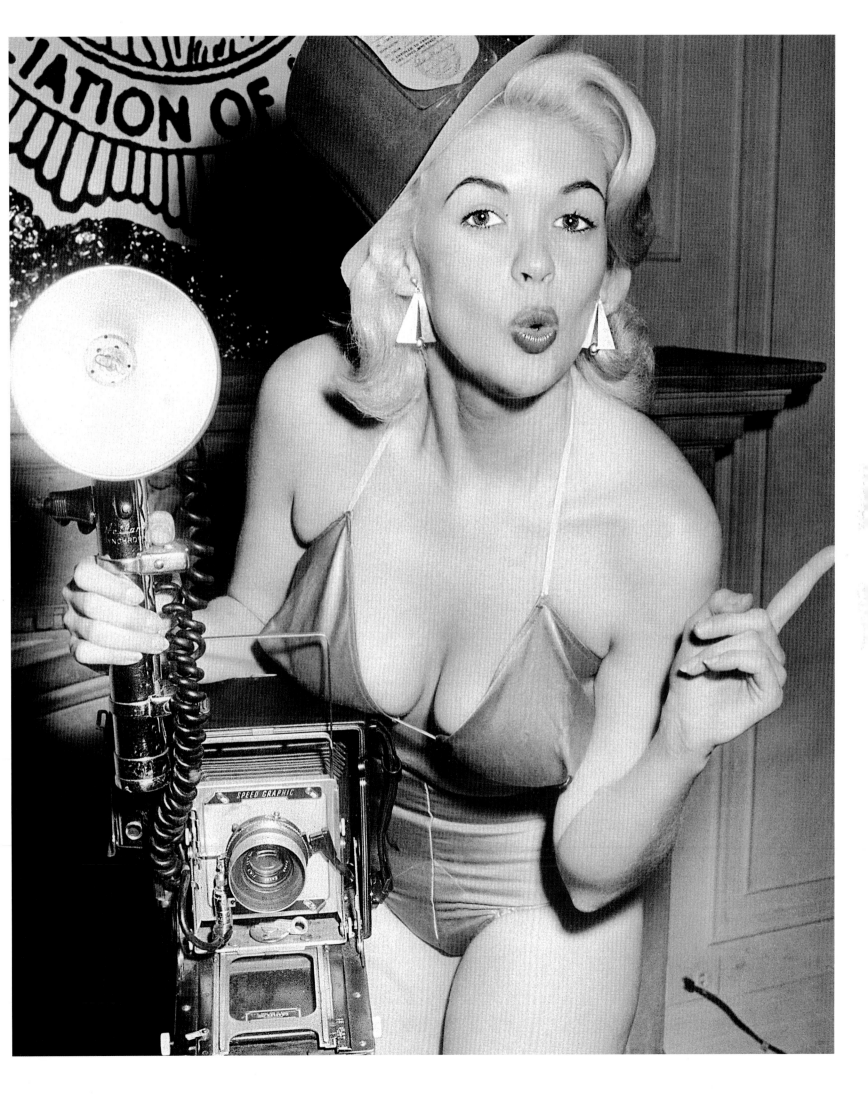

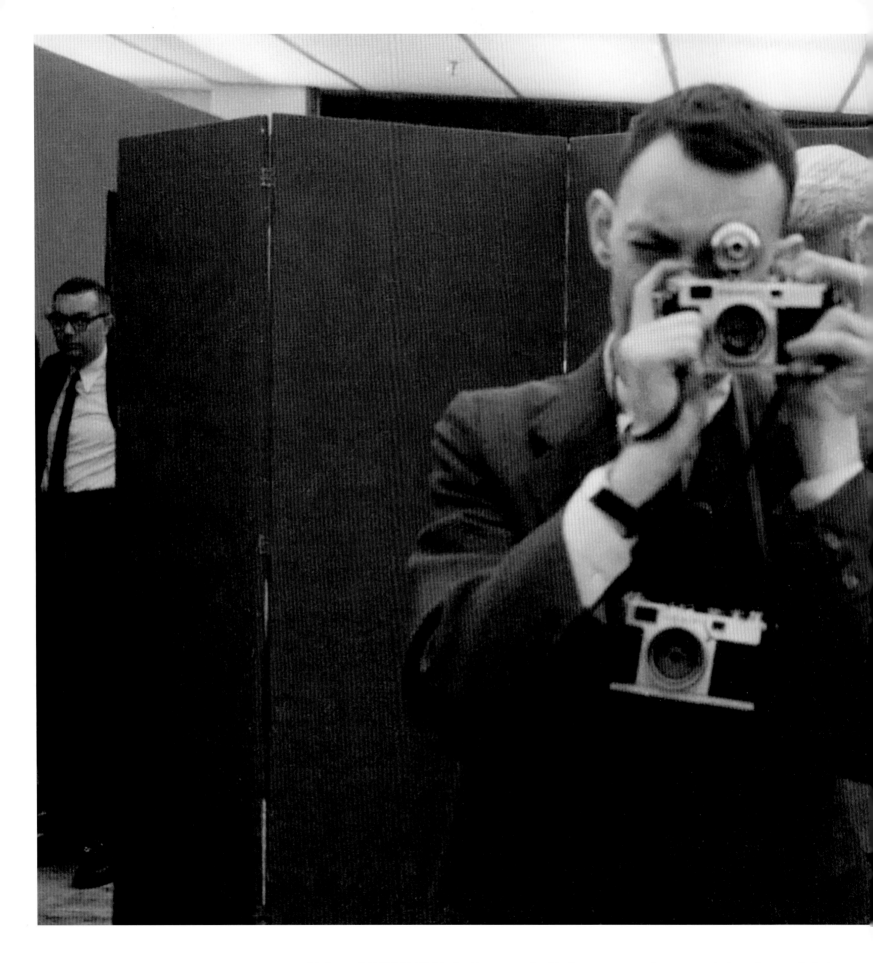

Ed Feingersh (1925-1961). Marilyn Monroe gets fitted for her costume in a dressing room before riding a pink elephant in Madison Square Garden for a circus charity, March 1955. Feingersh uses two Nikon rangefinder cameras. On the right, looking at Monroe, is Milton Greene (1922-1985), a fashion and celebrity photographer who also photographed Monroe.

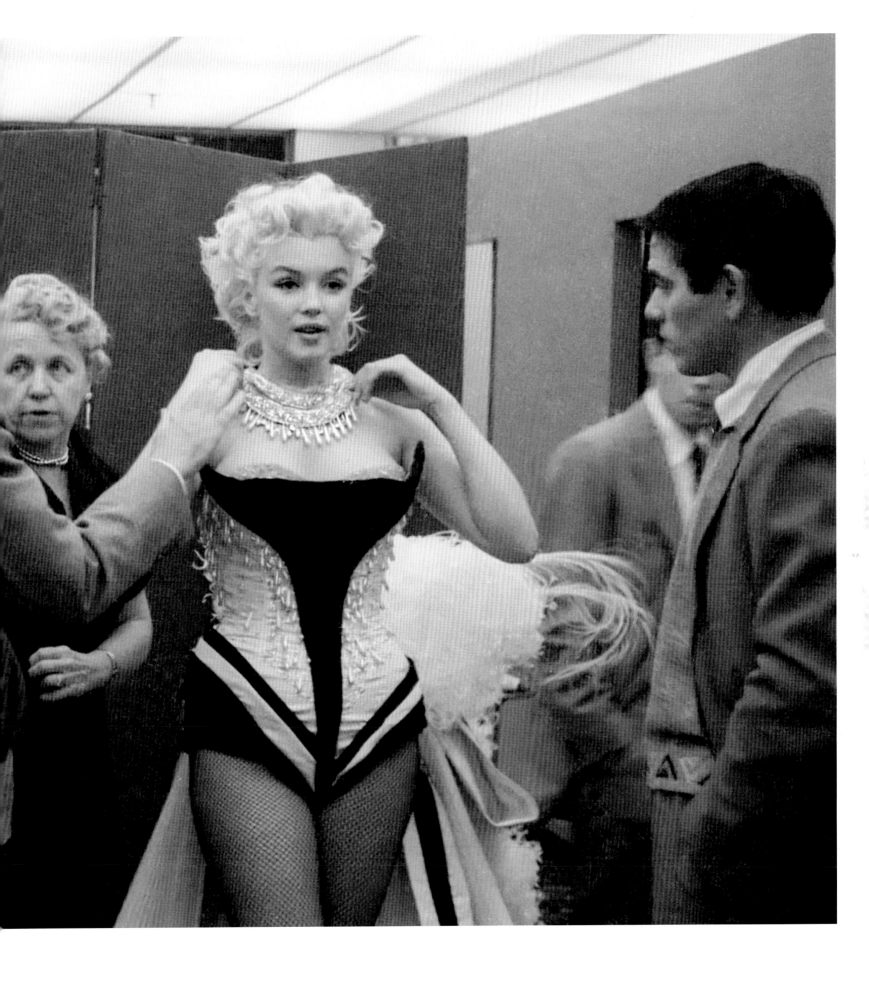

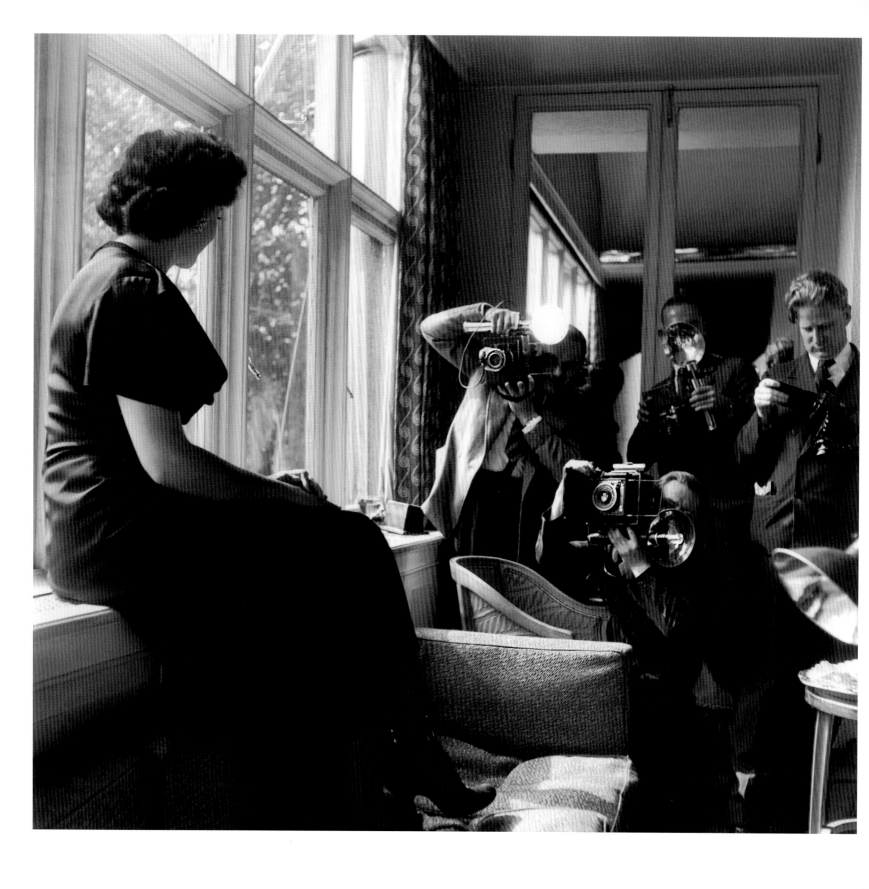

Above: **George Konig** (dates unknown). Jane Russell at the Savoy Hotel, London, during a press conference for her upcoming British stage debut, 23 September 1949. *Opposite:* Jane Russell has her picture taken to publicise the 3D musical comedy, *The French Line*, 1954. Russell (1921-2011) was one of Hollywood's leading stars during the 1940s and 1950s.

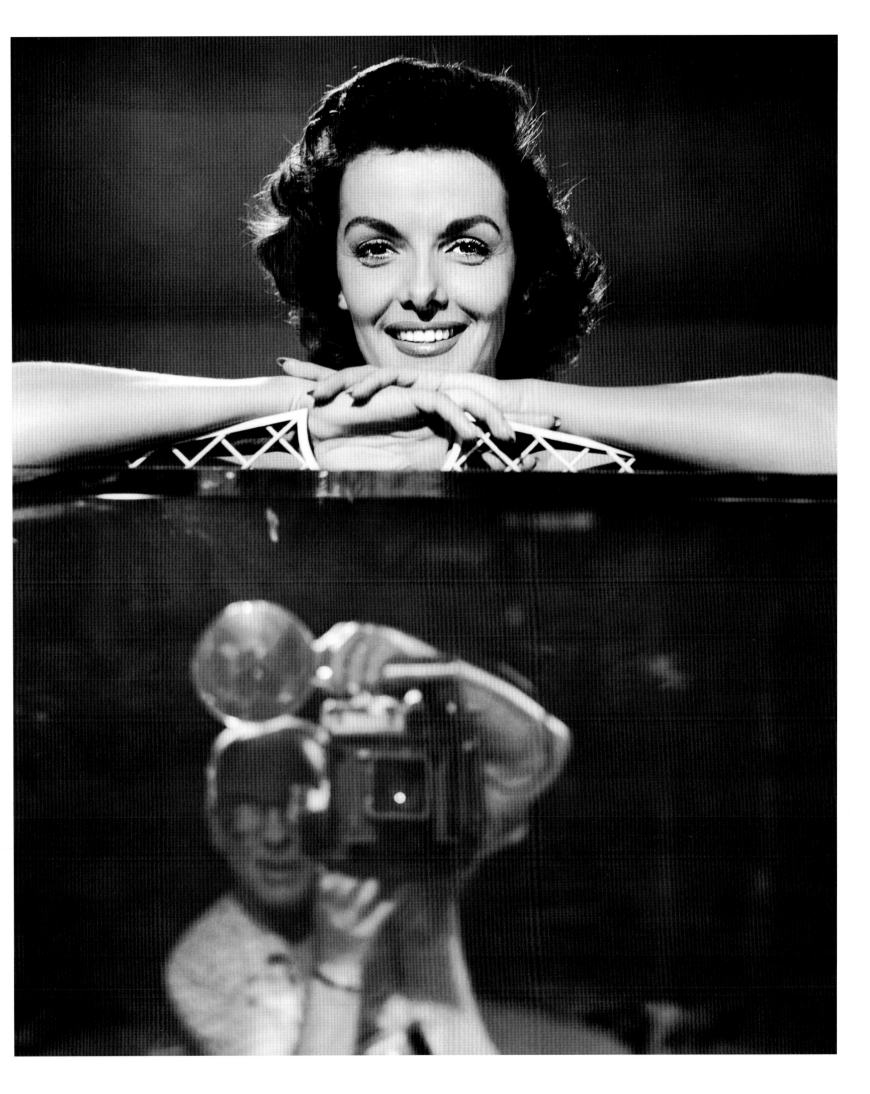

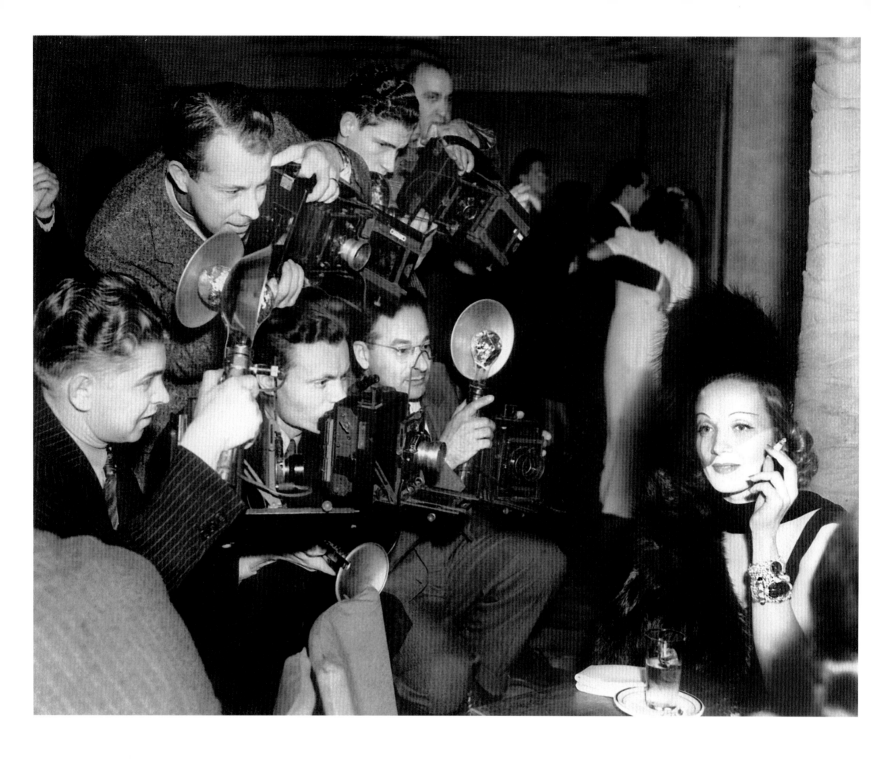

Photographers surround Marlene Dietrich during the inauguration of the La Conga cabaret in Hollywood, 3 March 1938. All the photographers hold Speed Graphic cameras shooting on to glass plates or cut film. Dietrich (1901-1992) remains characteristically impassive, her cigarette in hand.

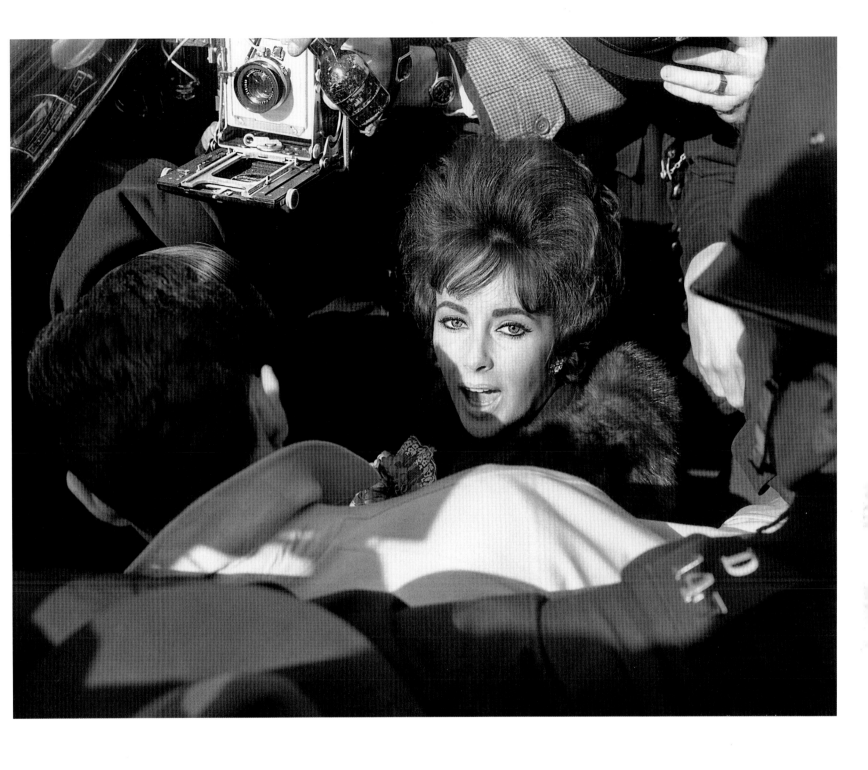

Harry Thompson (dates unknown). Elizabeth Taylor surrounded by the press, 27 March 1961. Taylor (1932-2011) plays up to the camera to give the photographer his shot, behind her a British MPP Technical camera struggles to find a shot in the melee. Thompson was photographing for the London *Evening Standard* newspaper.

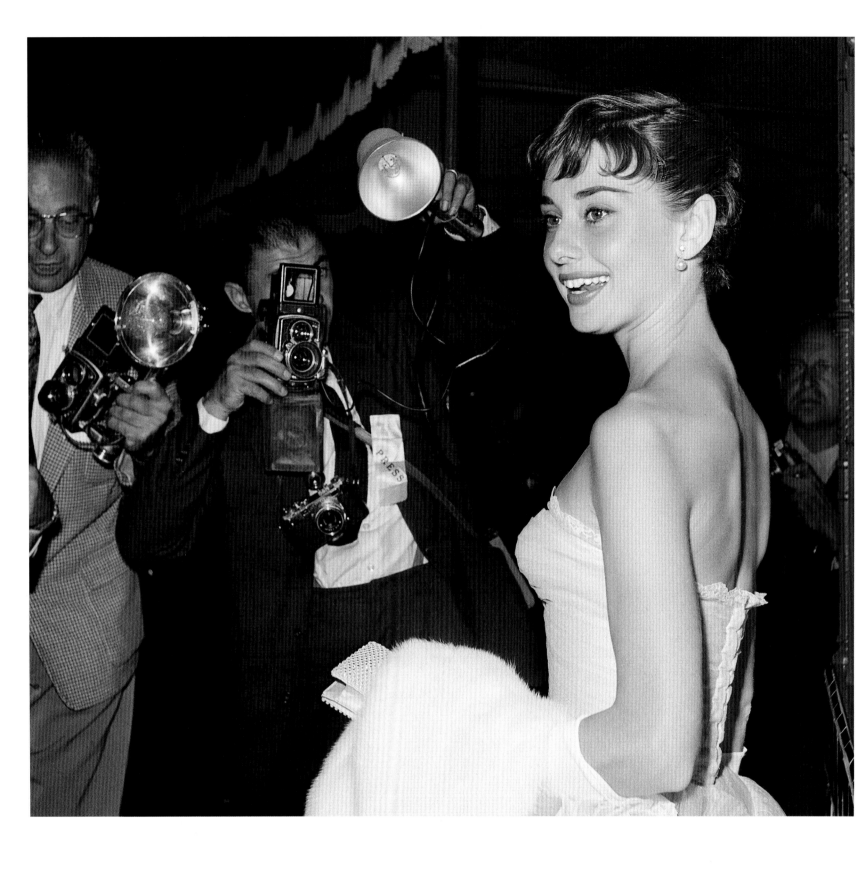

Audrey Hepburn faces the cameras while attending a benefit premiere for *Roman Holiday*, Westwood, California, 1953. Hepburn (1929-1993) smiles for the cameras. The press photographer behind her holds up his flash gun ready to get his own shot on his American-made twin lens reflex camera.

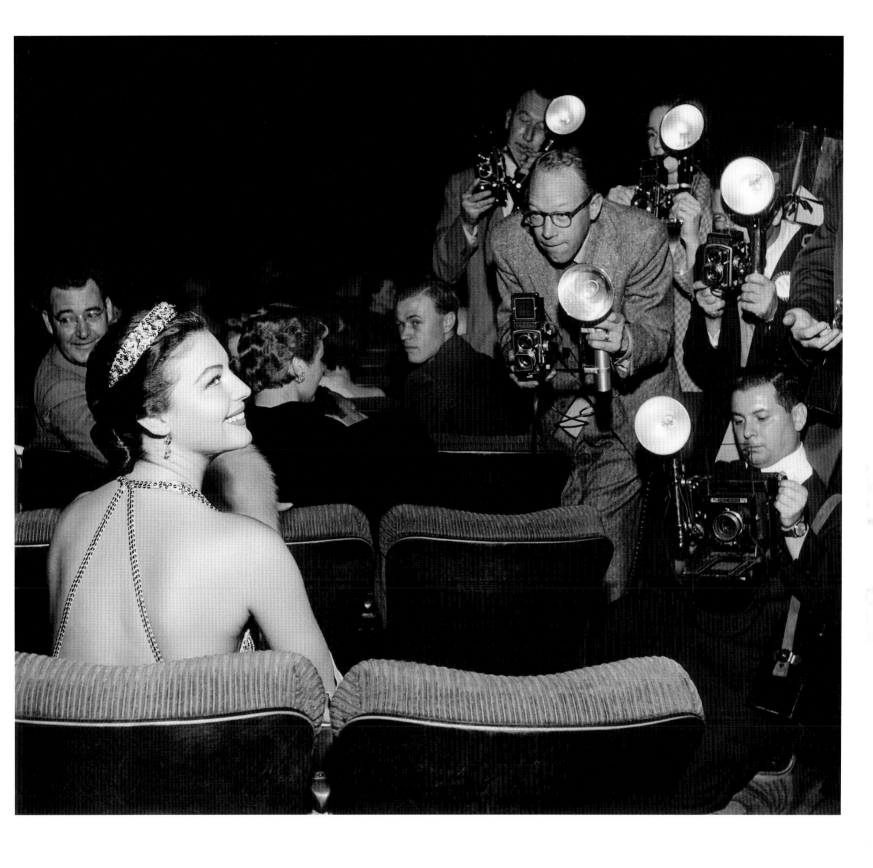

Ava Gardner sitting in a movie theatre for the premiere of *The Barefoot Contessa* in which she starred, 29 September 1954.
Gardner (1922-1990) looks at the American Speed Graphics and the Rolleiflex cameras of the press.

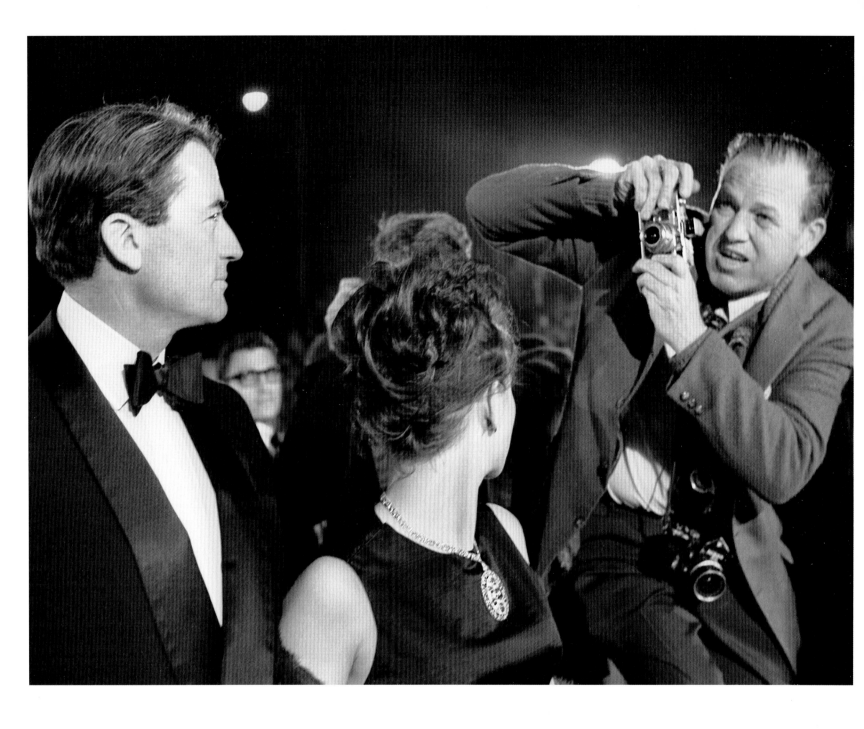

Above: **William Lovelace** (1924-2003). Actor Gregory Peck and his wife Veronique photographed at the Oscars ceremony, Hollywood, 9 April 1962. The press photographer holds a Leica M-series camera with a direct optical viewfinder mounted on top for quicker shooting. A Nikon F camera, which had been introduced in 1959, hangs off his neck. Peck (1916-2003) is illuminated by a spotlight allowing the photographer to dispense with a flash gun. *Opposite:* Warren Beatty escorts Natalie Wood to the 34th Annual Academy Awards, California, 9 April 1962. Beatty (b.1937) and Wood (1938-1981) both starred in Elia Kazan's *Splendor in the Grass*, for which Wood received a best actress nomination. She turns to face a photographer behind her. In front, scores of photographers wait for her to turn back so they can secure a shot of Beatty and Wood together.

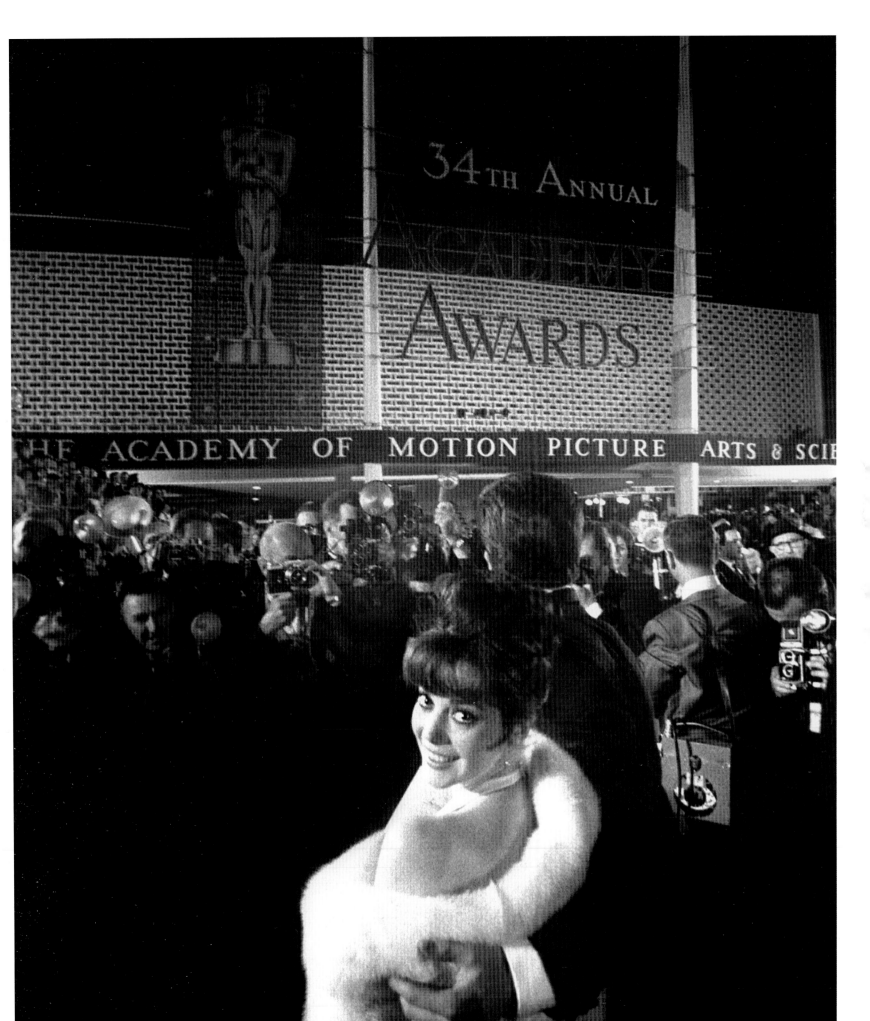

Above: British actress Diana Dors being photographed for her film, *Yield to the Night*, at Elstree Studios, 1956.
Opposite: **Norman Potter** (b.1932). Actress Diana Dors (1931-1984) prepares to film a bedroom scene for the crime drama, *West 11*, directed by Michael Winner. Potter worked for the *Daily Express* newspaper and is visible reflected in the make-up mirror as he takes the photograph.

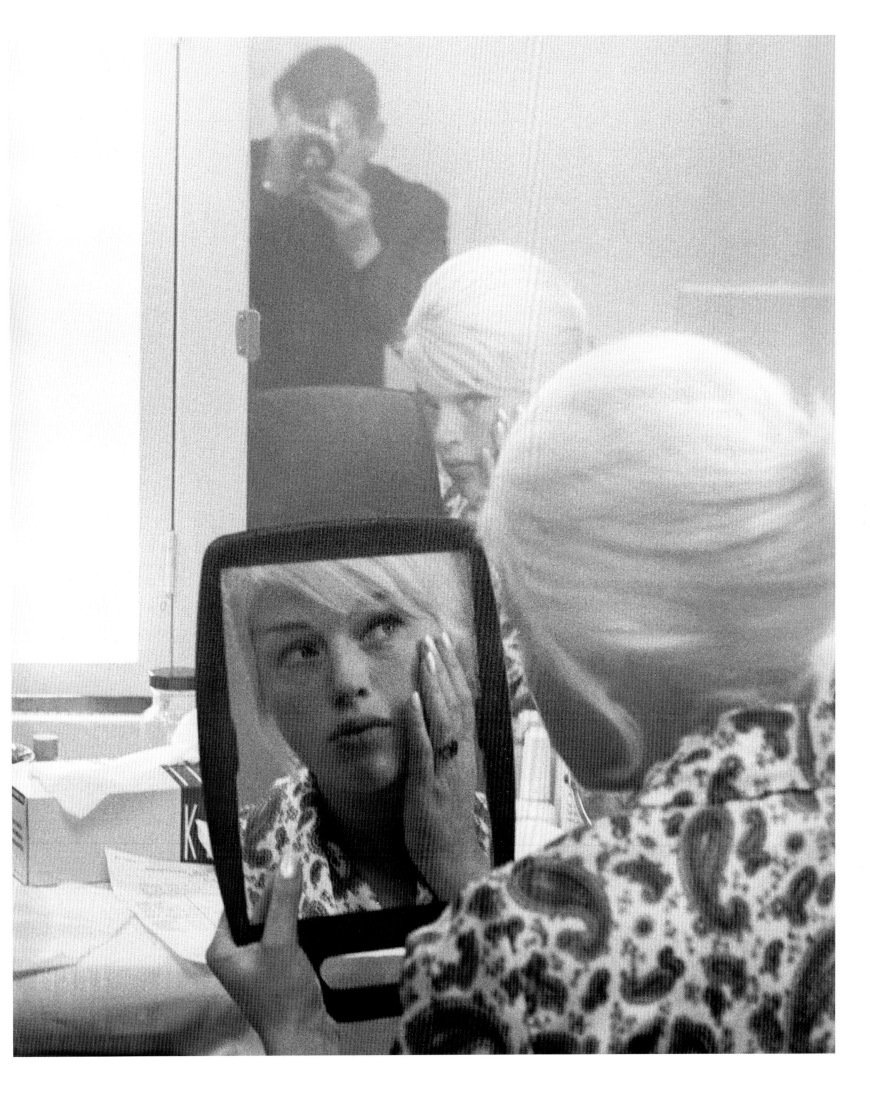

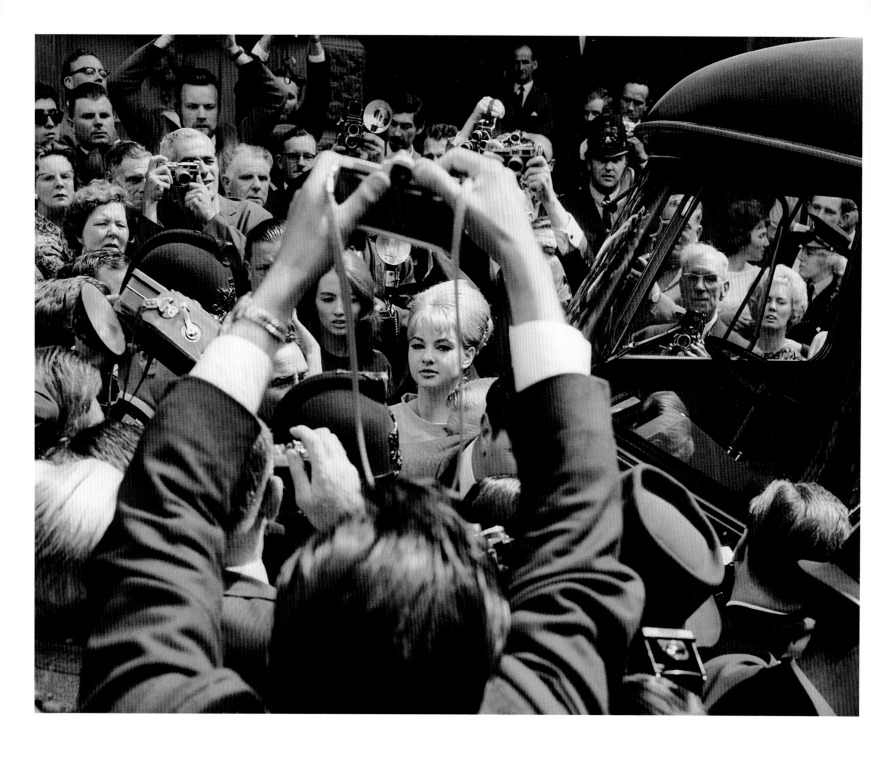

Above: Mandy Rice-Davies [centre] and Christine Keeler [behind] leave the Old Bailey during the trial of Dr Stephen Ward, 22 July 1963. The British Profumo Affair led to the resignation of the Secretary of State for War and, in part, resulted in the collapse of the Macmillan government. With a heady mix of politics, sex, spies and glamorous women – Davies (b.1944) and Keeler (b.1942) – it was inevitable that the press would be there to photograph the protagonists. They sport a range of Rolleiflex and Leica cameras. *Opposite:* Christine Keeler on her way to the Old Bailey, 25 July 1963.

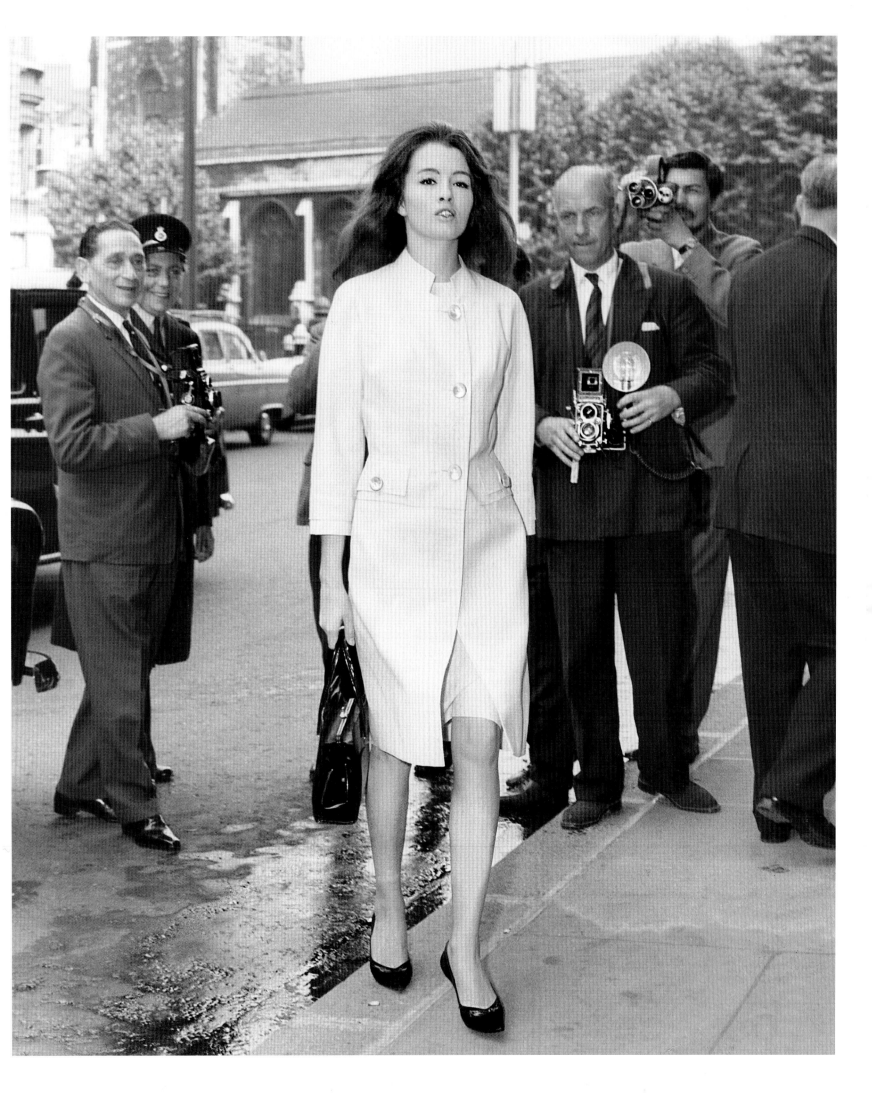

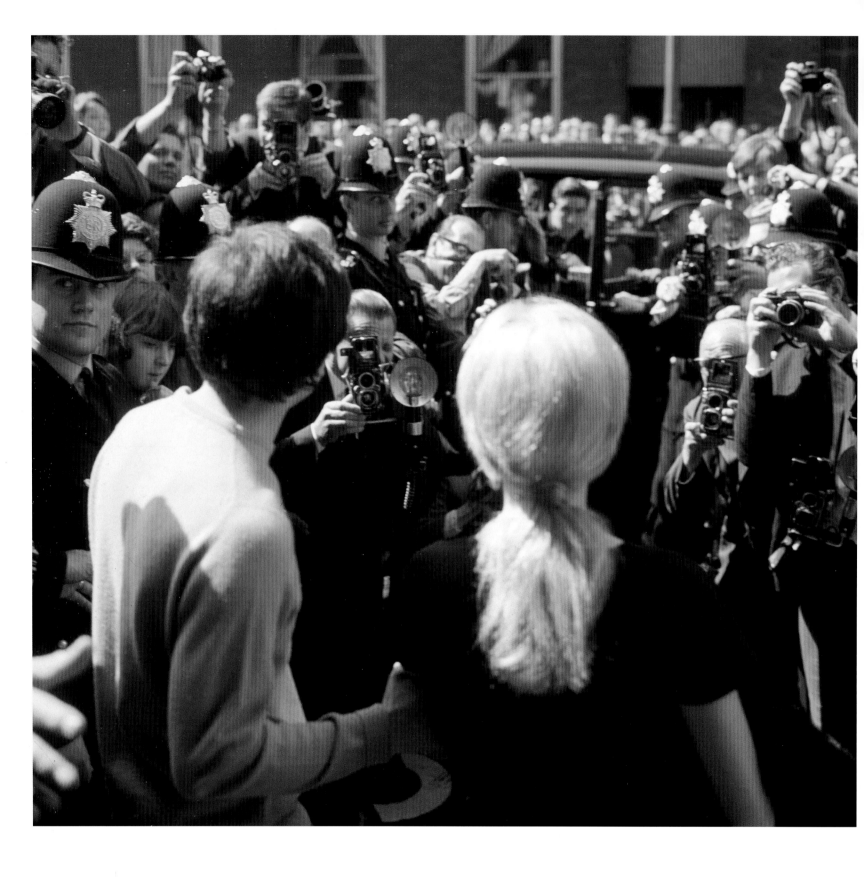

David Bailey and Catherine Deneuve on the steps of St Pancras Registry Office on their wedding day, 18 August 1965. Bailey (b.1938) epitomised the celebrity photographer during the 1960s as the mass of photographers and spectators around the couple show. The film *Blow-Up* (1966) was based, in part, on Bailey. Bailey and Deneuve (b.1943) remained married until 1972.

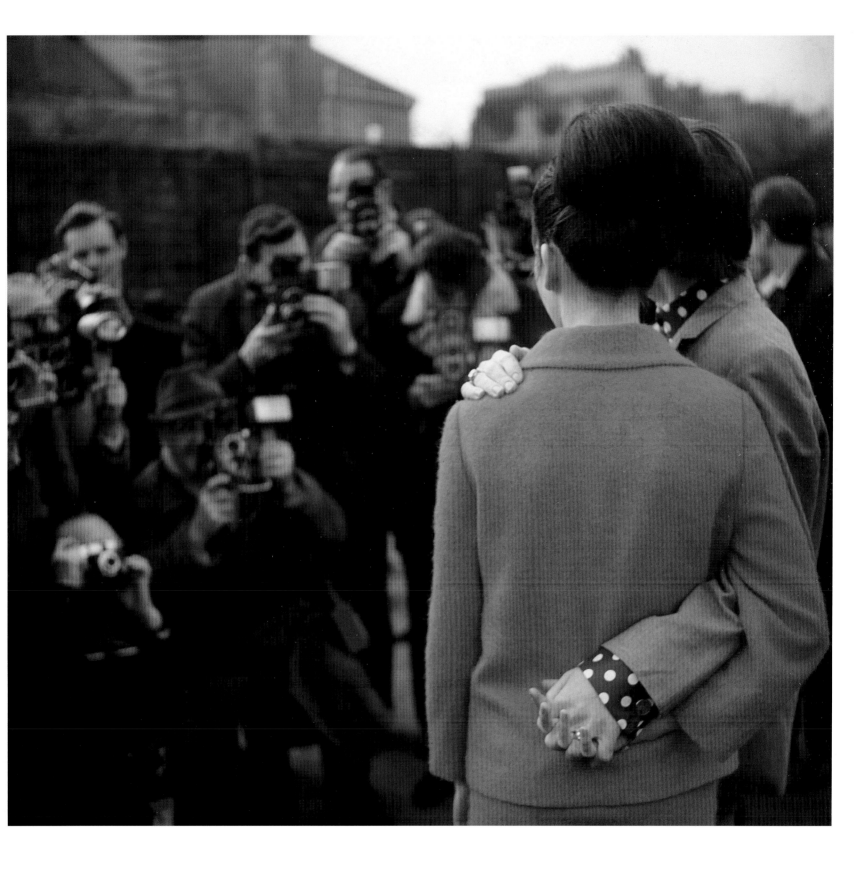

Beatles drummer Ringo Starr with wife Maureen the day after their marriage, 12 February 1965. Starr (b.1940) married Maureen Cox (1946-1994) on 11 February 1965. They divorced in 1975.

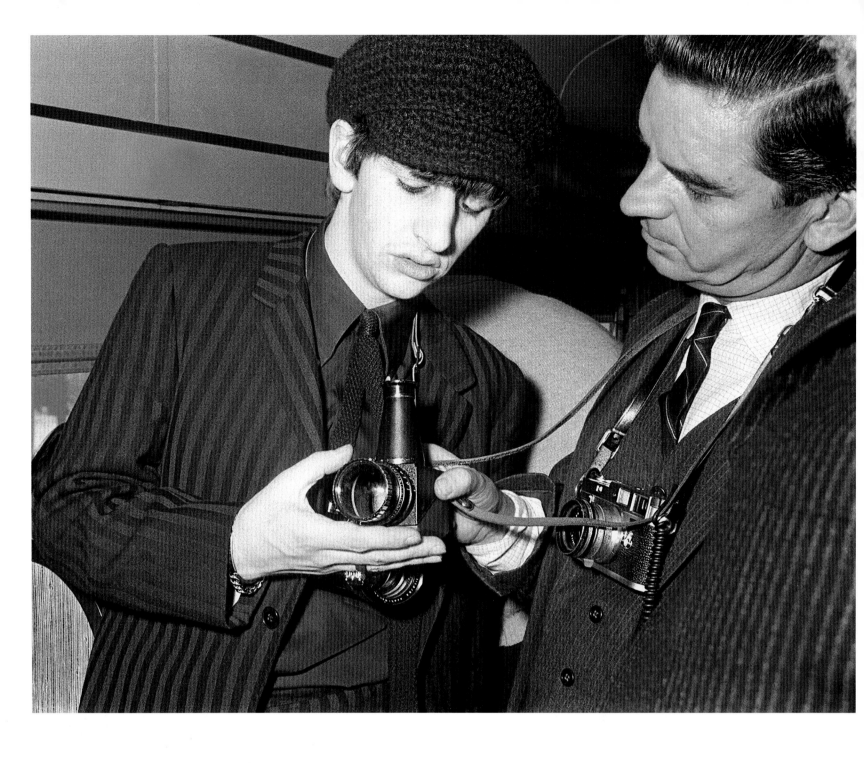

Above: Beatle Ringo Starr inspects the camera of one of the photographers accompanying the group on board the train from New York to Washington, 11 February 1964. Starr (b.1940) cradles a reflex housing. *Opposite:* **K and K Ulf Kruger** (publishers). Paul McCartney holds a camera on the set of *A Hard Day's Night* at the Scala Theatre, London, 1 March 1964. McCartney (b.1942) holds a Russian Leningrad 35mm camera.

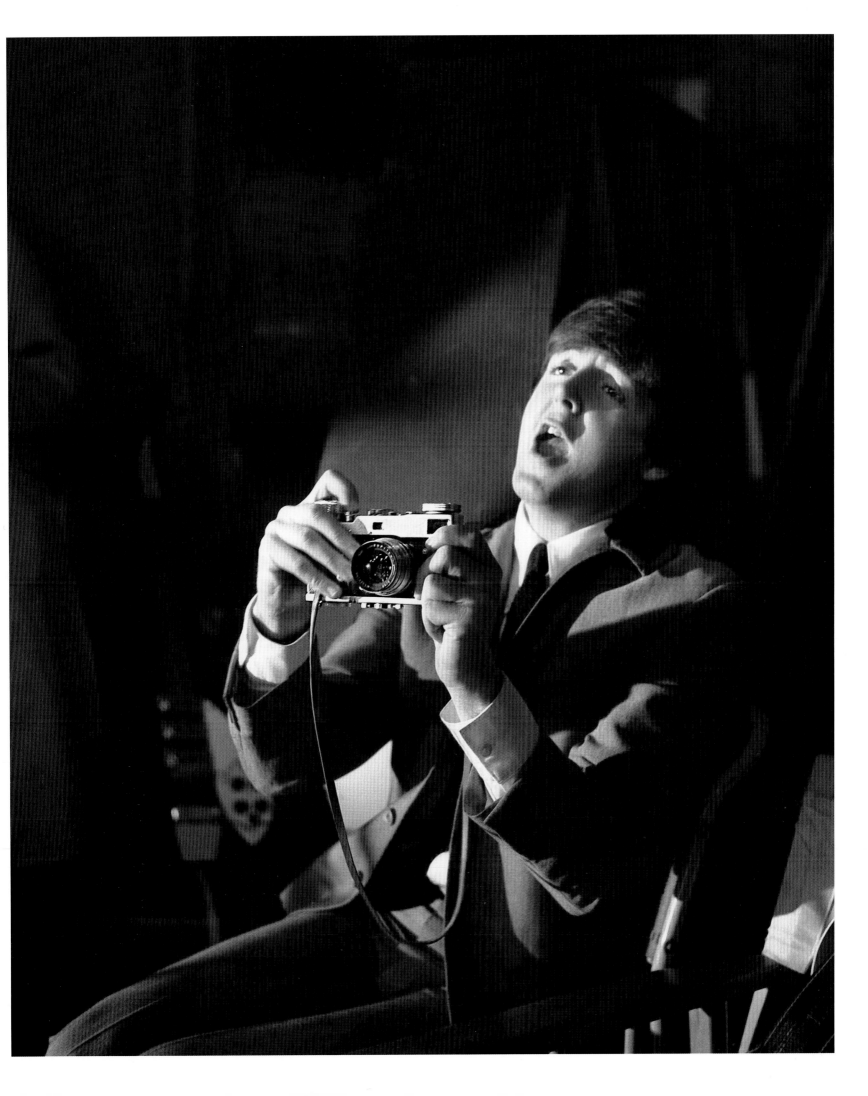

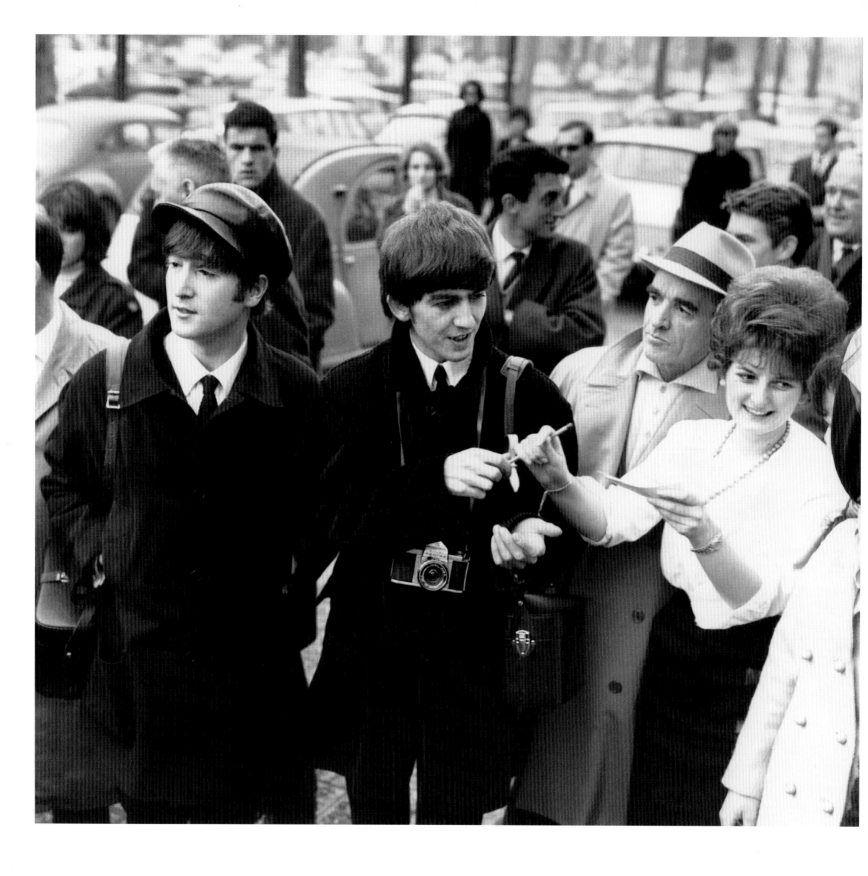

Above: John Lennon [1940-1980] and George Harrison sign autographs on their arrival in Paris before playing at the Olympia, 16 January 1964. Harrison (1943-2001) carries a Pentax 35mm single lens reflex camera.
Opposite: **Robert Whitaker** (1939-2011). George Harrison photographs Bob Whitaker in The Beatles' hotel, Anchorage, Alaska, 28 June 1966. Whitaker was best known for his photographs of The Beatles taken between 1964 and 1966. Harrison uses a Polaroid Land camera.

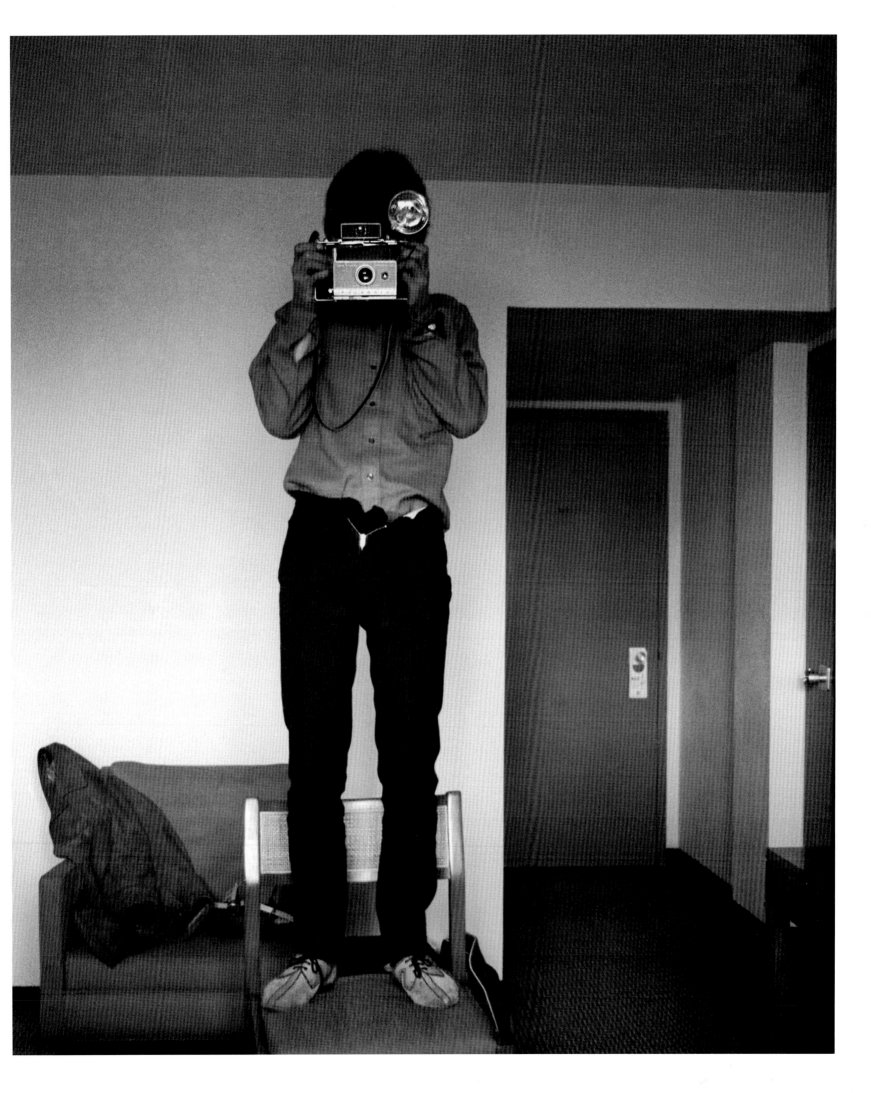

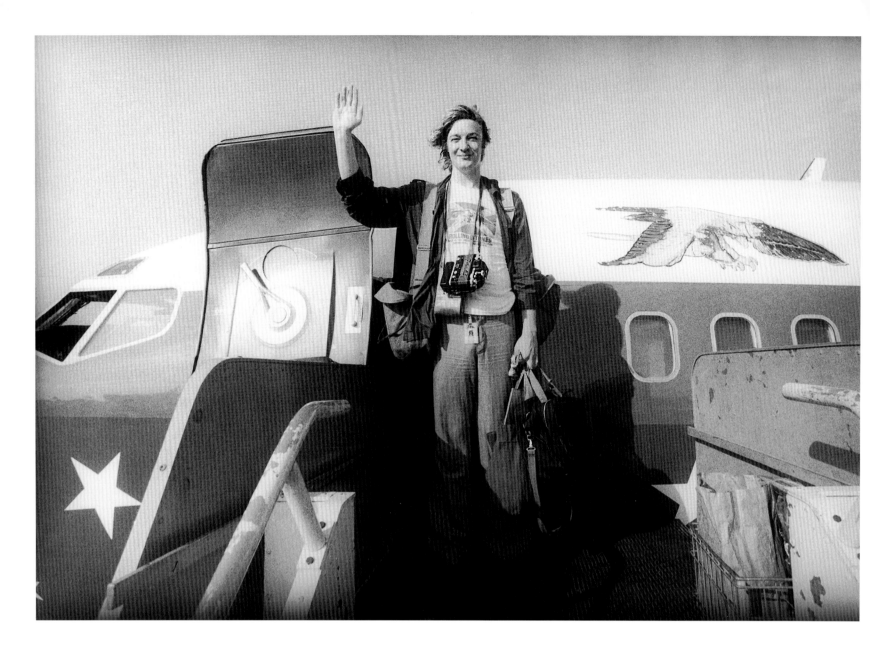

Christopher Simon Sykes (b.1948). Sykes boards the Starship, the private jet used by the Rolling Stones on their tour of the Americas, 1975. Sykes has a Nikon F camera fitted with a Photomic head and motor drive around his neck.

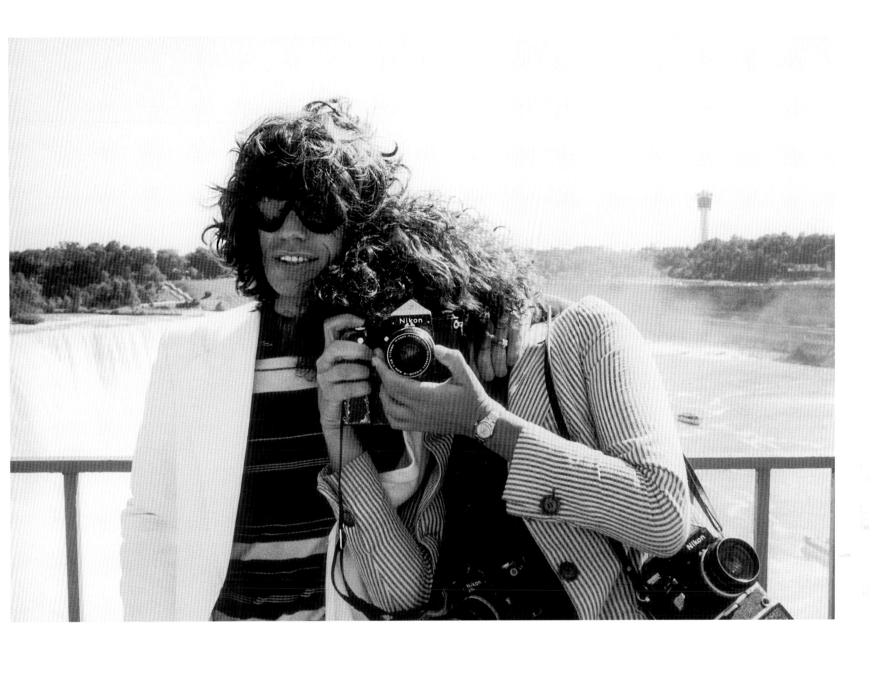

Christopher Simon Sykes (b.1948). Mick Jagger and photographer Annie Leibovitz pose at Niagara Falls during the Rolling Stones tour of the Americas, 1975. Leibovitz (b.1949) focuses her Nikon F camera on Sykes.

Andy Warhol holds up a hand-decorated point-and-shoot camera, New York, 1986. Warhol (1928-1987) understood fame and celebrity and the power of the image in modern culture, manipulating his own image and those of others through his art work.

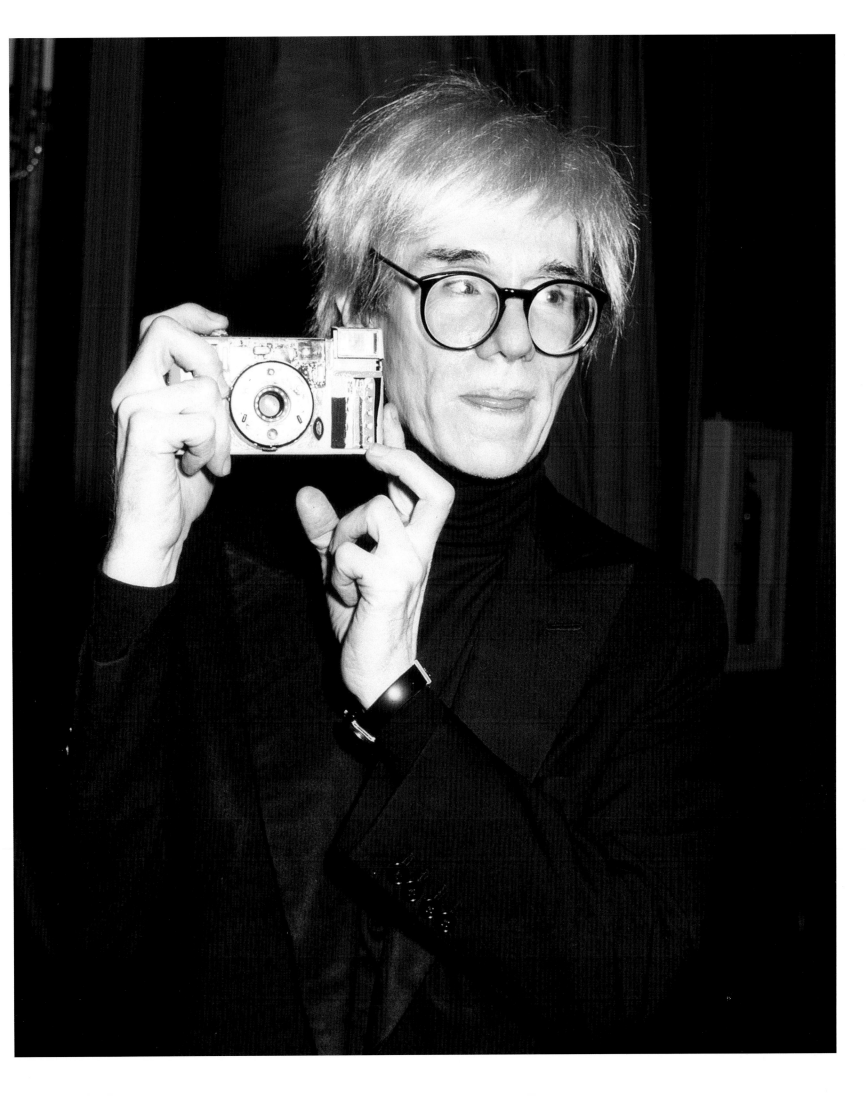

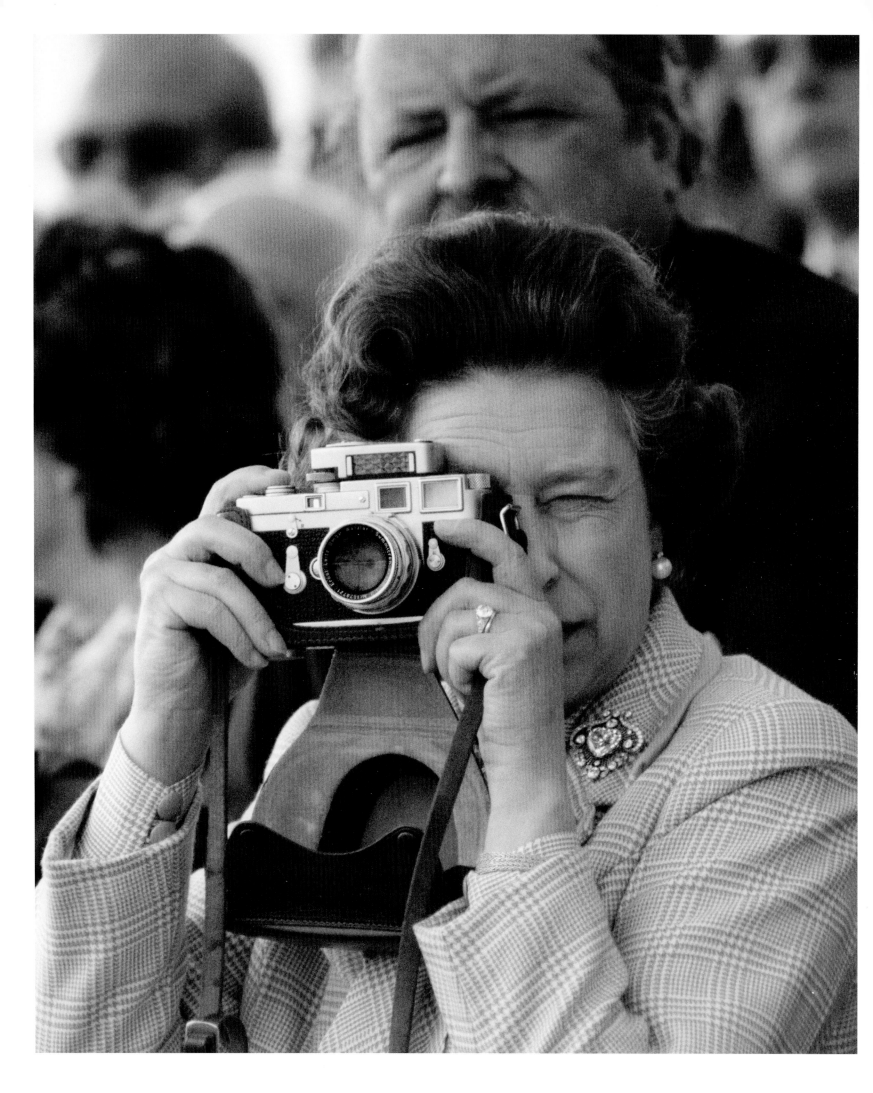

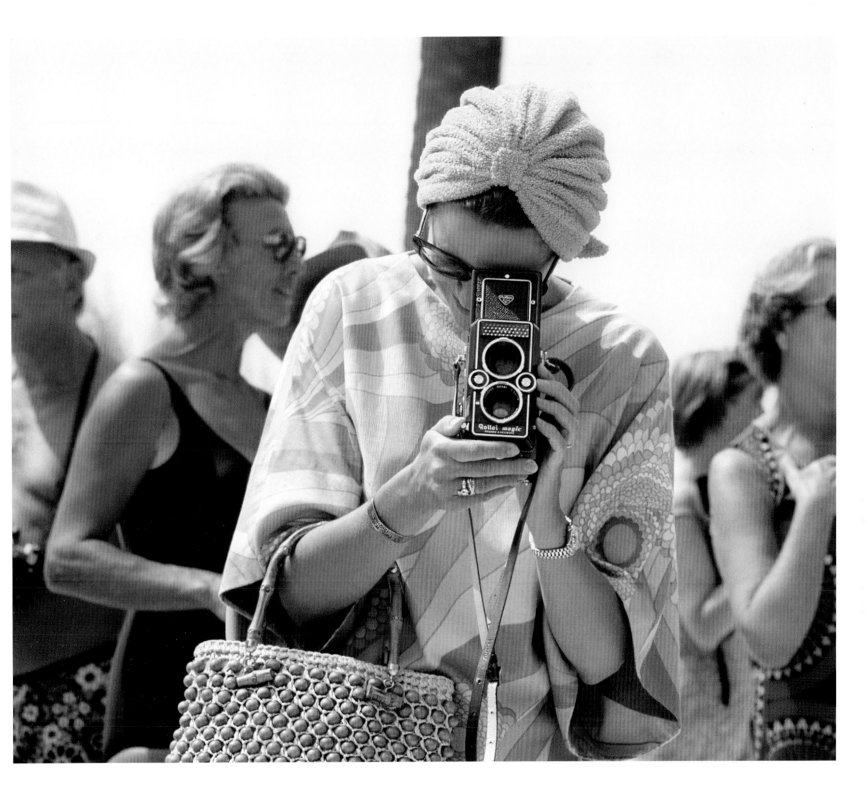

Opposite: **Tim Graham** (b.1948). Queen Elizabeth II at the Windsor horse show, 16 May 1982. The Queen (b.1926) is a photographer and is seen here using her Leica M3 camera. She was given the camera by the Leitz company in 1958 and it is serial numbered 919,000. Graham has been photographing royalty for more than thirty years and his archive is now owned by Getty Images. *Above:* Princess Grace of Monaco taking a photograph at a swimming competition, Palm Beach, Monte Carlo, 1972. Princess Grace is using a Rollei Magic II camera that was introduced in 1962. Unlike most Rollei cameras, the Magic offered automatic exposure control.

Above: **Weegee** [Arthur Fellig] (1899-1968). American singer and musician Johnnie Ray at a birthday celebration for WNEW radio disc jockey Art Ford, New York, c.1955. Ray (1927-1990) holds a Polaroid Land instant camera with a Polaroid flashgun mounted on its side. *Opposite:* **John Pratt** (dates unknown). British pop singer Karl Denver on the beach with the Vernon Girls, Great Yarmouth, 1962. Denver (1931-1998) is posing with a traditional mahogany field camera from c.1900. The Vernon Girls was an all-girl group formed by the Vernons pools company in the 1950s. It disbanded in 1964.

ON 'TELE' at
GT YARMOUTH

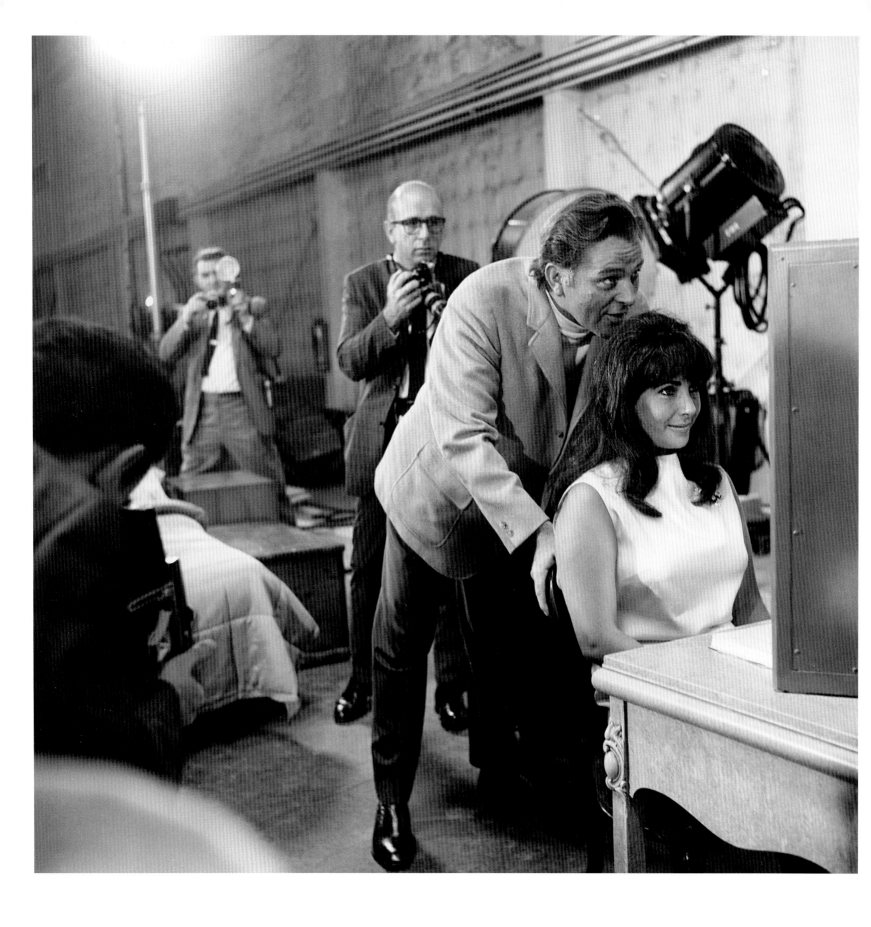

Actors Elizabeth Taylor and Richard Burton on the set of *Who's Afraid of Virginia Woolf?*, c.1966. Burton (1925-1984) and Taylor (1932-2011) are surrounded by three photographers. Immediately behind Burton is Bernie Abramson who worked for a number of a Hollywood stars and on a number of films as a set photographer. He also worked directly for John F. Kennedy and Bobby Kennedy.

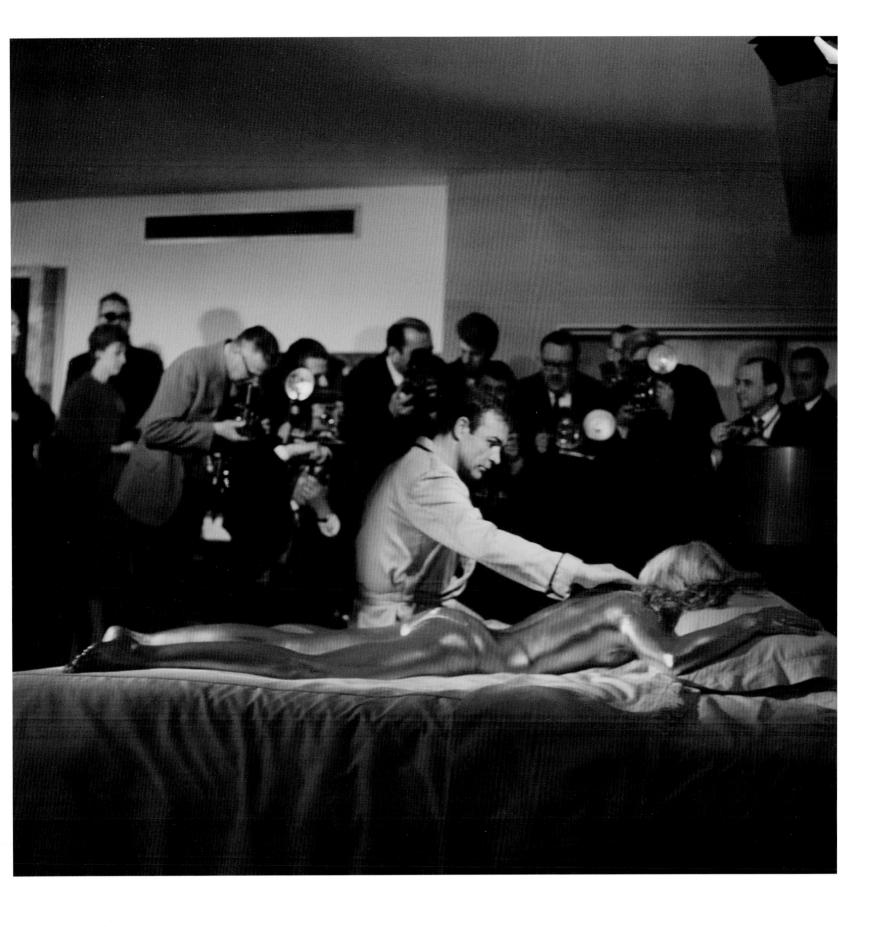

Paul Popper (d.1969). Sean Connery and a gold-painted Shirley Eaton being photographed on the set of the James Bond film *Goldfinger*, Pinewood Studios, 1964.

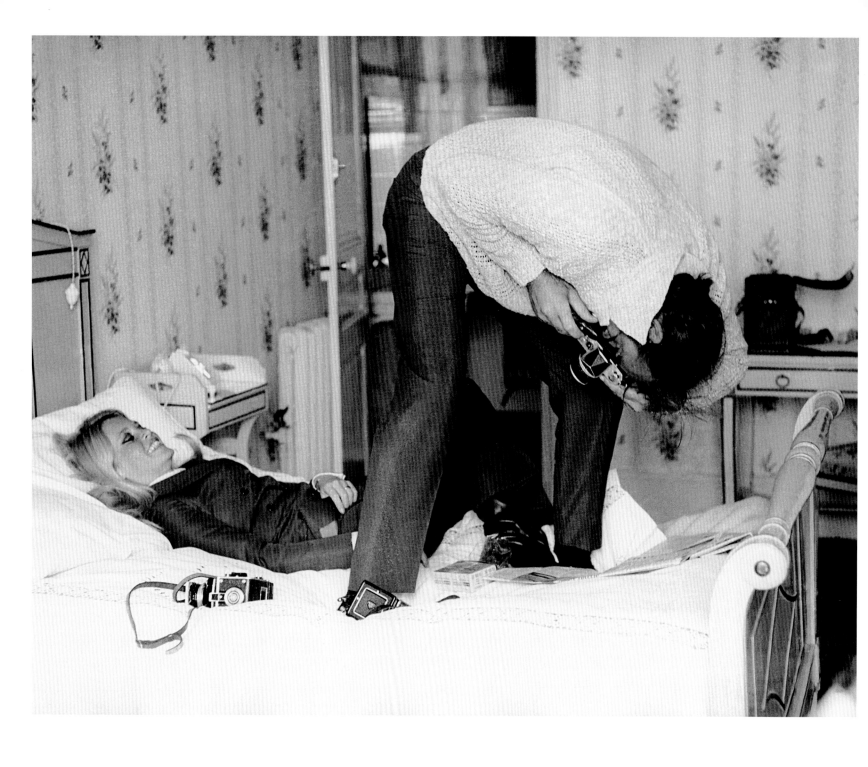

Above: **Terry O'Neill** (b.1938). Scottish actor Sean Connery takes a photograph of Brigitte Bardot during the filming of Edward Dmytryk's *Shalako*, Deauville, France, 1968. Connery (b.1930) holds a Nikon camera. On the bed are four unwrapped rolls of 35mm film and part hidden are two Rolleiflex twin lens reflex cameras. A camera outfit bag is on the top of the table in the background. *Opposite:* **Terry O'Neill** (b.1938). Sean Connery looks through a camera on the set of the James Bond film *Diamonds are Forever*, Las Vegas, 1971. Connery holds a Nikon camera that probably belonged to O'Neill.

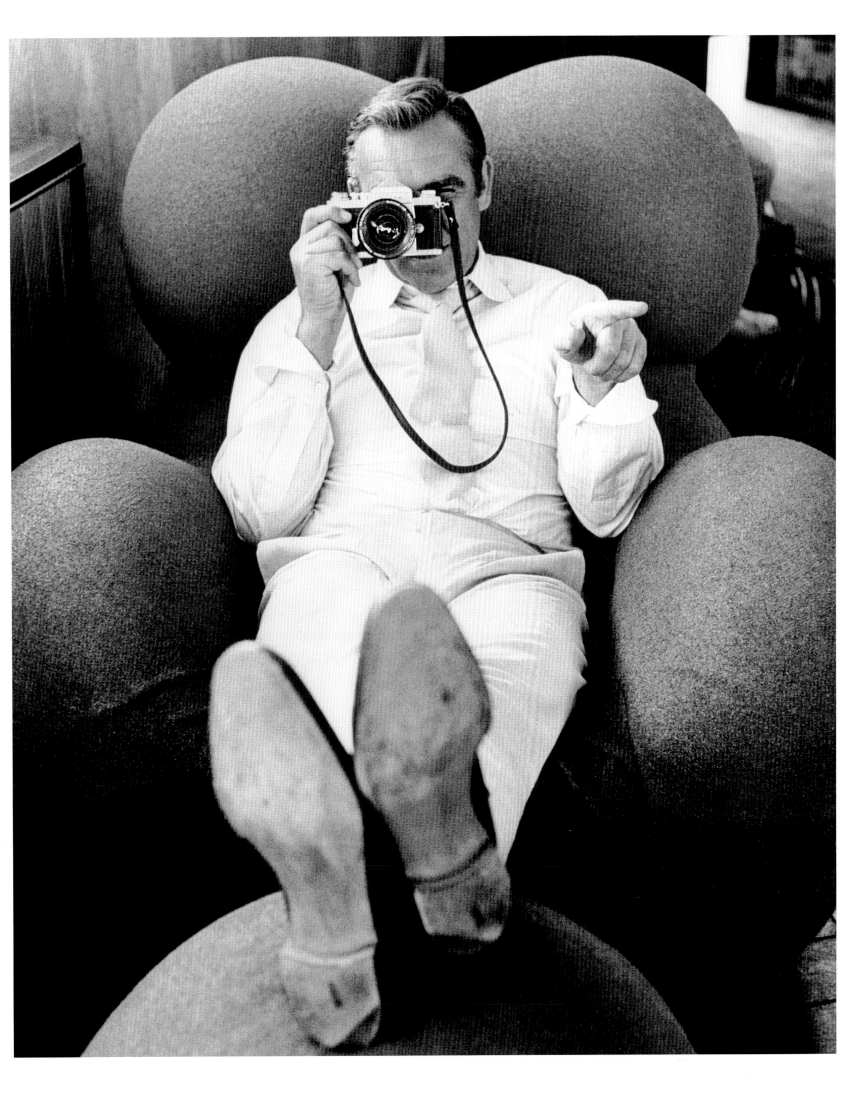

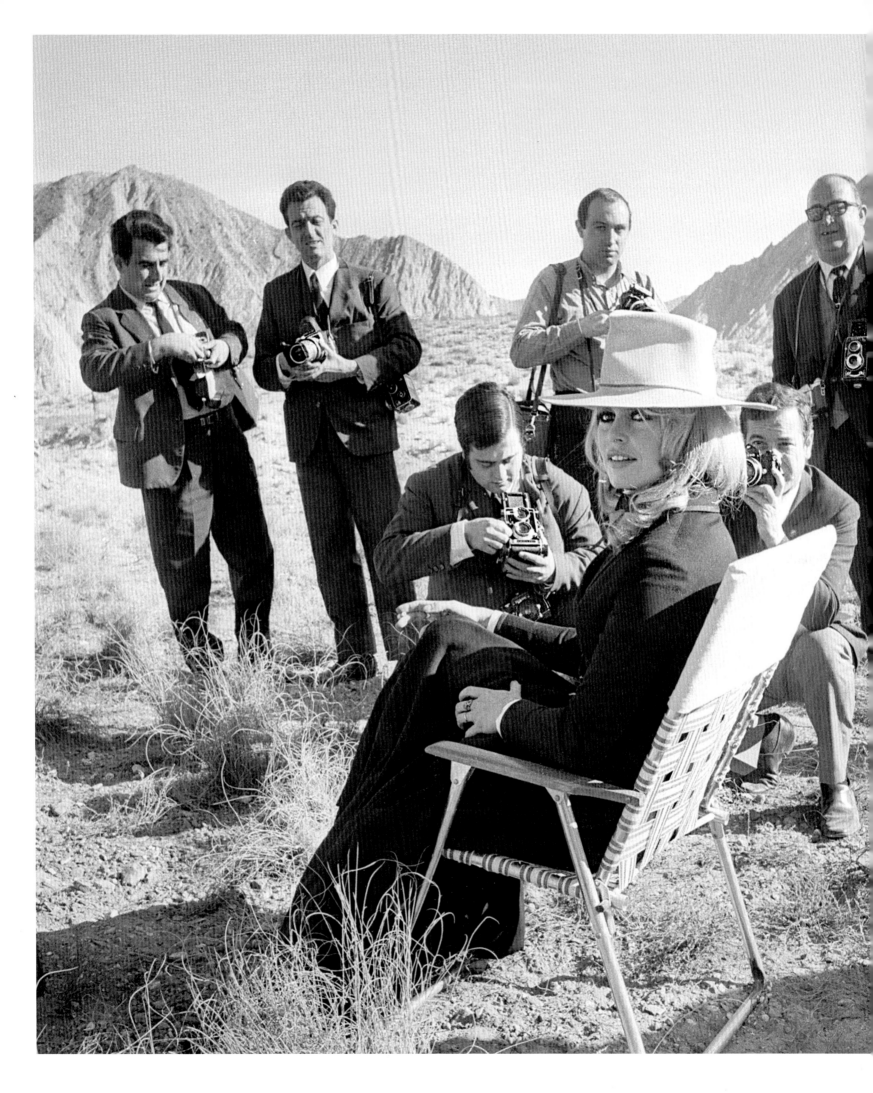

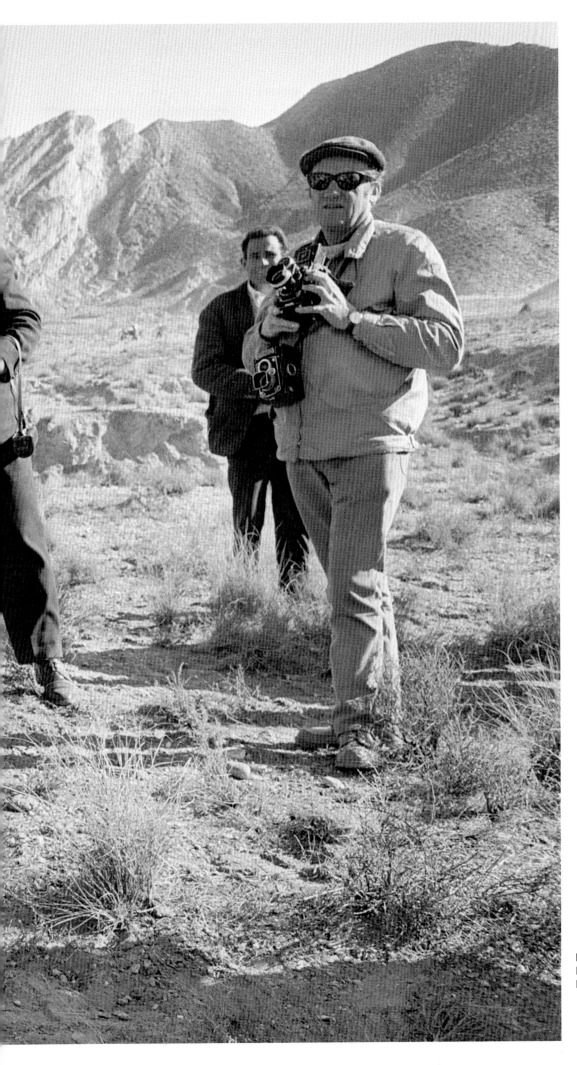

Len Trievnor (dates unknown). French actress Brigitte Bardot surrounded by photographers on the set of Edward Dmytryk's *Shalako*, 11 January 1968.

Above: Faye Dunaway in the film *Eyes of Laura Mars*, 1978. Dunaway (b.1941) holds a Nikon camera fitted with a motor wind. *Opposite:* Pam Grier as Friday Foster in American International's film *Friday Foster*, based on the syndicated comic strip, 1975. Grier (b.1949) played a model/photographer in the film.

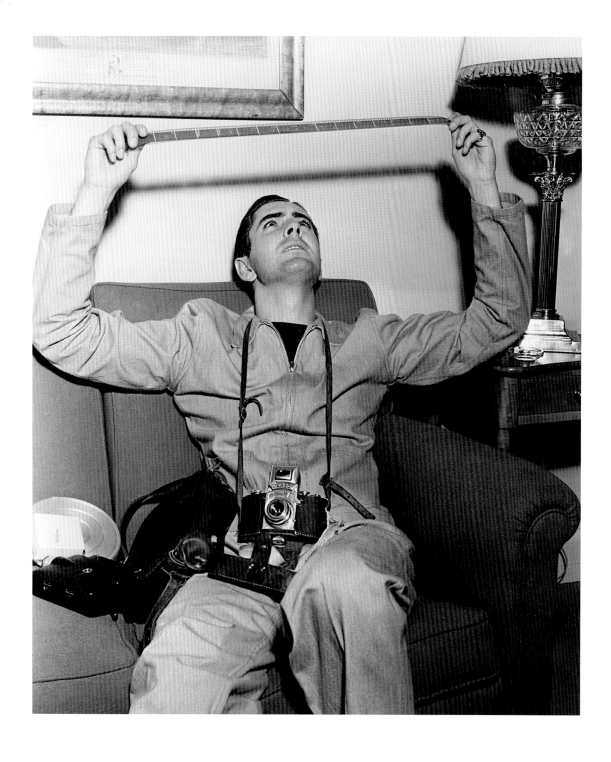

Above: American Actor Tyrone Power inspects a roll of film, c.1945. Power (1914-1958) holds a length of 35mm film that has been exposed and processed. Around his neck is a Kine Exakta I camera made between 1937 and 1948. *Opposite:* Actors Linda Christian and Tyrone Power look at snapshots with Rocky Cooper at a party at Gary Cooper's house, 1955. In the foreground is a Polaroid Land instant camera that has just been used to take the photograph in Power's hand.

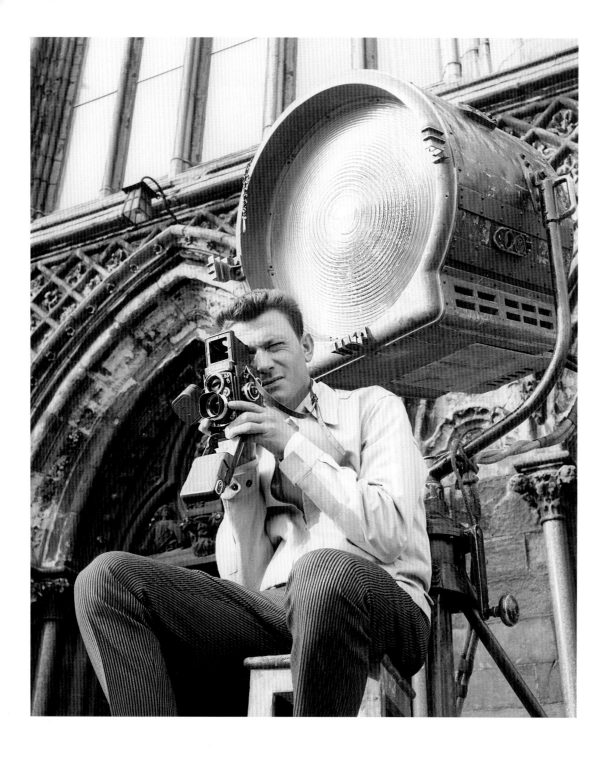

Above: **Laurence Harvey** (1928-1973). On the set of *Room at the Top*, 1958. *Opposite:* Novelist John Steinbeck beside his wife, the writer Elaine Anderson, 1947. Anderson is using a Rolleiflex twin lens reflex camera.

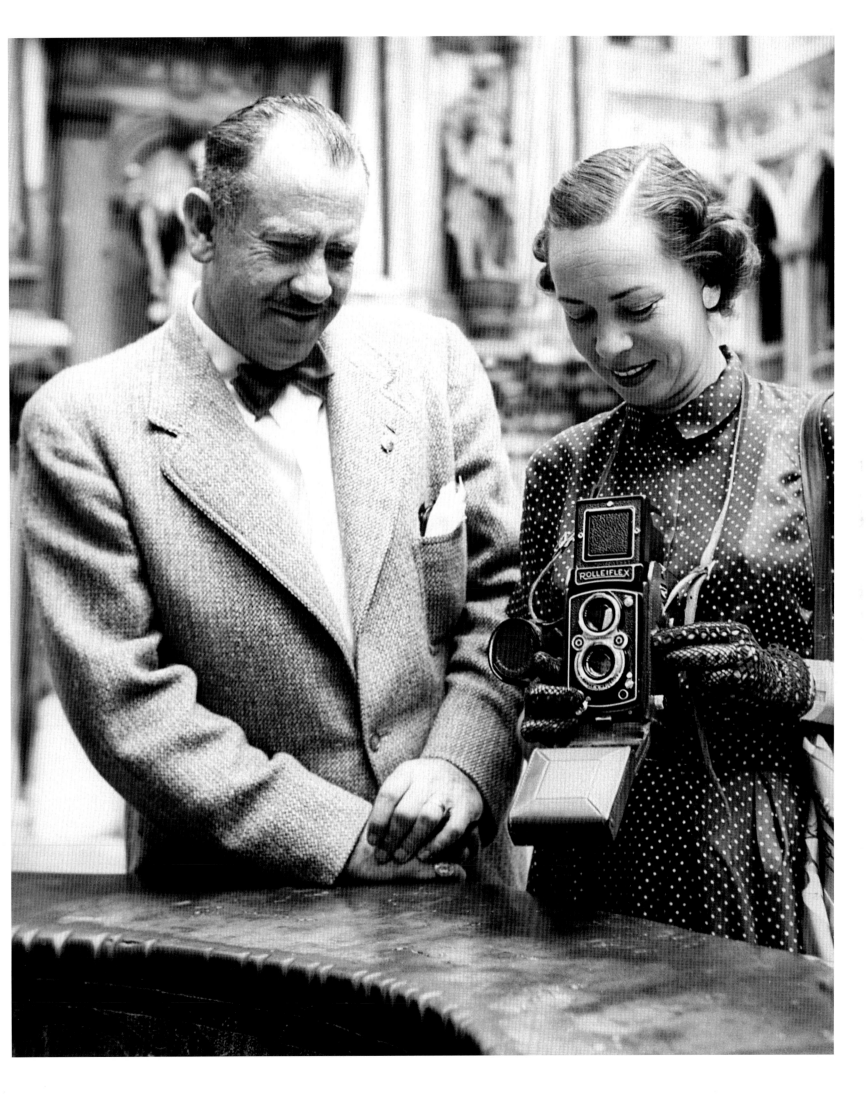

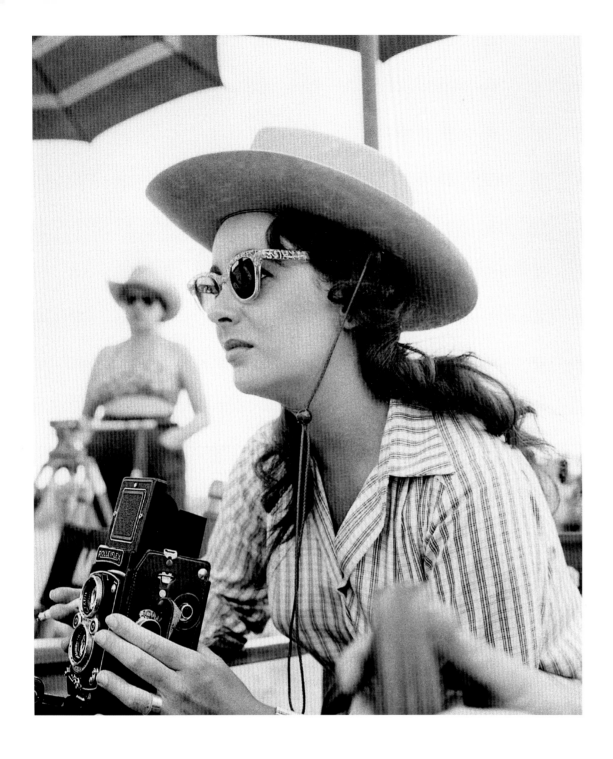

Above: **Frank Worth** (1923-2000). Elizabeth Taylor takes a photograph with a Rolleiflex camera on the set of *Giant*, 1956. Worth photographed many Hollywood film stars between 1939 and 1964 and was romantically linked with Jayne Mansfield and Marilyn Monroe amongst others. He filmed Taylor's first wedding. After his death, his archive was rediscovered and exhibited widely. *Opposite:* Elizabeth Taylor (1932-2011) holds a Rolleiflex twin lens reflex camera for a studio publicity still, 1953.

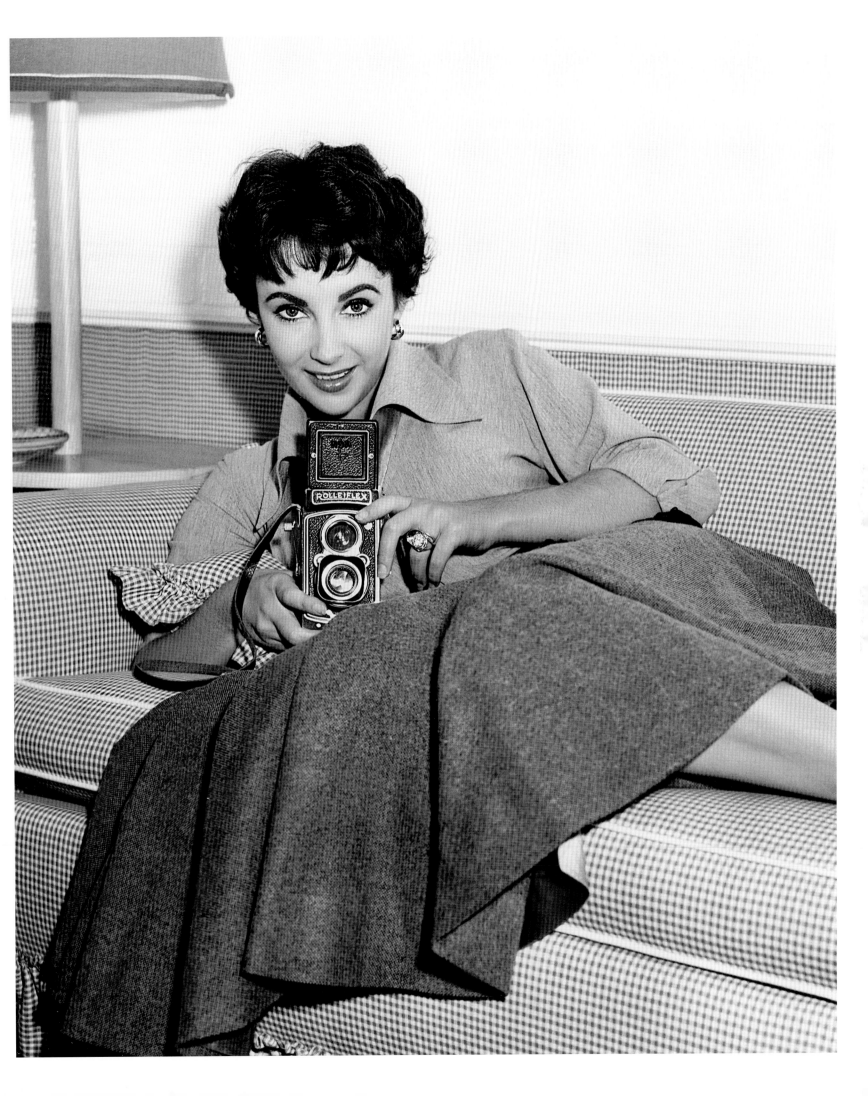

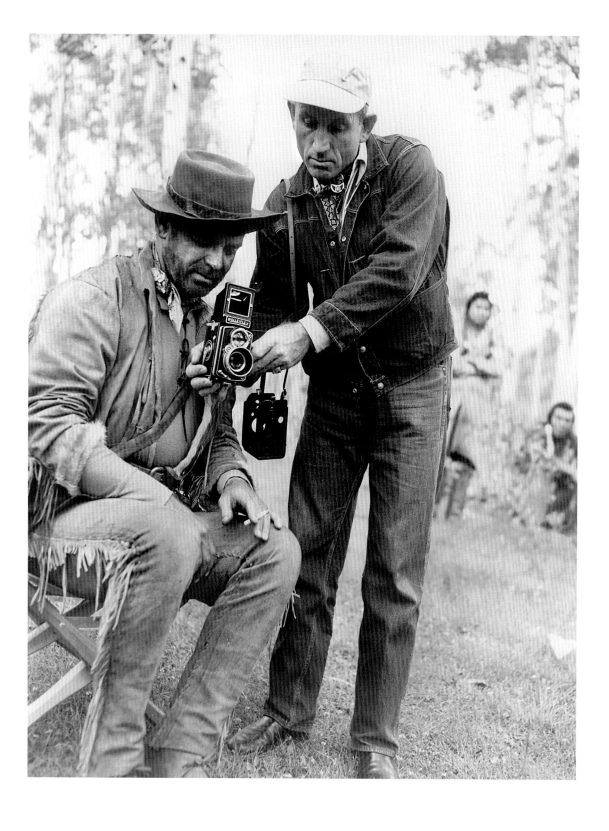

Above: Actor Clark Gable looks into a camera viewfinder during location shooting for the film *Across the Wide Missouri*, 1951. Photographer Earl Theisen (1903-1973) holds the Rolleiflex camera while Gable (1901-1960) looks through it. *Opposite:* American actor Clark Gable handles photographic plate holders while leaning on the seat of a convertible, c.1940.

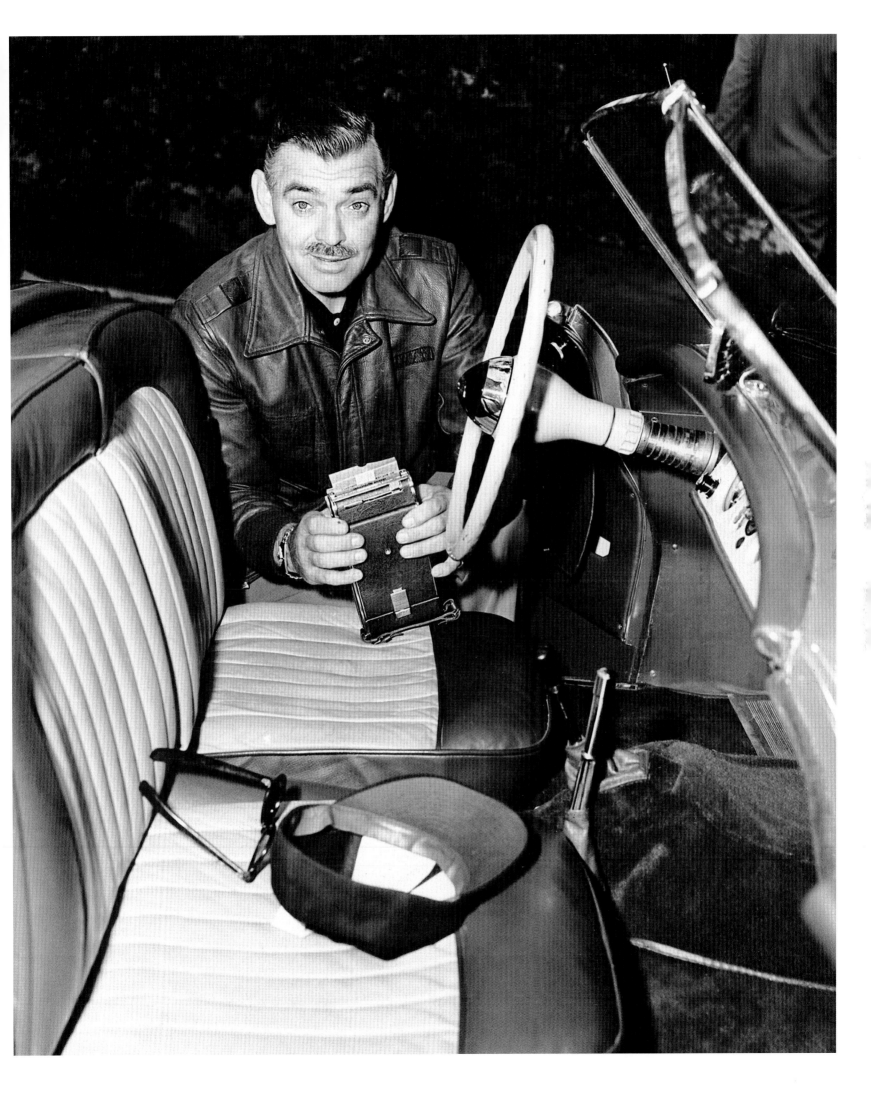

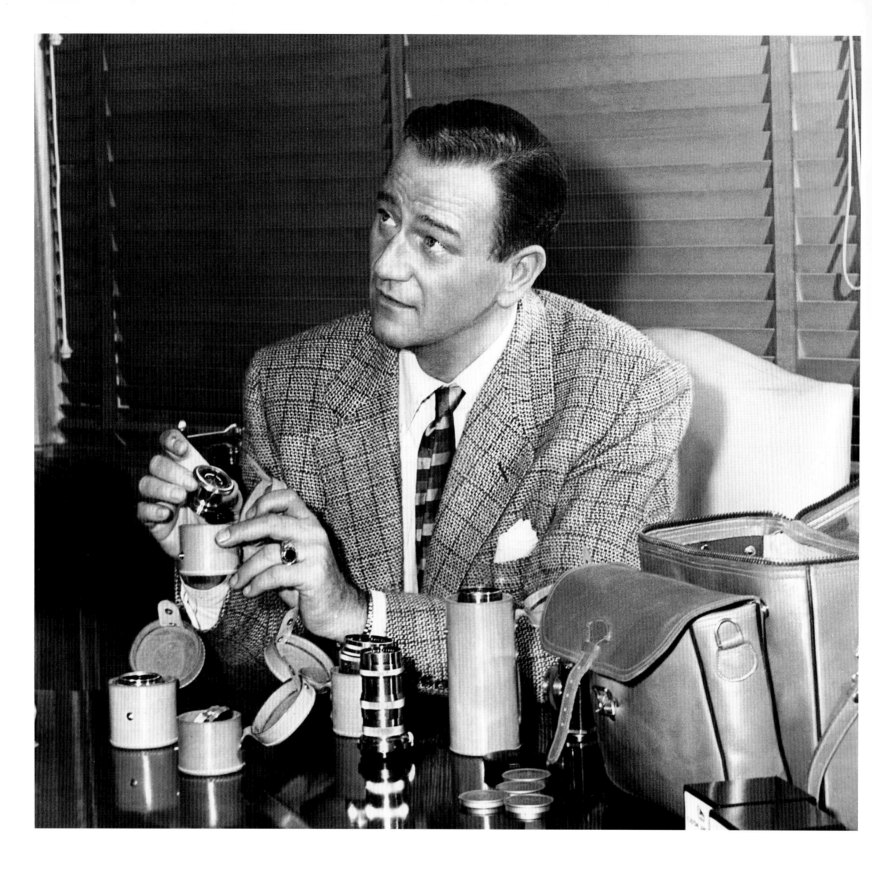

Above: American actor John Wayne takes a break during the filming of *Trouble Along the Way*, 1953. Wayne (1907-1979), who was a keen photographer, shows off some of his photographic equipment. He has a German-made Contax camera and a set of Zeiss lenses, from wide-angle to telephoto, to fit the camera. *Opposite:* Portrait of Robert Montgomery holding a camera, 1933. Montgomery (1904-1981) holds a Leica II camera serial numbered 85946, which dates to 1932.

Above: American actress and singer Nanette Fabray at LaGuardia airport, New York, c.1950. Fabray (b.1920) is holding a Stereo Realist camera that would produce pairs of images to be combined in a stereoscope to give the appearance of 3D.
Opposite: John Wayne on the set of *Big Jim McLain*, c.1952. Wayne (1907-1979) holds a Stereo Realist camera.

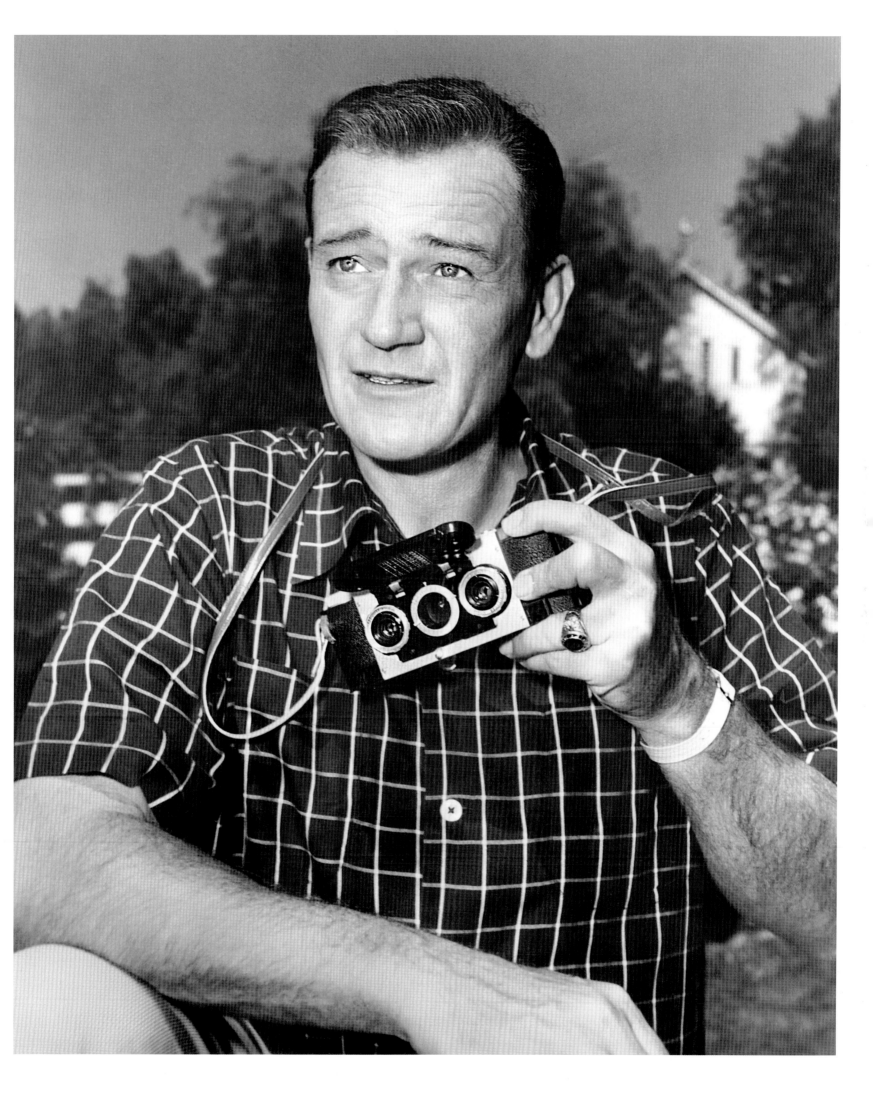

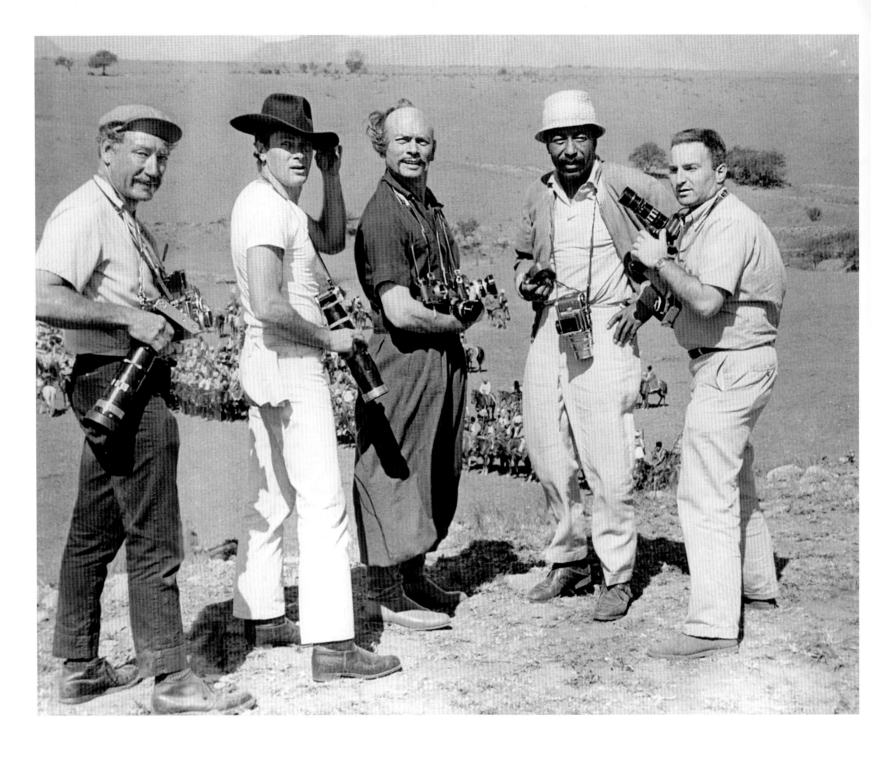

Above: Tony Curtis and Yul Brynner, the stars of the film *Taras Bulba*, and others hold cameras, 1962. Brynner (1920-1985) was a keen photographer and is shown here holding three cameras including a Leica. On the left of the picture is Ted Allen (1910-1993) who opened a Hollywood portrait studio in 1933 and worked extensively with Frank Sinatra. *Opposite:* Yul Brynner takes a photograph, c.1960.

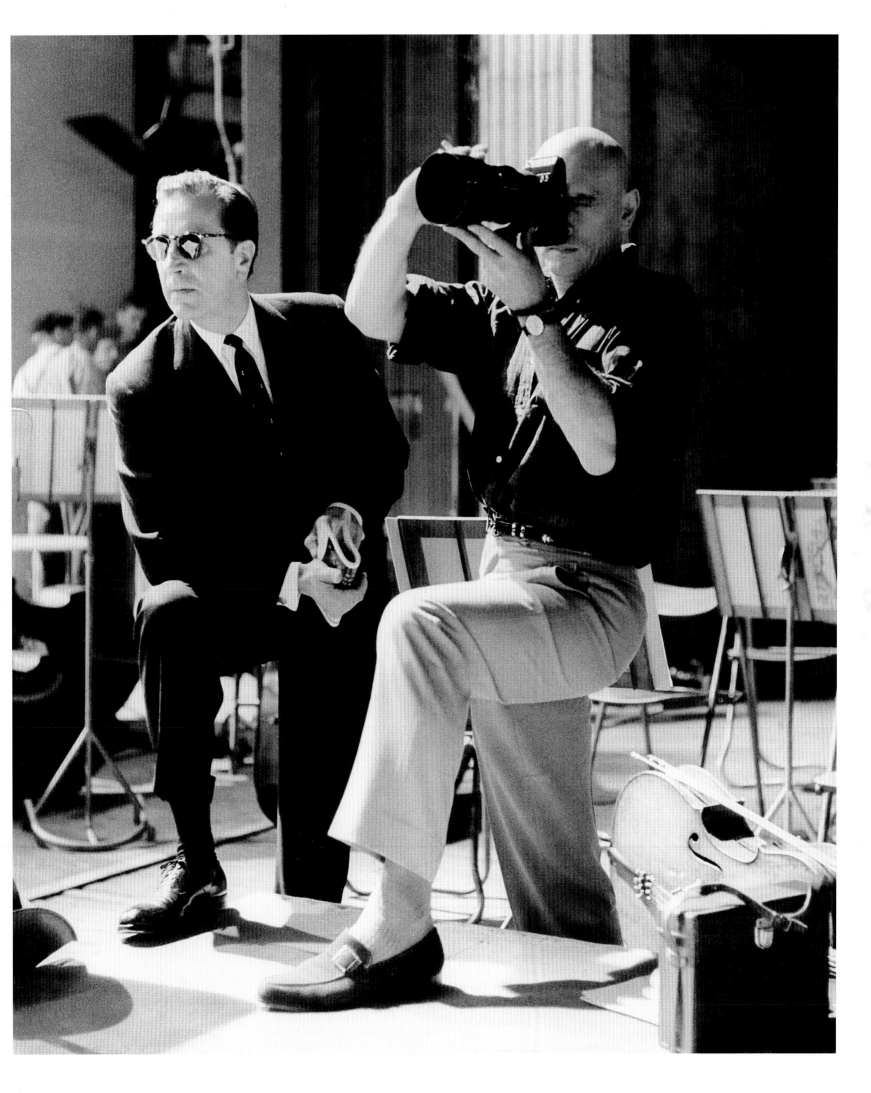

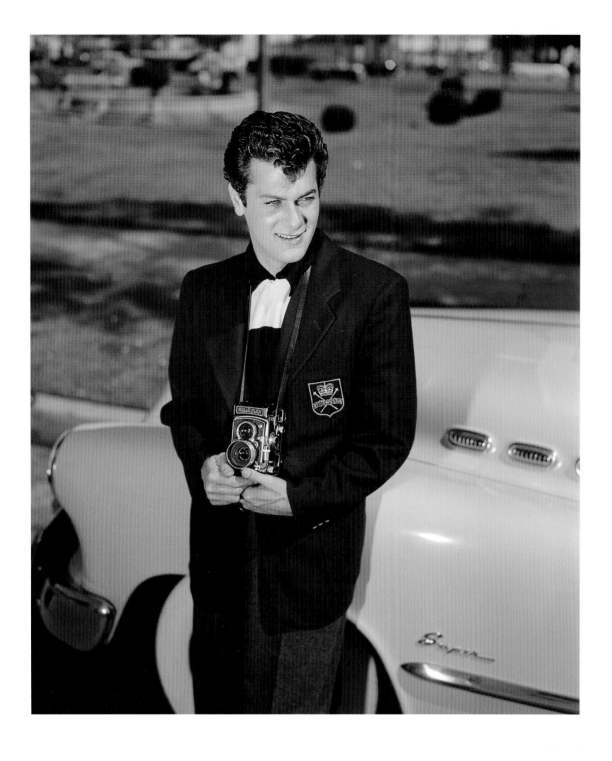

Above: American actor Tony Curtis posing against a car with a Rolleiflex camera, c.1955. *Opposite:* American actor Anthony Perkins holding a Rolleiflex camera, c.1960. Cameras, usually supplied by the photographer, were frequently used as a prop when photographing well-known actors, adding a point of interest to what might otherwise have been a simple portrait.

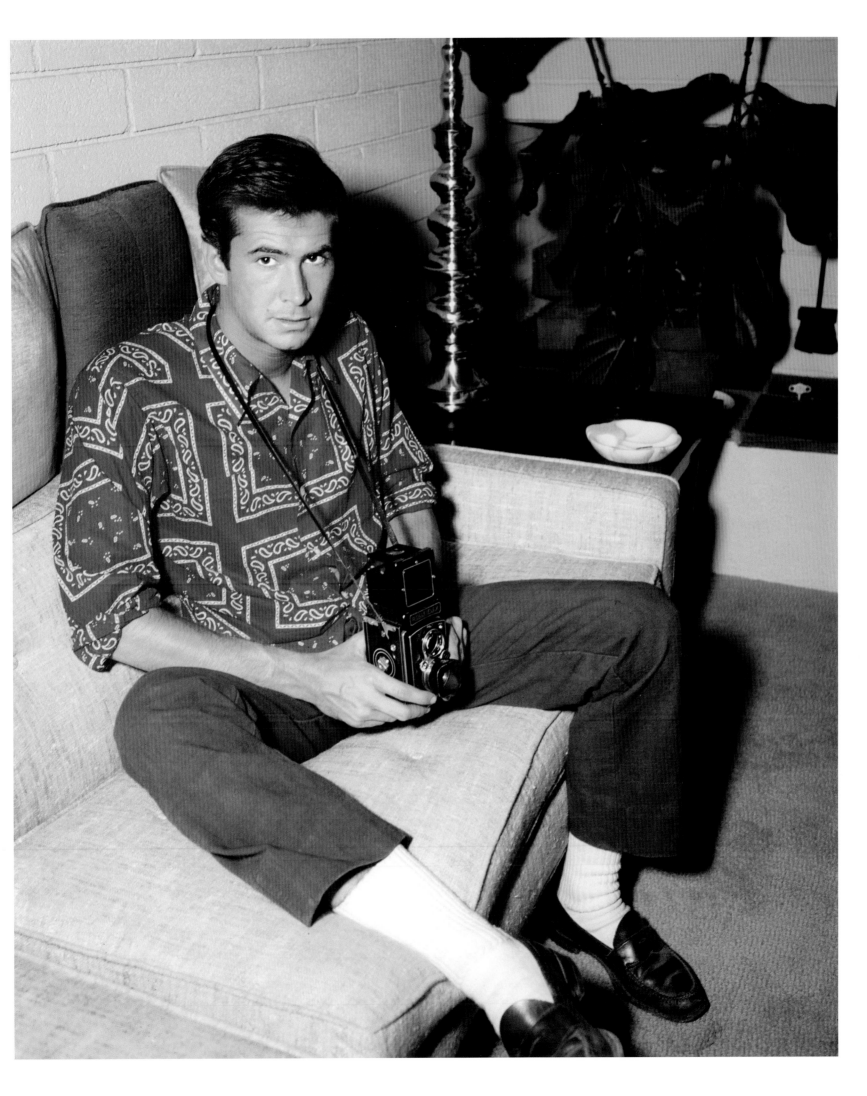

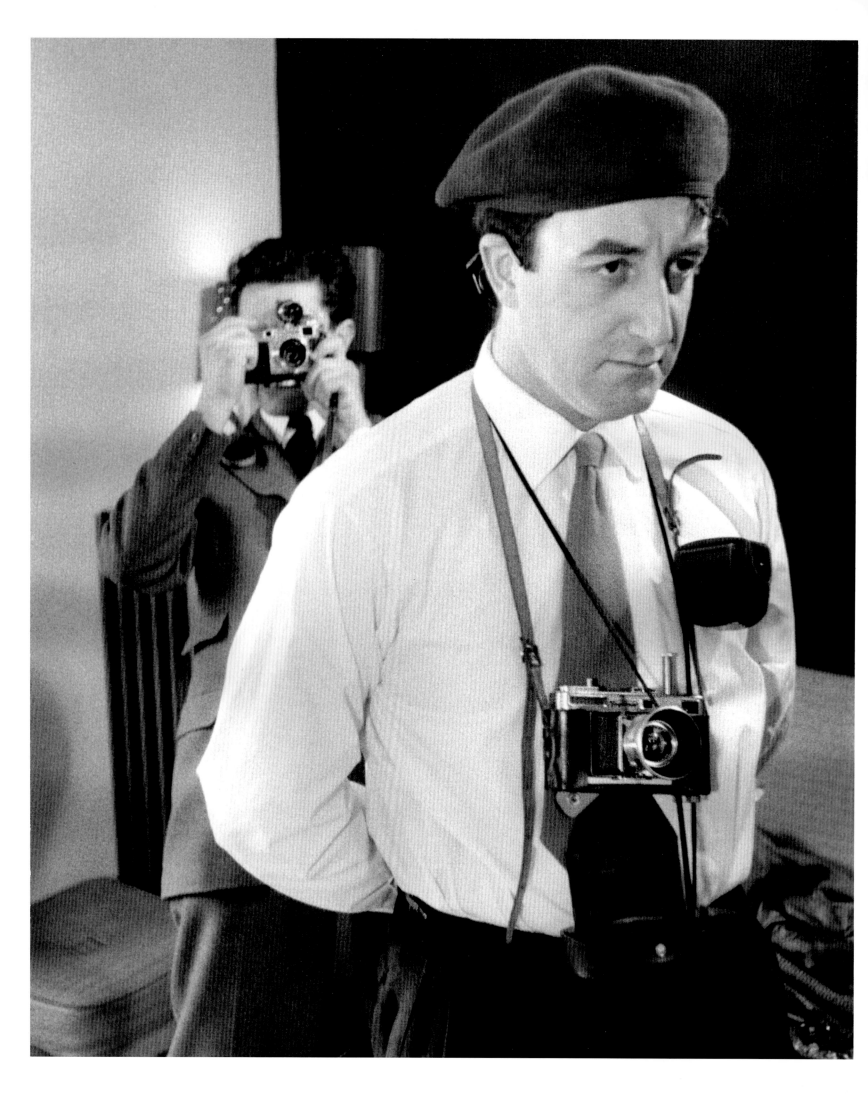

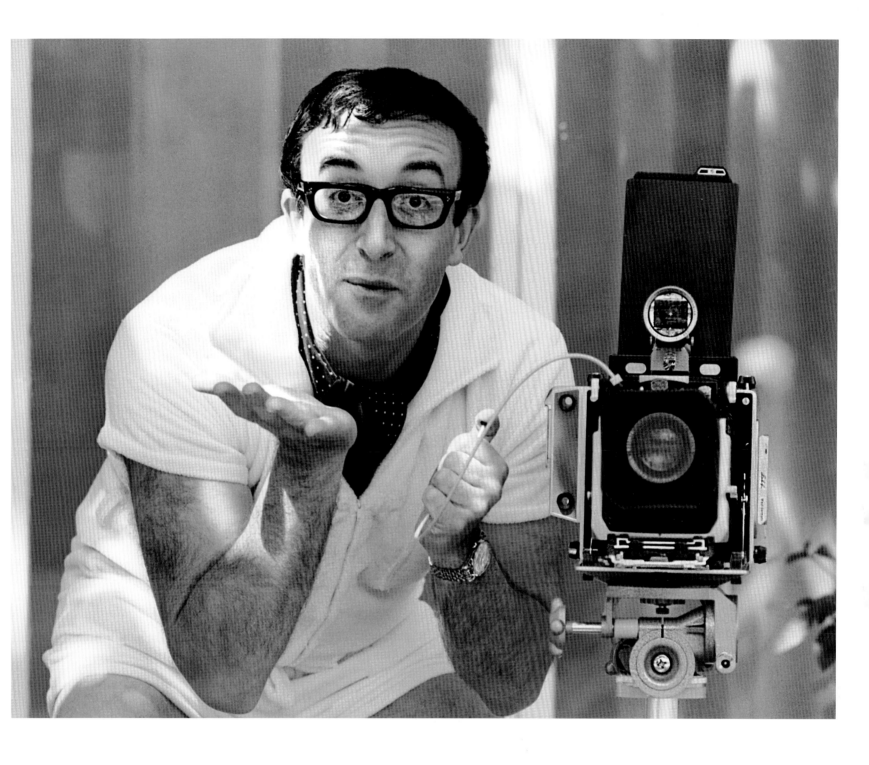

Opposite: **Thurston Hopkins** (b.1913). Peter Sellers at home in London being photographed by *Picture Post* photographer John Chillingworth, 1956. Chillingworth (b.1928) is using a pre-war Contax II camera. *Above:* **Terry O'Neill** (b.1938). Peter Sellers taking a photograph, Rome, 1965. Sellers (1925-1980) is using a German Linhof Technika camera.

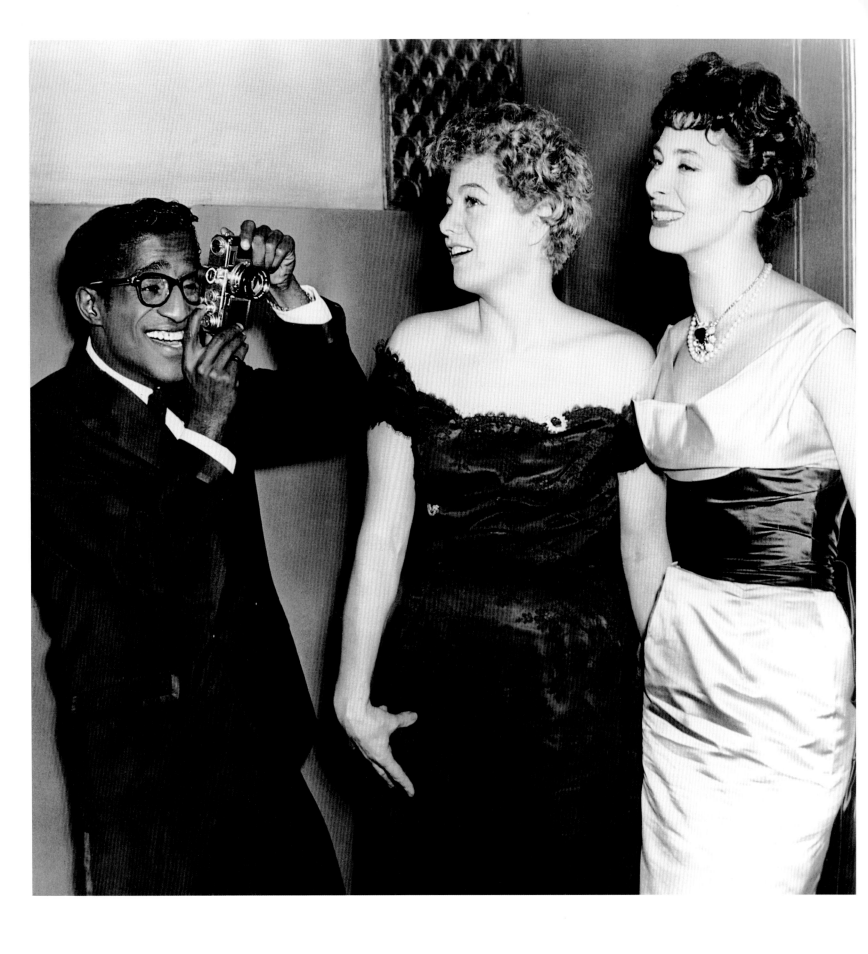

Sammy Davis Jr photographs actresses Shelley Winters and Rita Gam at the Waldorf Astoria Hotel, for a premiere of Elia Kazan's *Baby Doll*, New York, 18 December 1956. Davis (1925-1990) was an accomplished photographer.

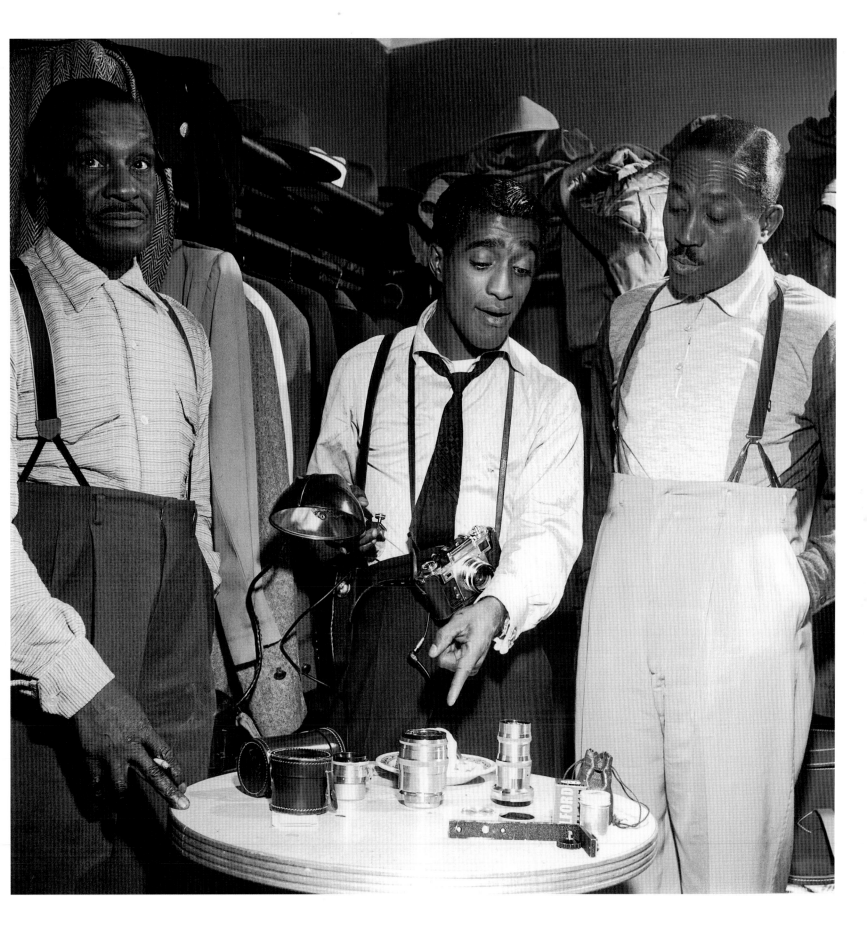

American singer and actor Sammy Davis Jr shows his photographic equipment to his father, Sammy Davis Sr (left), and Will Mastin in a dressing room, 1953. Davis has a Contax IIIa camera and a range of lenses, accessories and flash gun. The Contax IIIa was made between 1950 and 1961.

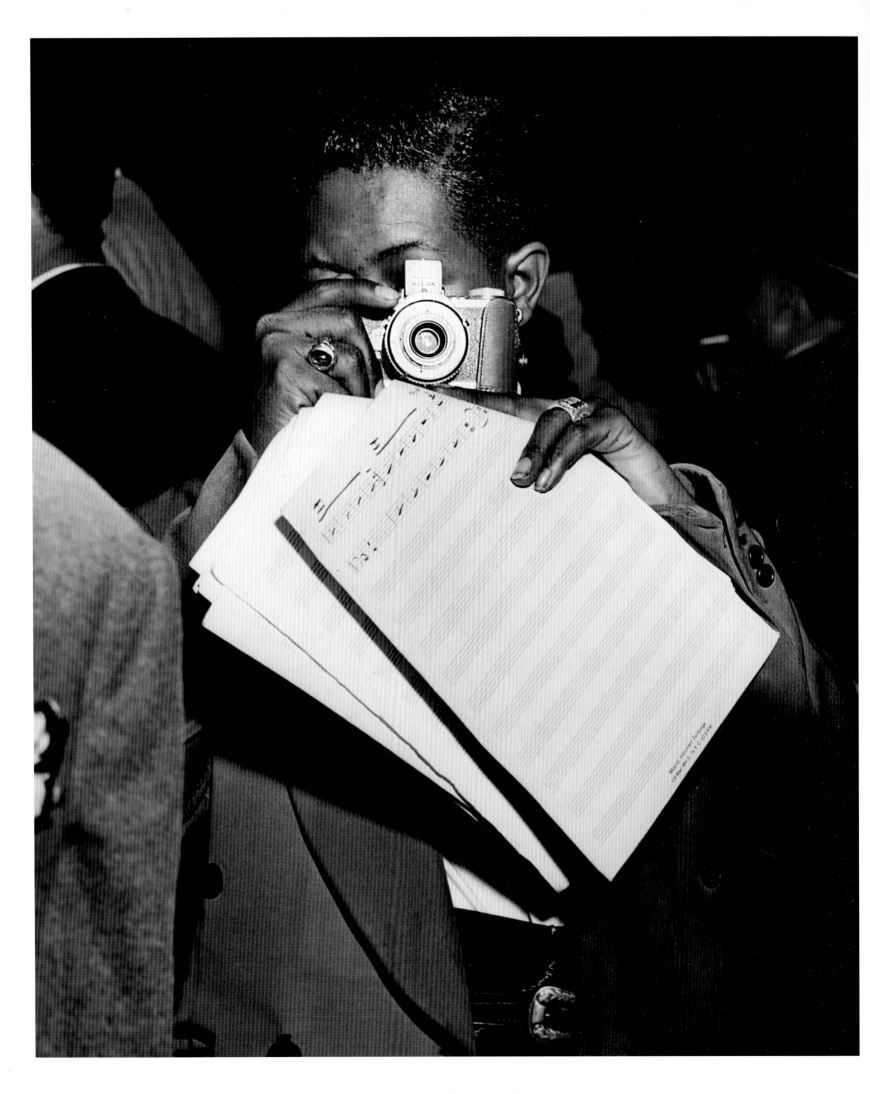

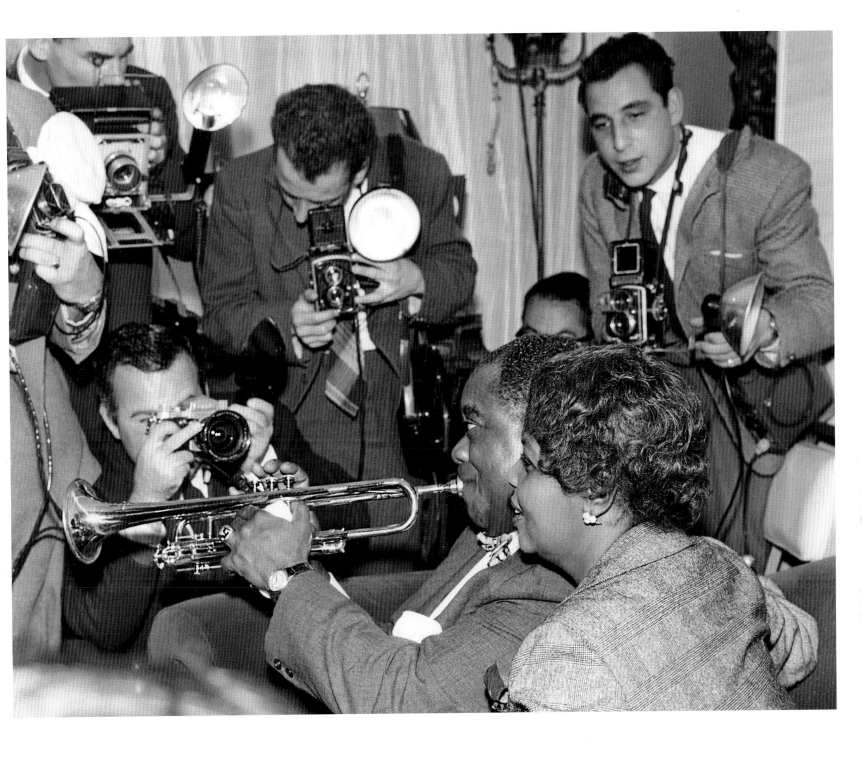

Opposite: **Weegee** [Arthur Fellig] (1899-1968). A musician takes a photograph of the photographer, New York, c.1945.
Above: Louis Armstrong (1901-1971) and his wife Lucille are photographed by the press at the Mayfair Hotel, London, 1 October 1969. The picture was captured by an *Evening Standard* photographer.

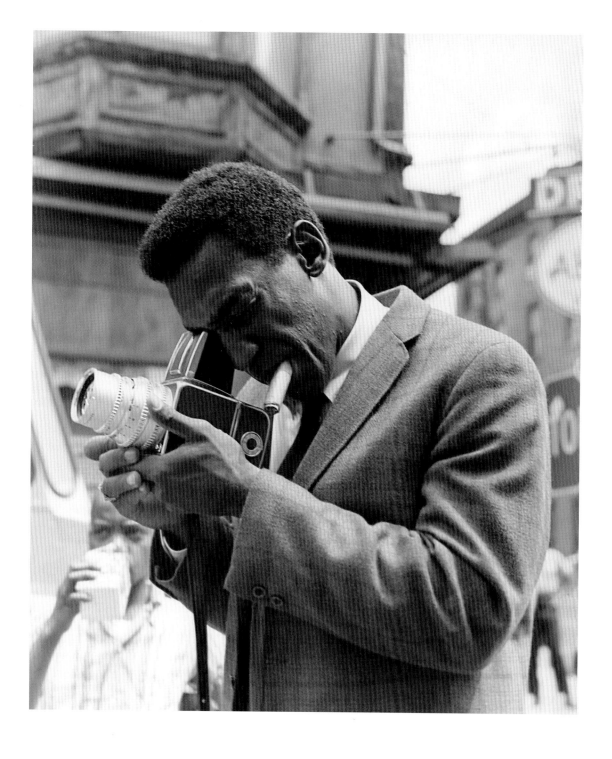

Above: American actor Bill Cosby holds a Hasselblad camera, c.1965. *Opposite:* **David Redfern** (b.1936). Jimmy Smith, Juan-les-Pins, France, 1963. Smith (1925-2005) was a jazz musician who helped popularise the Hammond B-3 electric organ. He is holding a Nikon F camera, a model that had been introduced in 1959.

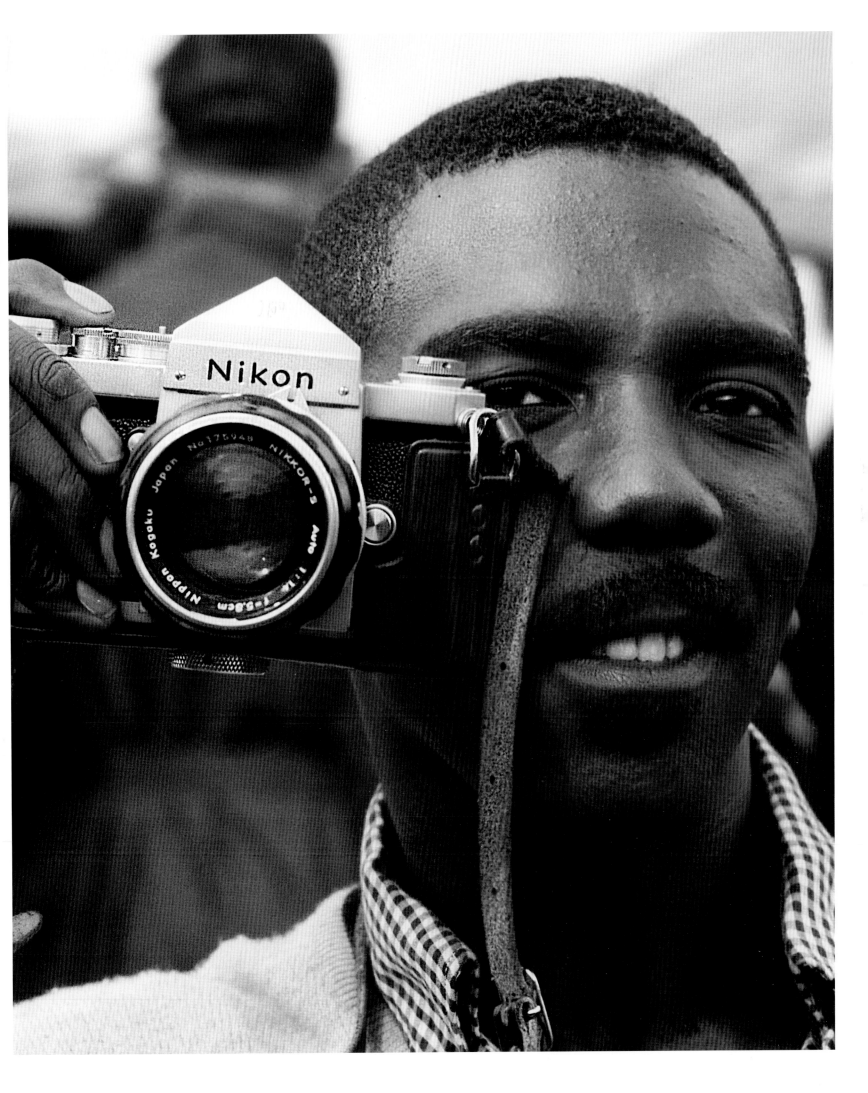

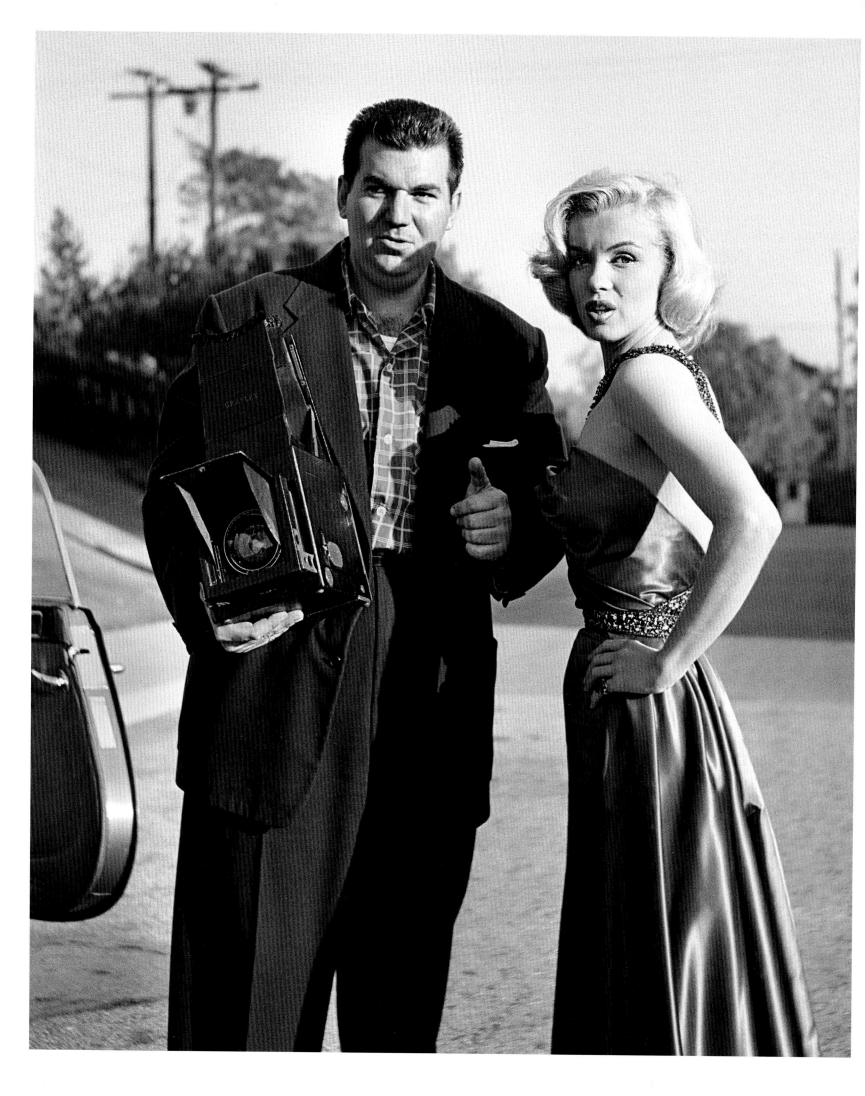

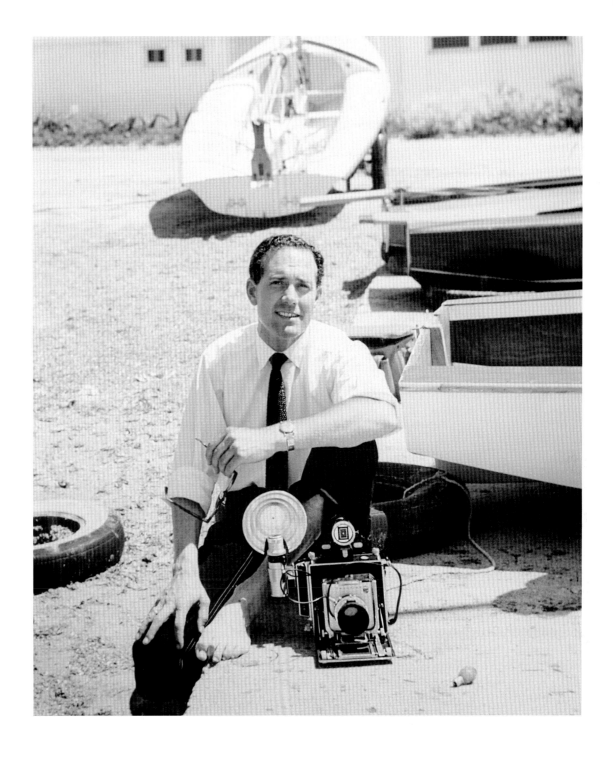

Opposite: **Sammy Davis Jr** (1925-1990). Marilyn Monroe poses for a portrait with photographer Frank Worth on the set of *How to Marry a Millionaire*, 1953. Worth (1923-2000) worked with many Hollywood stars, befriending a number of them. He carries a large format Graflex reflex camera. *Above:* **R. Mathews** (dates unknown). British portrait photographer Cornel Lucas, July 1958. Lucas (b.1920) sits with his technical camera, one expended flash bulb beside it.

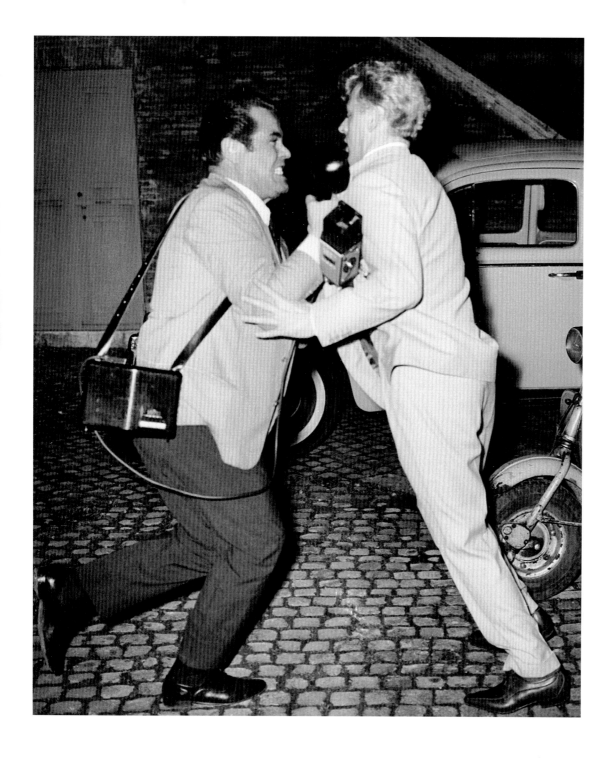

Above: Wee Willie Harris brawls with a press photographer on the Via Veneto, Rome, 27 August 1962. Harris (b.1933) was a British rock and roll star with a 'wild man' reputation. Although the press were important, sometimes photographers overstepped a mark and Harris had reacted. *Opposite:* Actress Sonia Romanoff attacks paparazzo Rino Barillari with an ice cream on the Via Veneto, Rome, 1966. Barillari (b.1945) is the self-styled King of Paparazzi and claims to have smashed 76 cameras and broken 11 ribs during his career. He was one of the original paparazzi whose antics inspired Federico Fellini to make *La Dolce Vita*.

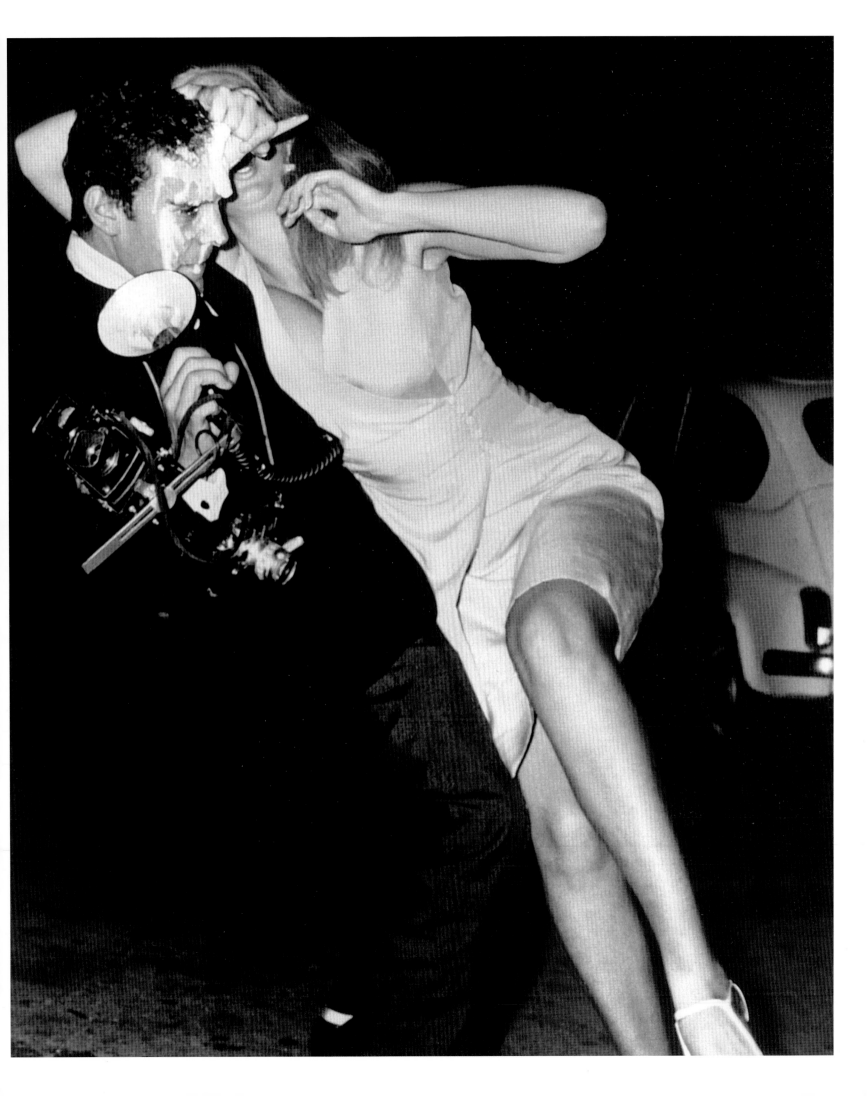

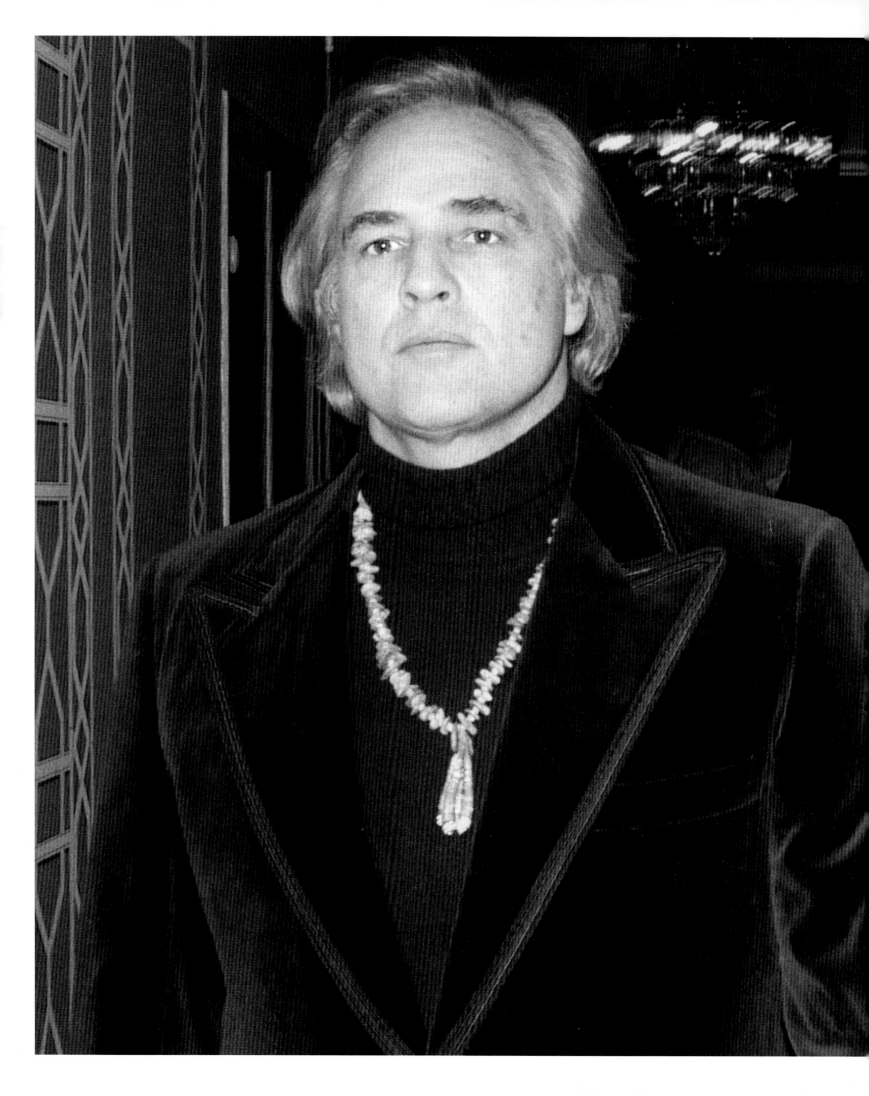

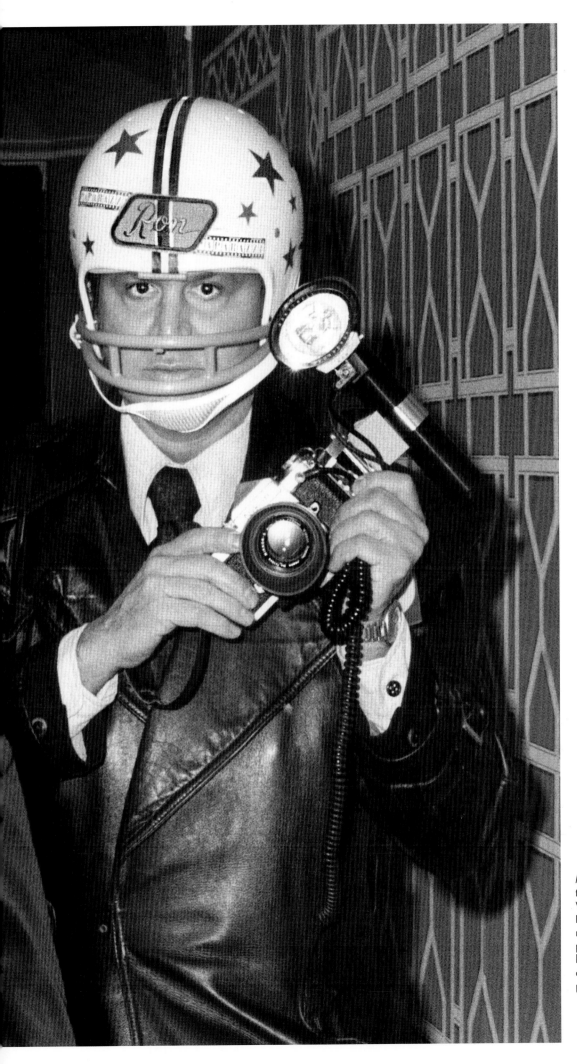

Marlon Brando and Ron Galella at the first gala benefitting the American Indian Development Association at the Waldorf Astoria Hotel, New York, 26 November 1974. Ron Galella (b.1931) has been described by *Time* magazine and *Vanity Fair* as 'the Godfather of the U.S. paparazzi culture'. On 12 June 1974, he was punched by Brando (1924-2004), who broke his jaw and knocked out five teeth. He wore an American football helmet for protection later that year when he stalked Brando again.

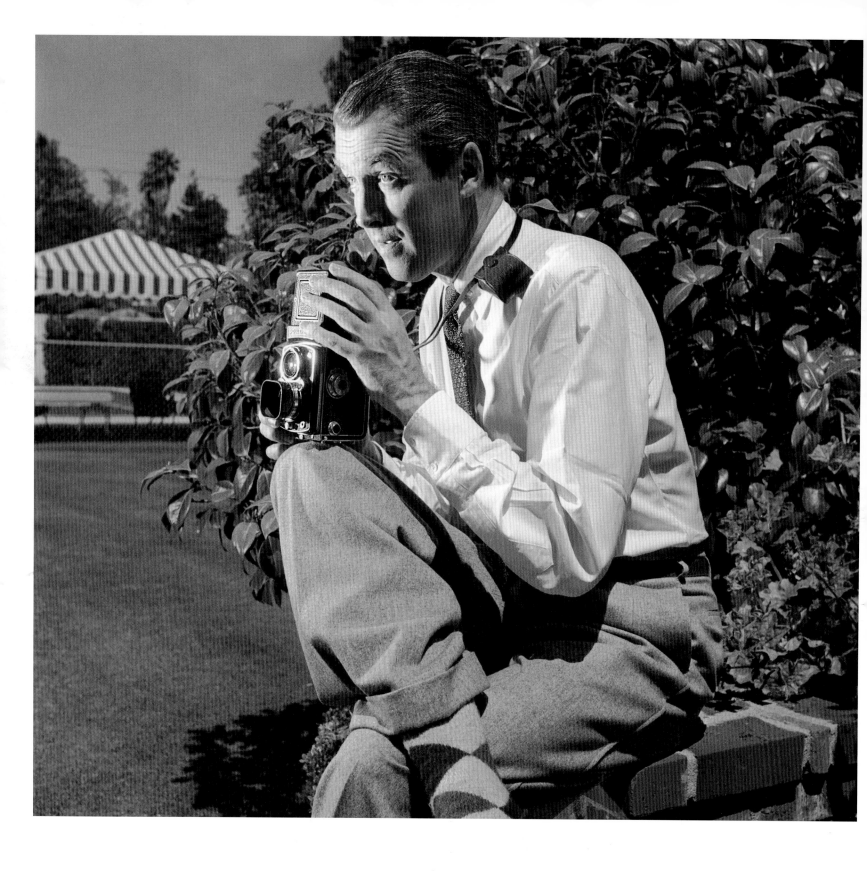

Above: **Gene Lester** (c.1910-1994). Actor James Stewart takes a photograph in his backyard, California, 1951. Stewart (1908-1997) uses a Rolleiflex twin lens reflex camera. *Opposite:* Film director Alfred Hitchcock holding a camera as he looks out on the Alps at St Moritz, Switzerland, c.1955.

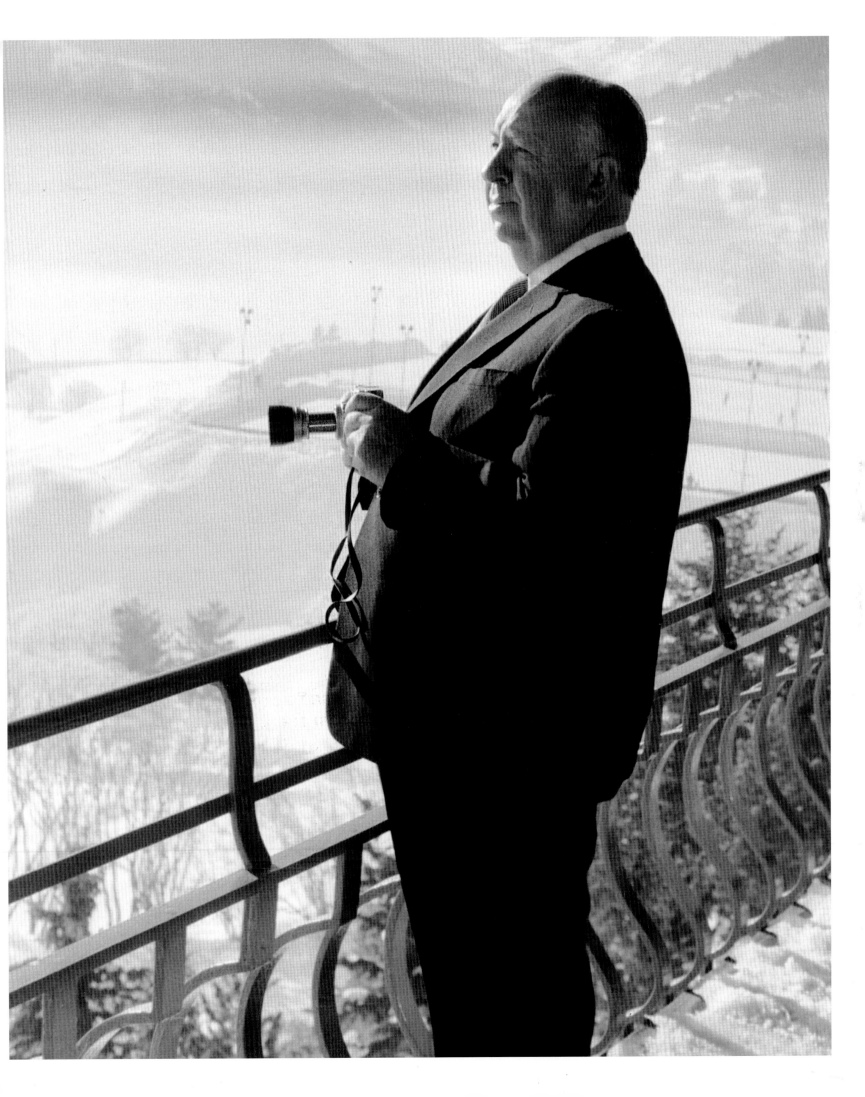

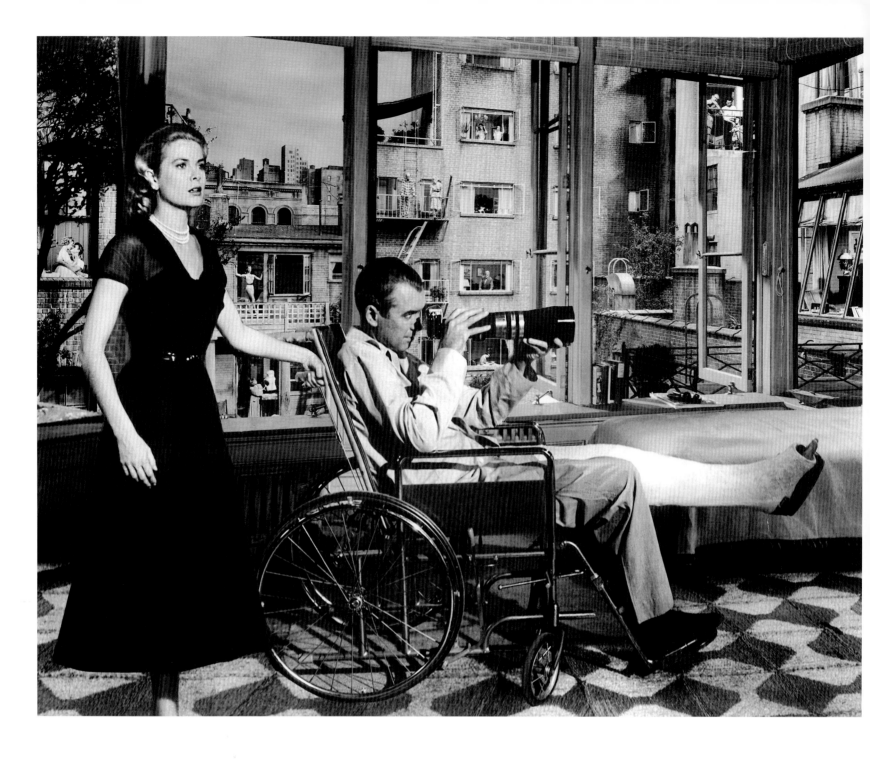

Grace Kelly stands behind Jimmy Stewart as he uses his camera to spy on neighbours in a scene from Alfred Hitchcock's film *Rear Window*, 1954. The two best-known films in which photography plays a starring role are *Blow-Up* and *Rear Window*. In the latter, Stewart made use of a German post-war Exakta Varex camera fitted with a German Kilfitt Fern-Kilar f/5.6 400mm lens that was made from 1952 to 1968.

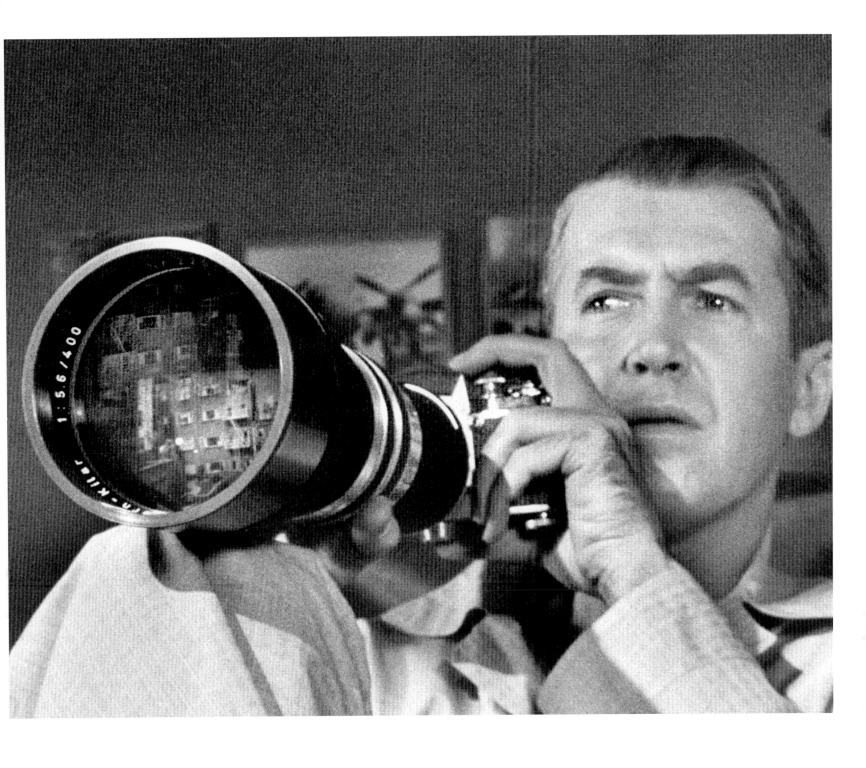

Bob Landry (1913-1960). Actor James Stewart holding his camera in a scene from *Rear Window*, 1954. Landry was a *Life* photographer and went in with the first wave of the D-Day Normandy landings. His post-war career was less dangerous.

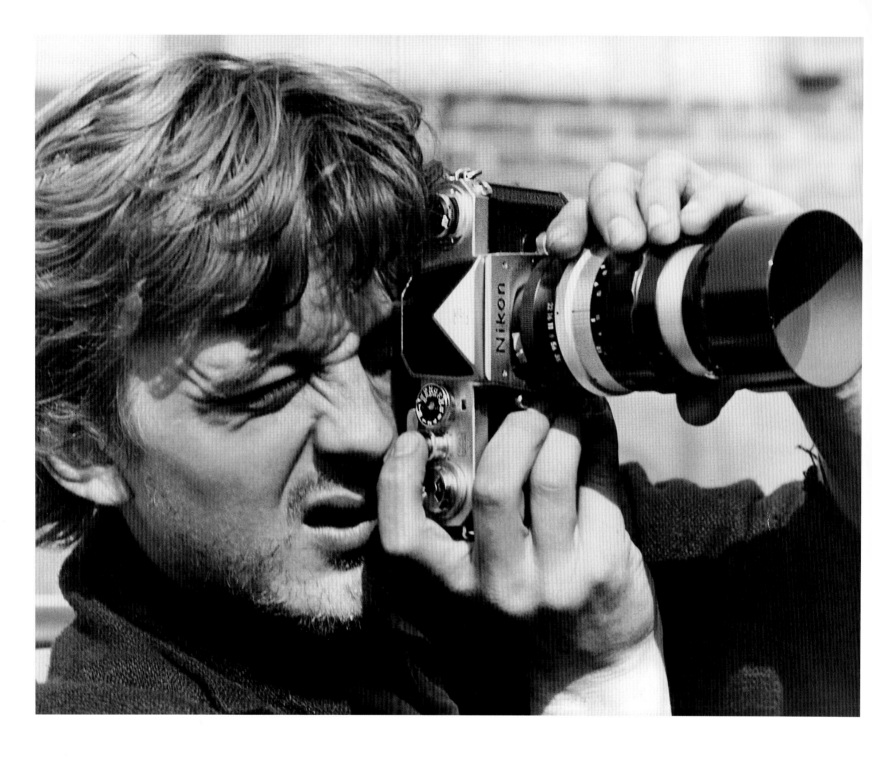

Above: David Hemmings in a scene from the film *Blow-Up*, 1966. Hemmings (1941-2003), as photographer Thomas, sports a beard following a stay in a down and out hostel where he has been taking photographs for a book. He uses a Nikon F camera with a Nikkor 50mm f/1.4 lens. *Opposite:* David Hemmings in his studio in the film *Blow-Up*, 1966. Hemmings is using a Hasselblad medium format camera.

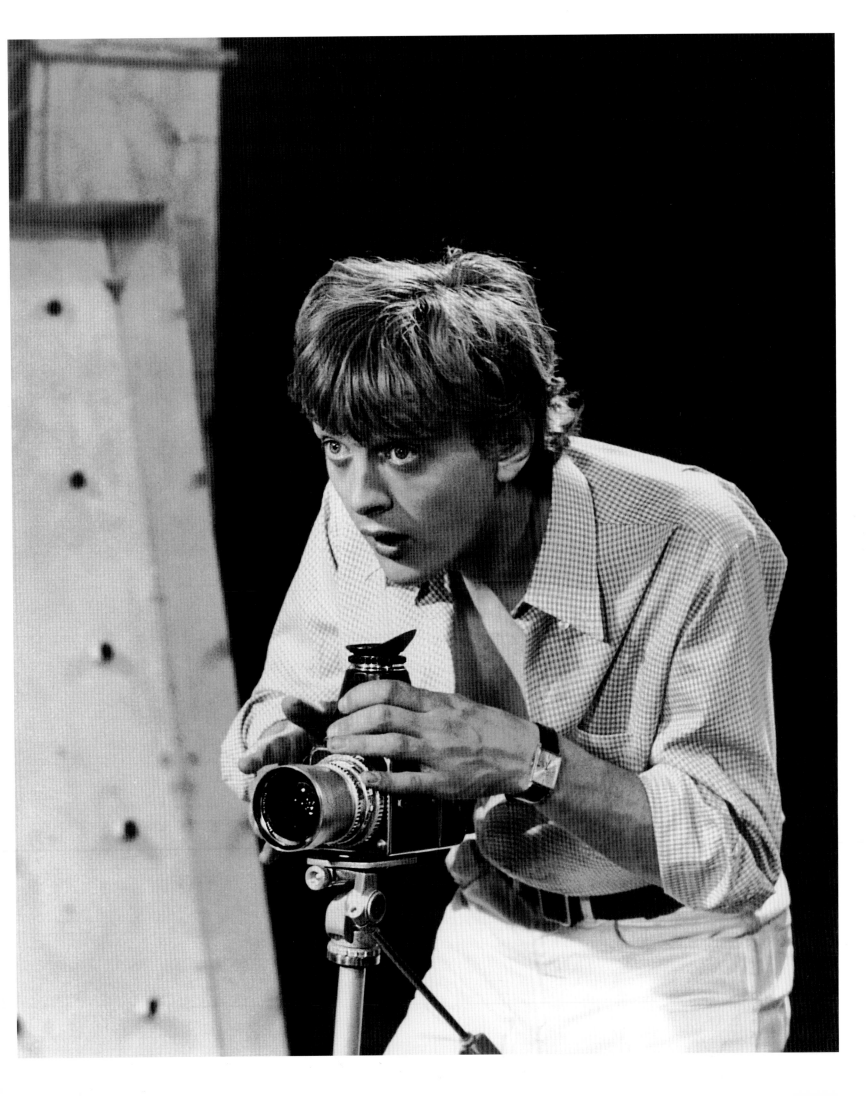

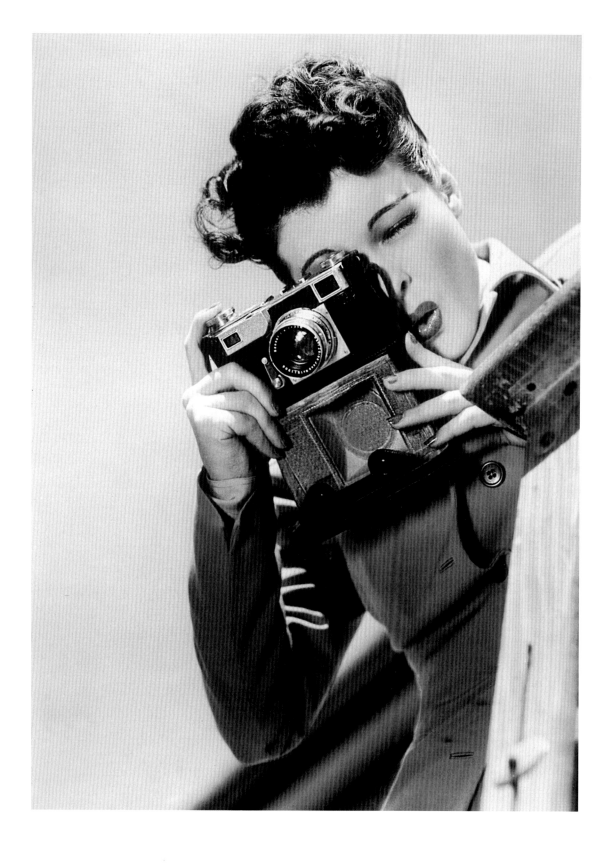

Above: Actress Ruth Hussey stars as photographer Elizabeth Imbrie in *The Philadelphia Story*, 1940. Hussey (1911-2005) played a cynical magazine photographer and almost-girlfriend of James Stewart's character Macaulay Connor in the film. She uses a Contax II camera with a Zeiss standard lens. In this studio shot from the film, the camera name has been painted out. *Opposite:* Ruth Hussey photographs another woman in *The Philadelphia Story*, 1940. Hussey uses a Contax II camera. Elsewhere in the film she is shown using an American-made Argus C3 camera which had been introduced in 1939.

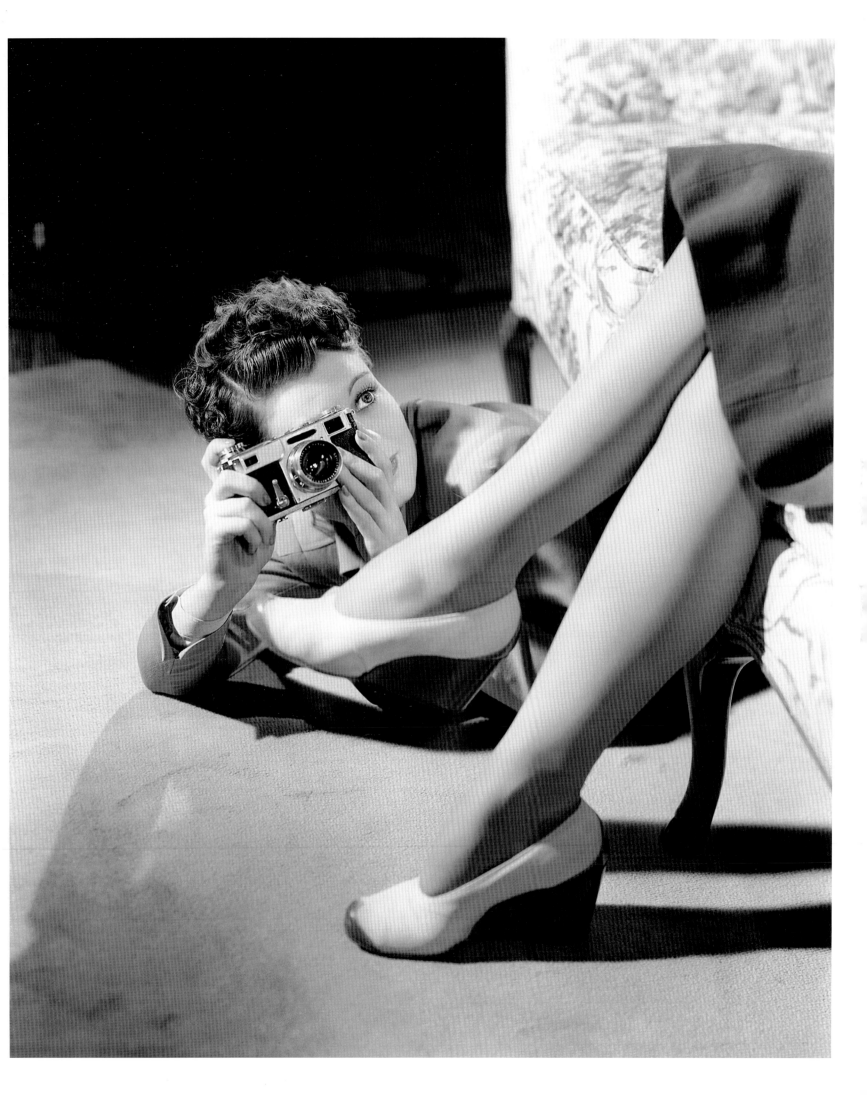

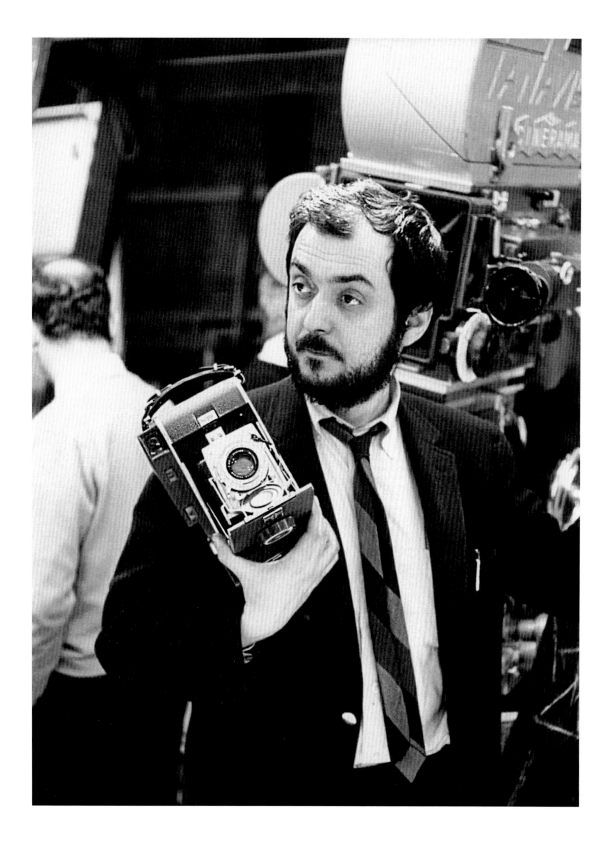

Above: **Dmitri Kessel** (1902-1995). Film director Stanley Kubrick holds a Polaroid camera during the filming of *2001: A Space Odyssey,* 1966. Kubrick (1928-1999) was a photographer as well as a film-maker and had an extensive collection of Nikon equipment. *Opposite:* Actor and director Orson Welles playing the Photographer-Reporter in *Time Runs,* his interpretation of Doctor Faustus, at the Edward VII Theatre, Paris, 15 June 1950. Welles holds a Rolleicord twin lens reflex camera.

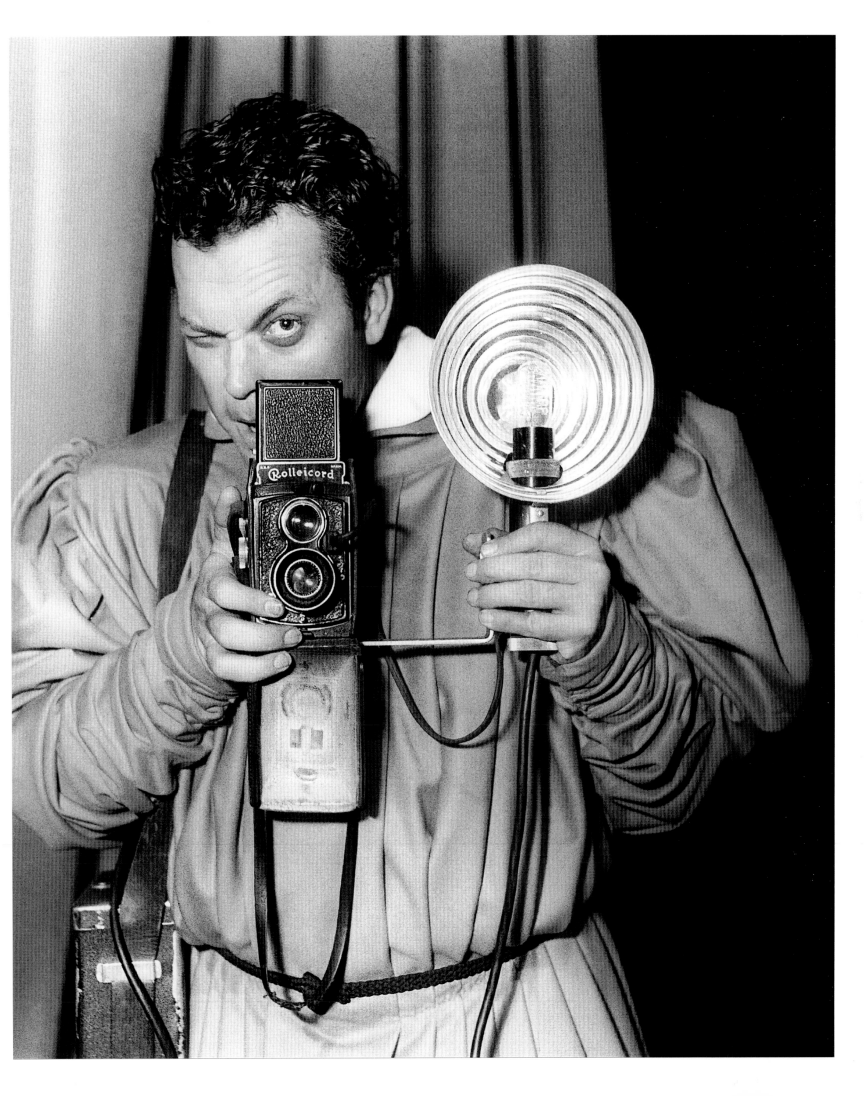

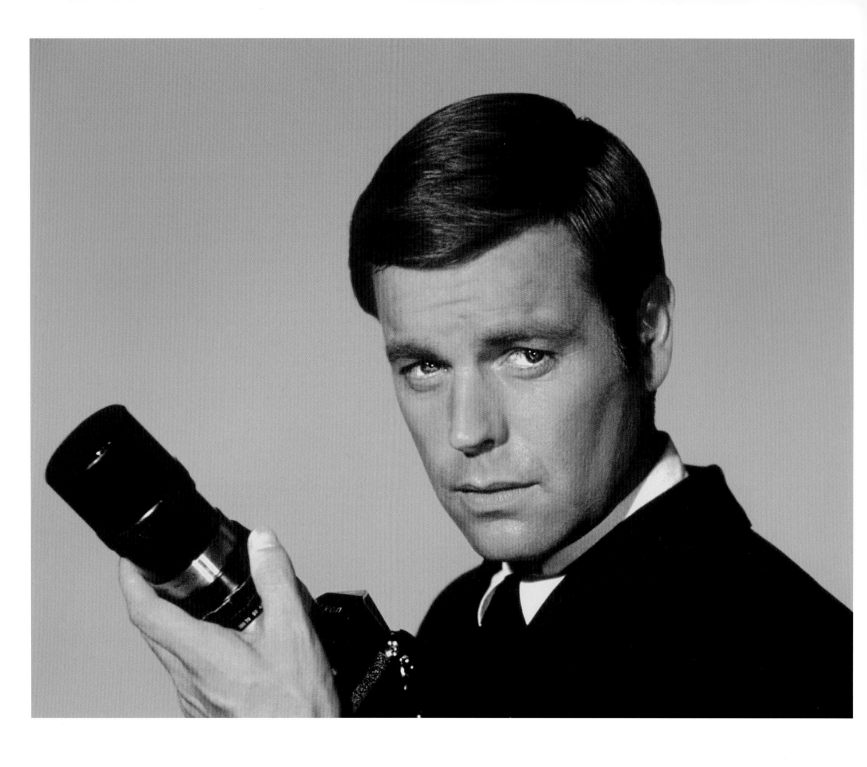

Above: Actor Robert Wagner in a publicity still for the American television series *It Takes a Thief,* 1969. Wagner (b.1930) holds a Nikon F camera. *Opposite:* Actor Robert Vaughn as Napoleon Solo in *The Man from U.N.C.L.E.,* c.1965. Vaughn (b.1932) holds a Nikon F camera.

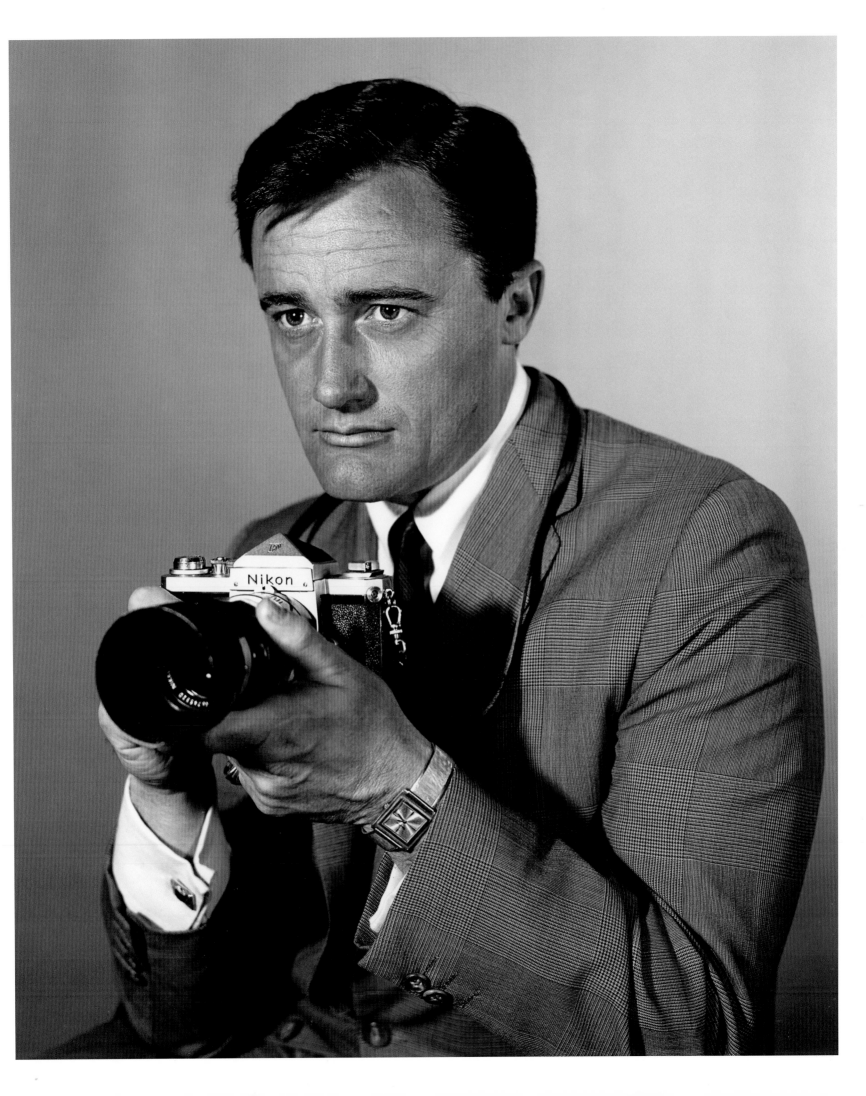

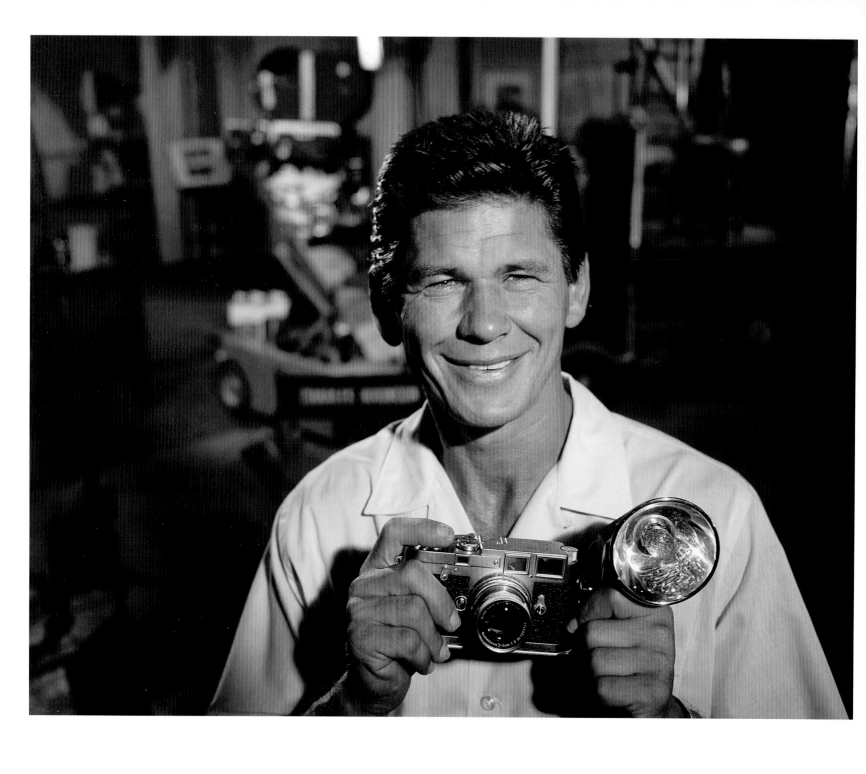

Gene Lester (c.1910-1994). Portrait of actor Charles Bronson who was starring in the television series *Man with a Camera*, 1958. Bronson (1921-2003) holds a Leica M3 camera with flash gun.

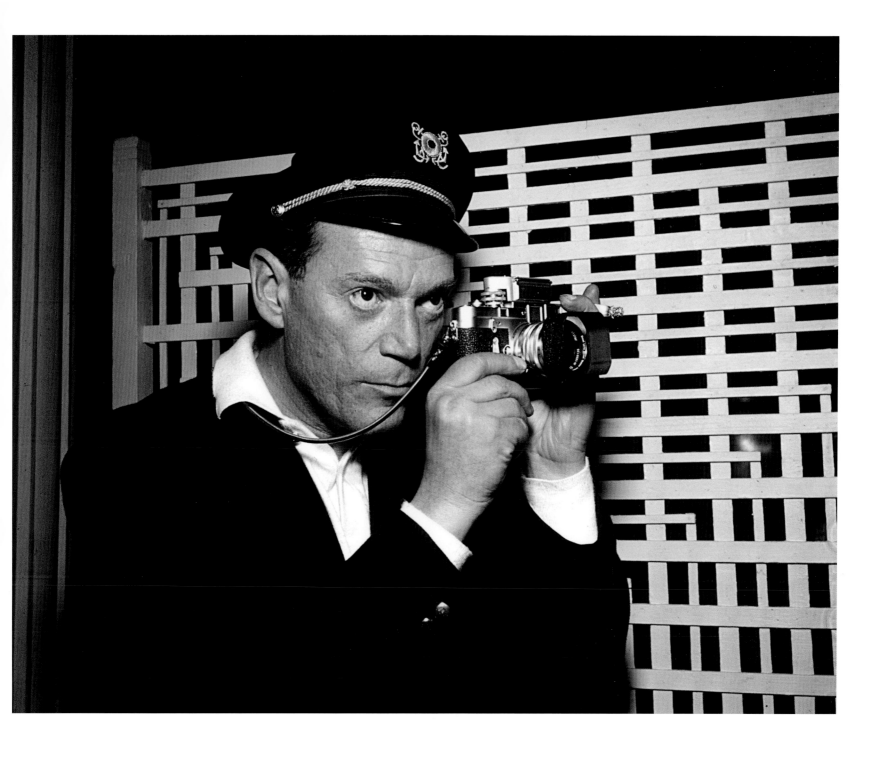

Portrait of actor and singer Eddie Constantine, 1950. Constantine (1917-1993) holds a Leica M3 camera. Mounted on top of it is a Leitz Leica-meter.

Weegee [Arthur Fellig] (1899-1968). Self-portrait from the inside of a police van, c.1944. Weegee was born in Ukraine before emigrating to New York in 1909. In 1935 he began a career as a freelance photographer concentrating on recording crime and low-life in Manhattan. He is shown here with his trademark Speed Graphic press camera fitted with a side-mounted flashgun.

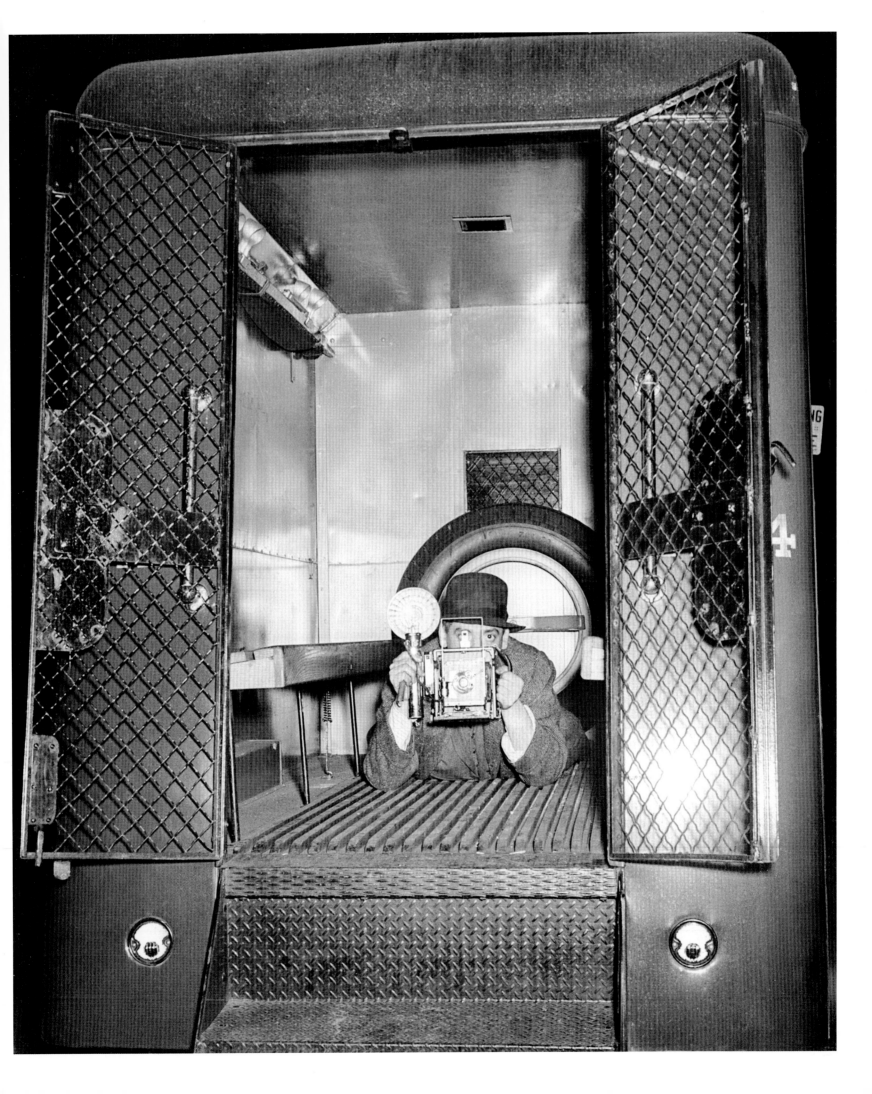

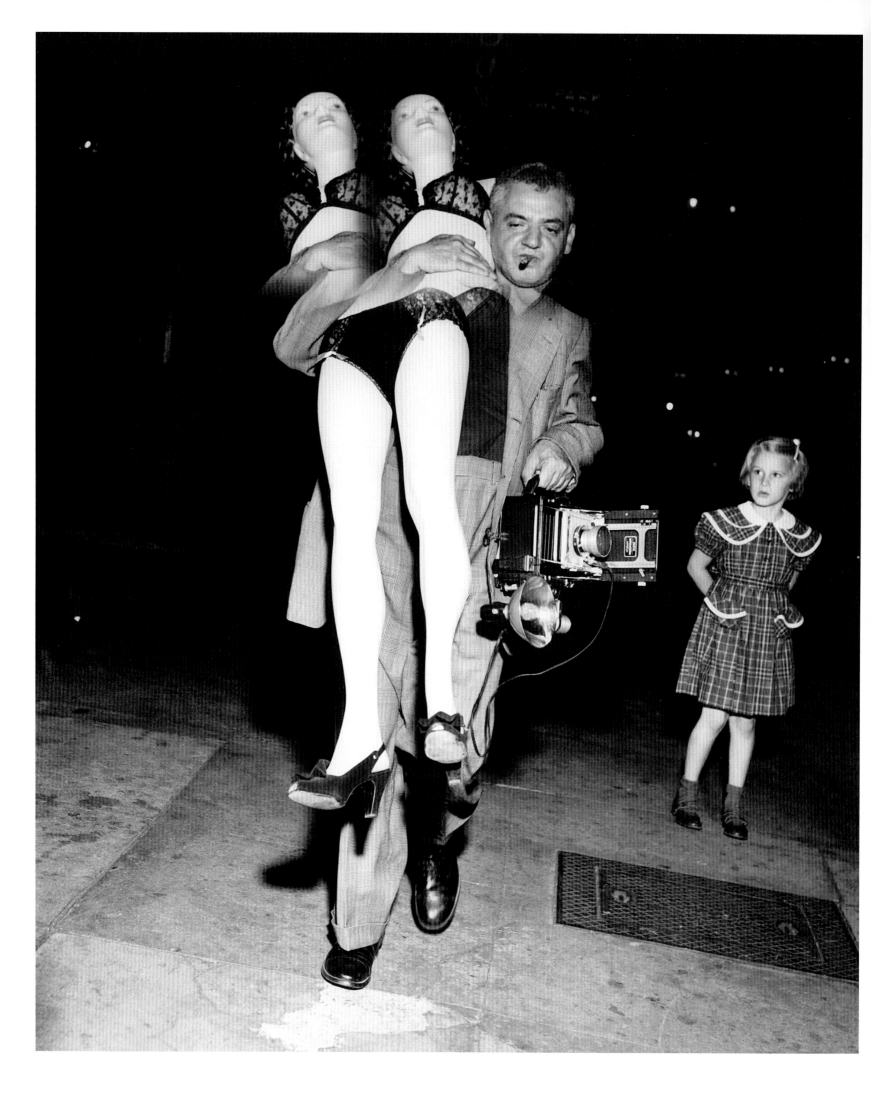

Opposite: **Weegee** [Arthur Fellig] (1899-1968). Self-portrait walking along a Los Angeles sidewalk, carrying a mannequin and watched by a young girl, c.1950. Weegee carries his trademark Speed Graphic camera with flashgun attached.
Above: **Weegee** [Arthur Fellig] (1899-1968). Self-portrait with Rolleiflex twin lens reflex camera, c.1950. Weegee with cigar in hand looks in to the extended viewing hood of his Rolleiflex camera.

Above: **Robert Abbott Sengstacke** (b.1943). Photographer Herman Santonio 'Tony' Rhoden prepares to take a shot, 1963. Rhoden (1920-1991) holds a Pentax camera. *Opposite:* **Robert Abbott Sengstacke** (b.1943). Portrait of photographer Herman Santonio 'Tony' Rhoden, Chicago, 1965. Rhoden holds a Speed Graphic camera with flash gun.

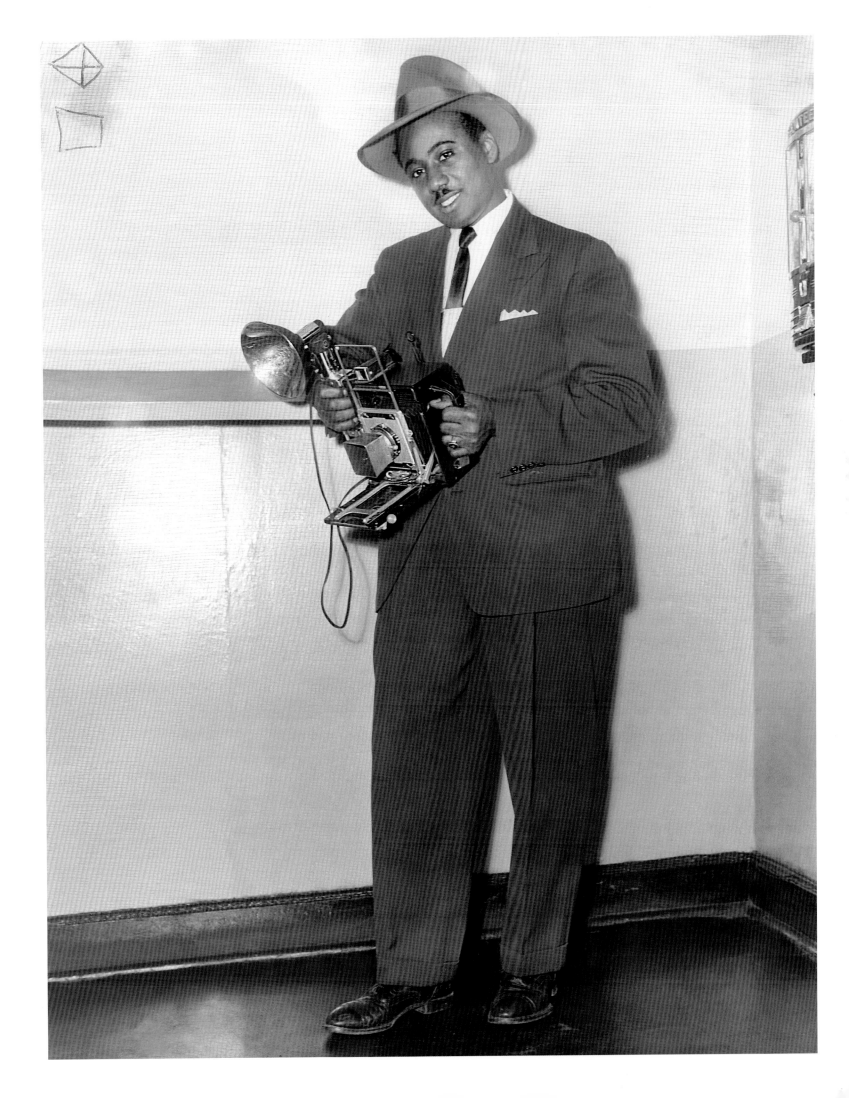

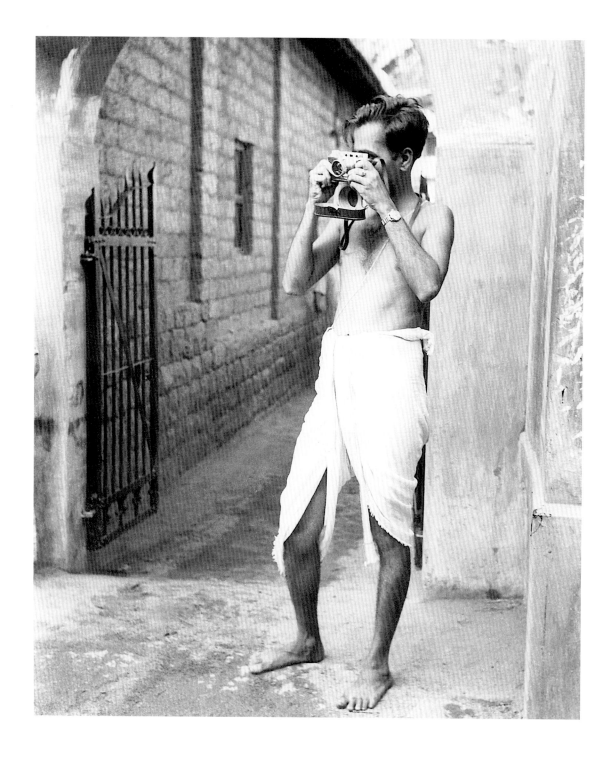

Above: Indian photojournalist T. S. Satyan shooting pictures at a temple in the holy town of Udupi, India, 1948. Tambrahalli Subramanya Satyanarayana Iyer (1923-2009) was better known as T. S. Satyan and was one of India's earliest and best-known photojournalists. He is using a Leica camera. *Opposite:* T. S. Satyan holding a Speed Graphic camera, 1948. Satyan was working as a staff photographer for the *Deccan Herald* newspaper.

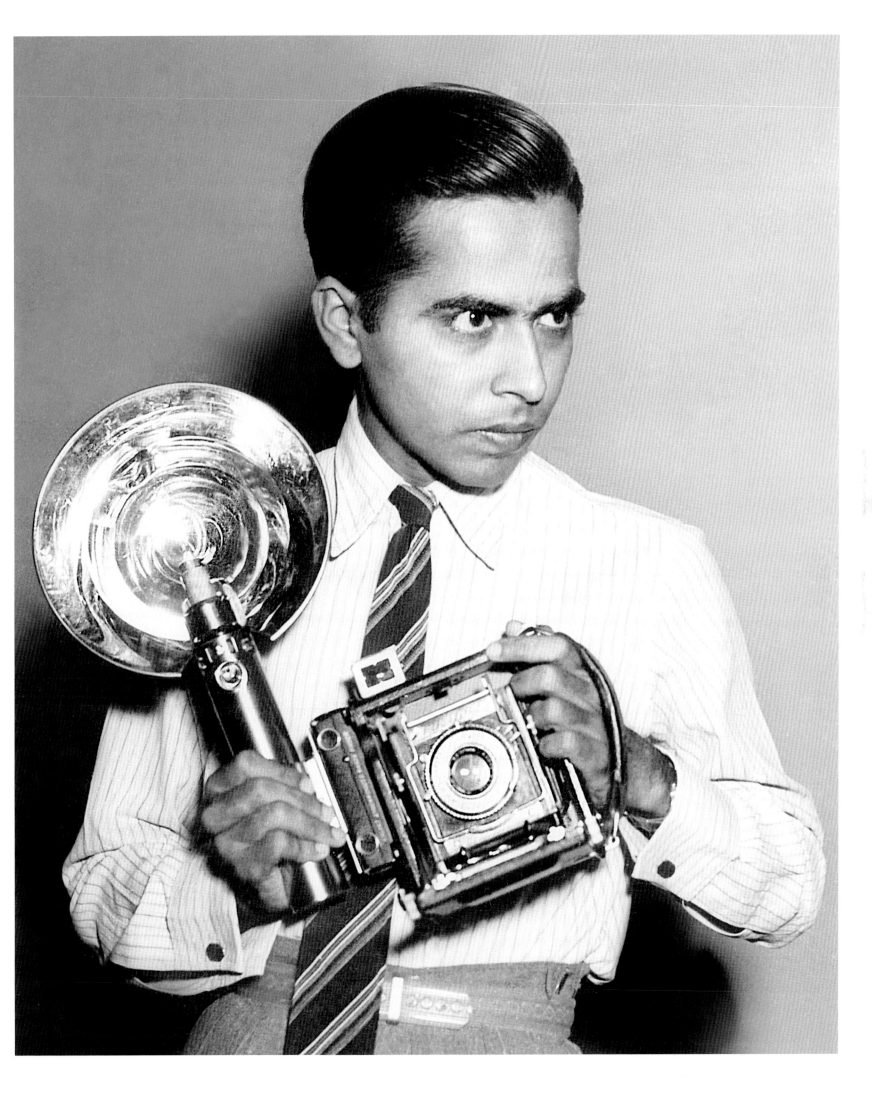

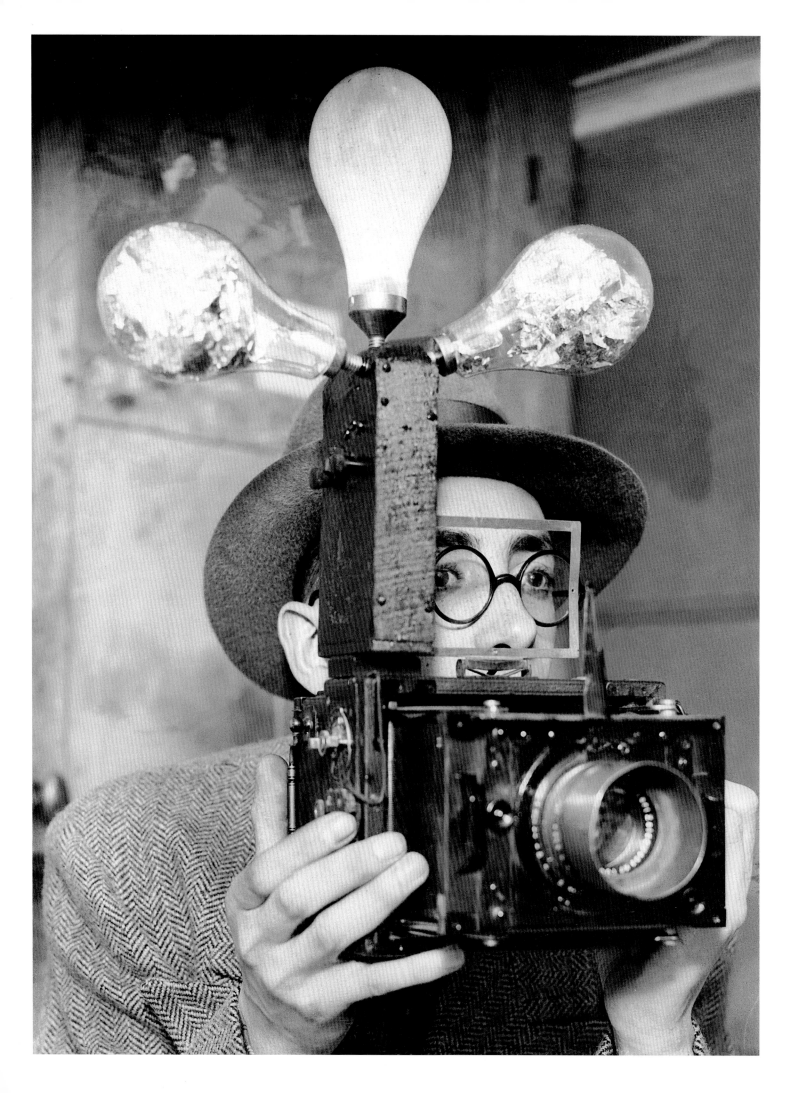

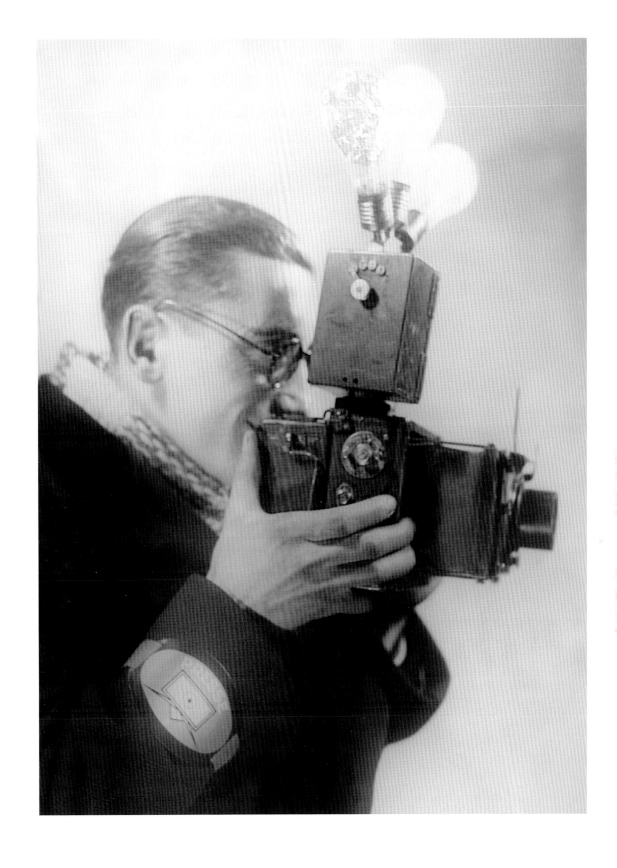

Opposite: Press camera fitted with a home-made three-bulb flash gun, 1931. All photographers – especially press photographers – have traditionally adapted their cameras for their own needs. Having three flash bulbs allowed the photographer to shoot three plates quickly or, if all three bulbs were fired at once, to photograph subjects further from the camera. *Above:* Press photographer, Paris, 1 November 1934. This press photographer shows off a special press badge on his cuff. It was created by the Paris Prefecture of Police for reporters and press photographers in a forerunner of today's press card.

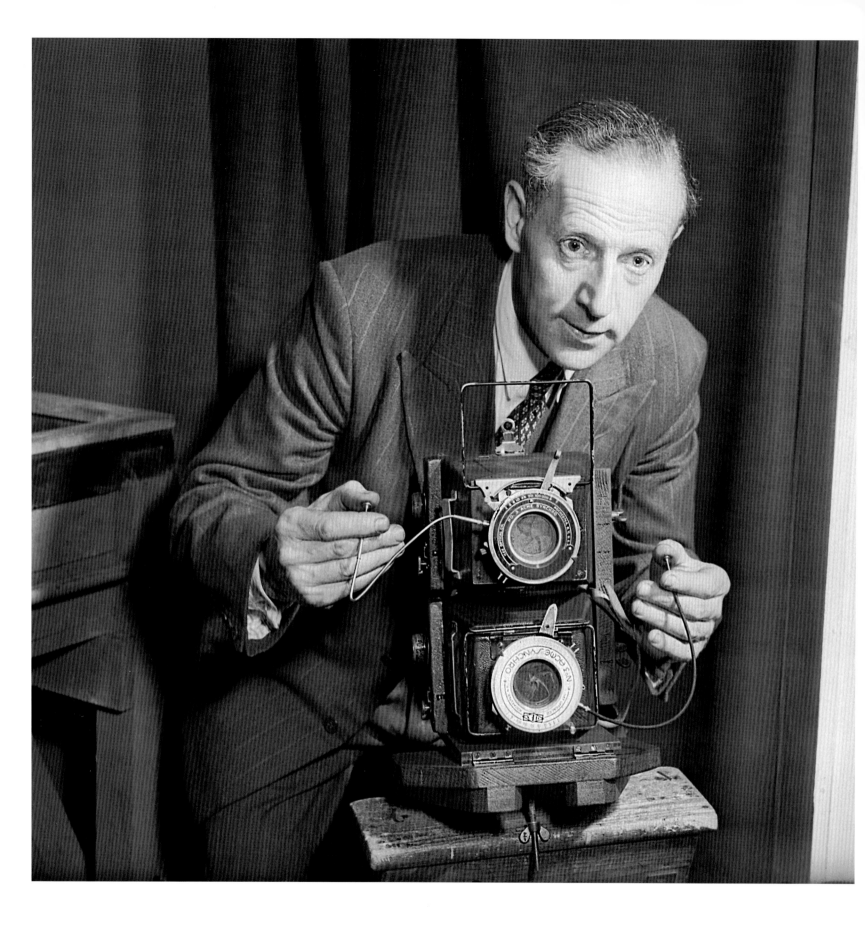

Above: **Norman Vigars** (1919-2010). Fox Photos photographer Reg Speller with a double camera for use at the Coronation of Queen Elizabeth II, 29 May 1953. *Opposite:* Press photographer with a Speed Graphic camera, c.1950. The photographer has designed a special support for five flash units, each with its own battery and synchronised to his camera.

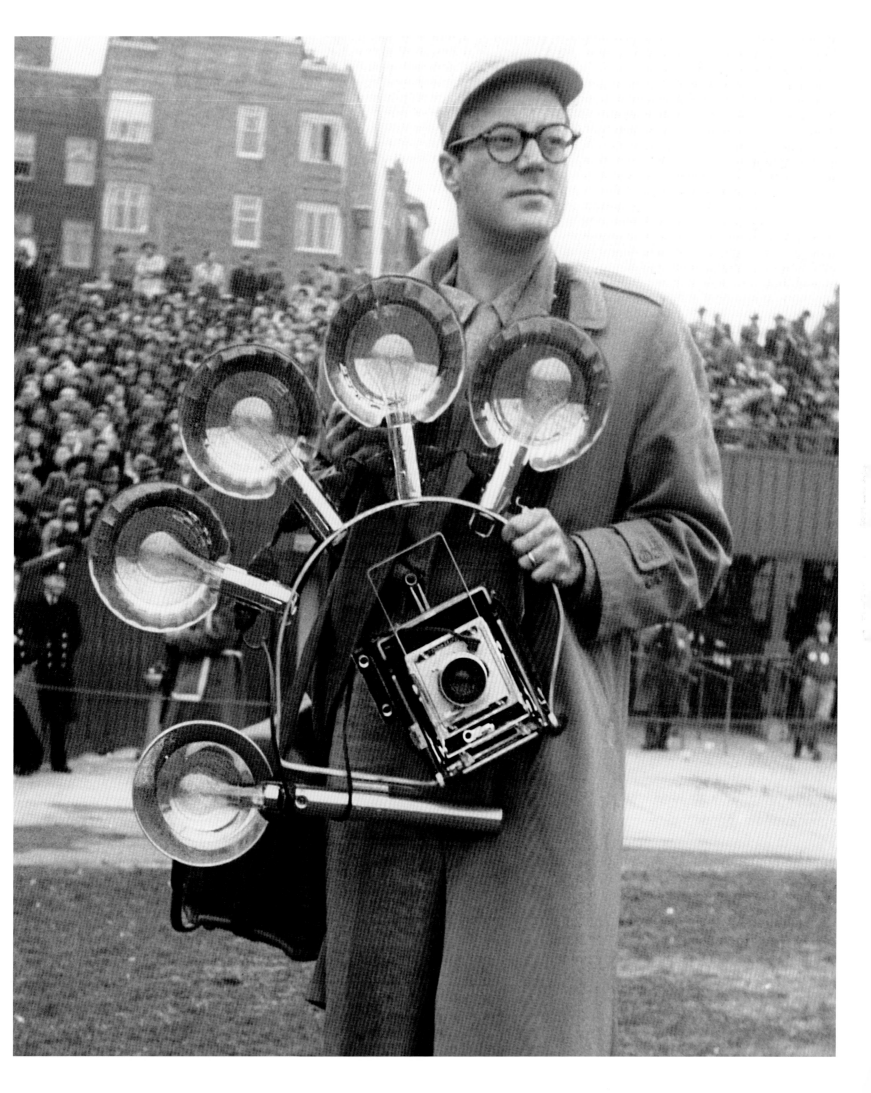

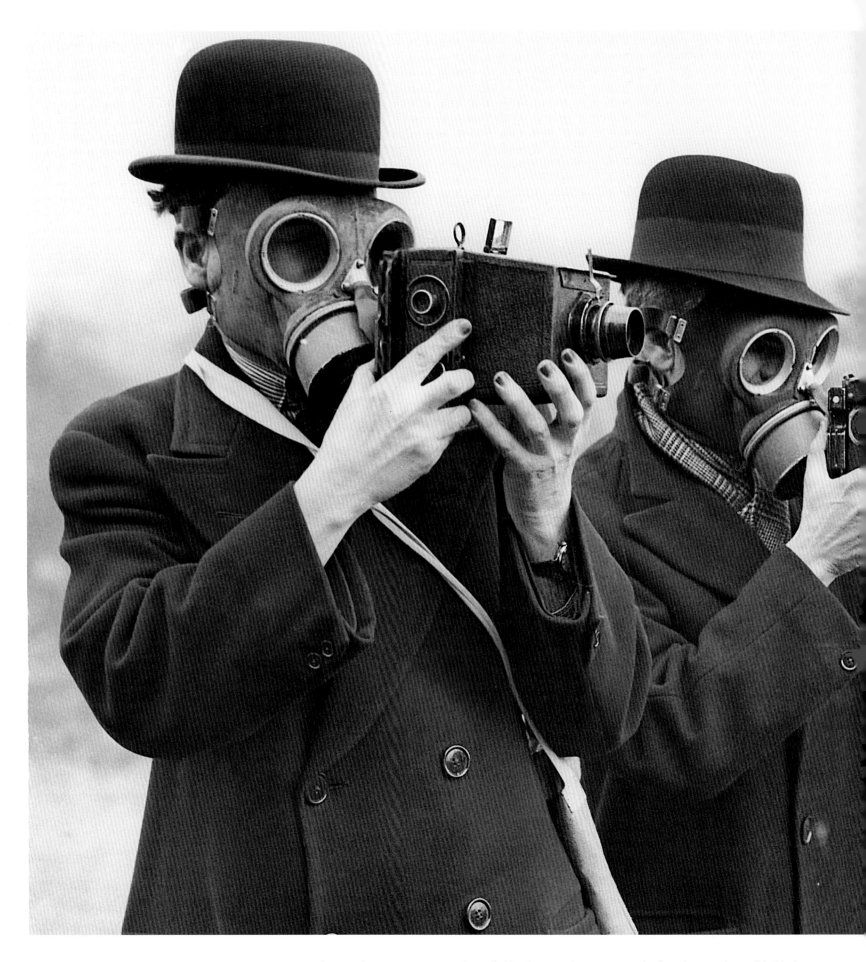

Press photographers wearing gas masks, Falfield, Gloucestershire, c.1935. The five photographers all hold plate press cameras. The two cameras nearest the photographer have been adapted with rigid sides to make them less susceptible to damage. The central camera has the more usual bellows that allowed the camera to fold compactly.

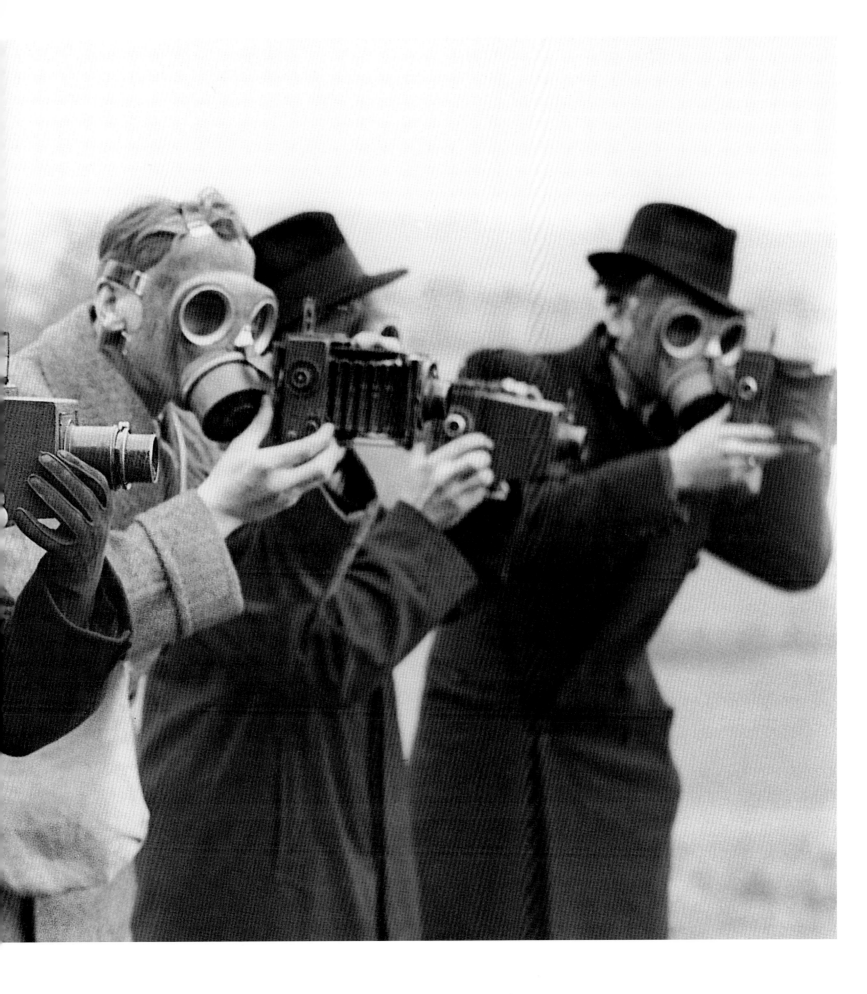

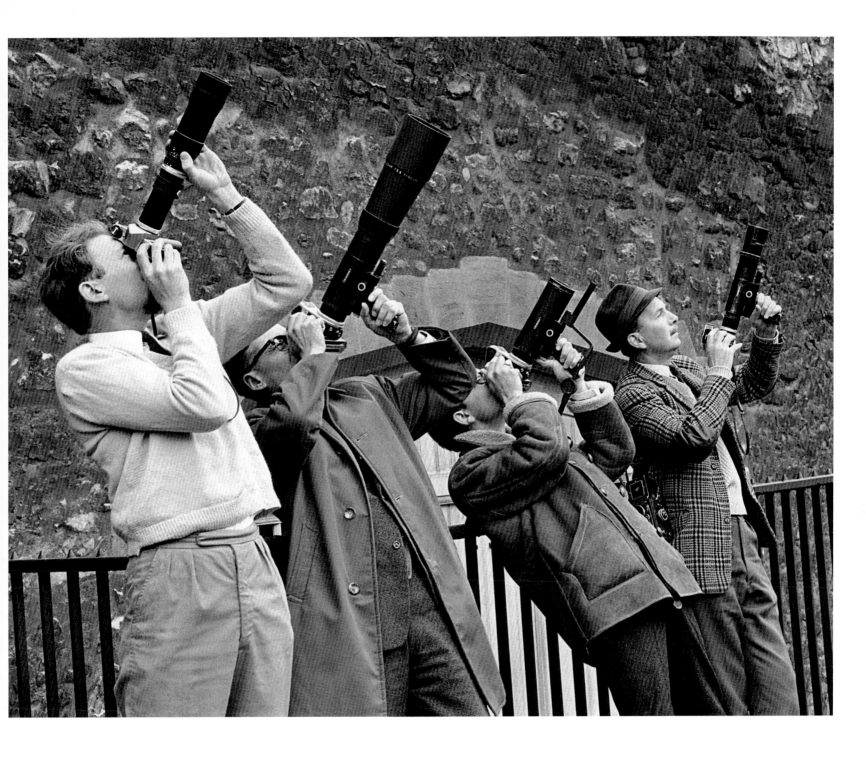

Opposite: A photographer with his Pentax camera at the Olympic Games, Rome, 1960. The Asahi Pentax single lens reflex camera carries a long focal length lens for capturing distant subjects. *Above:* **Roy Jones** (b.1941). Photographers aiming their cameras on the Victoria Tower, London, 12 May 1966. Jones started his career with the Central Press Photos Agency in Fleet Street, before joining London's *Evening Standard* as a news photographer between 1965 and 1995 when he retired. The three photographers furthest from the camera are using Novoflex lenses with their characteristic hand-grips.

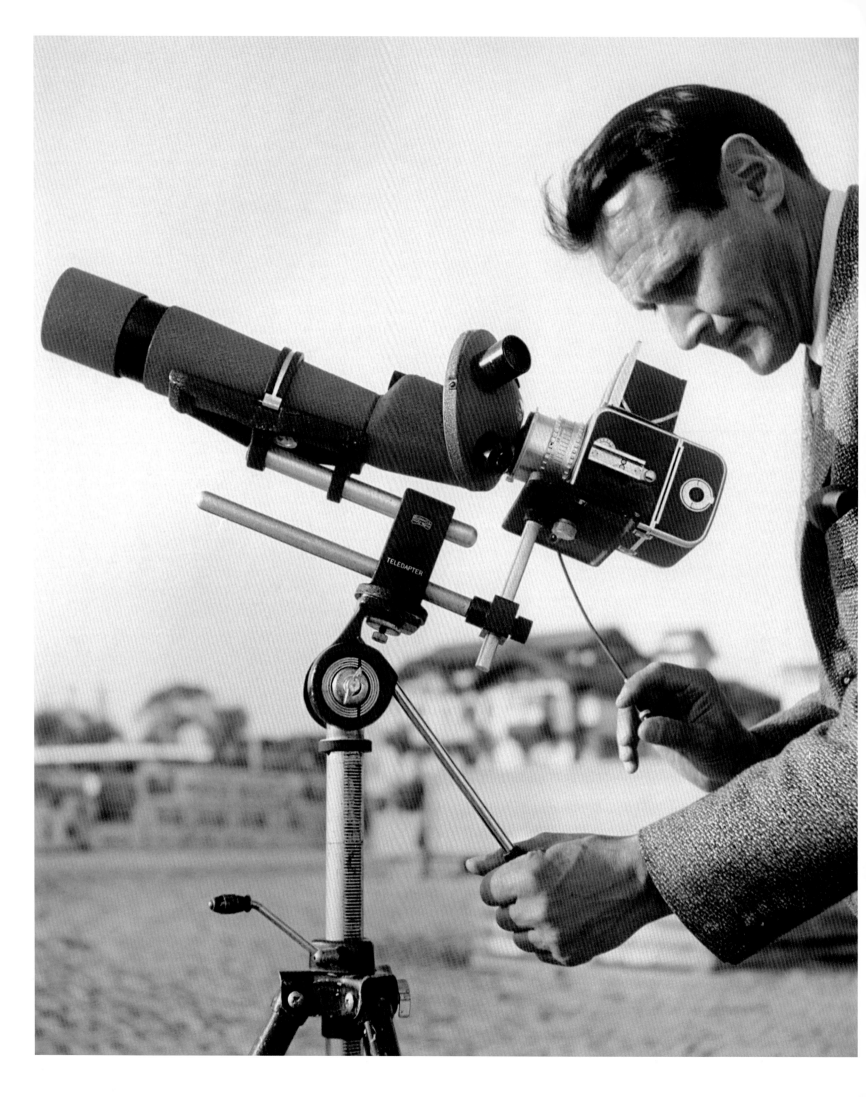

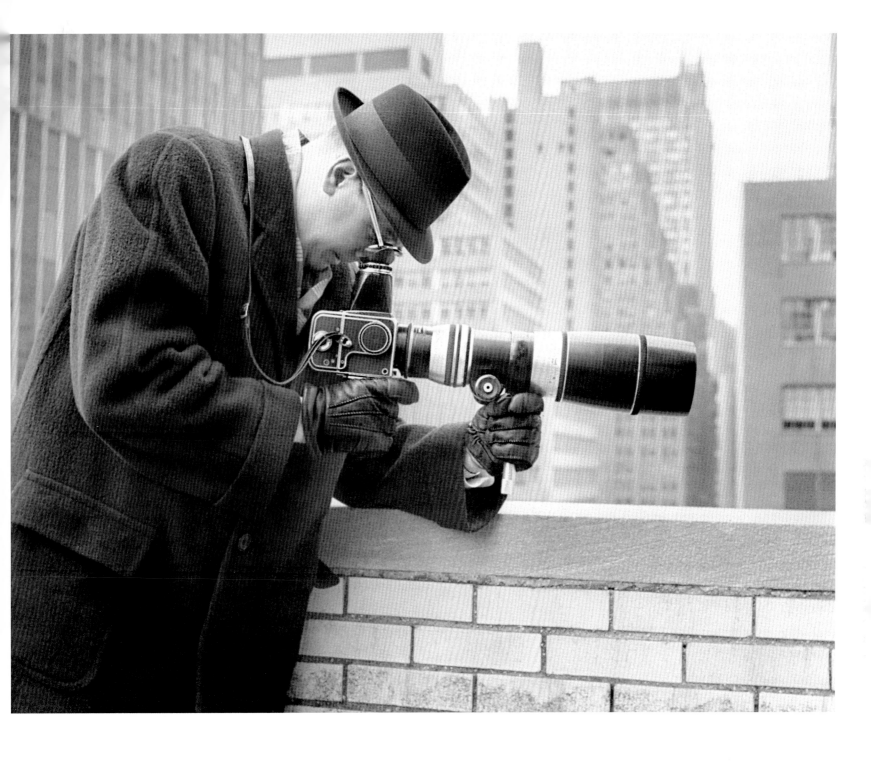

Opposite: **Ralph Crane** (1913-1988). Self-portrait with camera, 1958. Crane was a *Life* photographer. He is shown using a Hasselblad camera with a Bushnell Spacemaster scope mounted on to his camera to take distant subjects. *Above:* **Fred Morgan** (c.1917-2002). *Daily News* photographer Frank Hurley on the parapet at the News Building, 16 February 1962. Hurley is shown using a Hasselblad camera with a 400mm lens. Both Morgan and Hurley worked for the New York *Daily News* as staff photographers.

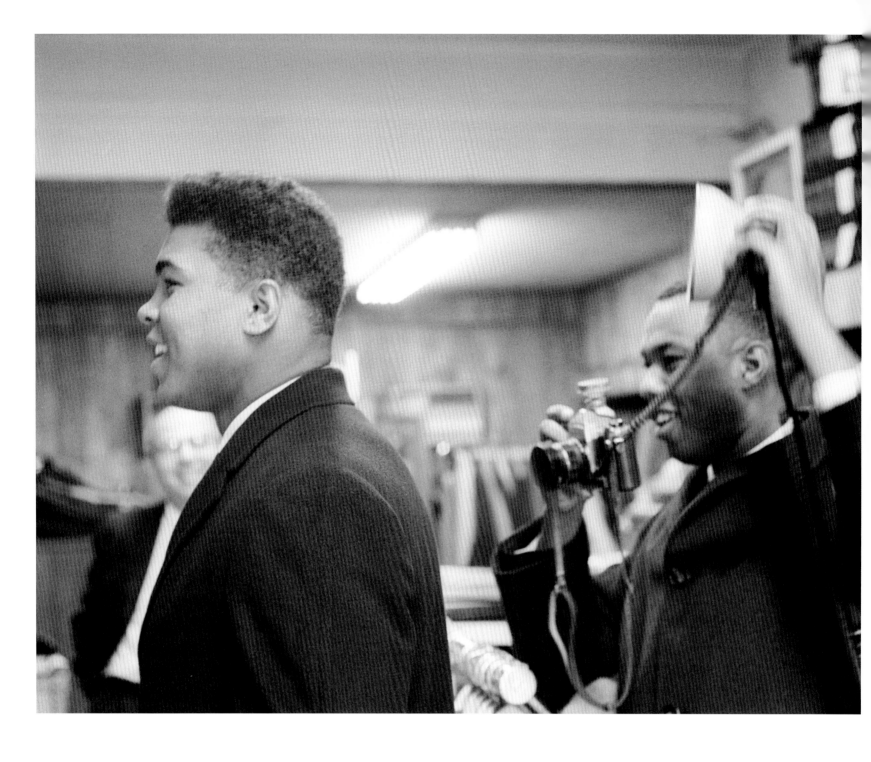

Above: **James Drake** (dates unknown). Howard Bingham takes a photograph of boxer Cassius Clay [Muhammad Ali], February 1963. After initially failing a photography course in 1958, Bingham (b.1939) was hired by the *Los Angeles Sentinel*, one of America's largest black newspapers, and met Cassius Clay. The two built up a close relationship and later Bingham created the definitive book of photographs of the world's greatest boxer, *Muhammad Ali: A Thirty-Year Journey*. Bingham is using a Pentax camera. *Opposite:* **Robert Abbott Sengstacke** (b.1943). Bill 'Fundy' Abernathy holding his camera during Martin Luther King Jr's funeral, Memphis, 9 April 1968. Abernathy holds a Leica M3 camera.

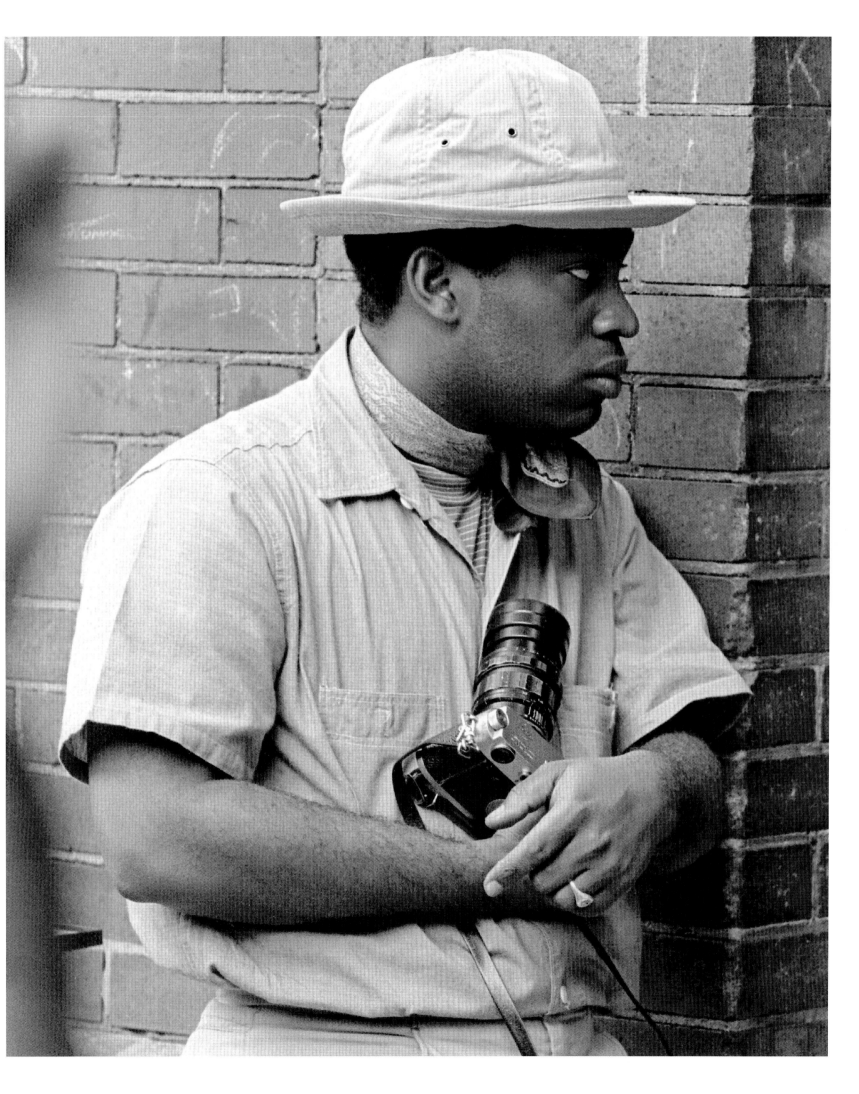

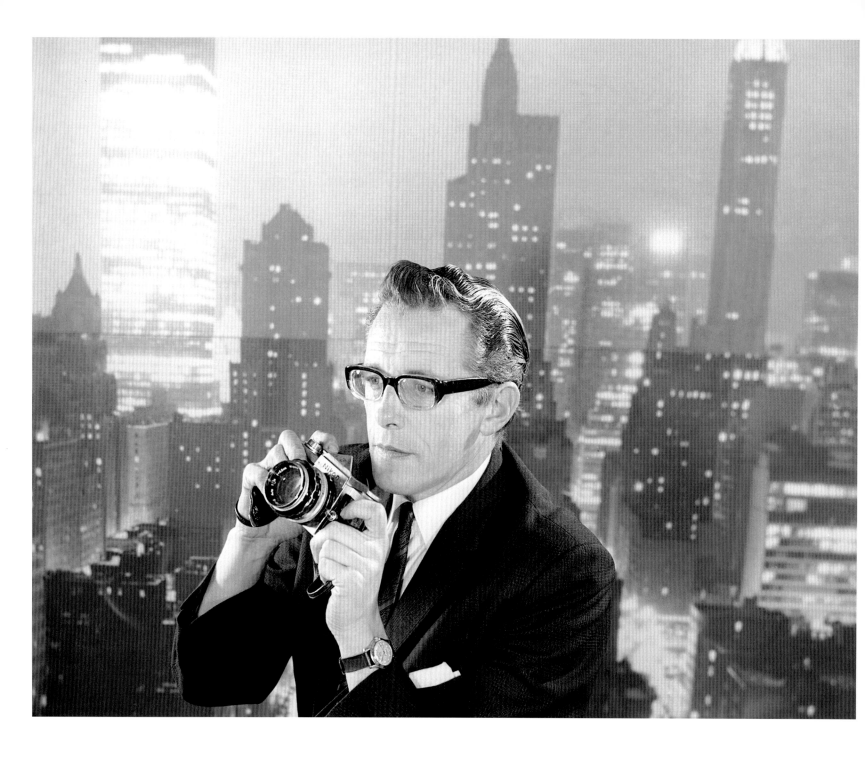

Above: **Larry Ellis** (b.1931). Victor Blackman, a photographer for the *Daily Express*, takes a photograph against a backdrop of skyscrapers, 25 November 1966. Blackman (c.1917-2009) is holding a Nikon F camera. Ellis and Blackman both worked for the *Daily Express*. Blackman published two autobiographical books and wrote a long series of columns about photography for *Amateur Photographer* magazine. *Opposite:* **Brian Wharton** (b.1939). *Daily Express* photographer Mike McKeown, 18 January 1963. McKeown holds a 35mm Canon rangefinder camera in his hand with a trigger-driven rapid winder. Wharton became a well-known photographer for *The Sunday Times* newspaper after initially working for the *Daily Express*.

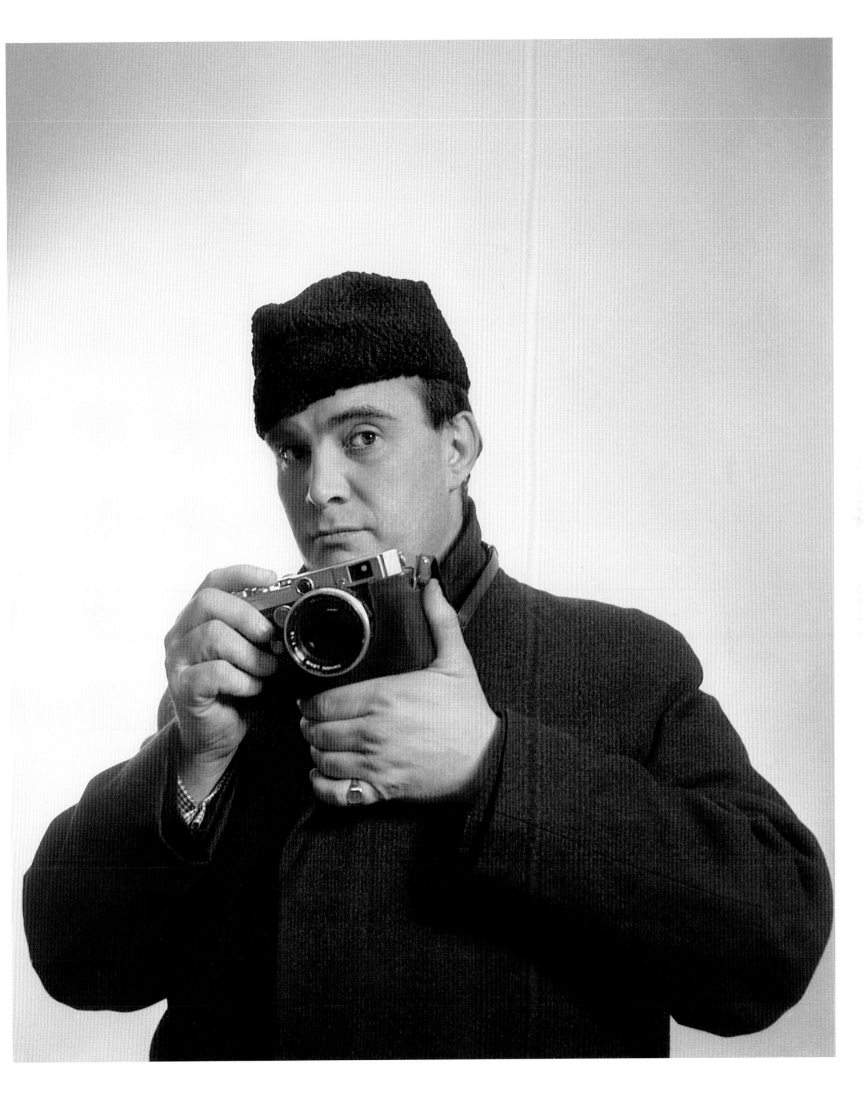

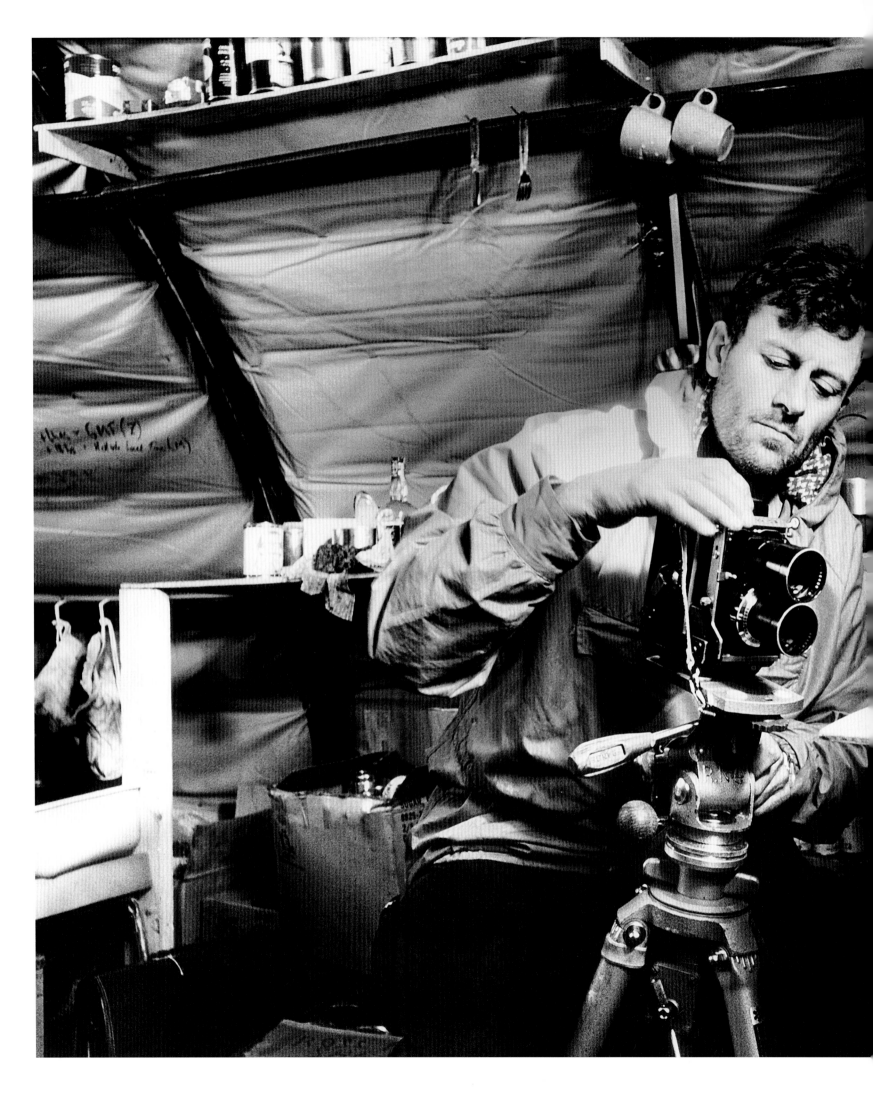

Life photographer Mike Rougier checking his camera, 16 December 1964. The photograph shows Rougier (1926-2012) in a tent on assignment in the Antarctic. He is using a Mamiya C3 twin lens reflex camera. Unlike the more popular Rolleiflex, the Mamiya allowed the viewing and taking lenses to be changed.

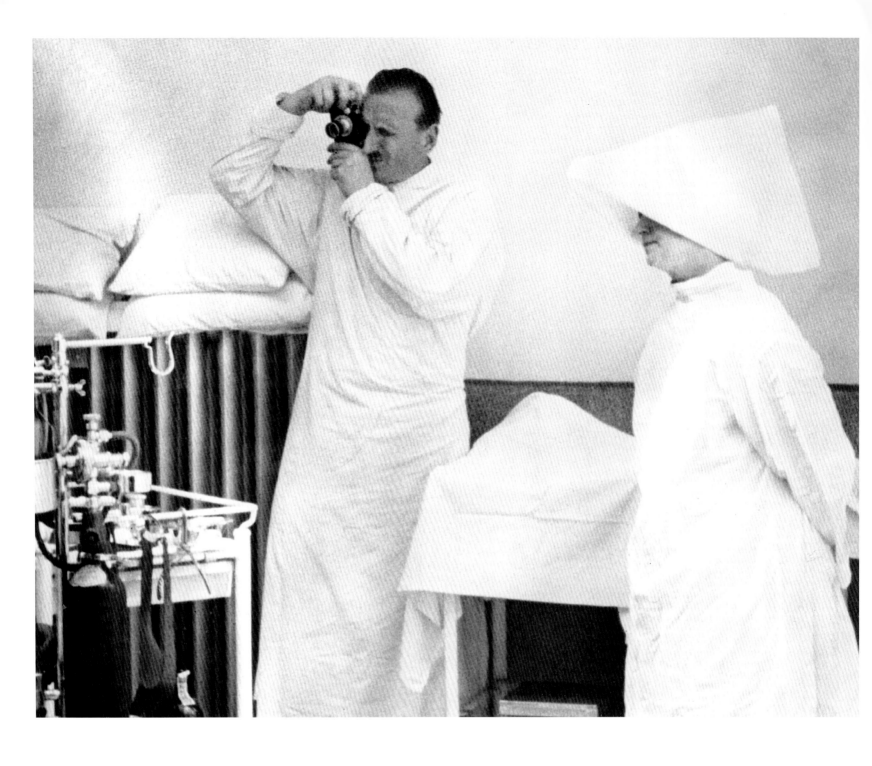

Above: Felix H. Man from *Picture Post* taking pictures in an operating theatre in a London hospital, 1 October 1938. Man (1893-1985) was active as a photojournalist from 1929. He moved to London in 1934 and became chief photographer for *Picture Post* between 1938 and 1945. He is shown holding a Leica camera. *Opposite:* Photographer Vagn Hansen pictured in a mirror with the cameras he used to record a trial heart operation performed by Danish surgeon Professor Erik Husfeldt, 1960. Hansen holds an Asahi Pentax camera with two Leica M series cameras hanging below.

Above: **Bernard Hoffmann** (1913-1979). Portrait of Carl Mydans, 1937. Mydans joined *Life* magazine in 1936 and was one of its earliest photographers. He has a Contax II camera in his hand fitted with a wide aperture lens and turret viewfinder. *Opposite:* **Alfred Eisenstaedt** (1898-1995). Carl Mydans covers Nikita Khrushchev's visit to New York, September 1959. *Life* photographer Mydans (1907-2004) carries two Leica M3 cameras each fitted with a Canon lens and supplementary viewfinder. A third camera is just visible in his left hand.

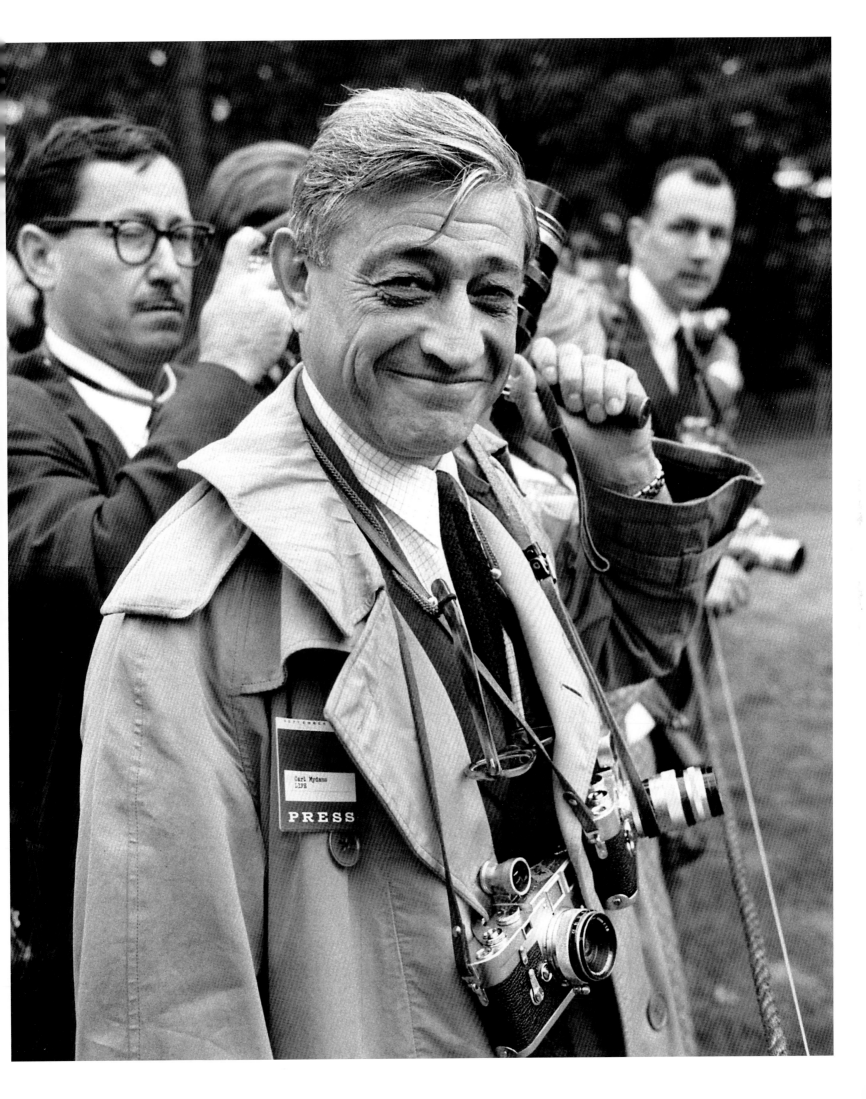

Above: **Bert Hardy** (1913-1995). Bert Hardy in Southend, Essex, 1954. Hardy worked for *Picture Post* magazine between 1941 and 1957. He is shown here with his Contax II camera on to which has been mounted a Cinemascope anamorphic lens. His picture story was published in *Picture Post* in August 1954. *Opposite:* Bert Hardy on assignment, 1941. Hardy (1913-1995) was a self-taught photographer and went on to become the *Picture Post*'s chief photographer, producing a number of its most well-known picture stories. He earned his first photographer credit for his 1 February 1941 photo-essay about Blitz-stressed firefighters, where this photograph was taken. He is using a Contax II camera.

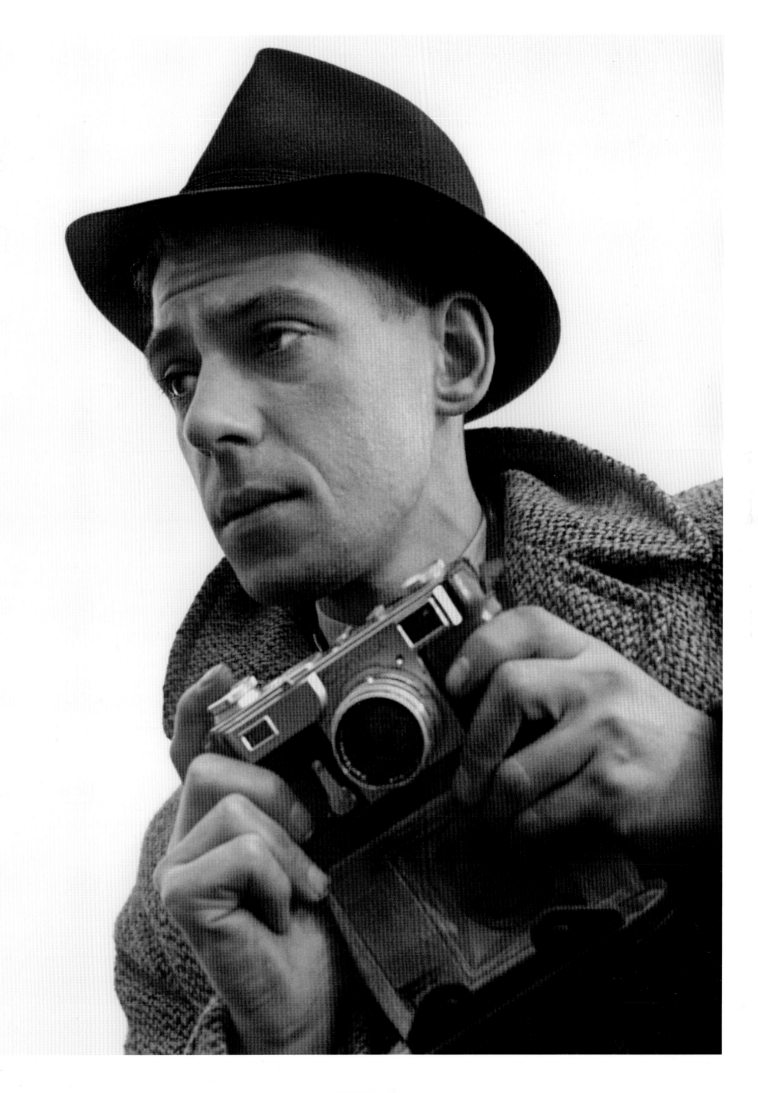

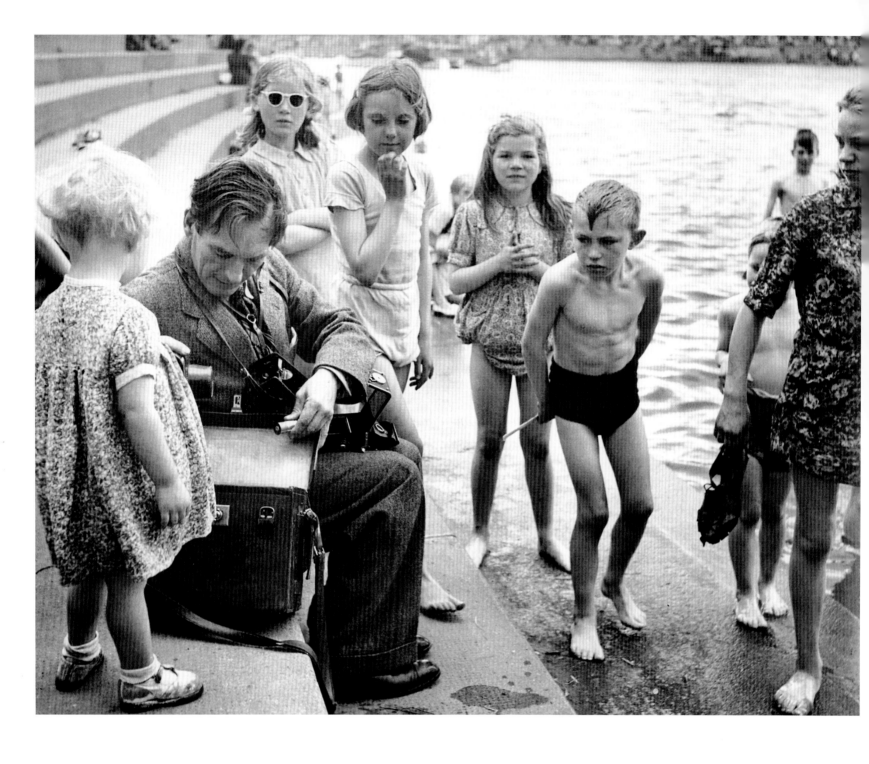

Above: Haywood Magee on assignment for *Picture Post*, c.1955. Magee is shown changing films on his Rolleiflex twin lens reflex camera. The photograph was published in *Picture Post*'s last issue dated 1 June 1957. *Opposite:* **Thurston Hopkins** (b.1913). *Picture Post* photographer Charles Hewitt working with Irene Mayo, fashion editor, 1 May 1954. Charles Hewitt (1915-1987) is shown with his Rolleiflex camera. He was working on a fashion feature on bathing hats for the magazine's 'Personality Girl' for May 1954. Mayo was a model before joining the magazine.

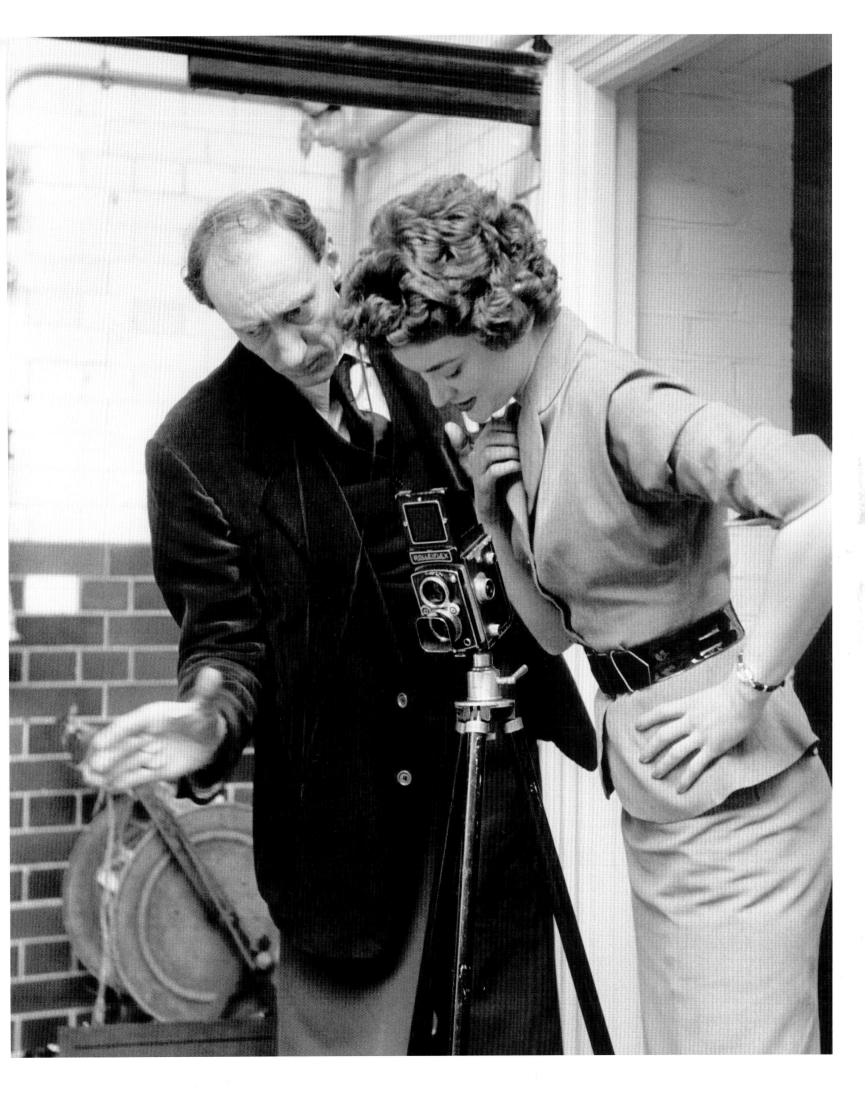

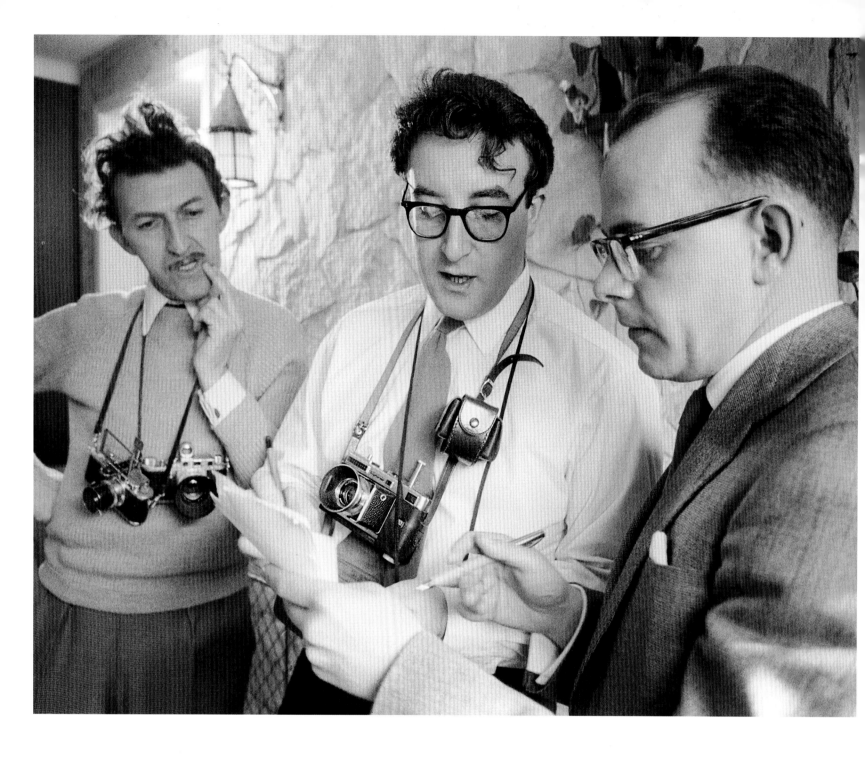

Above: **John Chillingworth** (b.1928). Peter Sellers at his London home with *Picture Post* journalist Bob Muller and photographer Thurston Hopkins, 17 April 1956. Sellers (1925-1980) enjoyed photography and making home movies. He is carrying a Voigtländer Vitessa T camera. Hopkins (b.1913) carries two Leica cameras. *Opposite:* **Daniel Farson** (1927-1997). *Picture Post* photographer John Chillingworth at work on a beach, August 1952. Chillingworth (b.1928) joined *Picture Post* during the Second World War. He is using Contax and Rolleiflex cameras.

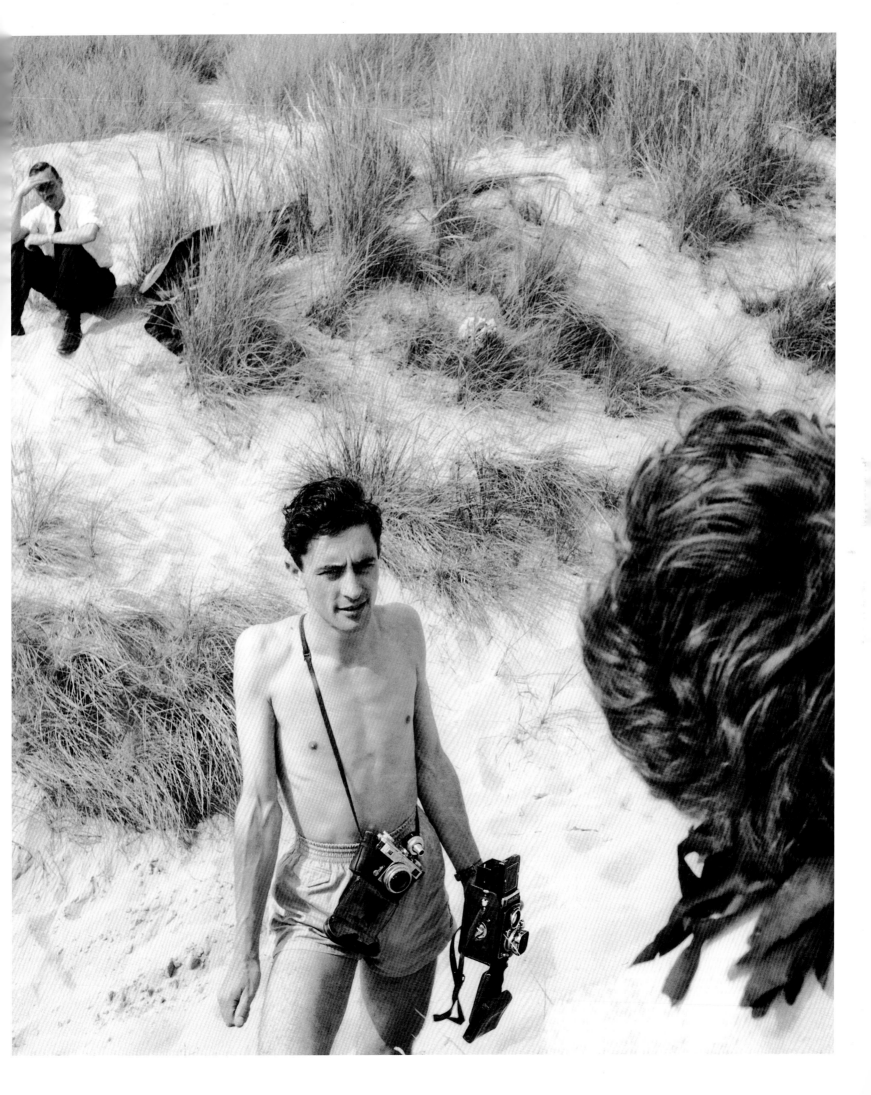

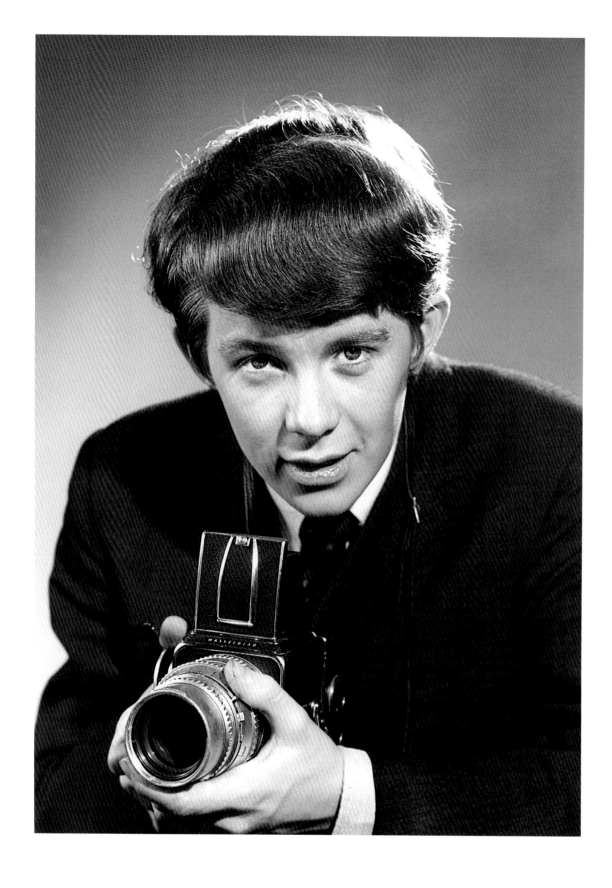

Above: Photographer Tim Graham with his Hasselblad camera, 8 December 1969. Graham (b.1948) was well known for his photographs of royalty and celebrity portraits. *Opposite:* Actor Terence Stamp prepares to take a photograph in a still from William Wyler's film, *The Collector*, 1965. Stamp (b.1938) holds a Hasselblad camera with a flash gun attached.

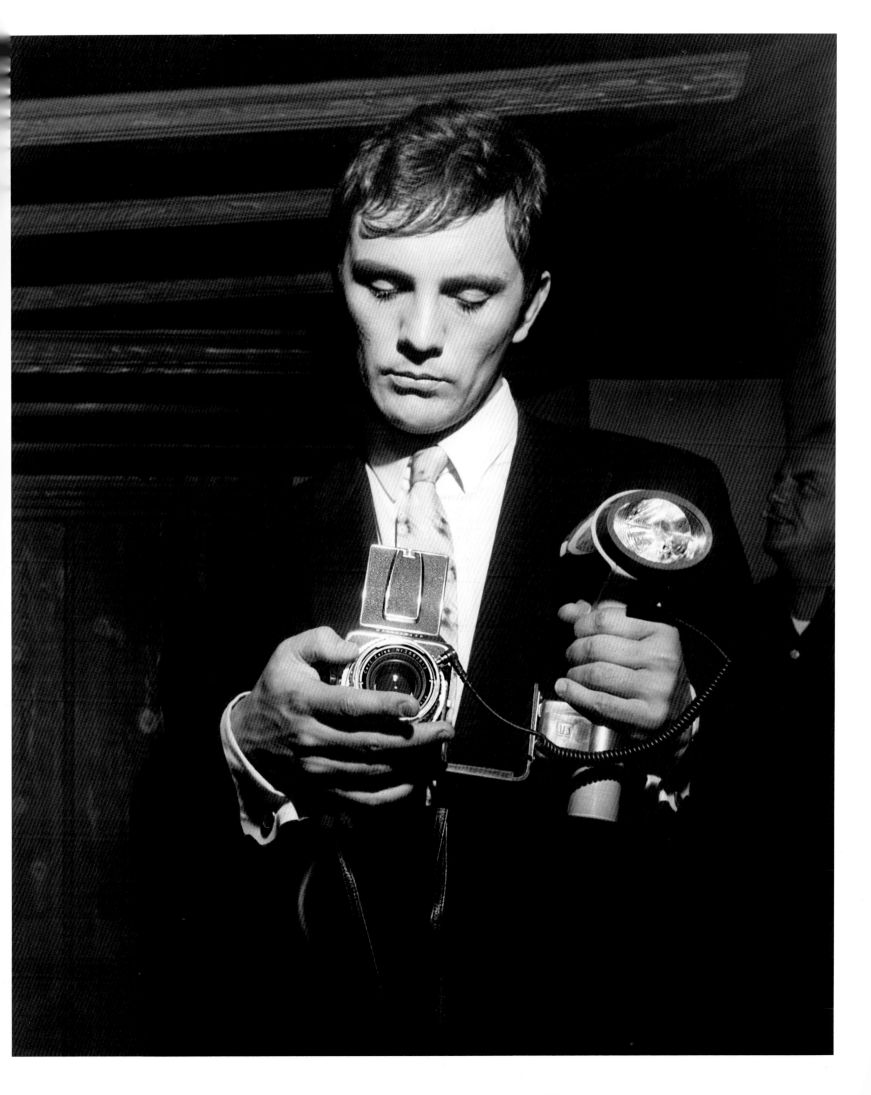

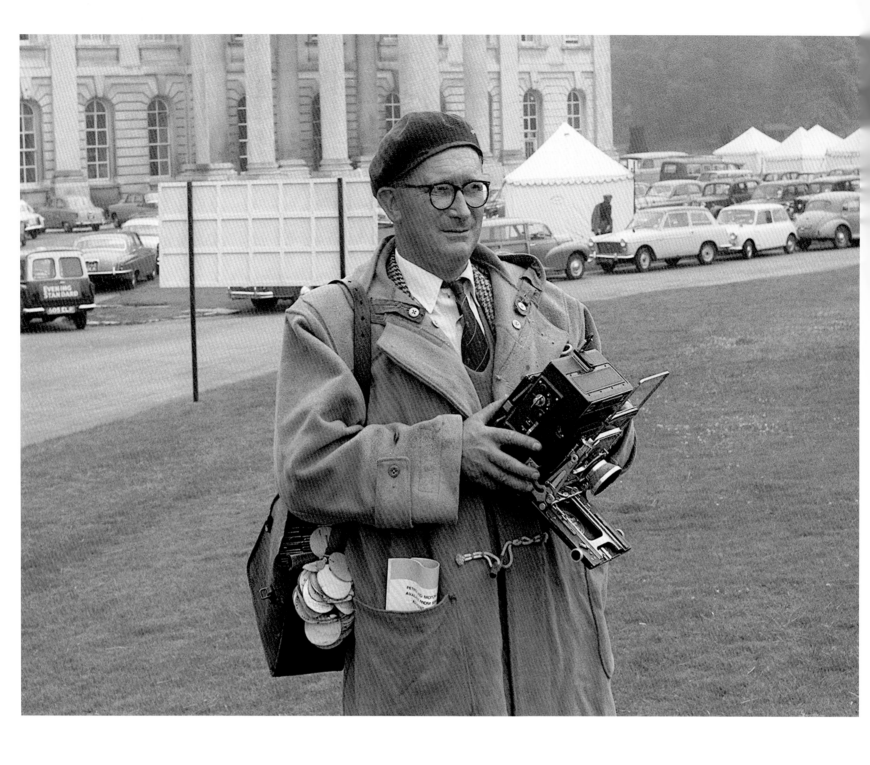

Above: British sports photographer Bert Neale at the Esso golf tournament, Moor Park, 1962. Neale is carrying a 5 x 4 inch MPP Technical camera. *Opposite:* Photographer John Topham at work, c.1950. Topham (1908-1992) described himself as photographing 'the little things of life – the way it really was'. In this photograph he is shown with a Goerz Anschütz type press camera with case to carry the dark slides holding their glass plates.

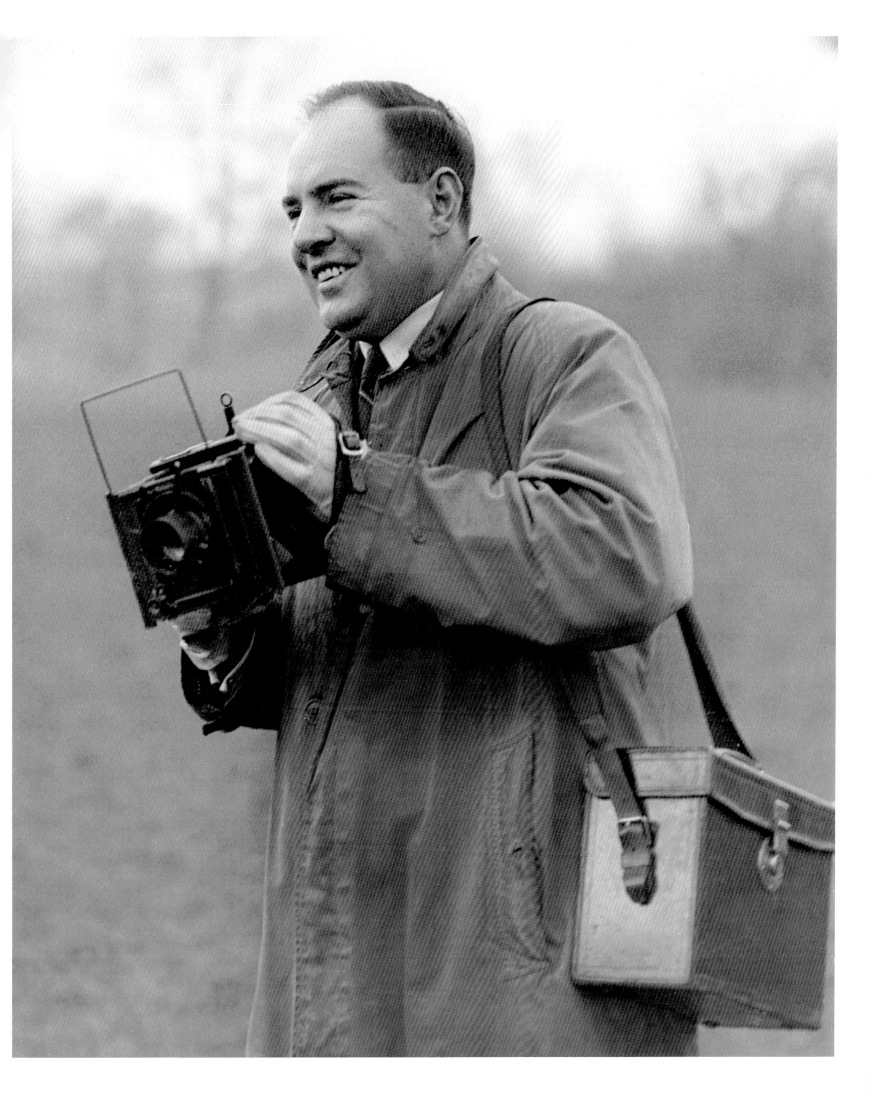

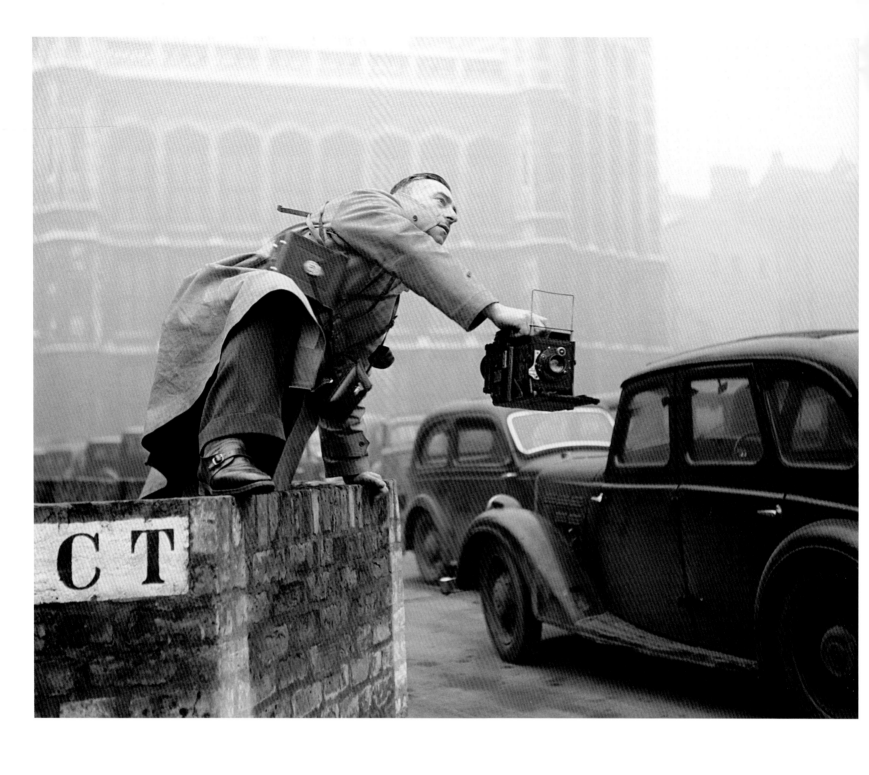

Keystone photographer Fred Ramage jumps a low wall into a fog-shrouded London street, 1946. Ramage (1900-1981) carries a Speed Graphic camera.

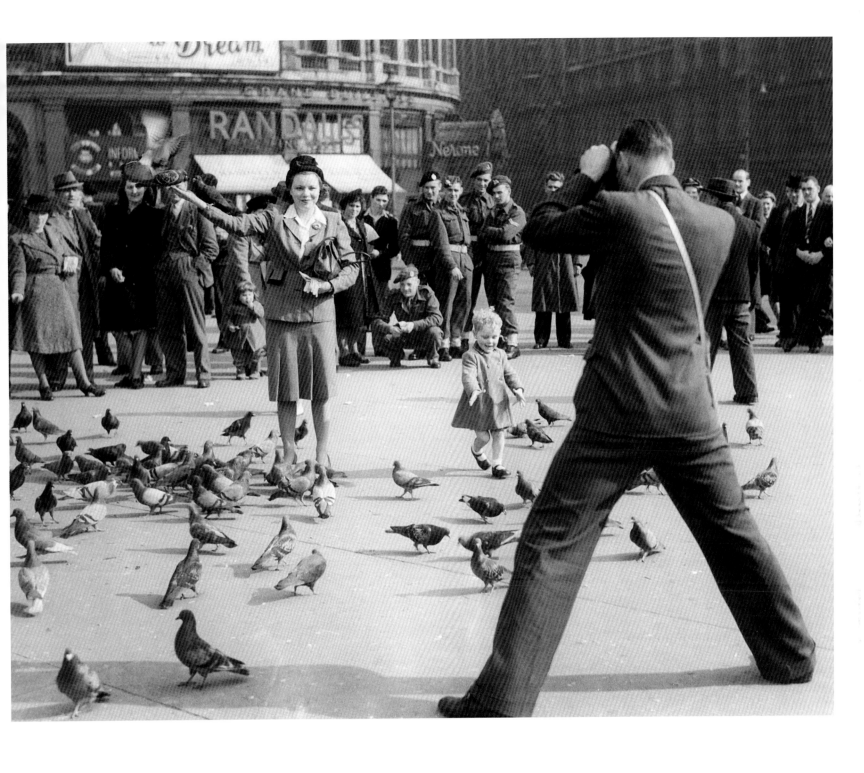

Francis Reiss (b.1927). Street photographer at work in Trafalgar Square, London, 27 March 1946. The photographer shoots the woman, hoping to sell the picture later. Reiss was a *Picture Post* photographer and this image appeared in the story, 'One Fine Day in Spring', published in 1946.

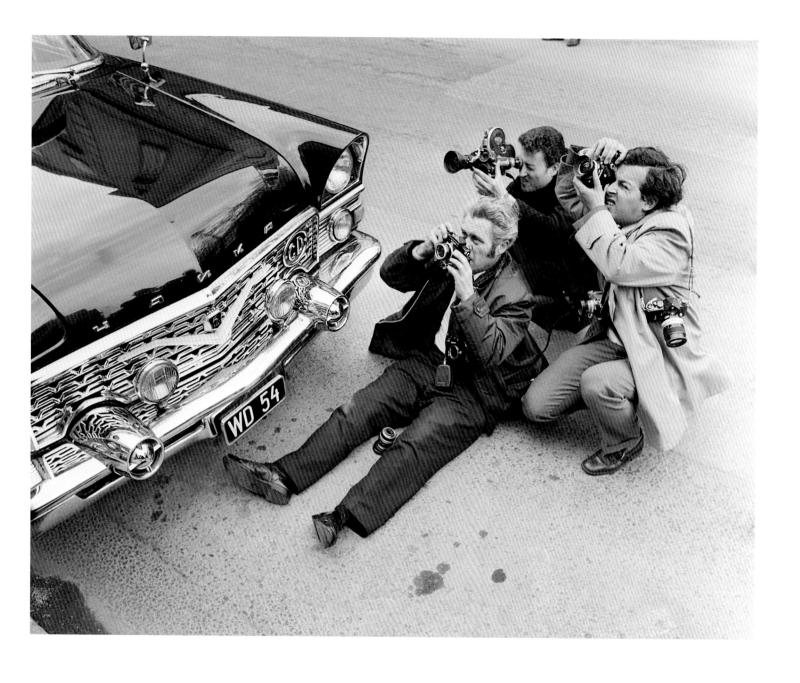

Above: Photographers in front of the American Embassy, Vienna, 1970. Two press photographers with their Nikon single lens reflex cameras are joined by a film cameraman during the Vienna SALT arms talks. *Opposite:* **Douglas Miller** (dates unknown). Press photographers take photographs of the Women's RAF small-bore shooting competition at RAF Uxbridge, 6 February 1969. The press photographers make use of 35mm and the medium-format Rolleiflex camera to secure their shots.

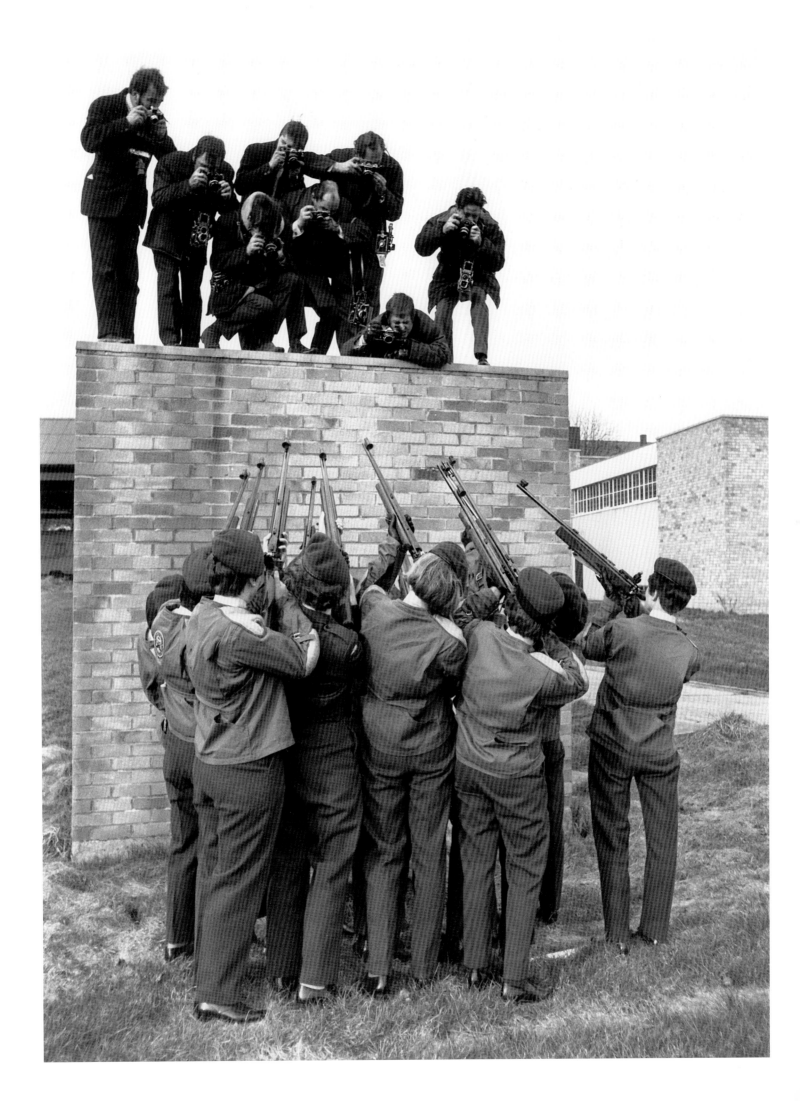

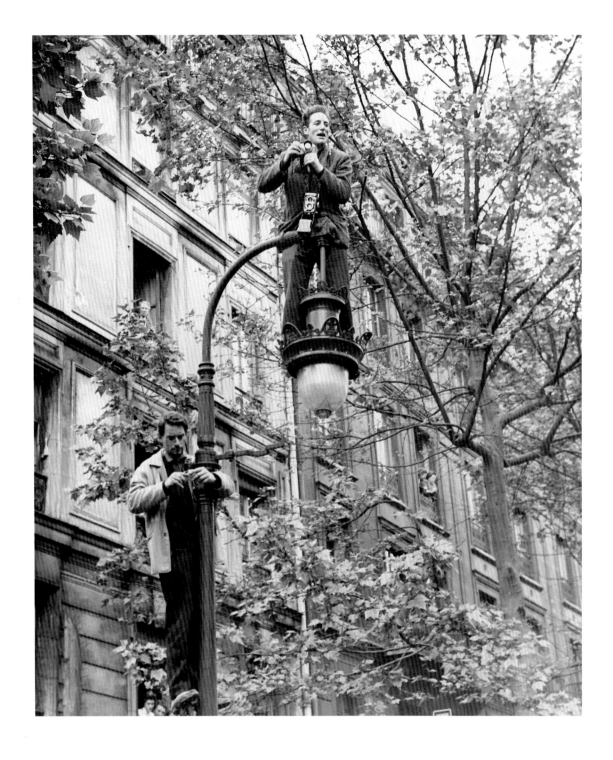

Above: Photographers during the demonstration for the protection of the Republic, Paris, 29 May 1958. The demonstration marked General de Gaulle's return to power in France. The photographers are using a lamp post to secure a high viewpoint over the demonstration. *Opposite:* **Harry Dempster** (1932-2000). A photographer standing on a road traffic bollard, 14 October 1962. Dempster was a staff photographer for the *Daily Express*. The photographer is using a Rolleiflex twin lens camera.

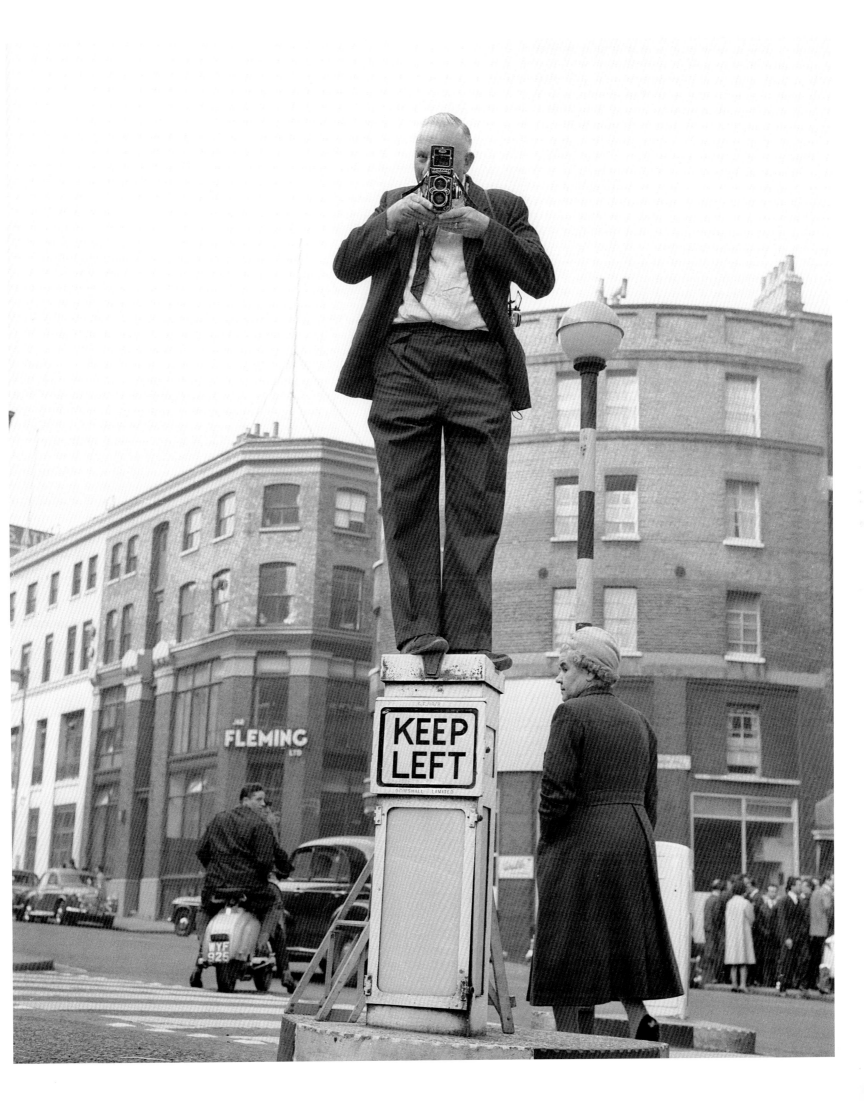

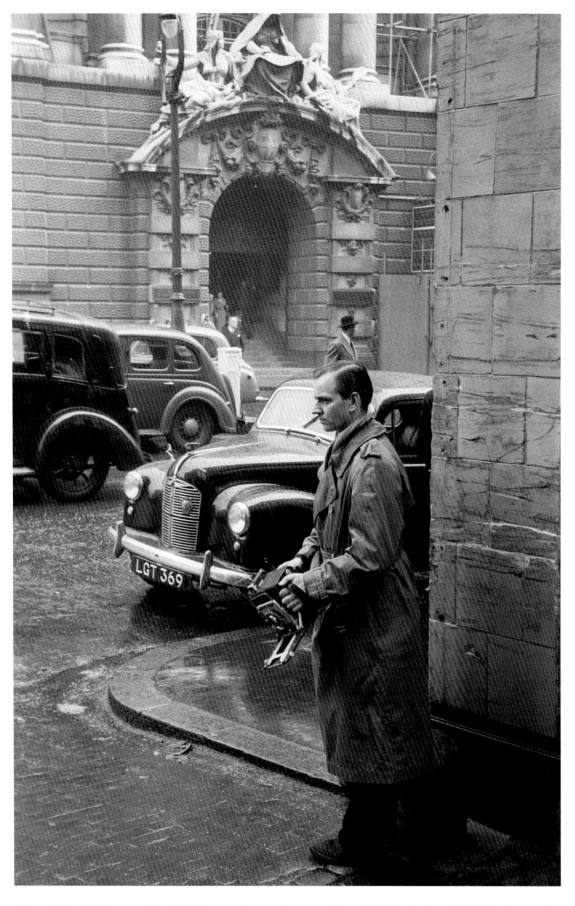

Above: **John Chillingworth** (b.1928). A press photographer outside the Old Bailey, London, 1953. The photographer holds a Micro Precision Products Technical camera. The MPP was widely used in the studio and by press photographers. It was a British version of the American Speed Graphic camera. Chillingworth shot this picture for a *Picture Post* photo story, 'The Pub that Overlooks Murder'. *Opposite:* **Walter Bellamy** (dates unknown). A photographer balancing on a ledge of a building while taking a photograph, 30 April 1947. Bellamy worked for the *Daily Express* newspaper. The photographer is holding a Rolleiflex twin lens reflex camera that had been pre-set and ready to capture a shot.

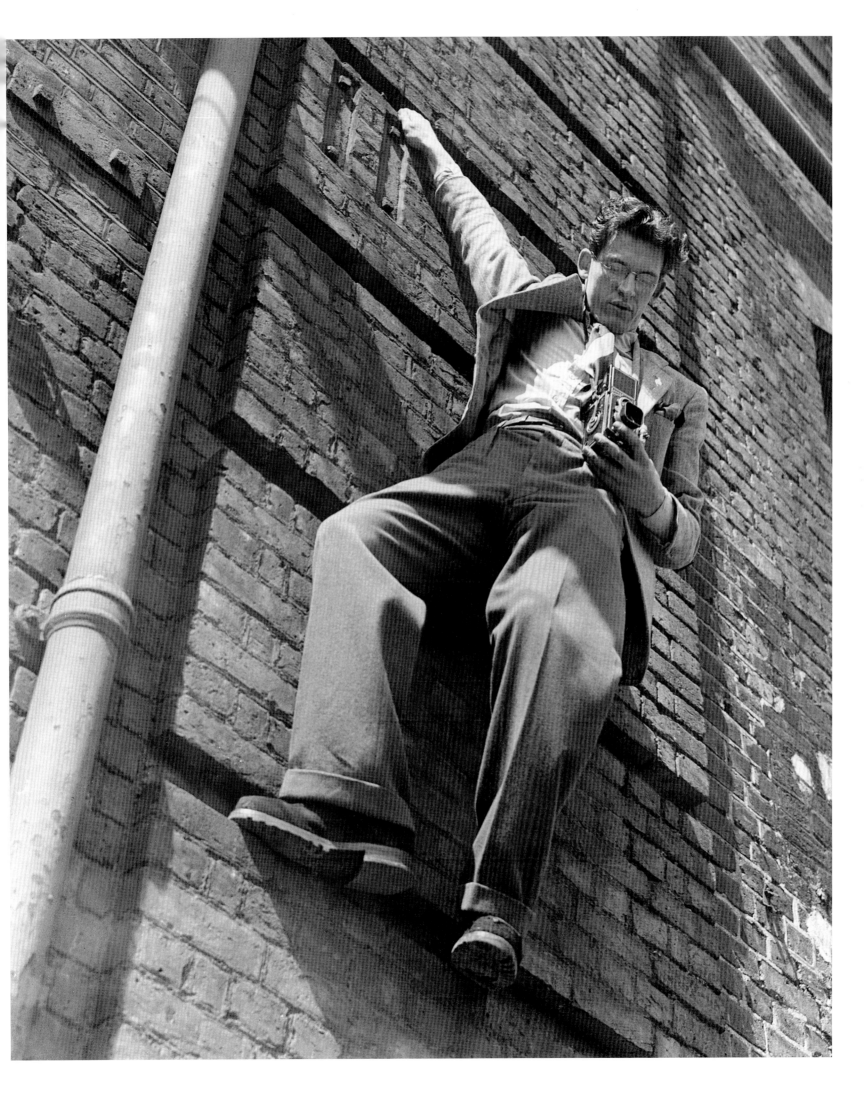

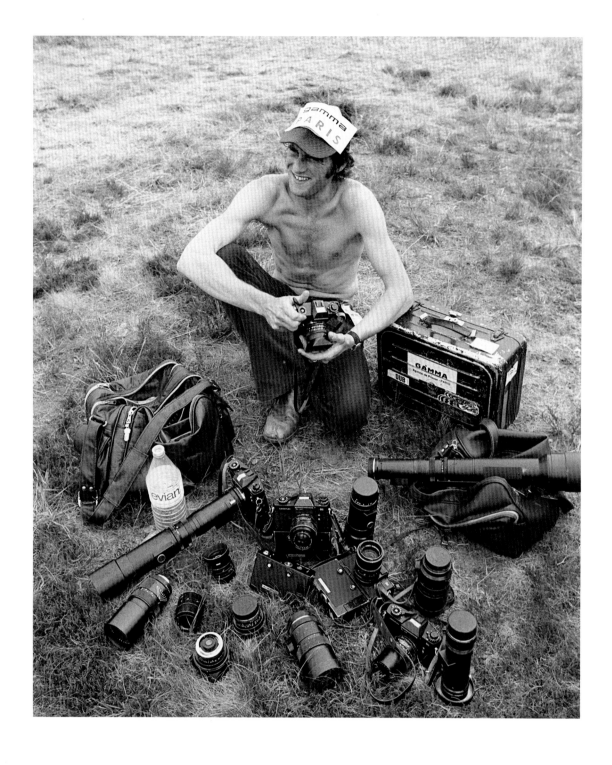

Above: **Michel Artault** (dates unknown). Matra wins 24 hours at Le Mans for the third time, 16 June 1974. Artault displays his black Leicaflex cameras with their motor drives, and a range of lenses. His case features the name of his agency – Gamma. *Opposite:* **John Iacono** (b.1941). Walter Iooss Jr on the sidelines during a USC vs Nebraska game at Memorial Stadium, Lincoln, Nebraska, 20 September 1969. Iooss (b.1943) was a photographer for *Sports Illustrated*. He is shown here using a Nikon F camera.

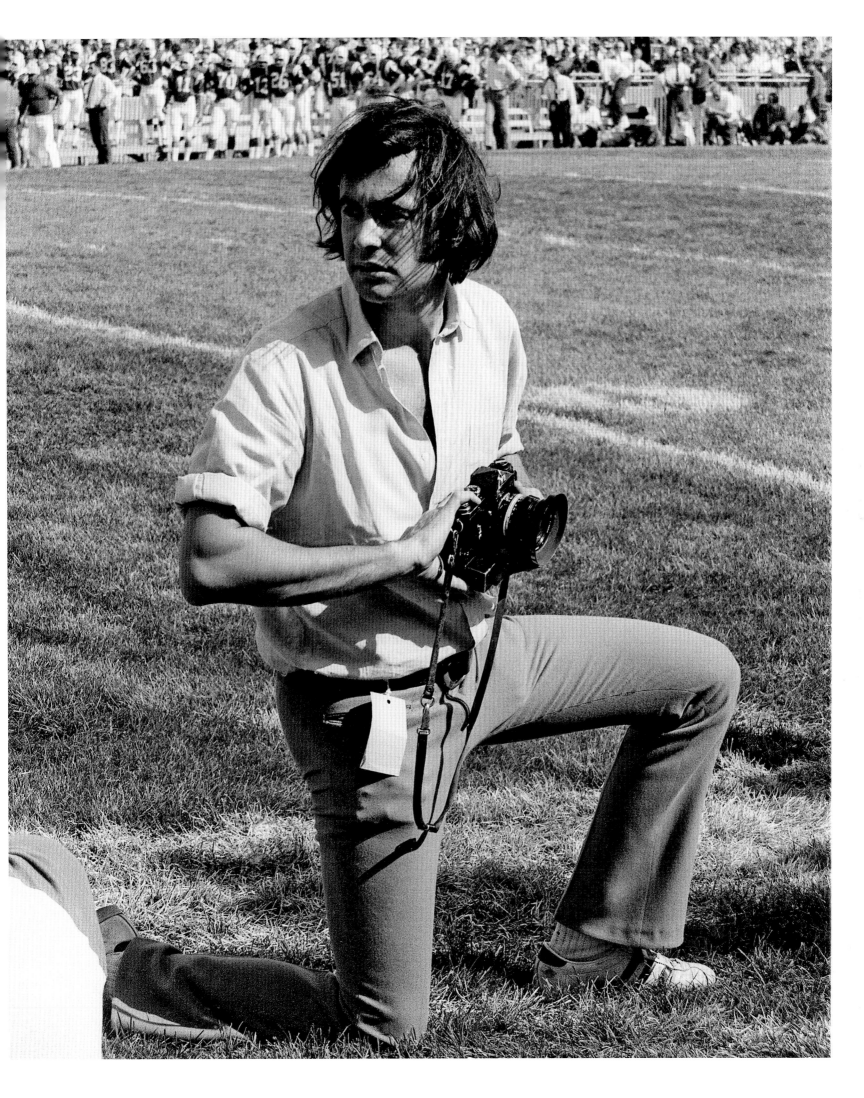

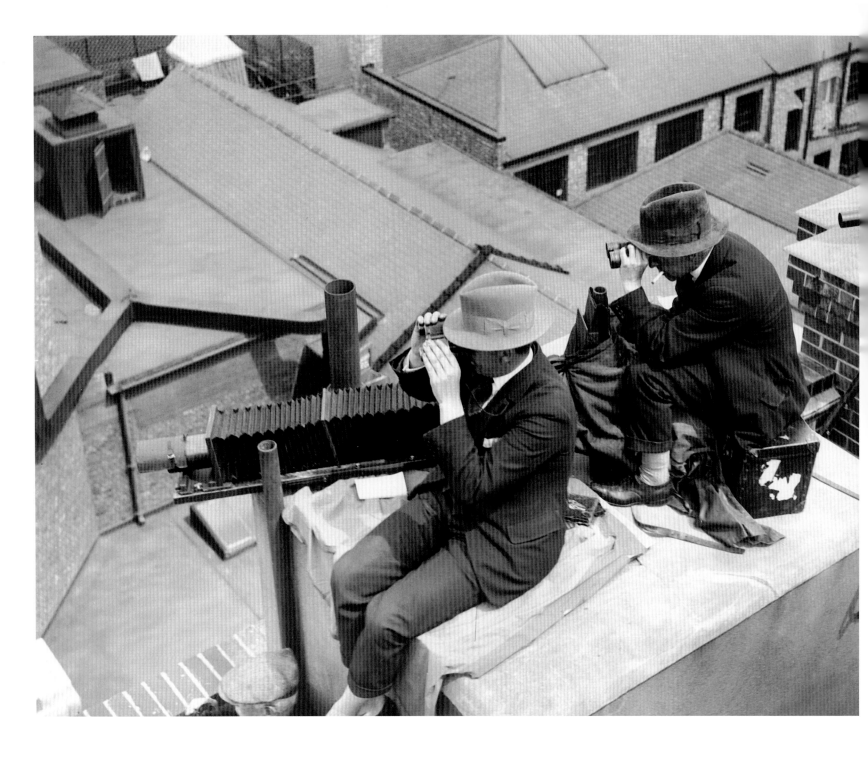

Above: **Kirby** (dates unknown). Press photographers at work on a rooftop, 28 June 1926. Both photographers are using binoculars to look out for their subject. The camera in the foreground has a large extension bellows so that a long-focus – or telephoto – lens can be used. *Opposite:* **Ernst Haas** (1921-1986). Photographers waiting for Queen Elizabeth II during her visit to New York, 1957. Compared to the pre-war period, photographers began to increasingly use smaller, more portable, 35mm and medium format cameras rather than large plate cameras.

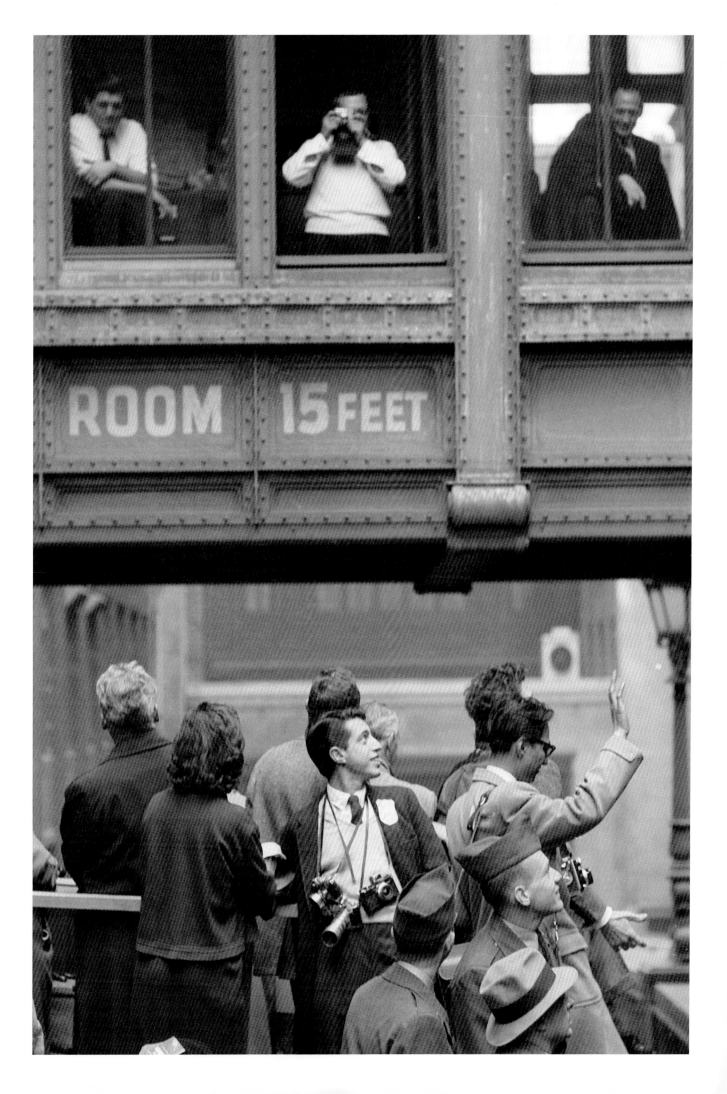

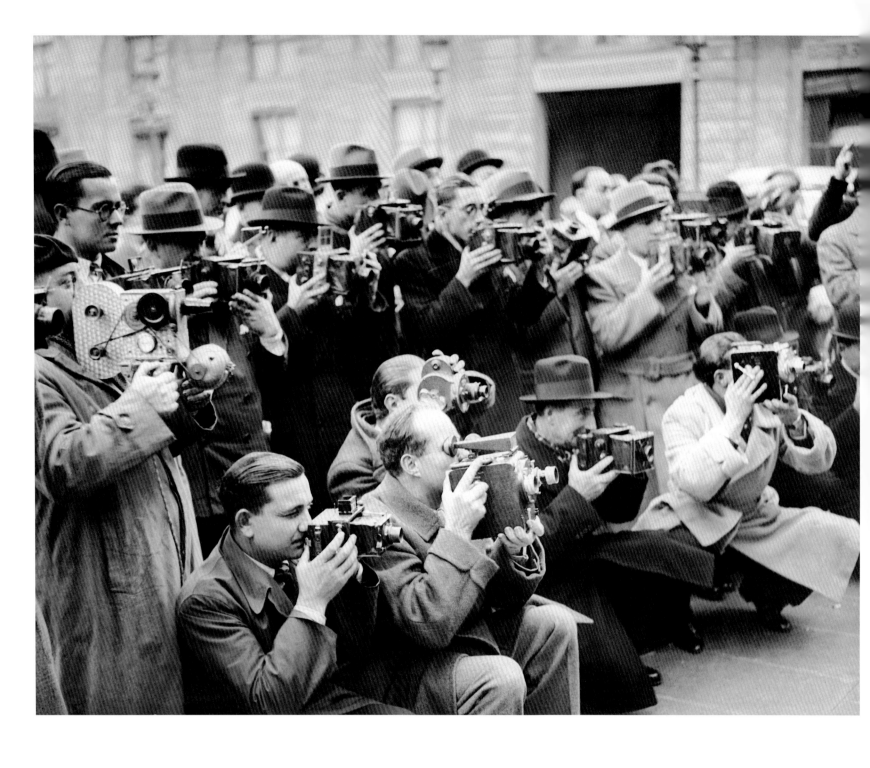

Press photographers outside the Élysée Palace, Paris, 8 November 1934. In a scene that will be familiar from newsreel footage, these press photographers await Gaston Doumergue, the French prime minister, after his government had resigned. They all use collapsible plate cameras and are joined by colleagues holding movie cameras.

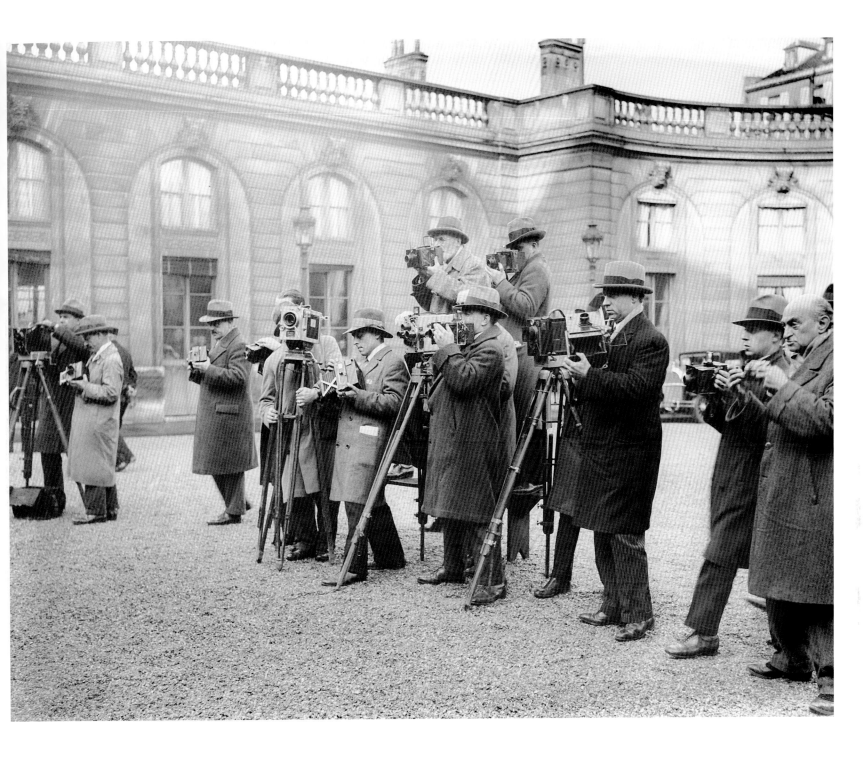

Press photographers outside the Élysée Palace, Paris, 1 December 1930. The photographers are awaiting the presentation of French government minister Théodore Steeg. They have just got their shot and are changing plates ready for the next.

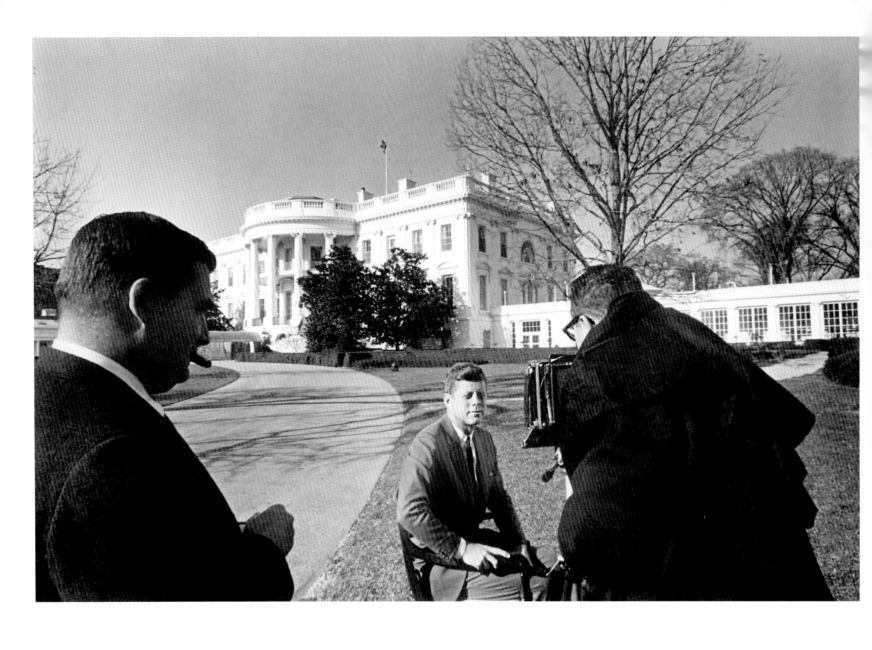

Arnold Newman (1918-2006). Photographer Arnold Newman photographs President Kennedy in front of the White House as press secretary Pierre Salinger looks on, Washington, 12 December 1961.

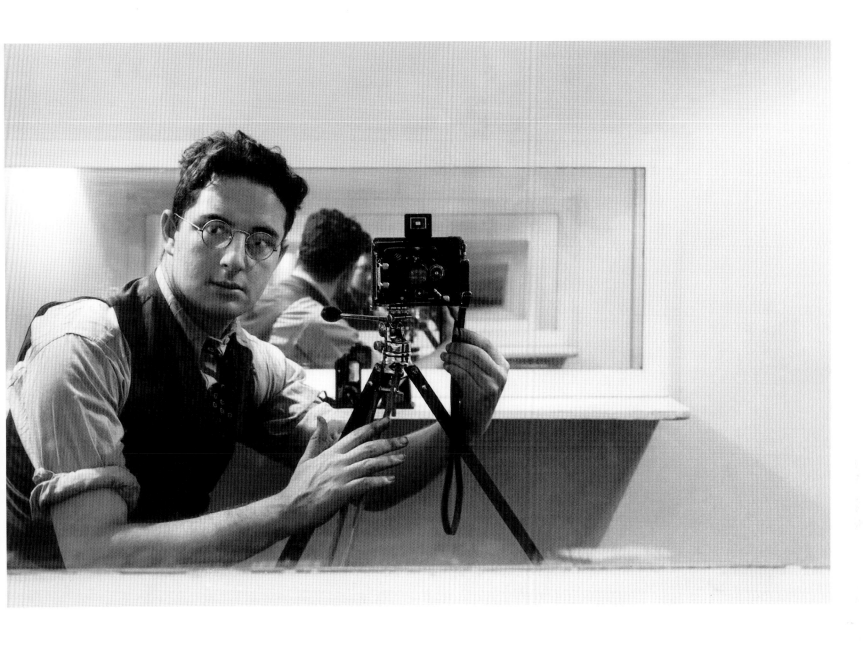

Arnold Newman (1918-2006). Self-portrait, c.1938. Newman is using a typical German folding plate camera from the 1930s.

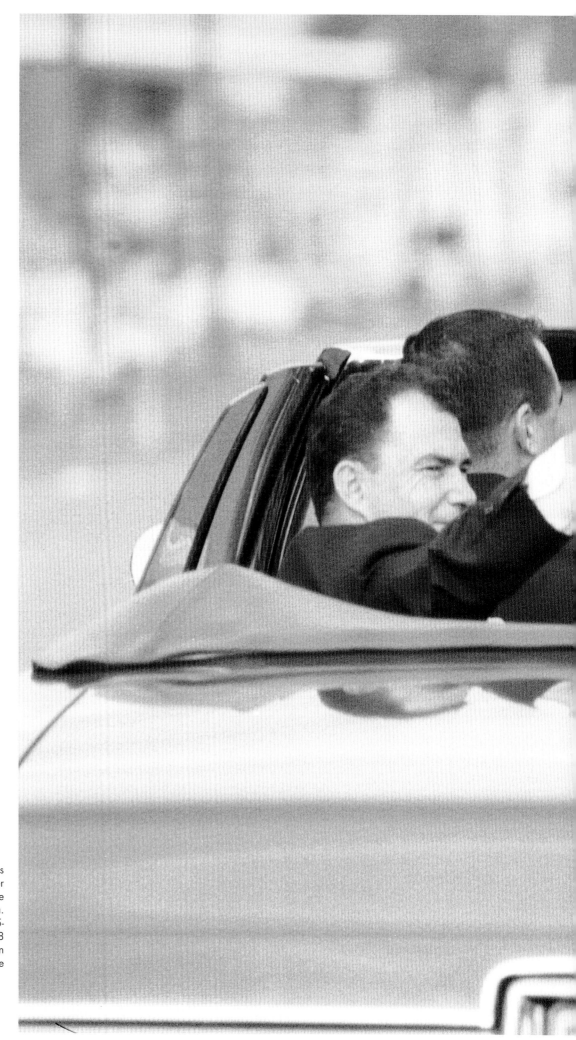

Bill Eppridge (b.1938). Senator Robert F. Kennedy rides in the back seat of an open-top car as a photographer takes his picture during a campaign tour, 1966. The photographer is using a Nikon rangefinder camera. Eppridge, a *Life* photographer, covered Kennedy's (1925-1968) first campaign tour in 1966 and later the 1968 presidential campaign. He photographed the Senator on the floor of the Ambassador Hotel kitchen seconds after he had been shot.

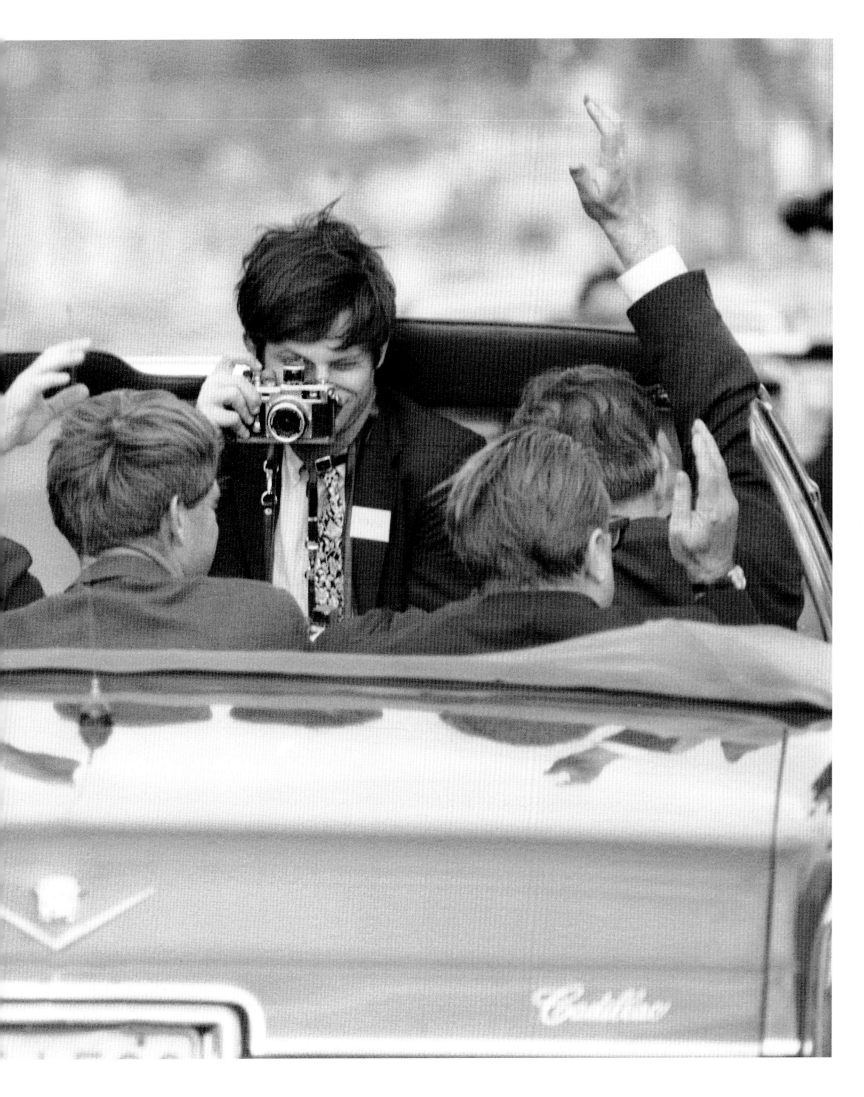

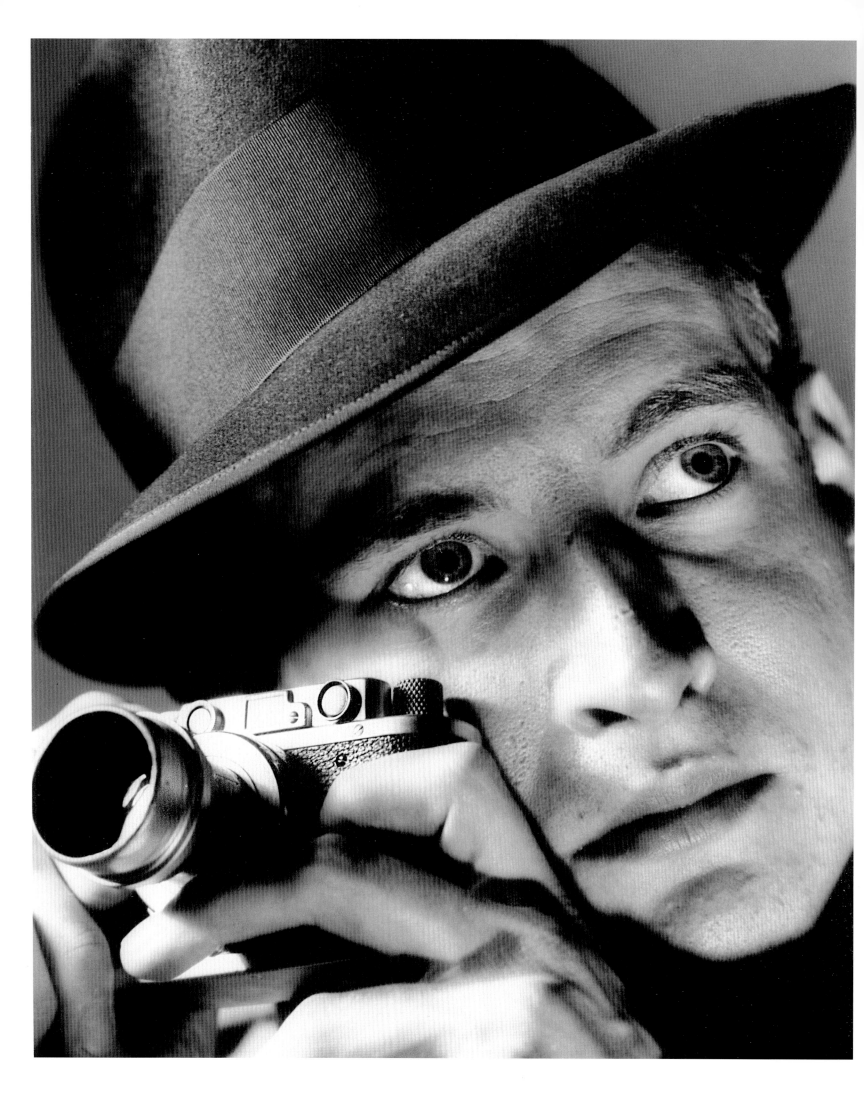

PHOTO CREDITS

A man holding a Leica camera, c.1944.

CAMERAS INDEX

A photographer captures the painting of the Forth Bridge at Queensferry, Scotland, 11 October 1933. The bridge was opened in 1890 to carry rail traffic over the Firth of Forth.

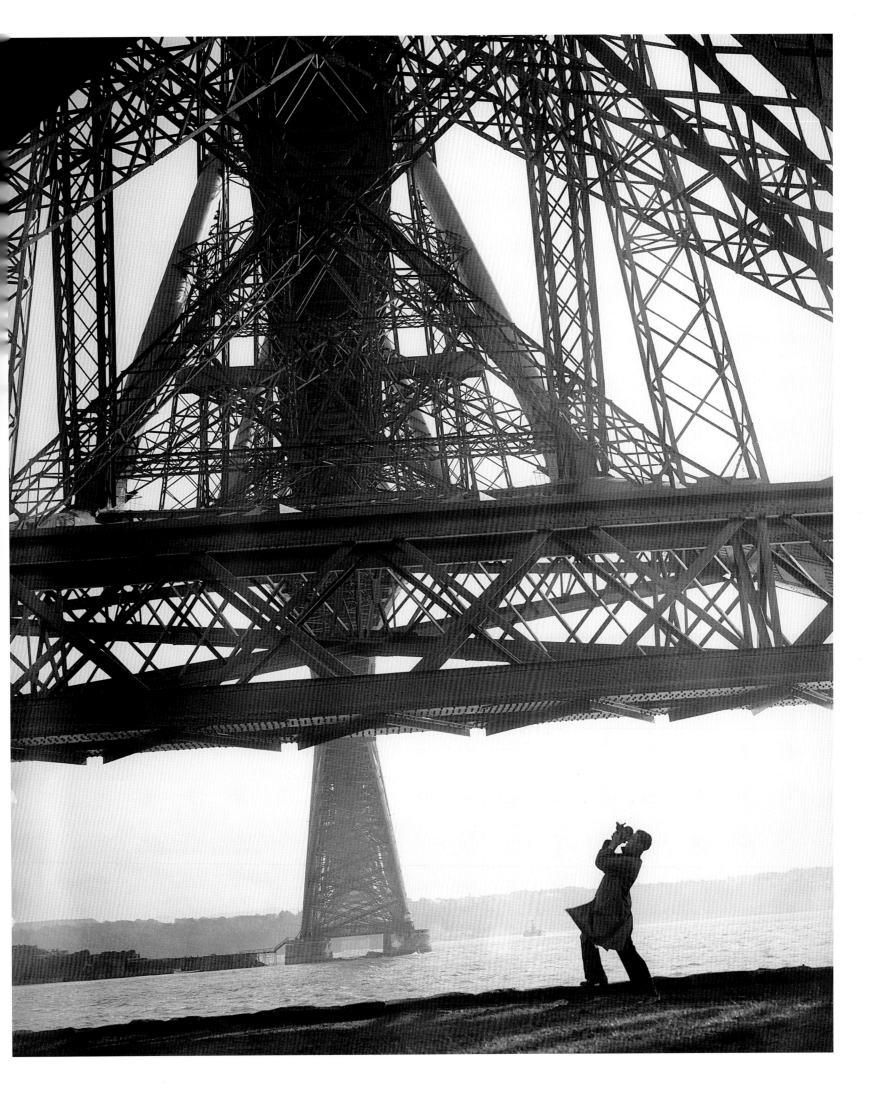

PHOTOGRAPHERS INDEX

Bold – photographer; Standard – subjects (except self-portraits)

A press photographer looks through the viewfinder of a Speed Graphic camera fitted with a side-mounted flash gun, c.1950s.

ACKNOWLEDGEMENTS

We would like to thank the following friends and colleagues for their continual help and support: Lisa Baker, Joseph Baldassare, Daniel Bouteiller, Luisa Brassi, Joe Burtis, Matthew Butson, Priya Elan, Christopher Frayling, John Gall, Leslie Gardner, Richard Garvey, Jim Gipe, Marc Glanville, Colin Harding (Curator, National Media Museum, Bradford, UK), Andy Howick, Andy and Maria Johnson, Sara Lindström, Rick Mayston, June Marsh, Phoebe Martel, Sarah McDonald (Curator, Getty Images), Bill Ndini, Samira Kafala Noakes, Jake Noakes, Bruno Nouril, Hamid and Doris Nourmand, Sammy and Shaeda Nourmand, Frank Osmers, Eric Rachlis, Steve Rose, The Royal Photographic Society (Bath, UK), Philip Shalam, Jonathan Stone, Claudia Teachman, Caroline Theakstone, Michael Wong and The Crew From The Island.

BIBLIOGRAPHY

In addition to the books below there are a number of excellent websites which provide good histories of the cameras described in this book.

Brian Coe, *Cameras. From Daguerreotypes to Instant Pictures*, London: Marshall Cavendish Editions, 1978; Robert Kee, *The Picture Post Album*, London: Barrie & Jenkins, 1989; Ulrich Koch, *Nikon F. The Camera*, Vienna: Peter Coeln, 2003; James L Lager, *Leica. An Illustrated History. Volume I-Cameras*, Closter, NJ: Lager Limited Editions, 1993; Dennis Laney, *Leica Pocket Book*, Steyning: Steyning Photo Books, 2012; Life editors, *The Great Life Photographers*, London: Thames & Hudson, 2004; Willard D Morgan and Henry M Lester, *Graphic Graflex Photography, the master book for the larger camera*, New York: Morgan & Morgan, various editions; Ian Parker, *Complete Rollei TLR Collector's Guide 1929-1994*, St Heliar: Hove Foto Books, 1993; Richard P Paine, *The All-American Cameras: a review of Graflex*, Houston, Texas: Alpha Publishing Company, 1981; Robert J Rotoloni, *The Complete Nikon Rangefinder System*, Hove Foto Books, 2007; Paul-Henry van Hasbroeck, *Leica. A History illustrating every Model and Accessory*, London: Sotheby Publications, 1993.

Monte Fresco (b.1936). Hungry pigeons perch on the camera of a Topical Press photographer, Trafalgar Square, London, 1 December 1956. Fresco had a long career as a press photographer starting aged 14 years in the 1950s. He joined the *Daily Mirror* in 1958, becoming Chief Sports photographer. He was awarded a MBE in 1995 for services to sports photography.

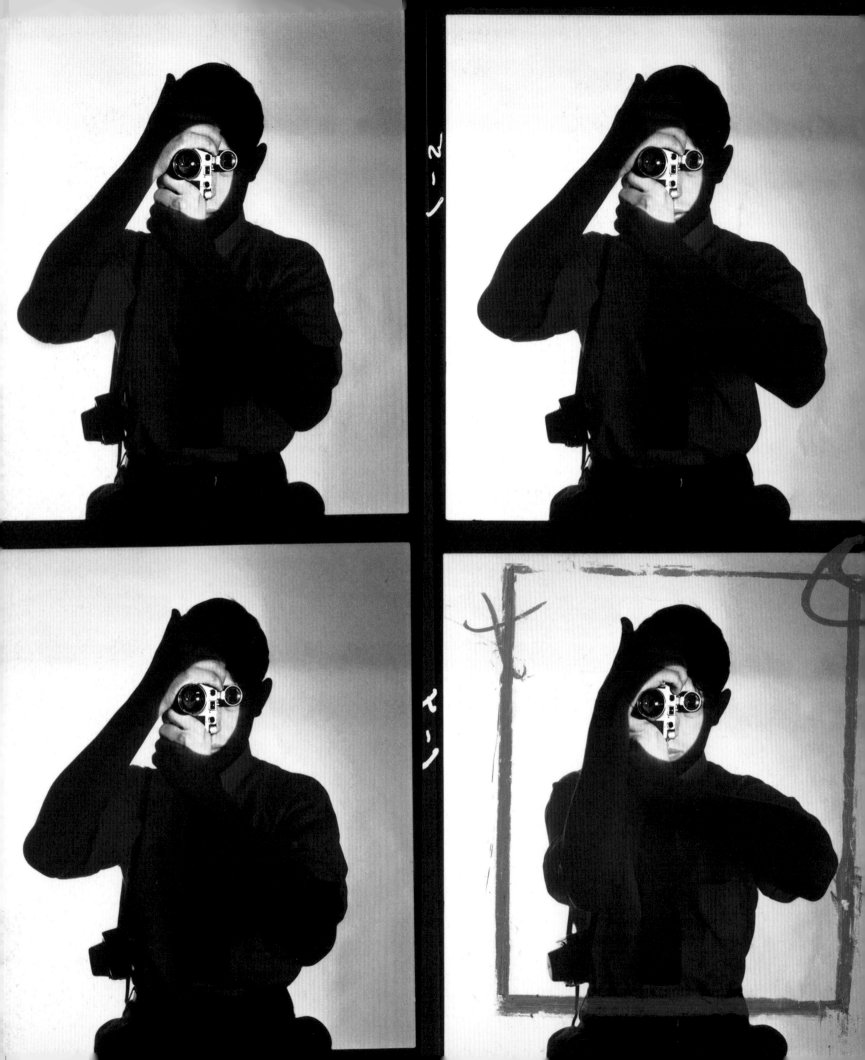